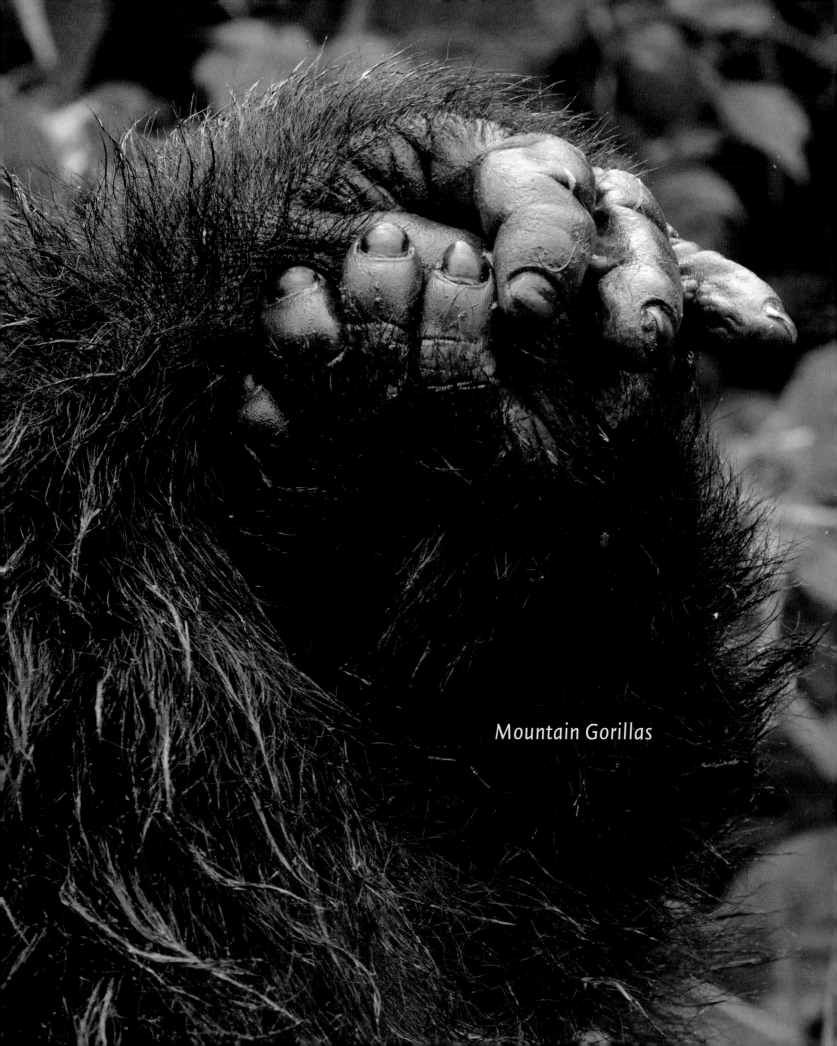

Mountain Gorillas

MOUNTAIN GORILLAS

Biology, Conservation, and Coexistence

GENE ECKHART AND ANNETTE LANJOUW

THE JOHNS HOPKINS UNIVERSITY PRESS *Baltimore*

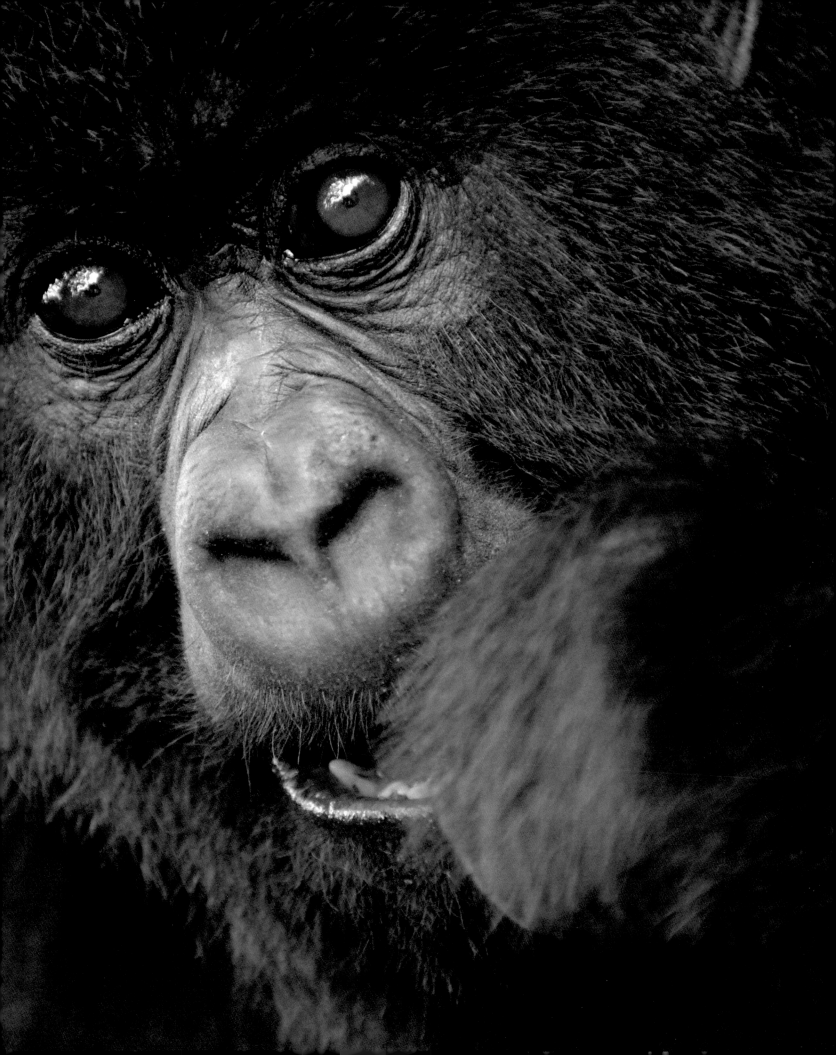

The authors wish to thank all of the contributing donors from the Mountain Gorilla Education and Policy Program for making copies of this book available at no cost to the governments of Rwanda, Uganda, and the Democratic Republic of Congo.

Special thanks to Darlene and Jeff Anderson.

The Johns Hopkins University Press
2715 North Charles Street
Baltimore, Maryland 21218-4363
www.press.jhu.edu

Library of Congress Cataloging-in-Publication Data
Eckhart, Gene, 1962–
Mountain gorillas : biology, conservation, and coexistence /
Gene Eckhart and Annette Lanjouw.
p. cm.
Includes bibliographical references and index.
ISBN-13: 978-0-8018-9011-6 (hardcover : alk. paper)
ISBN-10: 0-8018-9011-X (hardcover : alk. paper)
1. Gorilla—Uganda. 2. Gorilla—Rwanda. 3. Gorilla—Congo (Democratic Republic).
I. Lanjouw, Annette. II. Title.
QL737.P96E35 2008
599.884—dc22 2008006465

A catalog record for this book is available from the British Library.

Title page photograph: A close encounter with Ibigwi, from the Amahoro group in Parc National des Volcans, Rwanda.

Photography and Ilustration Credits
Figures on pages viii, 16, 55, 182: © Ivan M. Carter
Figures on pages 40, 42–43, 44–45: © Dian Fossey Gorilla Fund International / Veronica Vecellio
Figures on pages 166, 167: © Richard Hatfield / Delphine Malleret-King / IGCP
Figures on pages 143, 157: © Annette Lanjouw
Figures on pages 82, 217: © Alastair McNeilage
Figure on page 108: © Alastair McNeilage / IGCP
Figure on page 96: © IGCP
Figure on page 107: © NASA / IGCP
Figure on page 225: © 2002 John Bosco Nizeyi
Figures on pages 83, 104: © Martha M. Robbins / MPI-EVAN
Figures on pages 201, 202, 244: © Chris Whittier 2003-6

Special discounts are available for bulk purchases of this book.
For more information, please contact Special Sales at 410-516-6936 or specialsales@press.jhu.edu.

THIS BOOK IS DEDICATED TO THE MEN AND WOMEN OF THE PROTECTED AREA AUTHORITY (National Parks) organizations in Rwanda, Uganda, and the Democratic Republic of Congo, and the field staff from the Karisoke Research Center who lost their lives while protecting the areas' gorillas and attempting to preserve the integrity of the forests in which the gorillas live. Most people are unaware of the fact that so many people were killed in this cause. Theirs was the ultimate sacrifice. This region has suffered the hardships of war and conflict for many years. Still, these people have endured. The rangers, guides, porters, trackers, and camp staff are the people that make the work of research, conservation, and protection, not to mention publication, possible. The world owes them an eternal debt of gratitude. The names below are listed to honor their sacrifice and their memory, even though as this book goes to press, people are still being killed in the Democratic Republic of Congo. This list will no doubt be out of date by the time the book is available. All the more reason for this dedication and making the world aware that this has happened, and continues to happen.

RWANDA: Mathias Mpiranya, Gratien Nsabimana, Biganza, Vatiri André, Ntahontuye, Bapfakwita Vincent, Nshogoza Fidele, Sebazungu Leonald, Banyangandora Antoine, Ntibiringirwa Felicien, Harerimana Maurice, Mpiranya Mathias

UGANDA: Ross Wagaba

DEMOCRATIC REPUBLIC OF CONGO: Makabuza Kabirizi, Gakoti Zirimwabagabo, Murasira Bisukiro, Ruzuzi Manzubaze, Nzabandora Kalema, Ndimubanzi Mujinya, Kanyarwunga Nzabakurikiza, Karabaranga Rumazimizi, Masira Bosenibamwe, Bahati Rwakadigi, Sebihaza Singirangabo, Kaburembo Mporwiki, Bakenga Biryumuramu, Bendandunguka Baheba, Dunia Kanyamwa, Magayane Semidiburo, Ndangoma

Mutshinya, Ndimubanzi Maheshe, Ndumvago Barirumiza, Sendegeya
Ngendahimana, Ndibwami Habimana, Assani Bita, Barawigirira Kamoso, Bavanyuma
Hishamunda, Bibare Hakizumwami, Gahakwa Sebichamwa, Gasigwa Musamba,
Habimana Karonkano, Habimana Kwezi, Katsuva Matembela, Kazingufu, Majagi
Ntachobitwaye, Mbuzukongira Ibrahim, Muhindo Mesi, Ndibwami Kibasha,
Ngerageze Gasozi, Ngirwanabandi Tegera, Ntibahanana Barigora, Ntukwanumva
Gahinda, Ruvebo Bangirane, Sebinyenzi Semalaba, Sebiraro Baziyaka, Sindibuze
Bashiritimwe, Batunguka Sendegeya, Bizimana Kabagema, Kabagema Gatabazi,
Kasekura Munyangabe, Maliro Gasigwa, Munyandekwe Ndimurwango, Mutangana
Subwanone, Nkinamubanzi Murara, Nzabavanyuma Gachuma, Rwakadigi
Ntahorugiye, Semakuba Halarimana, Machozi Nzanzu, Ndorevutse Safari, Bajakahe
Shirambere, Hamisi Shabani, Kambale Kinda, Kambale Kipasula, Kambale Simisi,
Kambere Makasani, Kaposo Mugheni, Kasereka Katerya, Kasereka Shangoma,
Kayenga Syaherikola, Kitolu Mathe, Ligilima Kumbonyeki, Lubutu Muhongola,
Mambo Mabe Kanyalire, Mambo Mwendapole, Masimengo Rutega, Masumbuko
Kibesi, Mbwenye Ruhogo, Muhindo Kilumba, Muhindo Mughumalewa, Mungumwa
Saambili, Ntahondi Bangamwabo, Ntahorugiye Rwerekana, Shamukungu Mughunda,
Simpenzwe Ntamugabumwe, Yalala Sikulibasaka, Chimanuka Malyamungu,
Paluku Mabele, Kahindo Kiyirembera, Kasereka Katsala, Kambale Siyitwalwa,
Paluku Mihigo, Kambere Muhindo, Bashali Kaurwa, Muhindo Matimano, Vyadunia
Kanyalire, Kambale Twitebo, Kamondo Mayele, Mburanumwe Bangushaka,
Birangamoya Buregeya, Bakinahe Hakizimana, Bananie Ndorimana, Baryanagamba
Bazikobabonye, Bigororande Nkiriye, Buturu Mbyariyehe, Habimana Serusingi,
Kagano Mbarabukeye, Kalisya Muyenzi, Kambale Idembe, Kambale Musubao,
Kambere Mambo, Kasereka Tasilubakwa, Mashami Gashumba, Muhindo Katshupa,
Mujinya Tembea, Munyalulimbo Idembe, Muzindutsi Ndangungira, Ntarifite
Gasambi, Nzayaha Maniragaba, Safari Kyabehire, Salumu Majoro, Semuhanya
Bizimungu, Simba Ndianabo, Suhuko Ntabo, Bateranya Muhima, Kakule Sindani,
Kambere Mutungi, Kasereka Vutoli, Muhima Hangi Lubutu, Muhindo Silusawa,
Muhindo Tsongo, Mwanamolo Maiyarwindi, Ndianabo Kavuye, Nsanzu Muhire,
Nyakamwe Bihango, Serushago Hamuli, Tuombe Mungu Nyere, Paluku Jogoo,
Burongo Mupira, Kakule Kasay, Kakule Kavuya, Kamate Mutaka, Kanyamibwa J.
de Dieu, Kisuba wa Kisumba, Kwibesha Musekura, Mashara Bimenyimana, Paluku
Mundeke, Syauswa Binikere, Kambale Kasay, Kanyamushari, Katungu Vindu,
Rwamakuba Ntegerimisi, Bazagezahe Budo, Kabuyaya Makombo, Kasambasamba
Mulumyakenge, Semucho Ntabara, Zikama Uwimana, Serumondo Kavuse, Musekura
Imaniraguha, Sebuhinja Semiryango, Sulubika Safari, Barigira Sebahunde, Kahindo
Kambale, Kambale Shaule, Mambo Mamboleo, Mujinya Ndoba, Nendika Mamboli,
Senkwekwe Ntizihiwe, Seti Kasonya, Wambale Humba, Hakizumwami Gasasira,
Musubaho Mubake, Nyambatsi Kyabu, Kabambi Katsomibwa, Kahindo Kambi,
Kasereka, Kasereka Mutamo, Katarukumba Kinyatsi, Masumbuko Makambo, Mathe
Ngike, Matinda Yalala, Moma Mandane, Musubao Tembo, Mutavali Kikulameso,
Paluku Kamate, Paluku Musowa, Paluku Safari, Lutu Vagheni, Kambale Maleka,
Kambale Kahamwiti, Kambale Obesi, Kamwanya Ndioka, Kasongo, Paluku Dunia

Contents

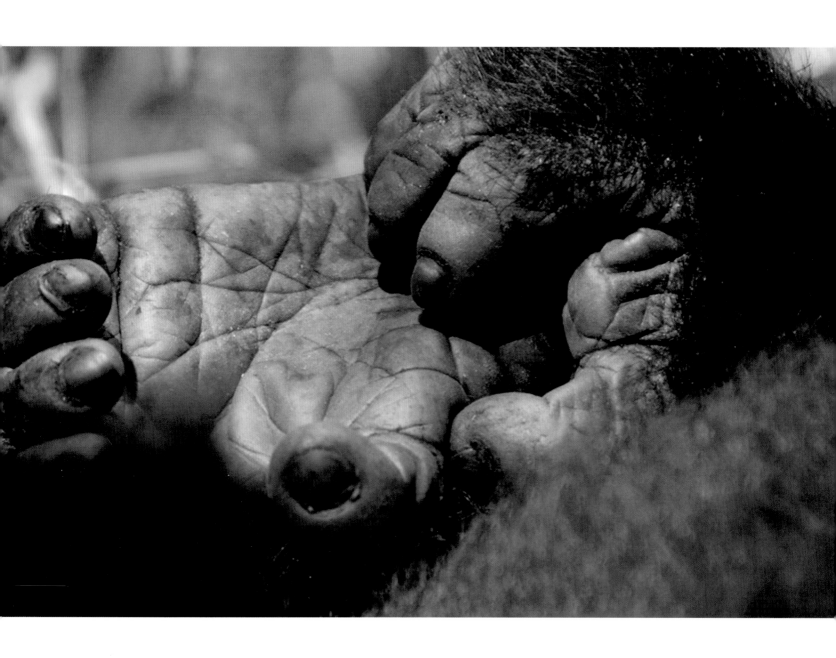

Preface

The paths that led each of us to collaborate on this book were as different as our own backgrounds. We met in the course of research for this book and found that we had very similar convictions on the subject of mountain gorillas. Like all people that spend time in Africa, the differences between our backgrounds quickly dissolved and faded away in the humbling presence of mountain gorillas. That magical moment when you are eye to eye with a free-living gorilla deep in the forest has a way of stripping everything else from your mind and focusing your attention on the things that matter most.

We felt a need to write this book for several reasons. There is the obvious reason: mountain gorilla conservation. But that is merely the surface answer. Underneath lies all that comes together to create, execute, and defend mountain gorilla conservation. Although we wanted to create a wonderful book full of information about mountain gorillas and filled with beautiful photos that all nature or conservation enthusiasts could learn from and enjoy, there are deeper reasons and broader goals for this book. We hope to provide information that will be meaningful and helpful to policy makers not only in Africa, where the mountain gorillas are found, but also in other countries around the world that help to fund scientific study as well as conservation and development efforts. These people and organizations have a tremendous potential for making a positive difference for mountain gorillas, the forests they live in, and the people that live near them. For years, researchers and conservationists have known that the human factor is vital to the conservation equation. They have studied it, written about it, and made recommendations. However, most people are not directly involved with research and conservation and may never see most of these publications. Part of our intent is to make available to a larger audience the valuable information gained through many people's work over the years.

We both feel strongly about the work being done in the Democratic Republic of Congo, Uganda, and Rwanda to save mountain gorillas, to learn more about them, and to help improve the lives of people living near them. It is important work. Our sincere desire is to support and promote that work with this book; for without their work, this book would not have been possible. We hope to inform, educate, entertain, and amuse. At the end of the day, if through this book, we are able to give the reader something to think about regarding mountain gorilla conservation or conservation in general, then we will have succeeded in our mission. For all great actions and victories, including those in conservation, are born when ideas are sparked in people's minds. Who knows where the next great scientist or aspiring conservationist will draw inspiration and make a choice to get involved?

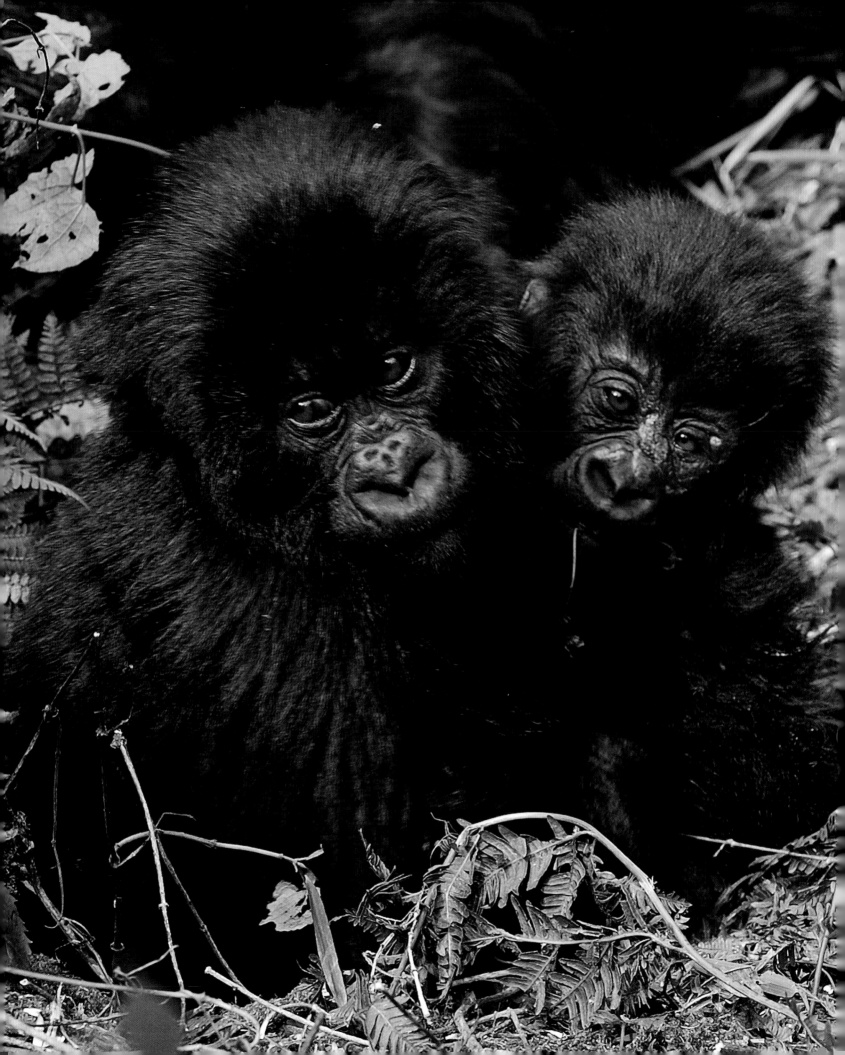

Acknowledgments

GENE

When I first conceived the idea of writing this book in 2002, I thought about all that would have to be done to complete it. The research, the fieldwork, interviews, and so on. I wondered how I would be received by the people I would interview and request things of. How would they feel about an outsider—a photographer of all things—writing a book about a subject most of them had dedicated years of their life's work to, in the pursuit of knowledge, understanding, and protecting this most iconic of endangered species? What I found in the course of researching and writing this book was inspiring and heartwarming. This book could not have been produced without the advice, guidance, openness, kindness, and support of so many people and organizations. Researchers, scientists, conservationists and guides, administrators and travel agents, drivers, porters, and trackers all opened their hearts and minds to me. They shared their data, their knowledge, their wisdom, and their experience so that I might be better able to share their ideas and tell their story; for, in the end, it is their story. I would like to express my profound gratitude to each of them. It is my sincere hope that our work honors theirs and the sacrifices that so many have made for the cause of mountain gorilla conservation.

There are so many people to thank, invariably I will forget someone and for that I am truly sorry; however, there are some that must be mentioned specifically:

First, I must thank the governments of Rwanda and Uganda for permission to work in Volcano National Park in Rwanda and Bwindi Impenetrable National Park in Uganda. I would like to extend a special thanks to Rosette Chantal Rugamba from the Office Rwandaise du Tourisme et des Parcs Nationaux in Rwanda and Moses Mapesa from the Ugandan Wildlife Authority in Uganda for their help and support. I was never able to connect directly with the leadership of the Institut Congolais pour la Conservacion de la Nature (ICCN) in the Democratic Republic of Congo. The ICCN and the people of the Democratic Republic of Congo should know that the hopes and prayers for peace of many people are with them always. Your challenges do not go unnoticed.

Trace and Teague—I want to thank you for putting up with me for the five years it took to complete this book. This kind of work can consume you. Often it was time spent with you that was the trade-off so that the work on this book could be done. I can't adequately express what your love and support meant to me. *Ivan Carter*—You taught me much of what I know of the bush and all that is to be found there. Thank you for the use of your fantastic gorilla photos. *Nancy Duncan and Lindsay Hebberd*—For selflessly sharing your experience, time, thoughts, and advice when I continually asked what must have seemed to be the silliest questions.

Dr. Alastair McNeilage from the Institute for Tropical Forest Conservation and Dr. Martha M. Robbins from the Max Planck Institute for Evolutionary Anthropology—For permission to use your data, chapter reviews, and all the support of the ITFC and MPIEA while I was working in the forest at Bwindi in Uganda. Dr. Katie Fawcett and the staff of the Karisoke Research Center—For access to the Karisoke Library, help with reviews, and all the support of the Dian Fossey Gorilla Fund International while I was working in Volcanoes National Park in Rwanda. Special thanks to Veronica and Felix who patiently answered my questions and allowed me to follow them around while they performed their daily monitoring of the Karisoke research groups. Extra special thanks to Veronica for permission to use her spectacular photos of the interaction between Beetsme's group and Shinda's group.

Drs. Chris Whittier and Felicia Nutter from MGVP—Your support was invaluable during the fieldwork for this book. I cannot even begin to list the number of ways that you helped me when I really needed it. Your friendship is special to me and made it a truly enjoyable experience that I will carry with me always. Dr. George Schaller—For your time, comments, and input on the original manuscript for this book. Your work has always been an inspiration to me. Ground Support—I want to thank Mark Nolting, Steve Turner, Joseph Birori, John Kayihura, Innocent Baguma, and William Karambizi for their fantastic support on the ground in Rwanda and Uganda. You guys are the best. There is truly no way I could have done this without you and your help. You opened doors, facilitated introductions, and made things happen. You handled all of my requests and dealt with a very demanding schedule, all with smiles on your faces. It's you and people like you that make my work possible and getting "the good stuff" attainable. I cannot thank you enough. Vegetation Documentation Teams—I wish to thank Alastair McNeilage, Martha Robbins, Dennis Babaasa, and John Bosco Nkuriunungi for assistance and guidance when documenting vegetation in Bwindi. I also wish to thank François Bigirimana, Felix (Shamba) Smivumbi, and Fidele Nsengiyumva, all professional guides from ORTPN for all their help with the vegetation documentation on the Rwandan side of the Virunga Volcanoes, and for their guidance when trekking.

Special thanks to Amy Vedder and Aimable Nsanzurwimo for their reviews of caption information for the Virunga vegetation. Gorilla Identification—Special thanks to Martha, Chris, Maryke, and Katie for identifying and confirming the names of the individual gorillas. Eugène Rutagarama and IGCP—For permission to reproduce several key graphics and maps. Craig Sholley—For being open and willing to share your thoughts, perspectives, and time with a stranger. Reviewers—I must thank all of the reviewers for their time and efforts in the initial editing of this book, and a special thanks to my copy editor, Andre Barnett. Your notes and comments have improved the manuscript significantly. I thank you all. Glenn Bush—For your insight into the economics of mountain gorilla tourism. John Omvik (Lexar Media) and Crystal Revak (SmartDisk)—Thank you for your generous support of my fieldwork. Your products made a difference for me when it counted most, in production, in the field under

challenging circumstances. *Room and Board*—A very special thank you to David and Loré, Steve and Jane, Chris and Felicia, and Murray for opening your homes to me while I was doing fieldwork for this book. Your kindness and hospitality was heartfelt when I was many, many miles from home. *All of my interviewees*—I want to thank all of the people who graciously consented to interviews. Sharing their time and their thoughts made all the difference in the accuracy of the information contained in this book. You are the true subject-matter experts. My work stands on the shoulders of yours. I know that and I get it. Thank you all.

Dr. Annette Lanjouw—To my co-author, you had an open mind when you met me and you were willing to share. You, as much as anyone, gave me insight and clarity on so many issues. You were patient and kind when helping me to understand my mistakes and how to correct them. You're the best! I can't thank you enough. *Anecto Kayitare and Stephen Asuma*—Thank you for your patience and willingness as you repeatedly tried to help me better understand things from the African perspective. *Vincent Burke*—Our editor and champion. You believed in this book from the beginning and helped to guide it through to fruition. Thank you for seeing to it that this most important story is addressed in print.

ANNETTE

I wish to acknowledge the wardens and guards of the Parc National des Virunga, Parc National des Volcans, Mgahinga Gorilla National Park, and Bwindi Impenetrable National Park that I have worked with over the many years that I have worked on mountain gorilla conservation and conservation in general in this part of Africa. Since 1987, I have had the honor and privilege, as well as enormous pleasure, of working in this most magnificent part of the world. My close and dear friends, Eugène Rutagarama, Anecto Kayitare, and Mbake Sivha have taught me so much and made these years such happy ones for me. Most importantly, I want to acknowledge Conservateur Laurent Muhindo Messi and Conservateur Makabuza, wardens of the Virunga National Park, who died in the conflict in the Congo. Both wardens were not only wonderful friends and colleagues but also dedicated themselves entirely to the conservation of these parks and to the mountain gorillas. Many people have suffered from the conflict in this region, and it is only through their tremendous work and dedication that the rest of the world can still enjoy and marvel at the magic of the Virunga and Bwindi region, and the mountain gorillas.

Mountain Gorillas

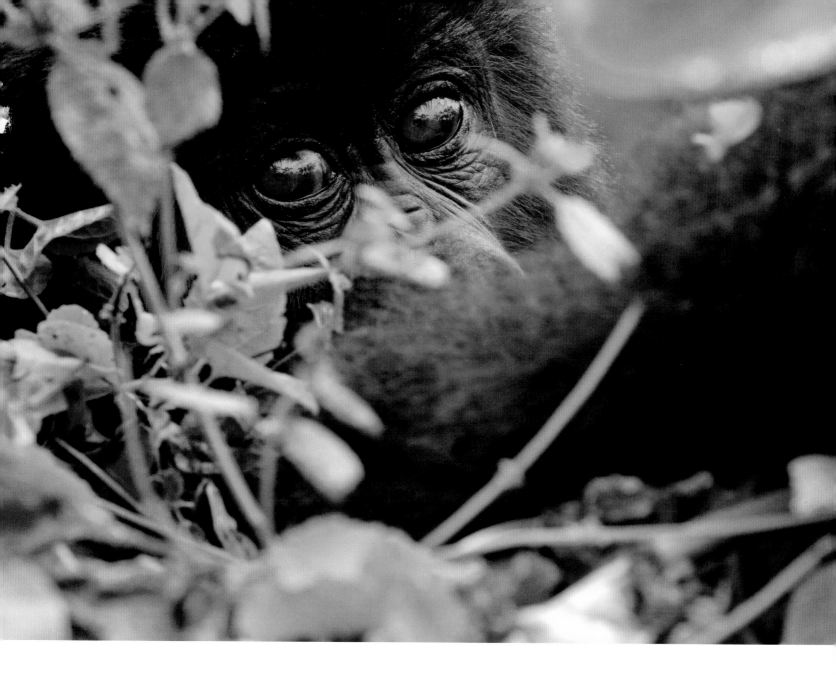

1 THE SUSA GROUP

Face to Face in the Land of the Great Apes

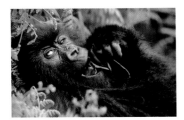

NOTHING MOVED. We had locked our gazes on the face in front of us and now, it was staring right back at us. We were so transfixed by the eyes of the young gorilla; we lost track of everything else on the side of the densely forested, dormant volcano. It was as if the rest of the forest, everything and everyone within it, had faded away. The only thing that mattered was peering out at us through a small opening in the bush. Those clear and deep reddish brown eyes were holding us accountable, not only for our presence within his domain but also for our behavior, and all without uttering so much as a sound or making a single move. Then, as if to drive home the point, there was a sound of breaking branches. We were surrounded. There were gorillas everywhere: in front of us, behind us, and on all sides.

That early June morning was no different than any other on this volcano, some 10,500 feet (3,200 meters) above the sea. The tourists had come from all parts of the world. John was a consultant from the United Kingdom, a wanderer by nature, and seeing gorillas was just another step in his never-ending journey of discovery. Bill and Mary, a retired couple from Australia, were avid naturalists who spent their retirement on safari in other parts of Africa, in South America, and in Asia. Visiting the gorillas was one of the last great nature experiences that they had hoped to accomplish in their lives. Their family was not sure they were up to the physical challenge of hiking through the rain forest at such high altitudes, but Bill and Mary had no reservations. Marie was a young university student from France on holiday. As a girl, Marie had dreamed of visiting the gorillas after reading Dian Fossey's famous book, Gorillas in the Mist. The members of this group had traveled from six countries—America, Australia, the United Kingdom, France, Germany, and Japan. They had come to the Virunga Volcanoes of central Africa with excitement and the hope of glimpsing the largest primate in the world, the critically endangered mountain gorilla.

Previous page: A cautious, yet curious infant mountain gorilla from the Shinda group peers through a break in the vegetation to see who is on the other side. Parc National des Volcans, Rwanda.

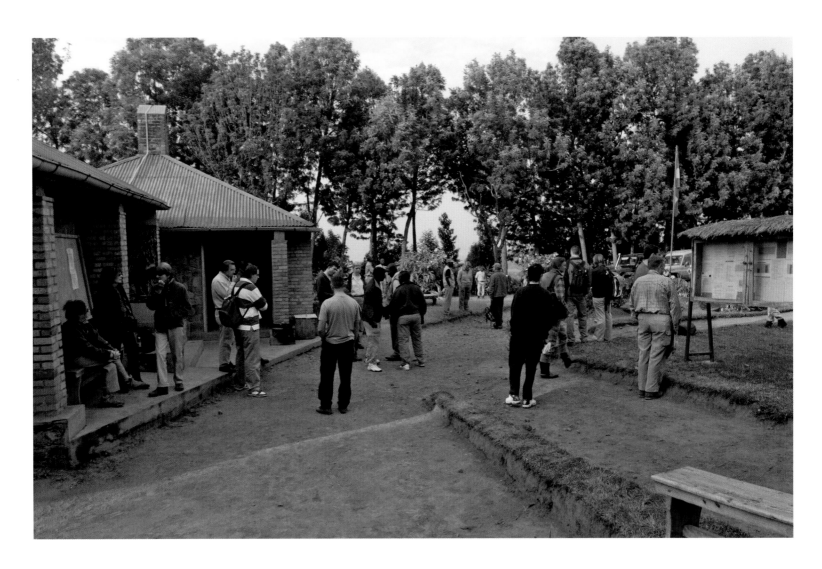

Tourists gather early in the morning at the park headquarters of Parc National des Volcans in Kinigi, Rwanda. The Office Rwandaise du Tourisme et des Parcs Nationaux assigns tourists to a specific group that will visit a particular group of gorillas. After a briefing at park headquarters, each group takes off for the starting point in their gorilla trek for the day.

MORNING came early that day in northwestern Rwanda. John was staying in nearby Ruhengeri town. He was up at 5:00 a.m. to pack his things and grab some breakfast before trying to catch a ride up the rough dirt road to the park headquarters in Kinigi. Bill and Mary had it easier. They were staying at one of the guest lodges near the park headquarters. They had time for a relaxed breakfast and a short drive to the park office. Marie, however, wasn't worried about getting up early. Her excitement had kept her awake the entire night. Coming to Africa to see the mountain gorillas had been such a huge dream for her, she couldn't believe she was actually here. In strained English, she tried to explain it to the others at breakfast. Listening to her and watching her face, it was clear what this day meant.

After converging at the park headquarters in Kinigi, the tourists were assembled and assigned to visit the Susa group of gorillas. It was an official ritual, simple and predictable. Everyone stood in front of the park headquarters building on the manicured lawn sipping hot tea, courtesy of the Rwandan National Parks staff, and watched the organizers move about and make arrangements. Soon the group was briefed by the national parks guides and then loaded into a Land Rover. Slowly, the vehicles bounced and bumped down a rough road with deep ruts carved from the

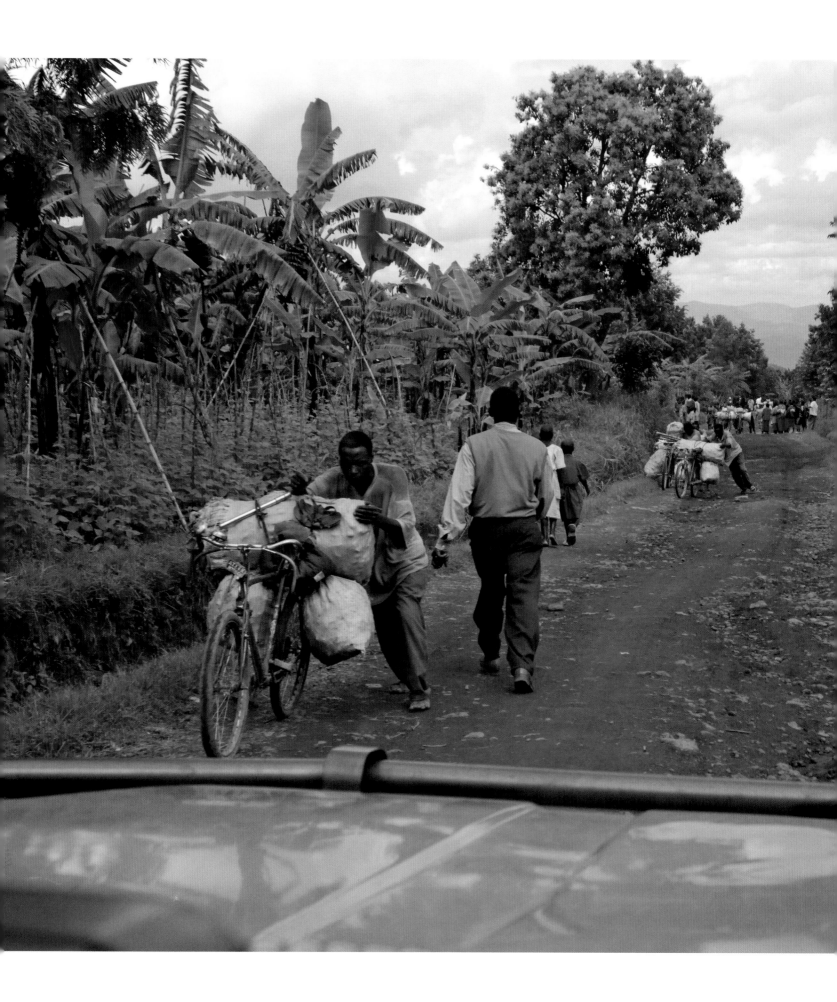

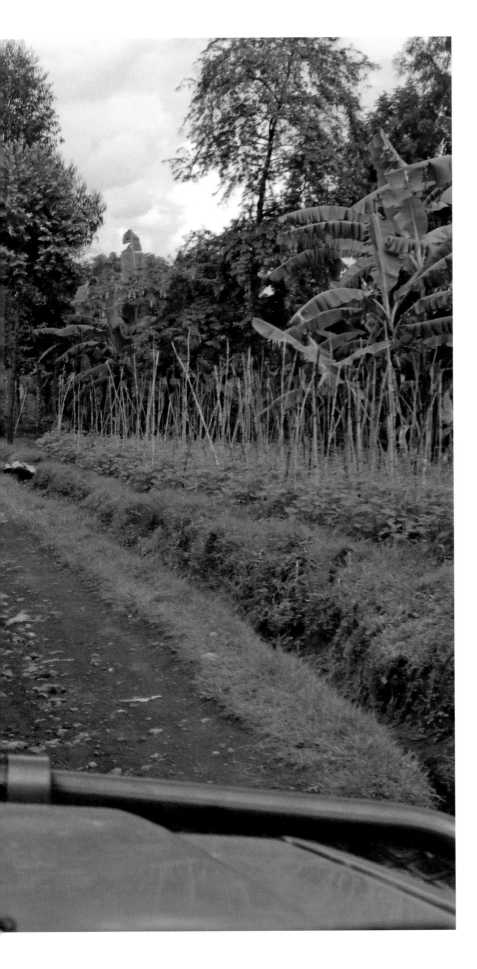

The rural country roads near the Virunga Volcanoes on the Rwandan side are rugged and full of ruts, particularly in the rainy seasons. People can be found everywhere near the parks.

heavy tropical rains of the previous month. Children by the side of the road chased the truck and waved. They laughed and yelled, "Gachupa! Gachupa!" Then they began to look around, taking in the spectacular scenery as the massive Virunga Volcanoes loomed over everything. Every thought, however, was interrupted by the constant bumps that tossed the group from their seats. The guide's last words echoed in the jarred conversations, "When we find the gorillas, you will have one hour to spend with them. One hour."

A light rain fell, as the group made its way through the countryside. None of the tourists reacted to it. The Land Rover eventually turned off the main road, up a side path, and headed straight toward the base of Mt. Karisimbi, the highest of the volcanoes. The driver pulled into an open area near one of the fields, and the group saw the waiting porters, though most of the group had no idea who these people were. The light rain suddenly turned into a heavy downpour, and the porters scattered to find shelter as the tourists sat in the Land Rover. After waiting unsuccessfully for the rain to lighten up, the group decided to get started anyway. Everyone piled out of the vehicle and donned their rain gear. The porters emerged to help carry the group's lunches, water, and backpacks.

After a few minutes, everyone adapted to the rain. We walked about a mile through the farm fields before reaching the forest. What we saw in those fields and what we had seen on the drive from the park headquarters made us worry about the gorillas. People. There were people everywhere. It is shocking to enter a remote sanctuary and see that humans are plentiful. Most of the tourists had never been to this part of central Africa and had expected something perhaps more remote, more like the national parks in the east African savannas or in southern Africa. Although the tourists were aware that forest clearing for agriculture was an issue, even the most traveled of them probably didn't suspect there would be so many people. Finally, the group arrived at the edge of the forest. The questions began: "Are they nearby?" "Have you heard anything?" "Do they know where the gorillas are?"

The guides assembled the group and explained how we should behave when we were with the gorillas. "What do you mean, if the silverback charges?" one of the tourists asked, hiding fear with a grin. The guides reassured everyone. It doesn't happen often, they explained, and if we followed the instructions, we would be fine. "It's so thick in there, I can't see anything," Marie said as she chatted to John. John teased her, "Welcome to the jungle, baby!"

The jungle was thick, and we had to walk single file like soldiers on a march. The guides and trackers cleared the path in front of them. We marched through the rain, continuing up the side of the volcano. The higher we climbed, the heavier our breathing became. Everyone's thighs strained up the increasingly steep mountain. Despite their varying physical abilities, the group struggled forward together, helping each other along the way. Bill and Mary were the oldest but were regular walkers at home. Their family's fears were unfounded because they were often at the front of the pack. The plants along the way changed with the elevation; soon we were

Tourists trek through the forest to see mountain gorillas in the Bwindi Impenetrable National Park, south-western Uganda. It's called "the impenetrable forest" for a reason!

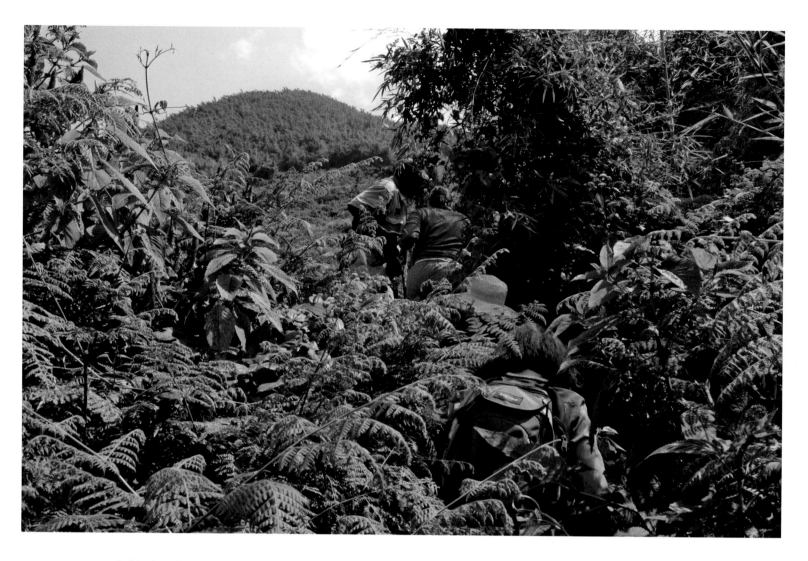

surrounded by bamboo. The forest was thick with it, and everyone had to squeeze between the towering stems to continue the climb up the mountain.

The bamboo zone eventually gave way to the Hagenia zone, named for the spectacular moss-covered Hagenia trees that define this habitat. The only words that can describe it are the *enchanted forest*. It feels magical. Here, one sees giant trees covered with moss and huge branches spreading out in all directions. The trees are surrounded by lush vegetation, and one senses what Eden might have been like.

Despite the breathtaking beauty of the scenery, the struggle was starting to take its toll. We had been walking strenuously for a solid hour or more in the pouring rain. Suddenly, as fast as it had started, the rain stopped. The water dripping off the soaking trees continued to fall, but everyone reacted as if we had finally been given a break. The tourists shrugged off their rain gear and felt their skin breathe again. The smell of damp vegetation was heavy in the air and misty clouds were hanging in the peaks and valleys of the volcano. We were now living the "gorillas in the mist" experience that everyone had traveled so far in search of.

The group continued on for another thirty minutes, when suddenly you could hear the guides talking. They were speaking fast and sounded anxious, but you couldn't

Tourists on the Rwandan side of the Virunga volcanoes in the Parc National des Volcans. This type of trekking is not for the faint of heart; yet, diverse groups of people are able to make it successfully. Desire and spirit carry many people much of the way.

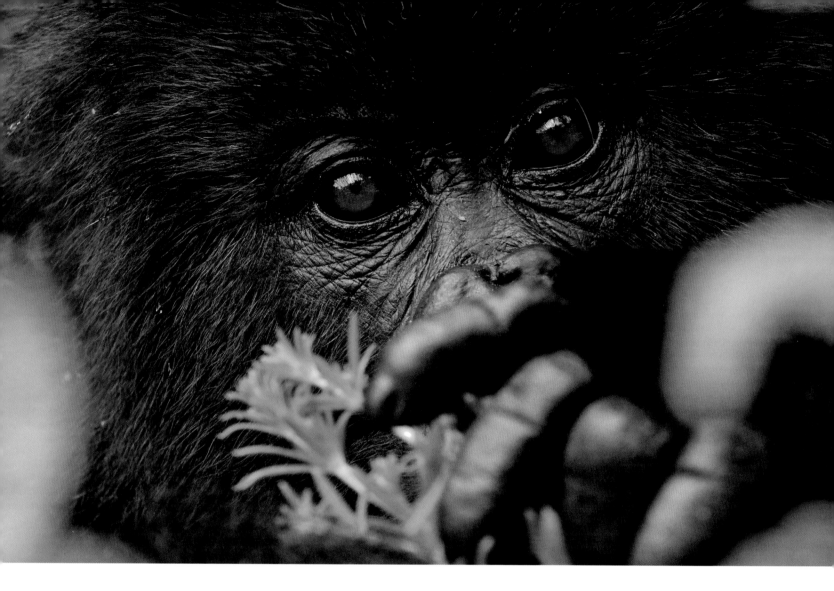

The air was thick with moisture and sweat from the hike as the young gorilla Ikaze chewed on galium vines and other plants nearby. Those deep eyes never lost contact with the visitors. No one wanted to move; no one wanted to go farther. Time stood still as humans and apes were joined in that endless moment of wonder and curiosity about each other, not knowing what the next move would be for the other side. Parc National des Volcans, Rwanda.

make out what they were saying. Then everyone heard it, a rhythmic sound—*pok-pok-pok-pok*. At first, the sound didn't register, but then the light bulb went off. It was a wild mountain gorilla nearby, beating its chest. You could see the excitement on everyone's faces as suddenly we realized they were close. The guides asked us to drop our backpacks, grab our cameras, and proceed slowly and quietly. As we complied, a guide leaned forward and whispered, "Slowly we have one hour; come with me." The timer had started. John glanced at his watch. We crept, quietly following our guides, our eyes mainly focused on the ground to avoid slipping on the dense ground cover; yet, we continued to steal glances up in the trees and all around, waiting for that first look. John glanced at his watch and thought, three minutes in, fifty-seven minutes left. As the group continued slowly through the bush, we encountered an unfamiliar, semisweet odor. The guide recognized it, gently tugged on the first person's shoulder, and whispered, "Gorillas! Gorillas, they are right there!"

About 12 feet in front of the group, two dark eyes from a young mountain gorilla stared out from a hole in the bush, watching the white "apes" slowly creep into its world. If he had looked at it, John's watch would have revealed that we were only five minutes into the visit. The air was thick with moisture and the smell of sweat. All the

while, his eyes never lost contact with us. We were all transfixed. Time stood still as humans and ape were joined in an endless moment of wonder and curiosity about one another, not knowing what the next move would be for the other side. If this had been all we would see, it would have been enough.

The long flights, the hiking, the rain, the mud, and the cold—in an instant, none of that mattered. Yet, soon some of us hoped for more. Bill and Mary signaled that there was only a half-hour remaining for the visit and wondered if this was all they were going to see.

At that moment, the branches snapped. We looked around to see that we were surrounded by thirty-seven gorillas of the Susa group. Roughly one in every twenty mountain gorillas alive in the world was there in front of us. The guides moved us away to a safe area but still in view of the gorillas. The guides cautioned us to move slowly, to keep quiet, and to stay together. John and Marie looked to the left and

Opposite: Giant mossy Hagenia trees and lush herbaceous vegetation surround this silverback from the Beetsme group, one of the research groups monitored and studied by the Karisoke Research Center in Parc National des Volcans, Rwanda.

Below: Two babies wrestle like little boys on the playground. By flashing their teeth and tumbling about, young gorillas begin to develop and test their strength and skills without injuring each other. As adults, they will use these skills as they vie for dominance in the group.

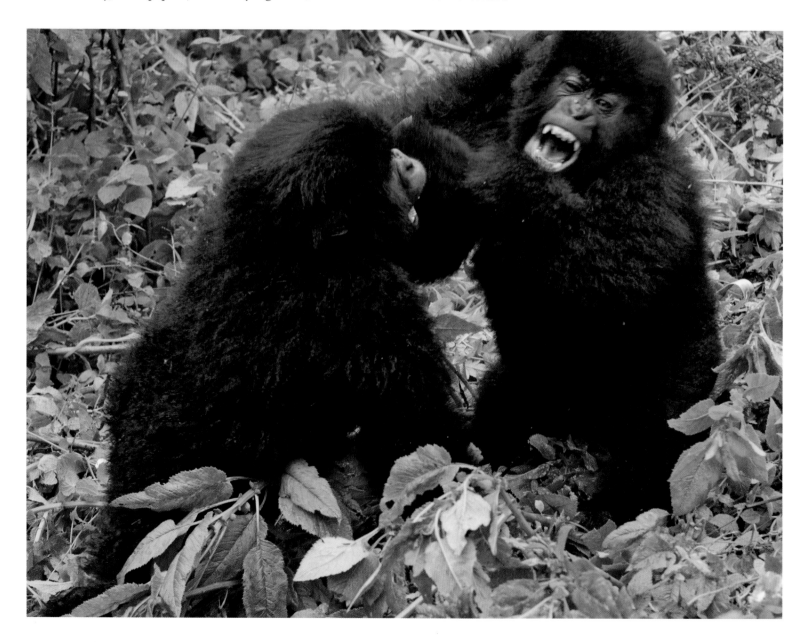

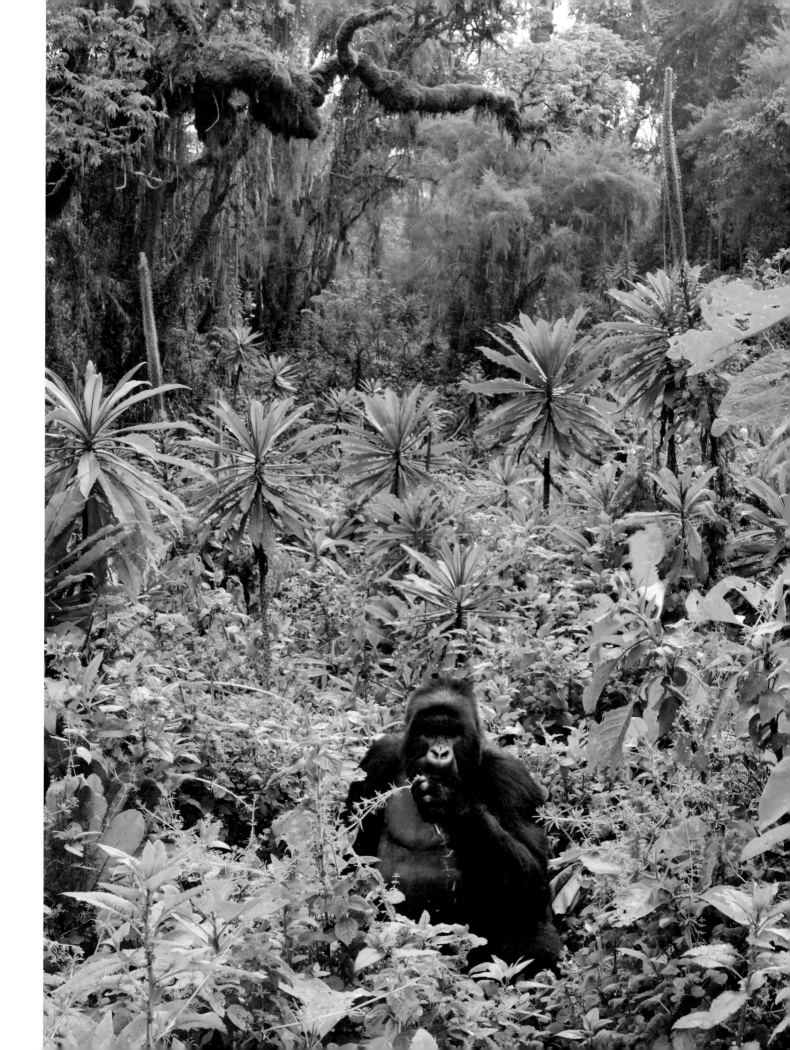

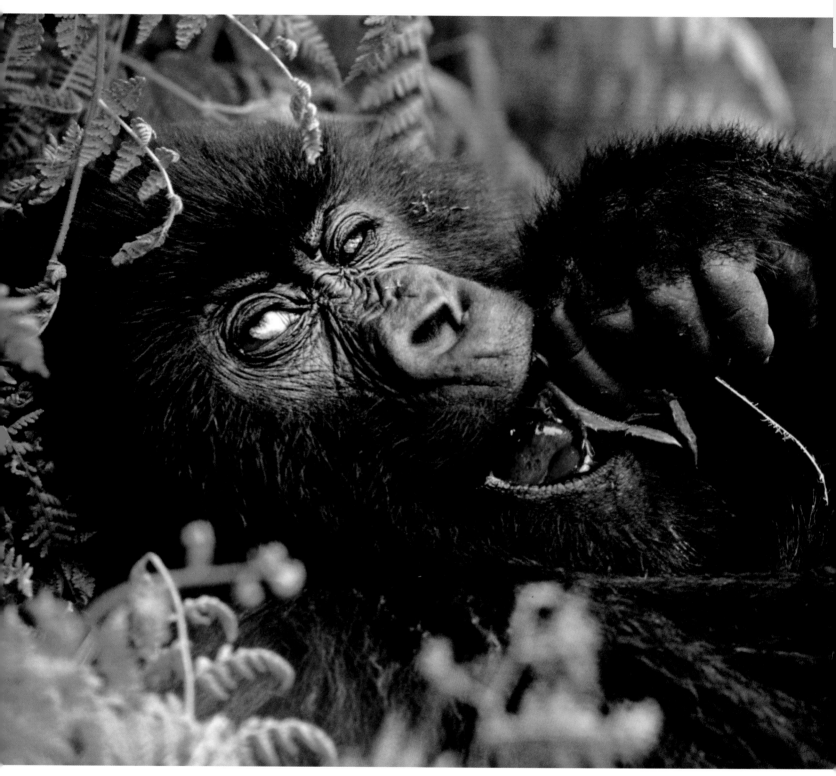

Gasindikira, from Group 13 in Rwanda, keeps a watchful eye while constantly eating. Gorillas possess different kinds of food processing skills that indicate a higher cognitive ability in apes. They have developed methods of processing food designed to overcome certain plants' natural defenses before they eat them, such as sharp, pointy plants like thistles or harsh stinging nettles. By processing the plant parts before ingesting, they can fold and wad parts together to reduce or eliminate any pain that the plants might naturally inflict.

watched a blackback (a subadult male) feeding nearby. They watched as he grasped large amounts of vegetation and meticulously folded it into a wad to stuff in his mouth. Fifteen minutes remained. Bill, Mary, and another tourist watched two babies wrestling; they flashed their teeth and tumbled about like little boys on the playground.

The guides quickly gathered everyone and ushered the group around the corner. With about eight minutes left, the guides wanted to reveal something extraordinary to us. As we walked around a large clump of stinging nettles, everyone gasped—before us were the adult female called Nyabatindore and her twins, Byishimo and Impano. Twin births are a rare occurrence among mountain gorillas, and usually both babies do not survive. Yet, despite the challenges they faced, the twins and their mother, Nyabatindore, seem to be doing fine. Watching Nyabatindore hold her babies close, in such a nurturing and protective way as all mountain gorilla mothers do, we could see the dignity of how these animals care for their young. We were mesmerized and photographed gorillas until the guides whispered, "Sorry, time is up." We slowly backed away from the Susa group and walked down the mountain, past where we had unloaded our backpacks until the guards signaled that we could rest.

We ate our lunch in a small clearing. At first, there was not much conversation. Every face looked affected in their own way. We started making eye contact with one another, asking the most basic questions. Some, like Marie, were simply at a loss for words to describe the experience. The quiet ones savored the experience internally, a sentiment made clear by the huge smiles on their faces that would not go away. Gradually, conversations increased. The questions flowed: Did you notice how much they are like—us? Do they eat *all* day? With so many people nearby, will the forest still be here in twenty years?

THIS BOOK is our effort to answer these and many other questions about the lives and future of one of the most rare and interesting animals on earth. Our theme is this: The fate of mountain gorillas cannot be separated from the fate of the people living near them. The story of gorillas and of people is one and the same—it is a story about coexistence. Peeling away the layers of this story was, for us, a journey into a complex world. We personally knew many parts of the story before we began, but in writing the story for you, we have been affected in how we see it. Mountain gorillas, like the forests in which they live, exist at the edge of survival. They may make it through this century, and they may not. If mountain gorillas survive the rest of this century, it will mean that gorillas and people have found a way to coexist as they share their small part of Africa.

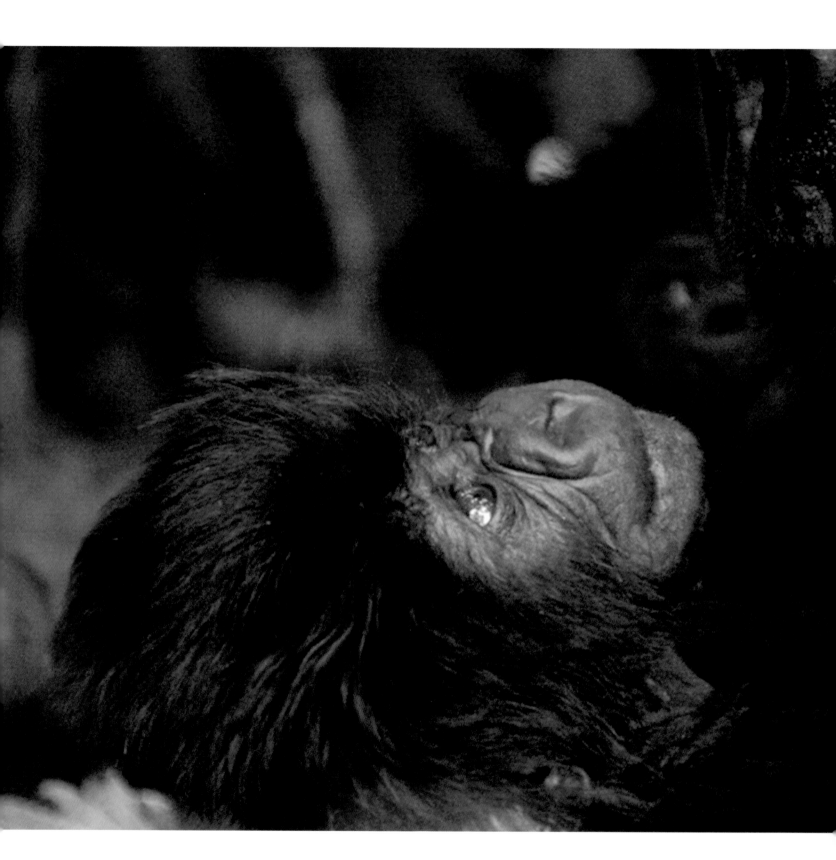

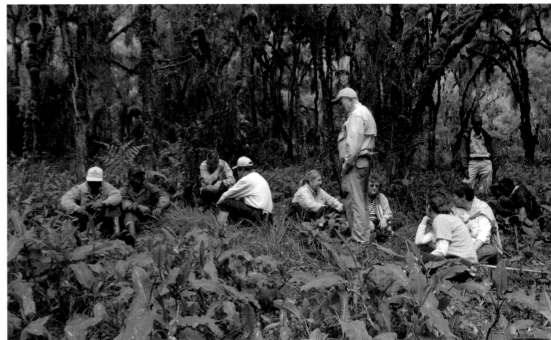

Left: As we round a large clump of stinging nettles, we see the adult female Nyabatindore and her twins. Twins rarely survive, so Byishimo and Impano have been the most publicized gorillas since their birth. They are the star attraction visitors want to see. Watching her hold her babies close in such a nurturing and protective way, as all mountain gorilla mothers do, one is forced to reflect on the dignity of how these animals care for their young.

Above: At first there was not much conversation as the group ate lunch and reflected on what they had just seen. As you looked around the group, there was not a face unaffected, each in their own way. Some asked the person next to them what they thought. Others, like Marie, were simply at a loss for words. They savored the experience internally, huge smiles on their faces.

2 EVOLUTION &
CLASSIFICATION

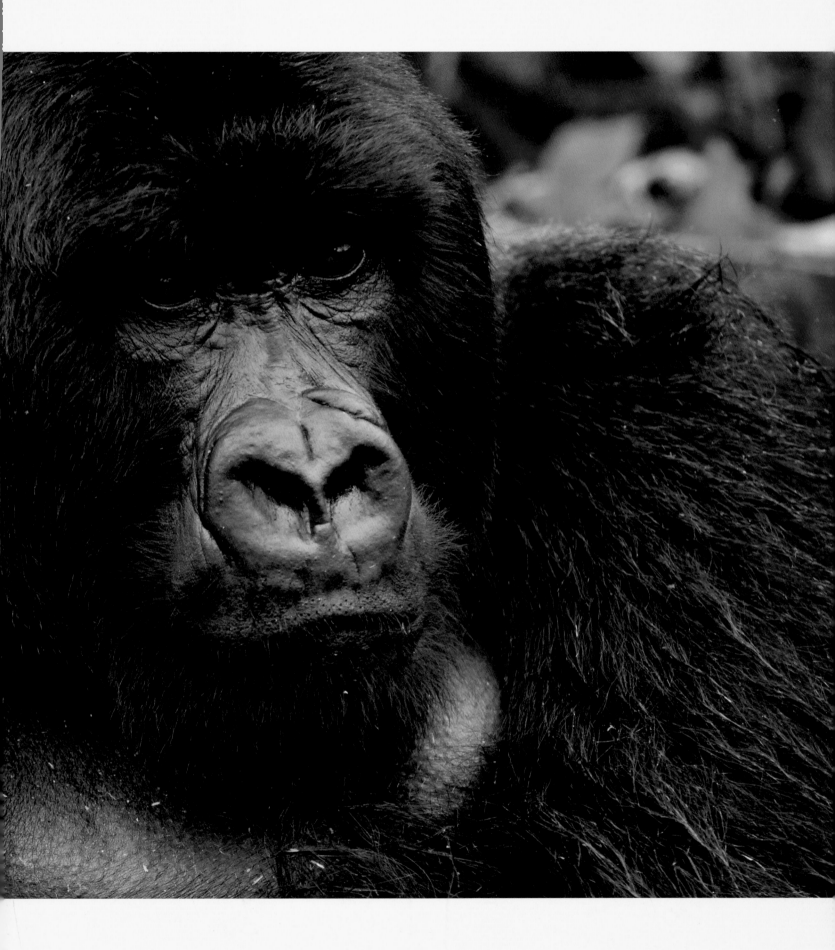

CAPTAIN OSCAR VON BERINGE, credited with the scientific discovery of mountain gorillas, was on a mission in August 1902. His goal was to visit Sultan Msinga of Rwanda before traveling to several German outposts. After completing these duties, he was charged with seeking out and interacting with local tribes in the hope of further promoting German interests in this faraway colony. Part of this mission took him to the Virunga volcanoes where he attempted to climb Mt. Sabyinyo. In his personal log, von Beringe wrote:

> From our campsite we were able to watch a herd of big, black monkeys which tried to climb the crest of the volcano. We succeeded in killing two of these animals, and with a rumbling noise they tumbled into a ravine, which had its opening in a north-easterly direction. After five hours of strenuous work we succeeded in retrieving one of these animals using a rope. It was a big, human-like male monkey of one and a half meters in height and a weight of more than 200 pounds. His chest had no hair, and his hand and feet were of enormous size. Unfortunately I was unable to determine its type; because of its size, it could not very well be a chimpanzee or a gorilla, and in any case the presence of gorillas had not been established in the area around the lakes.

One of these animals was sent to Paul Matschie at the Humboldt University Zoological Museum in Berlin. Matschie later described it as a new subspecies of gorilla and named it in Captain von Beringe's honor: *Gorilla gorilla beringei* (later renamed *Gorilla beringei beringei*).

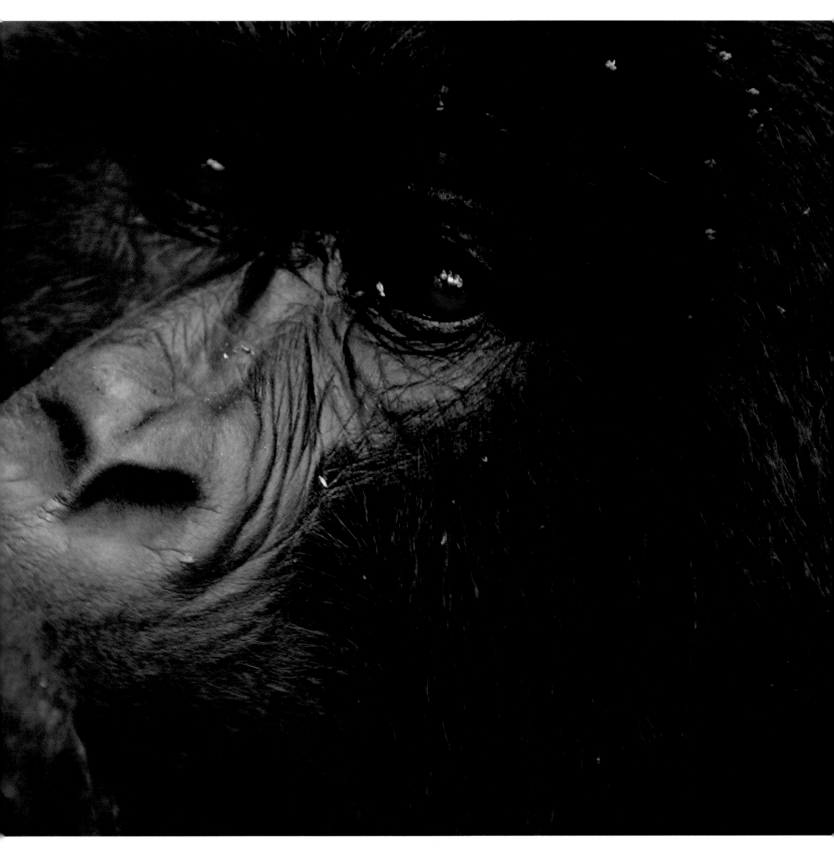

Bunyenyeri, a member of the Umubano group in Parc National des Volcans, Rwanda, finishes a morning feed. In 1902, Captain Oscar von Beringe shot two gorillas, and sent one to Paul Matschie at the Humboldt University Zoological Museum in Berlin, who would later describe it as a new subspecies of gorilla, which he called *Gorilla gorilla beringei* (later renamed *Gorilla beringei beringei*).

The story of mountain gorillas begins before there were gorillas or humans, in the Eocene epoch, between 55 and 34 million years ago. The Eocene was a time of serial warming and cooling of the earth. These temperature fluctuations resulted in the expansion and shrinking of habitats and thus affected the fates of animals across the earth. At the same time, landmasses were shifting and, in some cases, colliding. Continents were joining and separating. Warm tropical environments covered many parts of the planet. Primates in the Eocene were evolving into forms that began to resemble species we see today.

As the temperatures increased and rainfall became scarcer in certain zones, forests shrank and retreated to the areas that constitute our modern tropical zones. This in turn affected the distribution of various forms of vegetation, particularly grasses. The change in plant distribution and diversity likely had a significant impact on the evolution and distribution of land mammals. By the end of the Eocene, many of the Old World monkeys and apes could be found in either Africa or Arabia.

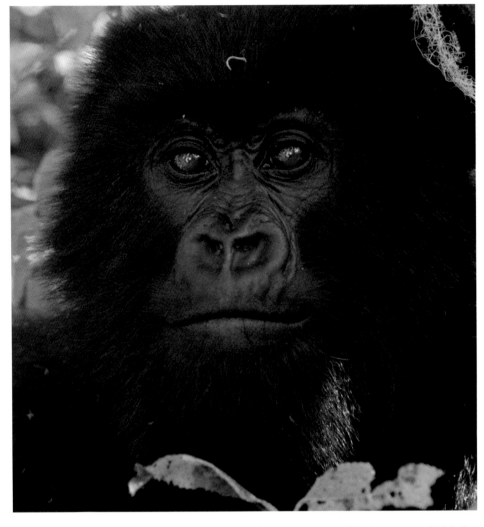

Ishema is a member of the Susa group, which is the largest group of mountain gorillas visited by tourists in the Parc National des Volcans, Rwanda.

The Oligocene epoch followed the Eocene, occurring between 34 and 24 million years ago. Global temperatures had cooled by as much as an astounding 18 degrees Fahrenheit (10 degrees Celsius), creating the first icecap over Antarctica and causing the forests to shrink almost everywhere. At the same time, open plains developed. Many of the modern mammal species, such as horses, cats, and dogs, evolved considerably during this time, while many archaic species became extinct. The brains and body sizes of primates generally increased during this epoch, but primates in what would become the Americas, or the New World, almost went extinct due to climatic changes. The primates of Africa, however, thrived. Based on studies of fossil remains, it is believed that these African primates moved about on all fours, spent much of their time in the trees, and fed primarily on fruits and leaves.

The Miocene epoch followed, lasting from about 24 to not quite 5 million years ago. This 18 million years was characterized by continued environmental change and further diversification of mammal species. The earth gradually warmed, and the

LOCOMOTION

Some scientists suggest that gorillas were arboreal (tree climbing) at one point in their evolutionary past but became more ground dwelling as their size increased, making daily life in the trees prohibitive. Today, you will still see gorillas in trees, although much less frequently than chimpanzees or orangutans. Young gorillas are more often observed climbing trees to create a bed for the night, to take a nap, to seek food, or to simply get a better view. When mature gorillas do climb trees, they proceed with caution, not moving until they are sure of their grip (as compared to some monkeys and other apes, which move from branch to branch with ease). On occasion one may see even older gorillas swinging from branch to branch, a form of locomotion called brachiation.

Most of the time mountain gorillas are observed traveling terrestrially and moving on all fours, or what is termed a *quadrupedal* mode. When quadrupedal, the gorillas distribute their weight on the knuckles of the hands (knuckle walking) rather than on their palms. Occasionally, mountain gorillas are observed walking in a bipedal manner (upright on their hind legs only) and resemble lumbering humans. Rarely do they cover more than 10 feet (3 m) at a time in this manner. Chest beating is typically performed when a gorilla is standing on its hind legs.

Top: Spending much less time in trees than chimpanzees or orangutans do, a mountain gorilla's days are spent largely on the ground. When gorillas do climb trees, going up is easy, but they do so cautiously, making sure of their grip and footing so they won't crash to the ground, sometimes to no avail. Younger, smaller gorillas may ascend a tree to build a nest for the night, to feed, to simply rest, or to take in the view. This female named Mugwere ascends a tree with her baby Happy clinging to her side. Mugwere and Happy are members of the Kyagurilo group in Bwindi Impenetrable National Park, Uganda. The Kyagurilo group is only visited by researchers for the purpose of long-term monitoring and study.

Middle: In trees, gorillas are usually quadrupedal, although they are capable brachiators, as long as the branches are strong enough. Brachiation is the motion of swinging by the arms from one branch or hold to another. Izuba from the Umubano group in Parc National des Volcans, Rwanda, swings and plays on this branch extending over the edge of a deep canyon.

Bottom: Agashya, the silverback from Group 13, chest beats as he dashes out of the bush bipedally. Gorillas usually walk on all fours (knuckle-walk) on the ground. Occasionally, mountain gorillas are observed walking bipedally (upright on their hind legs only). They rarely travel more than a few meters at a time in this manner. Chest beating is typically seen when they are standing on their hind legs. Parc National des Volcans, Rwanda.

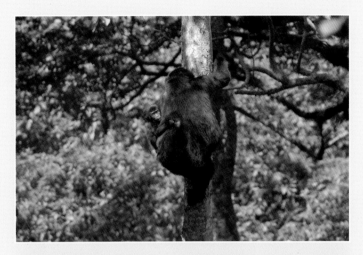

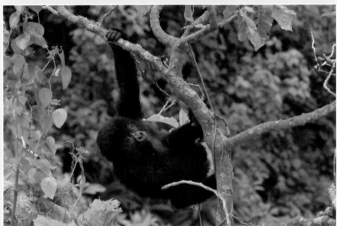

polar cap that had formed over Antarctica melted. Continents continued to shift and additional forest environments in Africa were replaced by open savannas. As Africa became more arid, some of the most significant changes would occur within the anthropoid primates (the anthropoids being monkeys, great apes, and humans, as opposed to prosimians, such as lemurs). There were many species of anthropoids during this time, significantly more than there are today, but the shrinking forests doomed many primates.

The fossil record reveals the presence of the first hominoid primates (the group to which both apes and humans belong) in east Africa during the Early Miocene, roughly 18 to 22 million years ago. The number of fossils available is somewhat limited, and as a result, some parts of the natural history of early hominoids are quite clear, while others are fuzzy. The record is particularly poor in the area where mountain gorillas are found. The rich and acidic volcanic soil tends to break fossils down over time rather than preserve them. Still, several theories have emerged. One holds that between 14 and 16 million years ago many apes migrated from Africa to Eurasia, and existing hominoids are descendants of those species. Most scientists believe, however, that modern apes and humans descended from the hominoid apes that remained in Africa.

About 9 million years ago, gorillas split off from the ancestor of humans and chimps. The genus *Gorilla* was born. About 3 million years later, the lineages that led to modern chimps and humans diverged.

Placing animals (and other life forms such as plants and fungi) into categories is a complex undertaking that involves comparisons based on anatomical, morphological, behavioral, and genetic characteristics. Ultimately, taxonomists and systematists hope to determine the evolutionary history of extant (meaning still living) and extinct species. The categories used in taxonomy range from the very broad to the very specific. The most inclusive category is the kingdom (for example, all animals are in the kingdom Animalia), and the most specific is the subspecies, with the following categories falling between the two extremes: phylum, class, order, family, genus, and species.

Nothing in science is static, and the taxonomy of anthropoids is subject to change with new discoveries and new lines of reasoning. However, many classifications tend to stabilize over time, suggesting that we have arrived close to the true evolutionary history of the group being examined. Gorillas have been the subject of great taxonomic debate, and work continues on the exact relationships of the various types. What follows is a historical examination of the classification of gorillas, up to and including the most recent proposed changes.

In 1847, Savage and Wyman first referenced gorillas, which were described as *Troglodytes gorilla*. I. Geoffroy Saint-Hilaire in 1852 authored and established the name change to the genus *Gorilla*, from *Troglodytes*. The genus *Gorilla* has been an accepted taxonomic classification since that time. The species classification, however, continues to be the subject of ongoing debate. In the first half of the twentieth

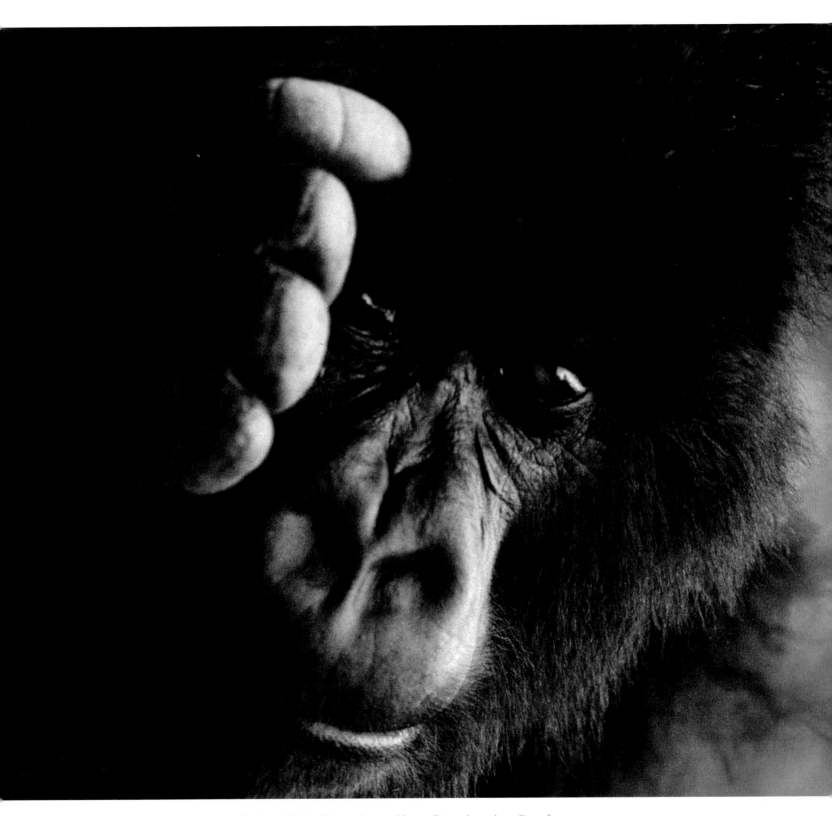

Nothing in science is static, and the taxonomy of anthropoids is subject to change with new discoveries and new lines of reasoning. The scientific classification of mountain gorillas has changed several times over the years and some aspects, such as the classification of the Bwindi gorillas, remain in debate to this day.

The inquisitive look on RwandaRushya's face makes you wonder what the gorillas are thinking when they look at you like this. RwandaRushya is a member of the Susa group in Parc National des Volcans, Rwanda.

century, many names and classifications were proposed. The most widely accepted classification was the result of a study done in 1929 by Harold Coolidge. Coolidge studied over two hundred skulls representing all of the known forms of the genus *Gorilla* and also examined a number of other morphological characteristics. Coolidge concluded that the eastern and western forms of gorilla were, in fact, different. He stated that the differences warranted recognizing two gorilla subspecies.

Coolidge's proposed classification was supported in 1951 when his data were reexamined by A. J. Haddow and R. W. Ross. In 1961, researcher C. Vogel published a paper that first suggested two species: the western gorilla (*Gorilla gorilla*) and the eastern gorilla (*Gorilla beringei*). In 1967, taxonomist Colin Groves proposed that gorillas all be regarded as one species (*Gorilla gorilla*), but with three subspecies. He divided the eastern gorilla into a lowland form and a mountain form, resulting in the following proposed classification: *Gorilla gorilla gorilla* (western lowland gorilla), *Gorilla gorilla graueri* (lowland gorillas found west of the Virungas), and *Gorilla gorilla beringei* (mountain gorillas found in the Virungas and Bwindi).

Groves's classification would remain in place for approximately twenty-five years. Recently (2003), the Primate Specialist Group

TABLE 2.1 | COOLIDGE'S TAXONOMY

Name	Location
Gorilla gorilla gorilla (Savage and Wyman)	West Africa
Gorilla gorilla beringei (Matschie)	Central Africa

Source: Schaller, George B. 1963. *The Mountain Gorilla: Ecology and Behavior.* University of Chicago Press, Chicago.

TABLE 2.2 | GROVES'S TAXONOMY

Eastern/Western	Name	Location
Western	*Gorilla gorilla gorilla*	Western Africa (Gabon, Democratic Republic of Congo, Congo, Equatorial Guinea, Cameroon, Central African Republic)
Eastern	*Gorilla gorilla beringei*	Virunga Volcanoes and Bwindi
Eastern	*Gorilla gorilla graueri*	Region west and northwest of Lake Tanganyika and Lake Kivu

Source: Robbins, Martha M., Pascale Sicotte, and Kelly Stewart, eds. 2001. *Mountain Gorillas: Three Decades of Research at Karisoke.* Cambridge University Press, Cambridge.
Note: This taxonomy was introduced by Colin Groves in 1970.

TABLE 2.3 | CURRENT TAXONOMY

Eastern/Western	Name	Location
Western	*Gorilla gorilla*	Western Africa (Gabon, Democratic Republic of Congo, Congo, Equatorial Guinea, Cameroon, Central African Republic)
Western (Cross River)	*Gorilla gorilla diehli*	Nigeria and Cameroon
Eastern	*Gorilla beringei beringei*	Virunga Volcanoes
Eastern	*Gorilla beringei beringei*	Bwindi Impenetrable National Forest, Uganda
Eastern	*Gorilla beringei graueri*	Region west and northwest of Lake Tanganyika and Lake Kivu

Source: Robbins, Martha M., Pascale Sicotte, and Kelly Stewart, eds. 2001. *Mountain Gorillas: Three Decades of Research at Karisoke.* Cambridge University Press, Cambridge.
Note: In February 2000, the Primate Specialist Group of the International Union for the Conservation of Nature (of which Colin Groves is a member) proposed a revised consensus taxonomy to include two species and four subspecies of gorillas. There is an ongoing debate as to whether the Bwindi gorillas should be a separate subspecies; however, insufficient genetic data are available to make that determination at this time.

Above: This chart illustrates the scientific classification of apes and humans, all part of the same family (Hominidae).

Following page: A young unidentified mountain gorilla in Bwindi Impenetrable National Park, Uganda, gazes at visiting tourists. This gorilla's shorter hair illustrates some of the subtle differences in appearance between the Bwindi gorillas and the Virunga gorillas. The Virunga gorillas living at higher altitudes have adapted to their environment with longer hair.

of The World Conservation Union (IUCN) reviewed the taxonomy of gorillas and defined two distinct species of gorillas: western (*Gorilla gorilla*) and eastern (*Gorilla beringei*). The *Gorilla beringei* species includes the mountain gorilla subspecies (*Gorilla beringei beringei*) found in the Virunga volcanoes and the population in the Bwindi Impenetrable Forest in Uganda. It also includes the subspecies formally classified as eastern lowland gorillas (*Gorilla beringei graueri*), now commonly referred to as "graueri gorillas" found west of Lake Kivu and northwest of Lake Tanganyika in the Democratic Republic of Congo (DRC). The Virungas form a contiguous protected area that crosses the borders of Rwanda, Uganda, and the DRC. Debate, of course, continues. Some researchers believe the gorilla population in the Bwindi Impenetrable National Park of Uganda is unique enough to deserve classification as a subspecies (possibly *Gorilla beringei bwindi*). The differences found to date between the two populations of mountain gorillas are based on ecological and behavioral data, rather than on genetic data, leaving some researchers unconvinced.

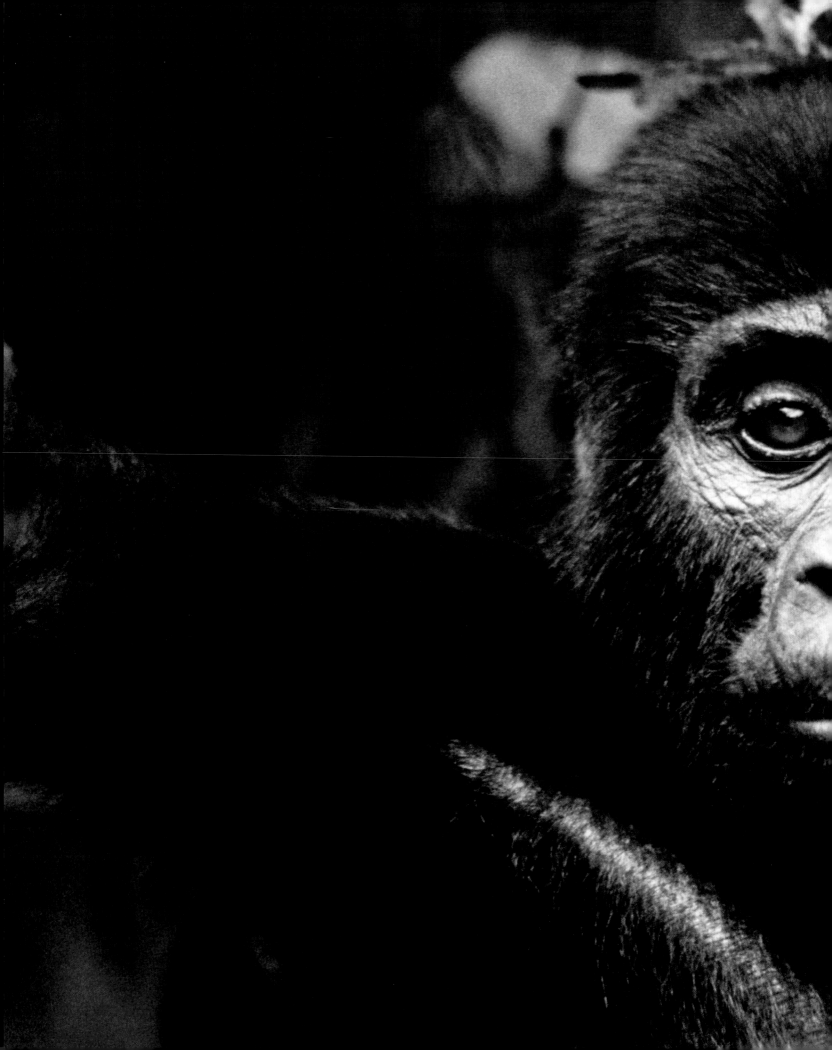

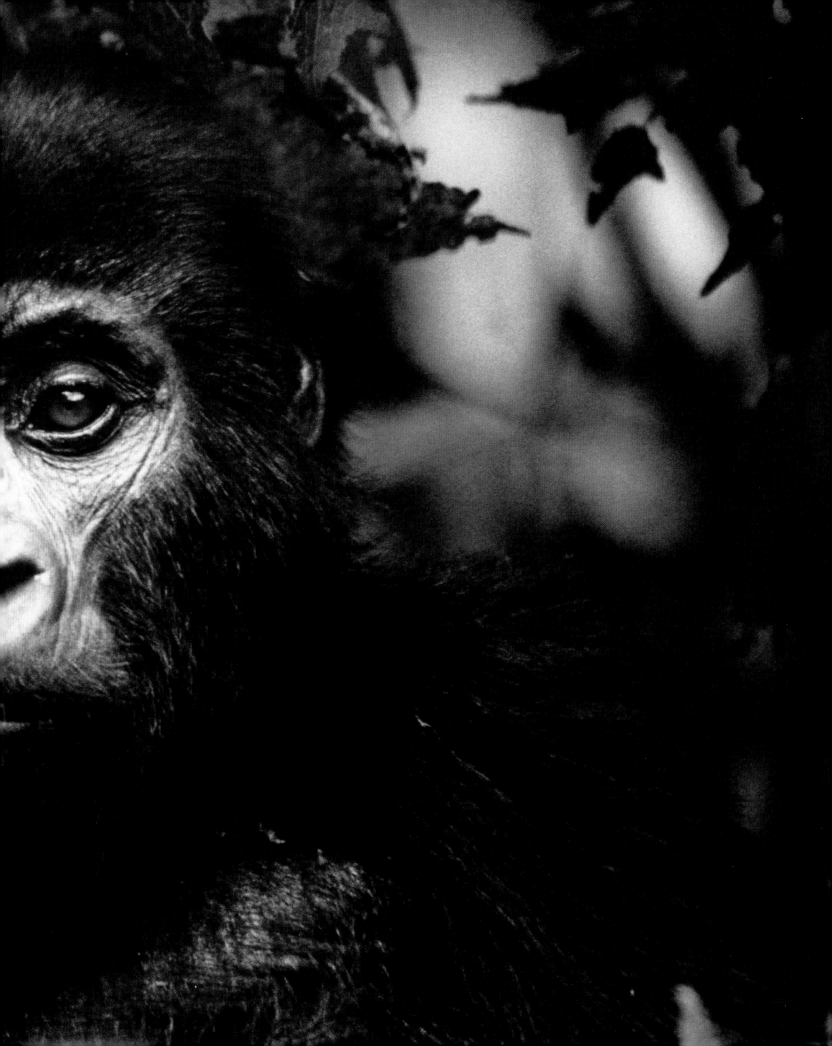

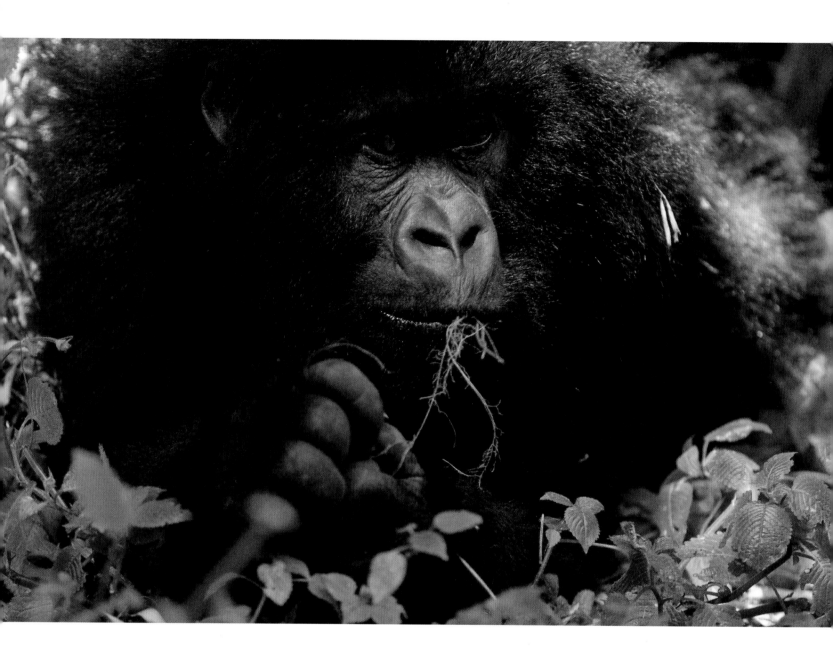

3 GROWING UP IN A GROUP

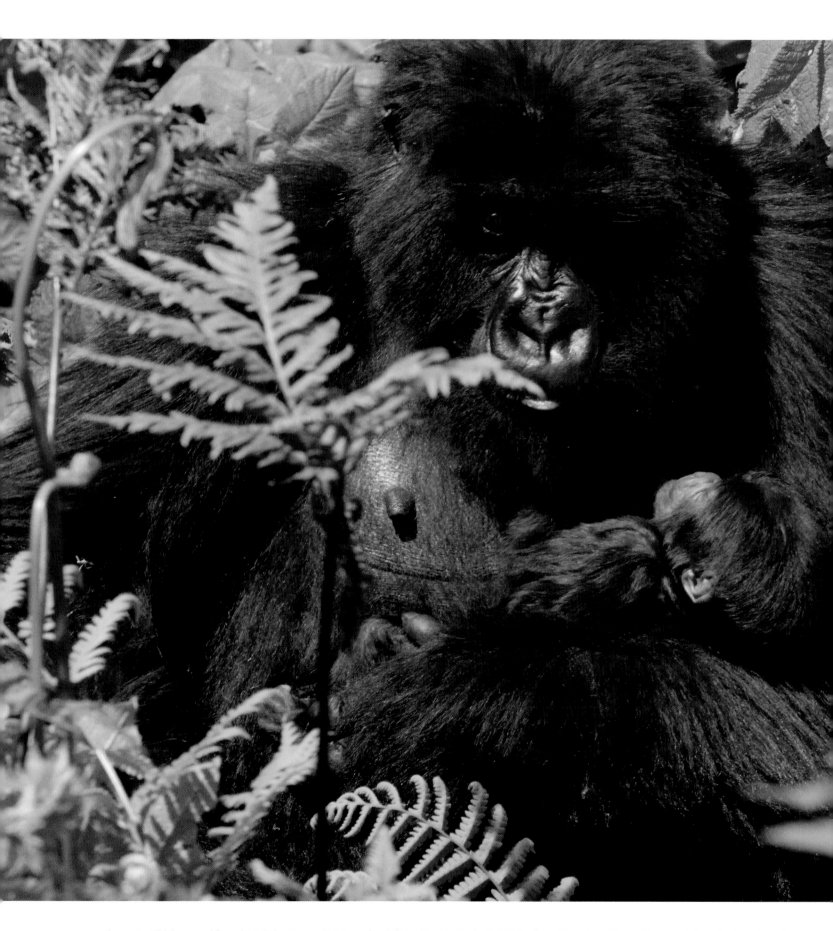

Previous page: Gihishamwotsi from the Sabyinyo group in Parc National des Volcans, Rwanda, lies on the forest floor, casually snacking on whatever is close at hand.

THE PATH of a mountain gorilla's life is largely determined at conception. Two baby gorillas, one a male, the other a female, entering the world at the same time are predestined to become as different as one can imagine. Yet both males and females begin life with little differentiation between them. The bond between an infant mountain gorilla and its mother is virtually unbreakable. The mother attends to every need of her helpless newborn. Unlike many species, which can move soon after birth, mountain gorilla babies are as incapable of surviving on their own as neonate humans. They can feed only from their mother's breast, and they need her for warmth, for shelter, and for transport. These babies must be protected, fed, cared for, and taught how to exist in this new world with all of its dangers.

As the babies grow, their senses develop too. Their sight, hearing, and smell will be comparable to humans. Their vision will be acute, allowing them to detect virtually any movement throughout their environment. They will also learn the sounds of the forest over time. As they mature, sounds that are out of context will stand out, such as an intruder entering their midst. Although smell will be an important sense, they will often rely on sight to confirm what their noses detect. Even up to the age of one year, infants of either sex are rarely allowed to wander more than a few meters from their mothers. The Karisoke Research Center, part of the Dian Fossey Gorilla Fund International, has monitored several of the

REPRODUCTIVE CYCLE

Actual observations of gorillas mating in the wild are fairly common. The reproductive cycle in gorillas is similar to that of humans. The menstrual cycle of gorillas is very similar to humans, typically a twenty-eight-day estrus cycle. Once impregnated, the gestation period for a gorilla typically averages around 255 days—estimated from captive studies. The average human gestation period is approximately 265 days with a variation for both species of fifteen to twenty days.

Agashya, the silverback from Group 13, mates with the female Icyuzuzo in Parc National des Volcans, Rwanda. Mating occurs once the politics and dynamics of mate selection have been satisfied. Actual observations of gorillas mating in the wild are fairly common.

groups of the Virunga gorillas in Rwanda for the past forty years. Studies at Karisoke indicate that during the first four to five months, there will be direct physical contact between the mother and the baby 100 percent of the time.

After months of complete focus on their mothers, the infants become more interested in the world around them. They begin to notice other members of their group. As the months pass, and as their physical skills increase, infants wander throughout the immediate area of the group as they rest and forage for food on their own. At a year old, mothers slowly allow their young to become more independent and to express their curiosity through increased social interaction within the group. This often takes the form of playing with other infants. As the "one-year-olds" become more integrated over time, they begin to leave the watchful gaze of their mothers, but only for brief periods. Independence has its cost. Mothers begin to wean them, and deny milk to their offspring. The young gorillas are sometimes furious at their mothers' refusal. However, they must find their own food and get less of their nutrition from milk.

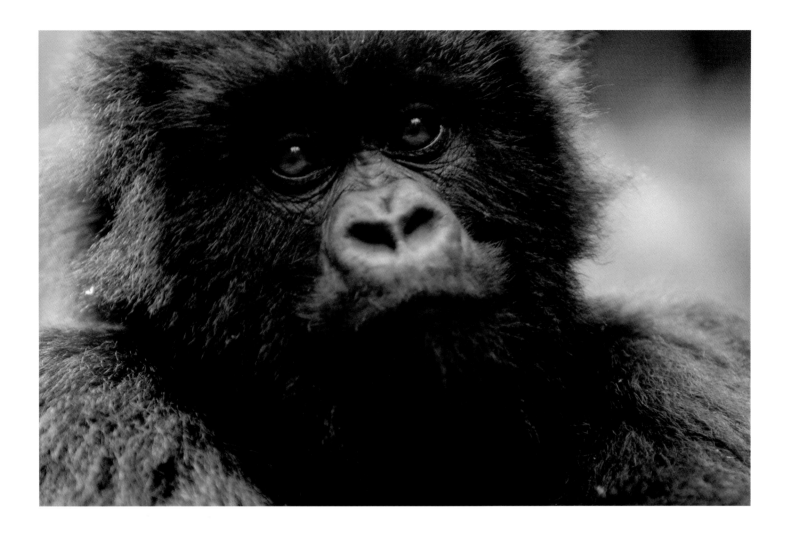

Shirimpumu is from the Sabyinyo group in Parc National des Volcans, Rwanda. Infanticide or expulsion from the group is one of the greatest risks facing a young mountain gorilla as a result of a transfer or new group formation. The new silverback is not tolerant of immature young sired by another silverback. Unweaned babies could be killed in an act of infanticide. An infant male could be killed or possibly expelled from the group when a new silverback takes over. When a young male is expelled, he will typically take up with an all-male group or live a solitary existence.

Somewhere around thirty months of age, the young are weaned and spend only half their time with their mothers. There are exceptions to this rule: the age record for a gorilla suckling is an astounding forty months. At weaning, some of the differences between male and female mountain gorillas start to surface. Typically, female infants are weaned months earlier than males. Mother gorillas may extend weaning in males to improve their sons' chances of becoming dominant and having high reproductive success. Whereas reproduction is almost guaranteed for females that survive to maturity, only certain males will have that chance. Some males will never reproduce, and others will sire a dozen or more offspring. Thus, a mother's early investment in her male offspring gives him a head start in preparation for the competition to come. By weaning daughters when they are capable of feeding themselves, mothers can accelerate their daughters' plunge into independence. At weaning, the mother resumes estrus (becomes able to reproduce again), and eventually, she will devote herself to a new baby.

The greatest risk facing infant gorillas up to the time of weaning is infanticide or, in some cases, expulsion from the group could occur. A change in the status of the group could initiate this dramatic turn of events. If a new silverback becomes the dominant male, he will usually not tolerate young gorillas that were sired by the previous silverback. Babies that have not been weaned are often killed, a fairly common act in the animal kingdom. The new dominant male targets the young before they are weaned to shorten the time it takes for the females to come into estrus again. Soon after, the females are pregnant with his offspring who carry his genes.

After weaning young gorillas are reclassified because they no longer bear the typical traits of infancy. By age four, a gorilla is called a juvenile. Juveniles tend to seek out proximity to the dominant silverback, and he is generally tolerant of them. Grooming of the dominant silverback by the juveniles, and even vice versa, is a common sight.

Even younger gorillas will follow silverbacks around. In particular, if a maternal orphan survives the loss of its mother, it will spend a great deal of time near or in physical contact with the dominant silverback. This appears to further develop the social skills of the young gorilla and makes for tighter integration within the group. It will also help to provide better protection, even from threats within the group, such as attacks by older males.

Much like humans, the emotional well-being of gorillas seems to be a critical aspect of their overall welfare. They have a need to feel comfortable and safe within their environment and in the company of their immediate family or group members. Constant stimulation, often in the form of physical contact, is a hallmark of gorillas' interpersonal dynamics, particularly for infants. Without it, they will eventually become depressed, which could lead to loss of appetite and illness, and in some cases, this could lead to death. As juveniles near maturity, they are typically referred to as "subadults."

Females will become fully mature before males. Noticeable differences in development become obvious between six and eight years of age. As young females mature, they generally leave their natal group to join another social unit. Indeed, it is not abnormal for a female to transition between groups more than once in her life. Males will often disperse from their natal group as well, although it is common for mature males to peacefully coexist within their own group for many years beyond maturity.

Although male gorillas begin copulating at around eight years of age, they become sexually mature and are referred to as blackbacks from around age ten to twelve. The males do not reach full physical maturity until they are between thirteen and fifteen years of age, when the hairs on their backs generally start to become silvery gray, hence the title "silverback." Silverback mountain gorillas are the largest primates in

AGE CLASSIFICATION AND MATURATION

The age and maturation of mountain gorillas are categorized as infants, juveniles, subadults, and fully mature adults. Young gorillas are classified as infants, roughly until they are weaned, which can occur around age three or four years old when the transition from infant to juvenile occurs.

A gorilla between ages four and six is classified as a juvenile. The subadult phase is between six and eight years of age, when females may start to copulate. The transition from immature to mature adult is different for males and females. Female gorillas are classified as adults at age eight and will give birth for the first time on average at the age of ten. No further distinction is made regarding the maturation of females. Male gorillas are sexually mature and are referred to as blackbacks from the age of eight to twelve. The males do not reach full physical maturity until they are between thirteen and fifteen years of age, when the hairs on their backs start to become silvery gray; they are then referred to as "silverbacks."

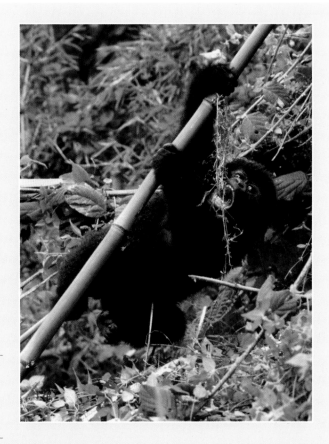

Young gorillas are infants roughly until they are weaned, around age three to four when the transition from infant to juvenile occurs. An animal is classified as a juvenile between ages four and six. This young gorilla is part of the Susa group in Parc National des Volcans, Rwanda.

TABLE 3.1 | AGE AND MATURITY CLASSIFICATION

Age and Sex Class	Approximate Age (in years)	Definition and Characteristics
Infant	0–4	Any gorilla not yet fully weaned from its mother.
Juvenile	4–6	Gorillas that have been weaned.
Adolescent	6–8	Females begin to copulate.
Subadult	8–10	Males begin to copulate. Females begin to give birth.
Blackback male	10–12/13	Males are sexually mature but not fully mature physically.
Silverback male	13+	Males are fully mature.

Source: Stewart, Kelly. 2001. Social relationships of immature gorillas and silverbacks. Chap. 7 in *Mountain Gorillas: Three Decades of Research at Karisoke*. Cambridge University Press, Cambridge.

the world and experience a dramatic increase in size and shape by age twelve. By the time they are thirteen to fifteen, they can easily be twice the size of an adult female, reaching standing heights of over 5 feet and weighing up to 450 pounds.

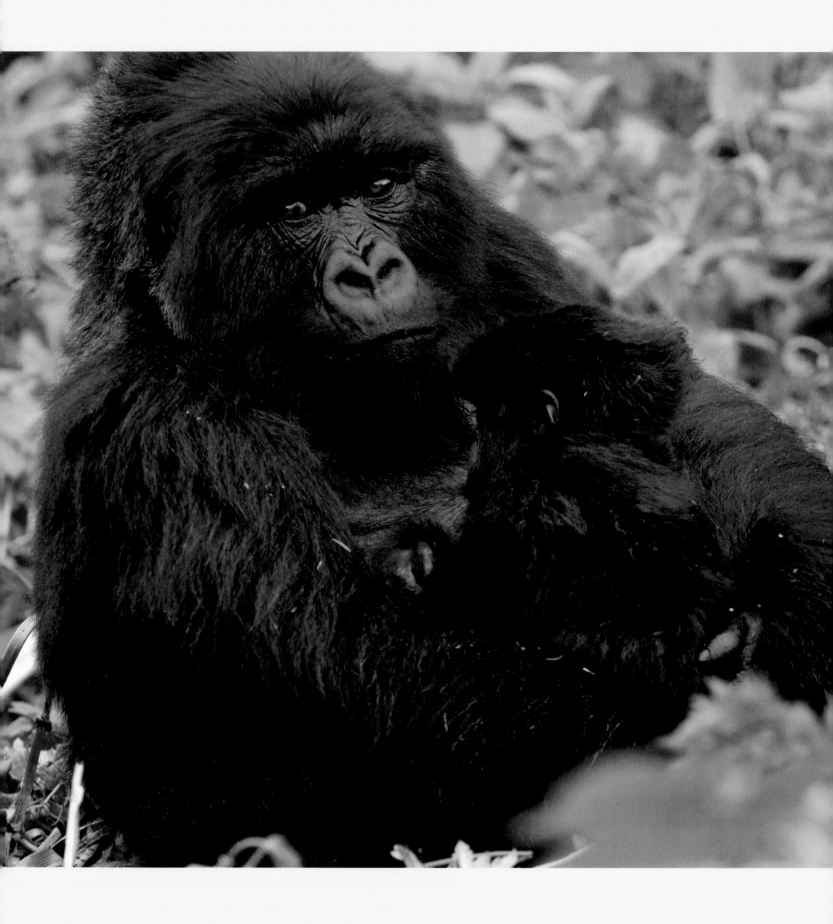

4 THE DYNAMICS OF GROUP FORMATION

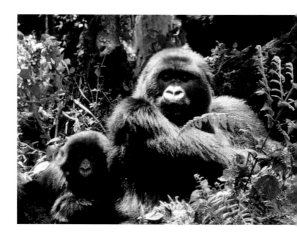

TYPICALLY, mountain gorilla groups are only formed a couple of different ways: through group fission, emigration, and immigration. Fission is when one group of gorillas splits, forming two or more groups. Transfers generally occur when groups interact with one another in the forest, as an individual animal chooses to either emigrate (leave their group) or immigrate into another group. These actions are or can be a result of an interaction. An interaction happens when a group of gorillas encounters either a lone gorilla or another group. These interactions are the key opportunity for individuals to transfer, and mountain gorillas might choose to emigrate from their birth group for many reasons. A gorilla's decision to transfer into or out of a group is based on which group will offer them the greatest advantage to mate and successfully reproduce. These are the fundamental dynamics to the group formation of mountain gorillas.

Males will often disperse from their birth group when they reach maturity. When this occurs, there can be any number of potential outcomes for a mature male mountain gorilla. Some will become solitary silverbacks, wandering the forest and searching for females to start their own families. In one circumstance in the Bwindi Impenetrable Forest, a subordinate silverback left his natal group only to return after a period of time. After returning, there were a series of challenges and confrontations with the dominant silverback in which the latter was ultimately deposed. Had the older silverback accepted the transfer of power more peacefully, he might have been allowed to remain within the group. In this case, he continually resisted, and there was a violent confrontation between the two, resulting in serious injuries to the older silverback inflicted by his younger challenger's massive canine teeth as they ripped a large wound into his head. After being defeated in combat, the older animal left the group and finished his life in a solitary existence while his young rival, now

the dominant silverback of the group, carried on establishing his own legacy and lineage as the undisputed leader.

The reasons that females transfer are different, and a female could choose to transfer more than once in her lifetime. The transfer of females from one group to another occurs infrequently and only during interactions. A female could reach full sexual maturity while she is still in the same group with her father. To avoid inbreeding, a female would have to transfer out of her birth group. The avoidance of inbreeding or a lack of suitable males for mating are not the only motivating factors in female transfer. The size and composition of a group can also be a factor. In some cases, females transfer to smaller groups to avoid competition. In other cases, females will transfer to larger multimale groups because the options for greater reproductive success are higher. In a multimale group, a female may conceive in a shorter time because of access to more males. In addition, offspring are less likely to suffer the fate of infanticide in a larger multimale group.

Harassment from other females and certain influencing behaviors from males can also affect a female's decision to transfer. Some scientists believe that male mountain gorillas use such behavior as displays, affiliative behaviors, and coercion tactics to influence a female's choice. Male displays during intergroup encounters typically include strutting about (either bipedally or quadrupedally) and chest beating. This could be a means of demonstrating fighting ability to attract the females or it could be a display, or herding tactic, to physically prevent female(s) from leaving their group. During these types of encounters, male aggression has more to do with retention and acquisition of females than defense of territory or food.

In March 2006, an interaction occurred between the Pablo group and the Beetsme group on the Rwandan side of the Virungas. These two research groups are monitored by the Karisoke Research Center, and the researchers witnessed the interaction. Captured on film by one of the researchers, the action was so widespread that only parts of it could be filmed because the camera's lens could not go wide enough to capture the entire scene. Suddenly caught in the middle of an interaction between two of the largest-known groups of gorillas in the world, the researchers were ecstatic as this spectacular event unfolded before them. There were more than eighty gorillas in one place at the same time as the interaction played out. The two groups faced each other at the beginning of the interaction, the Beetsme group on the left and the Pablo group on the right. The females and the young retired to a safe position to watch as the silverbacks proceeded to square off for battle. Rarely are so many silverbacks in one place at one time. Even with the larger multimale groups that contain multiple silverbacks, it is uncommon to see them together in one area. There were nine silverbacks between the two groups. As the silverbacks rushed in for a violent fight, the researchers snapped photographs and tried to follow the dynamics occurring all around them. The incredible power generated by these massive animals was being unleashed as each group's silverbacks made their play. The forceful series of displays between the silverbacks would continue for almost two hours.

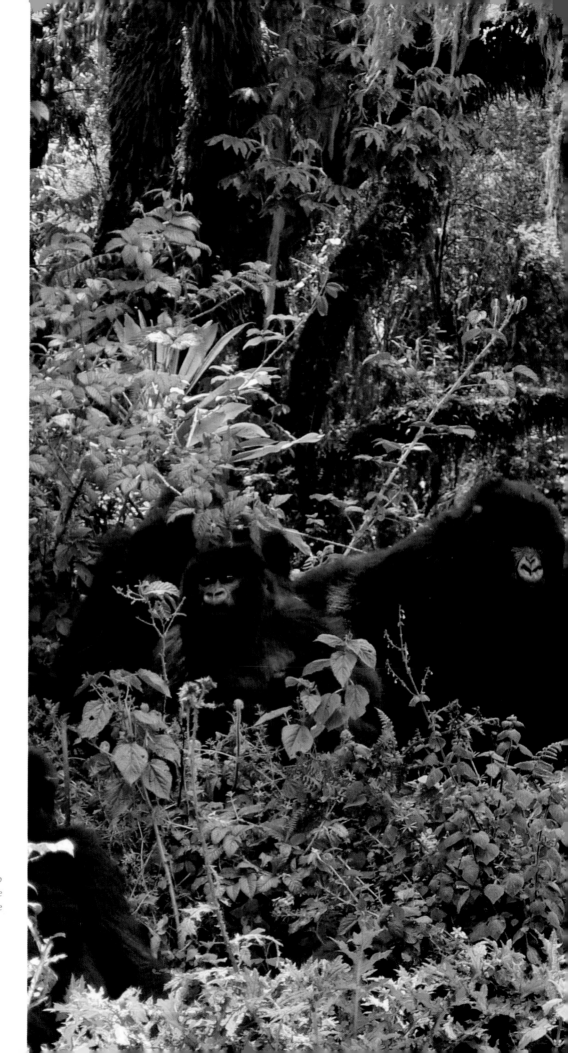

The females and young of the Pablo group were retired in a safe position and observe the fight between the Pablo group and the Beetsme group from a distance. Soon the forceful series of displays will start which involved the males for almost two hours.

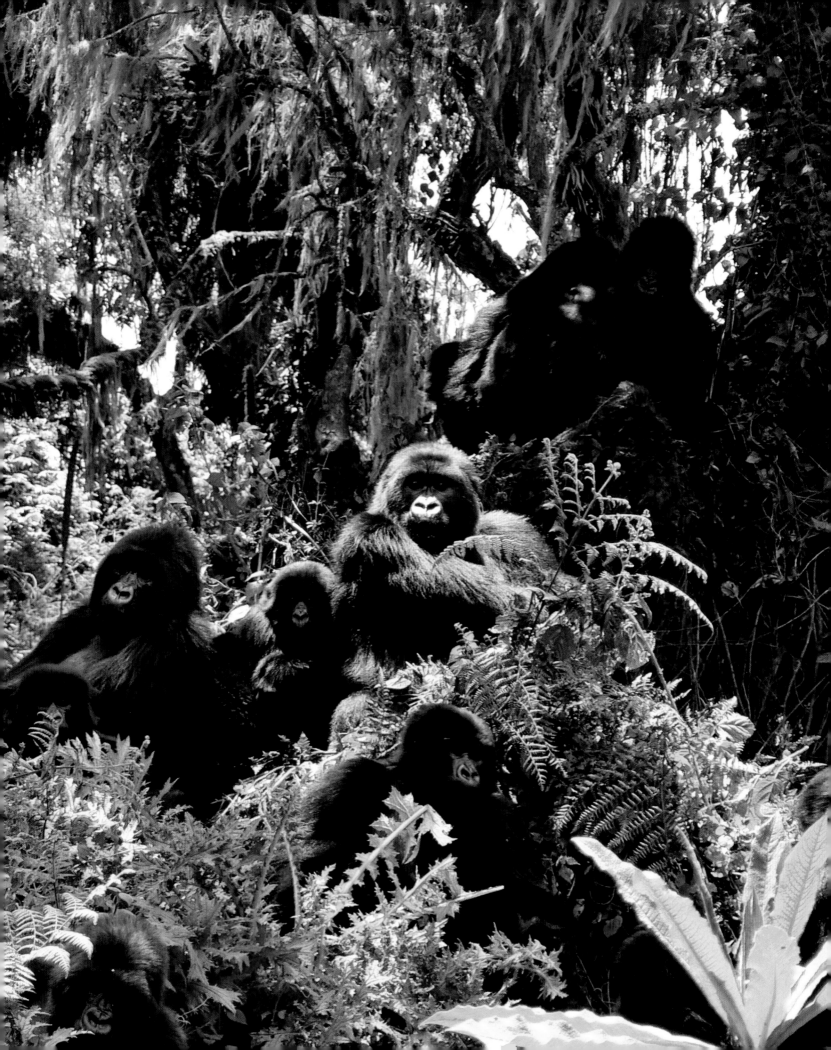

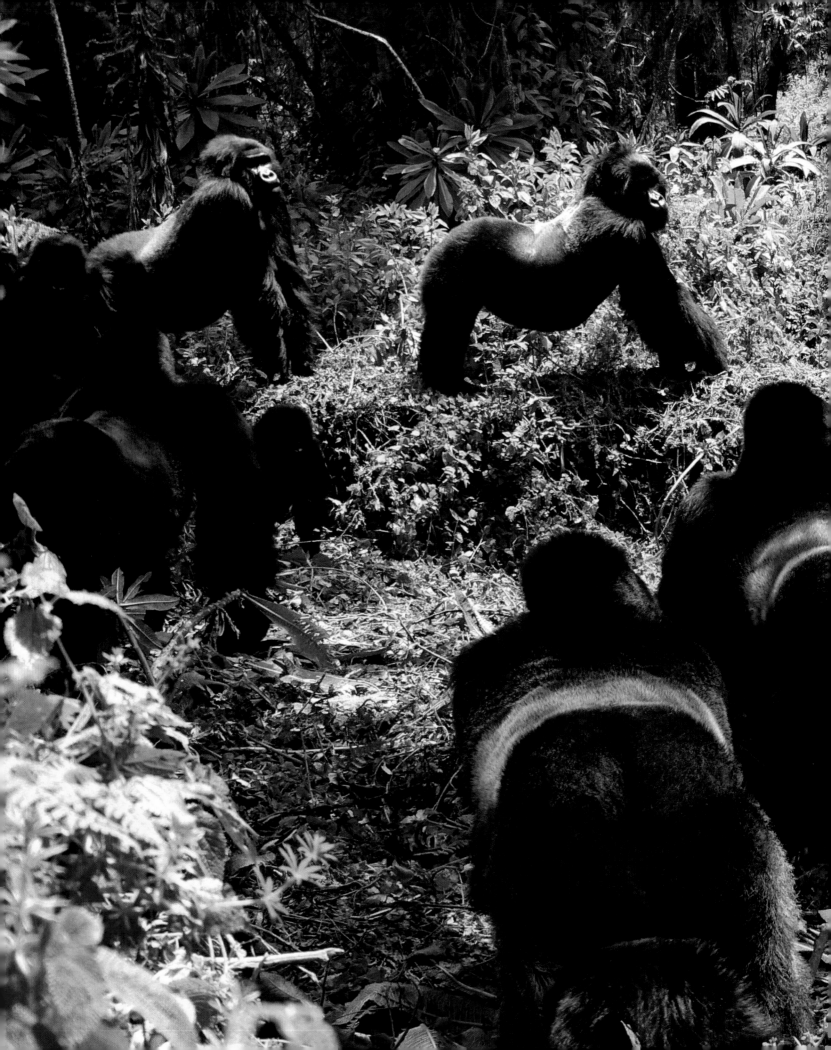

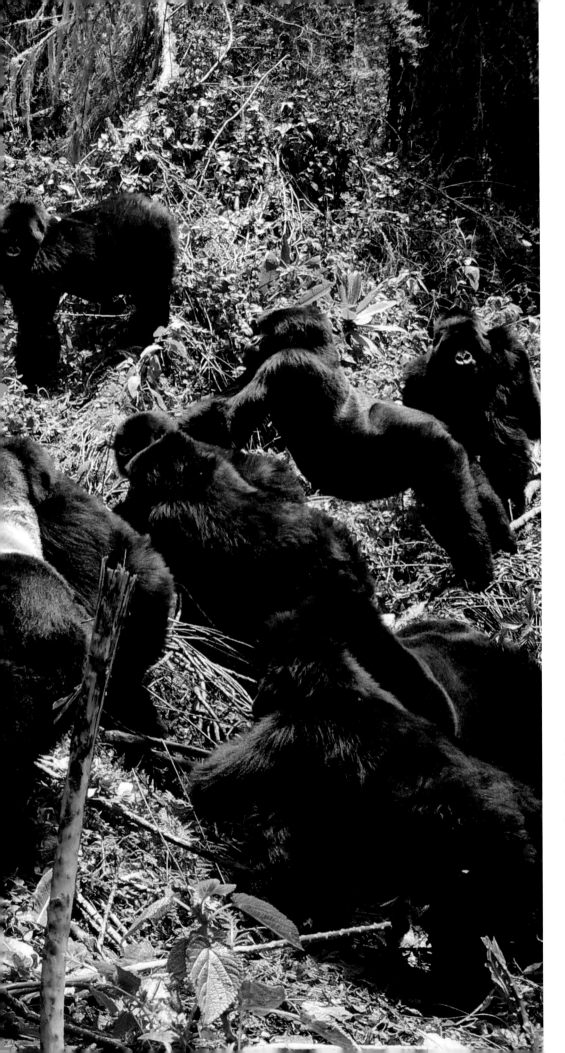

Interactions that occur when two groups of gorillas encounter each other can play out in many different ways. These are the prime opportunities for dominant males to acquire new females into their group. This can be the result of coercive tactics by the males or by the females' choice. This interaction between two of the largest known groups of gorillas in the world was a spectacular event. Over eighty gorillas were in one place while the interaction played out. In this photo, the two groups faced each other at the beginning of the interaction. The Beetsme group is on the left and upper side and the Pablo group is on the right side. Can you count all of the silverbacks in this photo?

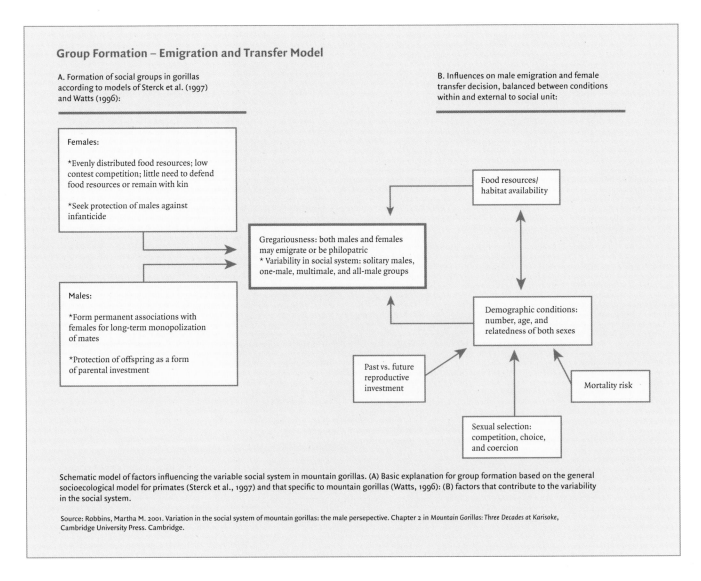

Group Formation – Emigration and Transfer Model

A. Formation of social groups in gorillas according to models of Sterck et al. (1997) and Watts (1996):

B. Influences on male emigration and female transfer decision, balanced between conditions within and external to social unit:

Females:

*Evenly distributed food resources; low contest competition; little need to defend food resources or remain with kin

*Seek protection of males against infanticide

Males:

*Form permanent associations with females for long-term monopolization of mates

*Protection of offspring as a form of parental investment

Gregariousness: both males and females may emigrate or be philopatric
* Variability in social system: solitary males, one-male, multimale, and all-male groups

Food resources/ habitat availability

Demographic conditions: number, age, and relatedness of both sexes

Past vs. future reproductive investment

Mortality risk

Sexual selection: competition, choice, and coercion

Schematic model of factors influencing the variable social system in mountain gorillas. (A) Basic explanation for group formation based on the general socioecological model for primates (Sterck et al., 1997) and that specific to mountain gorillas (Watts, 1996): (B) factors that contribute to the variability in the social system.

Source: Robbins, Martha M. 2001. Variation in the social system of mountain gorillas: the male persepective. Chapter 2 in *Mountain Gorillas: Three Decades at Karisoke*, Cambridge University Press. Cambridge.

As the displays were happening and the hair was flying, Isaro and Taraja, two of the subadult females from the Beetsme group tried to transfer into the Pablo group. Turatsinze, a silverback from the Pablo group, tried to keep them in his group after the transfer, but the silverbacks from the Beetsme group would not have it. They intervened and forced the females back into the Beetsme group. After the females had been herded back into their group, the interaction ended as the two groups moved away from each other in opposite directions. Within a few days, the wounds inflicted during the fight were healed and all of the gorillas were fine. In 2007, there was another interaction between these two groups, and this time, two females from the Pablo group transferred to the Beetsme group. Such is the way of mountain gorillas, although relatively stable over time, the situation and their outcomes can change at any point in time.

Factors that influence the transfer of mountain gorillas are illustrated in this chart.

5 THE HIERARCHY

THE ROLES, relationships, and dominance hierarchies of mountain gorillas are complex and can be affected by many factors, including group structure, internal and external pressures on individual animals, and to some extent, even the environment that the animals are living in. Much has been learned from the long-term studies conducted at the Karisoke Research Center in Rwanda and by the Max Planck and Mbarara University teams in the Bwindi Impenetrable Forest in Uganda. The information gained from those studies has added greatly to our knowledge of the sociality and individual relationships of mountain gorillas. Our understanding of the nature of group composition and the hierarchies that exist between males and females has changed over the years primarily because the composition of the study groups has changed over time. As the composition of those groups changed, the dominance hierarchies and the nature of the relationships between the animals in the group also changed presenting researchers with different perspectives about those relationships.

The silverback's role in group social structure is that of leader and protector. Leading the group in its daily quest for food, determining where and when the group will bed down for the night, silverbacks are dominant over all other members of the group. When there is more than one silverback in a group, one animal will be dominant until

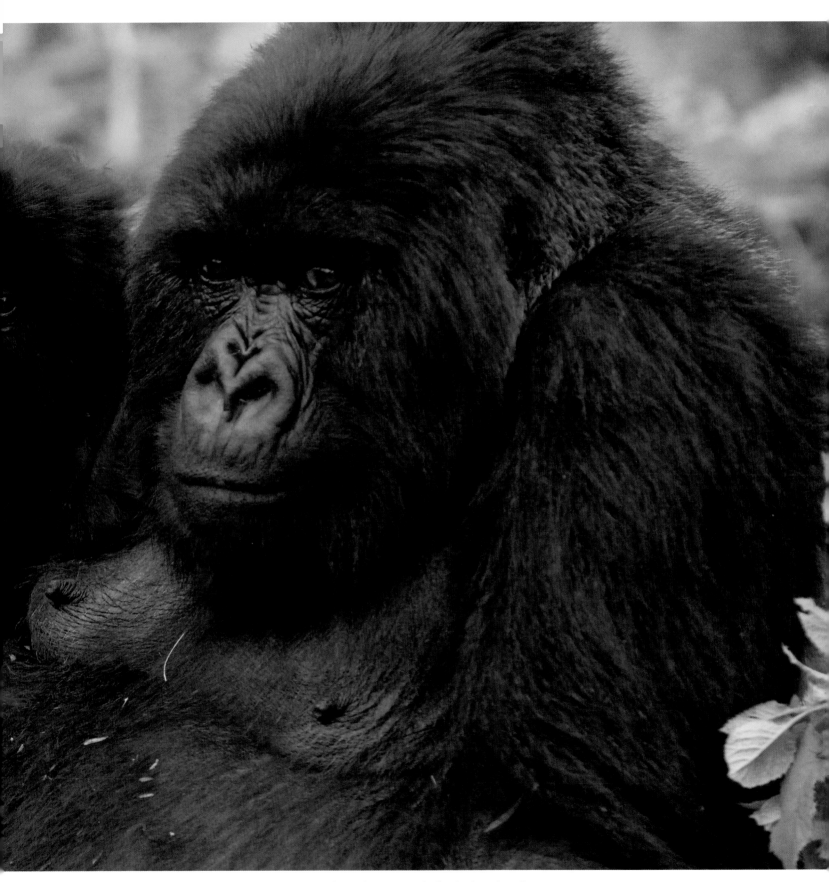

The female's role is to produce offspring and participate in the care of the infants. Poppy, the female shown here, is one of the grande dames of Rwandan mountain gorillas having produced babies for many years. Poppy and her infant Ishyaka Laurentine are members of the Susa group. As young females grow to maturity, they may and generally do leave their birth or natal group to join another social unit. It is not abnormal for a female to transition between groups more than once in her life. Parc National des Volcans, Rwanda.

replaced by another silverback. The dominance relationships are generally clear, but they are not always directly linked to age. When younger males in multimale groups challenge or successfully achieve dominant status, the older silverback in some cases does stay within the group.

Although interactions between groups or with a solitary silverback will clearly affect the hierarchy of a group and potentially all the relationships within the group, the death of a dominant silverback male can cause any number of possible outcomes for the group structure. In either single-male or multimale groups (a group with more than one silverback), a new leader could emerge from the males within the group or a new leader could come in and assume the dominant role. In groups where the remaining males are unable to maintain group integrity, the results can be devastating. In these cases, it can mean the complete disintegration of the group with females transferring with their young to other groups and the remaining males emigrating to all male groups or taking on a solitary existence. Researchers with the Karisoke study groups in Rwanda have witnessed the disintegration of three groups after the death of their dominant silverbacks; Group 8, Nunkie group, and Tiger group. In 1993, a group fission occurred when Group 5 (a multimale group) split as a result of the death of its dominant silverback. The result of this fission was the formation of a single-male group named Shinda and a multimale group named Pablo. The Pablo group would continue on to become the largest mountain gorilla group ever known, with several silverbacks, many females, and their offspring creating complex dominance hierarchies and relationship dynamics. Because the remaining population of mountain gorillas is so small, the death of a dominant silverback and its effect on the rest of the group can actually affect the population as a whole. When silverback deaths change the dominance hierarchy of a group, infanticide may rise as a new dominant silverback is established or as females and their young immigrate into new groups. The death of unweaned infants can be yet another consequence in this sequence of events potentially further reducing the total population of this critically endangered species.

Subordinate adult males and subadult males can also be found in a typical group of gorillas. Silverbacks are dominant over all blackbacks; however, it is these blackbacks that will one day mature to become the likely challengers to the dominant silverback's authority or emigrate to find their own females and start their own families. Avoiding conflict with silverbacks and adult females, blackbacks will often spend a great deal of time on the periphery of the group. The dominance hierarchy between blackbacks is not as clearly defined as their relationships with the older silverbacks. Avoidance and tolerance are the typical paths to coexistence in multimale groups.

While silverback males are dominant over all females and mature females can assert dominance over blackbacks, aggression directed from males toward females can occur and generally takes the form of displays rather than actual physical attacks. It is quite normal, in fact even common, for a group to have several adult females outnumbering the males in a group.

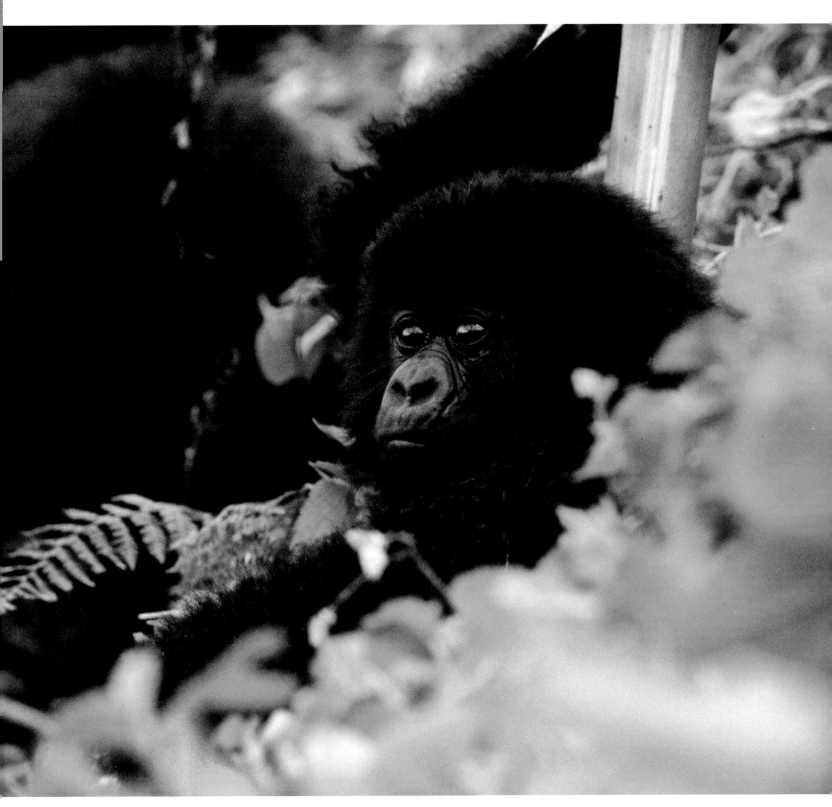

The infant Isonga from the Susa group in Parc National des Volcans, Rwanda, sits quietly while the silverback rests nearby. Infants will also tend to follow the silverbacks as they move about seeking to maintain their spatial relationship. In particular, with maternal orphans, a great deal of time was spent in proximity to or physical contact with the dominant silverback. The significance of this behavior for the infant appears to be further development of their social skills, tighter integration within the group, protection from extra-group encounters, and protection from older dominant and aggressive animals within the group. The tolerance demonstrated by the silverback to the infant can serve to strengthen the bonds and protection of the infant or to demonstrate to the females the silverback's ability to provide protection, thereby influencing female mate choice.

The female's role in group structure is essentially to produce offspring and participate in the care of the infants. The dominance hierarchy between females is usually dependent on relationships between individuals and with the changes in group composition, the hierarchy can change. This female dominance ranking is weak and appears to be related to age but relatively stable dominance relationships among females do occur over time.

The infants and juveniles are subordinate to all other animals; yet, they are an important unifying factor and central focus of the group. They are extremely curious by nature spending most of their time at play with each other and with the older members of the group. A young gorilla's curiosity about everything in its environment is a hallmark behavioral trait that will aid in the development of the gorilla's ability to adapt to different situations in the forest and ultimately thrive. Within an established group, the relationship between the young animals and the dominant silverback will change as the infants get older. Silverbacks will defend any of the members of their group to the death, including the infants, but during the first few years of their lives, infants have closer relationships with their mothers. As young gorillas become juveniles, those dynamics change. As the mothers start to have new babies, the juveniles become closer to the dominant silverback. At this crucial juncture in a young gorilla's development when the bonds with their mother are weakening, the juveniles could be using the silverback as an attachment figure to cope with the waning relationship with their mother. Strengthening the relationship with the dominant male within the larger hierarchy has to do with protection from external predatory threats such as leopards and gorillas from other groups. The relationship also limits the amount of aggression juveniles have to endure from other adult members of the group as they continue to grow and mature.

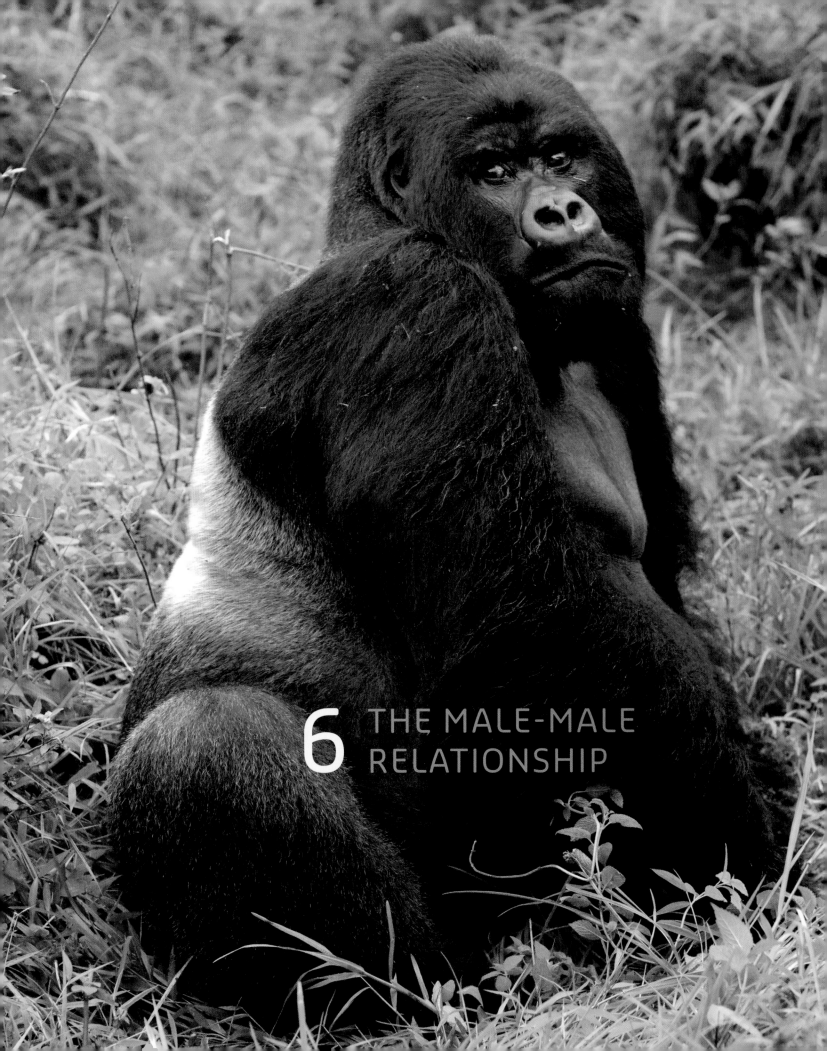

6 THE MALE-MALE
RELATIONSHIP

LIKE MANY PRIMATES, the relationships between male mountain gorillas are typically weak compared with relationships between males and females or even female-female relationships for that matter. Unlike relationships between females, which are more often centered around competition for food, the relationships between males have mostly to do with competition for access to females. How the aggression between individuals or affiliative behavior affect male relationships is also affected by the group structure that a male lives in, as well as the personalities of the individuals involved. For example, a solitary silverback doesn't have the opportunities for social interaction on a daily basis that silverbacks in groups do. The interactions that would occur normally in a group structure, whether it is all male or heterosexual, can have an impact on many choices that an adult male gorilla might make, including whether to emigrate from the group. They are valuable learning opportunities that can influence future interactions in other group situations. The relationships between males in heterosexual groups are different, with different dynamics even between single-male and multimale groups.

Indicative of their weak social relationships, males in heterosexual groups do not spend a lot of time in close proximity to one another. The aggressive behavior between males in these groups is affected by whether the females are receptive to mating, the number of females in the group, and the stability of the relationships between the gorillas in the group. Even though the silverback in single-male groups dominates all animals within the group, when the females are in estrus, subordinate males will often demonstrate aggression to the dominant silverback. Even though relationships between silverbacks and blackbacks in heterosexual groups are weak, some scientists believe that the strength of the relationship between a silverback and a blackback can be a determining factor in whether the blackback chooses to emigrate. Blackbacks with weaker relationships appear to be more inclined to emigrate.

Previous page: Guhonda from the Sabyinyo group in Parc National des Volcans, Rwanda, is the largest silverback mountain gorilla in the world weighing in at approximately 450 pounds.

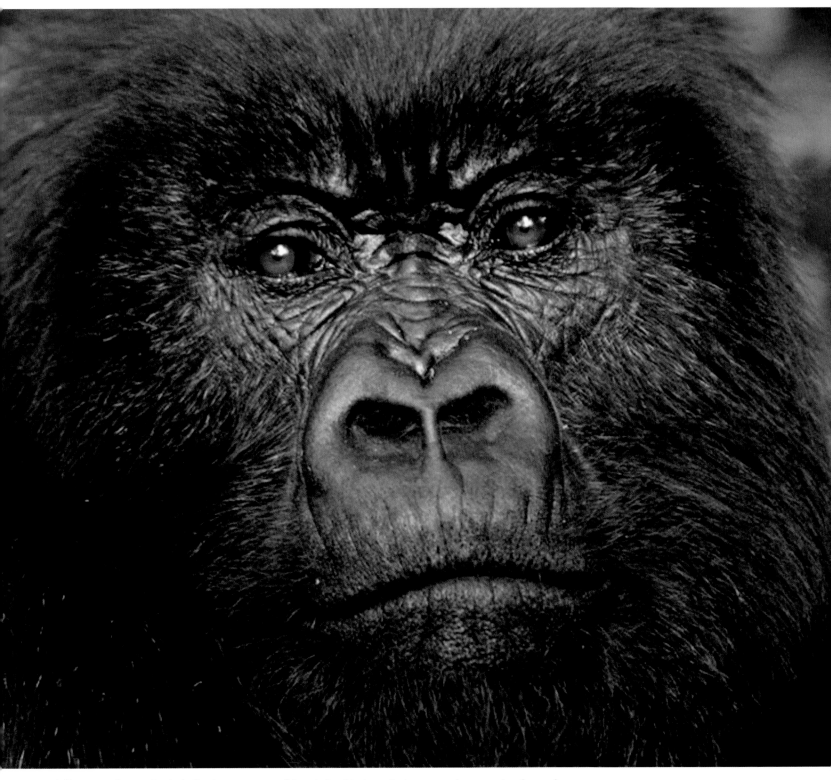

Much like many other species, including humans, many of the relationship dynamics between males are centered around access to females like Poppy from the Susa group shown in this picture in Parc National des Volcans, Rwanda.

Male gorillas born into single-male group structures can stay in a group for many years barring unforeseen circumstances such as the death of the dominant silverback. It takes thirteen to fifteen years for a male gorilla to reach full maturity. When a male does remain within his natal group until he becomes a silverback, the group structure then changes to multimale. The relationship dynamics between the males, in fact all of the animals in the group, will change at that point. Silverbacks have existed peacefully in multimale groups for many years until the dominant silverback either dies or is successfully deposed. When present, the paternal or sibling nature of the relationships between silverbacks in multimale groups can contribute to the group's ability to maintain integrity and keep the assertiveness of an up-and-coming silverback in check for longer periods of time. One contributing factor to the patience of a secondary silverback is that he is more than likely mating with some of the females in the group already. Male gorillas in multimale groups appear to be more successful in the ever-present quest to obtain reproductive opportunities than solitary males trying to form new groups. To that end, individual

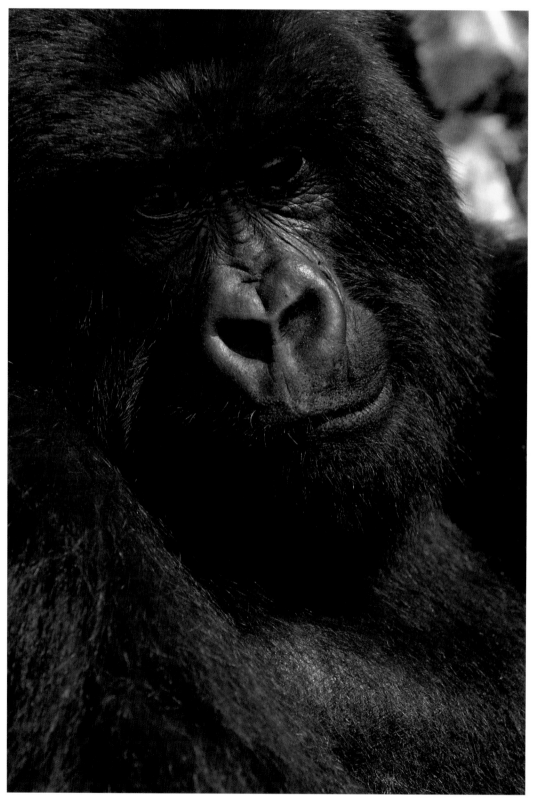

Rugendo is a member of Group 13 in Parc National des Volcans, Rwanda.

males in multimale groups will form coalitions during intergroup encounters to better protect their females and their offspring and to prevent the females from transferring to other groups. Despite this cooperative behavior, relationships between males in heterosexual groups are weak. That weakness indicates that the competition over access to females within the group for reproduction actually has a stronger influence on their relationships than any potential advantage that could be gained by cooperating to defend females against other males from outside the group. Some of their behavior may seem to the contrary, but in the end, male gorillas are largely in it for themselves.

When changes in the hierarchy of heterosexual groups occur, regardless of the underlying cause, it generally means that there is a new dominant silverback. When a new silverback assumes dominance over a heterosexual group, an infant male could be killed or possibly expelled from the group. If a young male is expelled and manages to survive, he will either take up residence with an all-male group or choose the path of a solitary existence affecting all of his relationships with other gorillas. Solitary silverbacks are constantly in search of females to form their own groups because their immigration options are limited. There are no known instances of solitary silverbacks successfully immigrating into established heterosexual groups, leaving only the options of acquiring his own females through an interaction with an existing group, or choosing the alternative of immigrating into an all-male group.

All-male groups are not common, and the relationships in all-male groups are substantially different. In the all-male group setting, mature male gorillas spend much more time in close proximity to each other, contrary to their behavior in heterosexual groups. Activities such as grooming and playing are more frequent than in heterosexual groups and are indicative of stronger relationships in the all-male structure. Instances of homosexual behavior have been observed in all-male groups and the frequency of that behavior when it does occur appears to be related to the presence of subadult males within the group.

Life in an all-male groups does not offer males any opportunities for mating, but it does help to form stable relationships with other adult males that they would not have if they had chosen life as a solitary silverback. These relationships provide a male gorilla with valuable experience in both aggressive and affiliative behavior that will be helpful later in life. Studies have shown higher rates of aggression in all-male groups than in multimale heterosexual groups. In some instances, younger animals in all-male groups will mediate in fights between older silverbacks, which could contribute in some way toward maintaining group stability. The reasons that lead to an animal emigrating from an all-male group are not fully understood. In one observation of an all-male group, researchers noted that when the dominant silverback chose to leave the group, there was no real indication as to why. There were no obvious interactions with other group members, aggressive or otherwise, that seemed to influence the decision of the silverback to leave. In the end, the desire to reproduce is probably the factor that drives most males out of all-male groups.

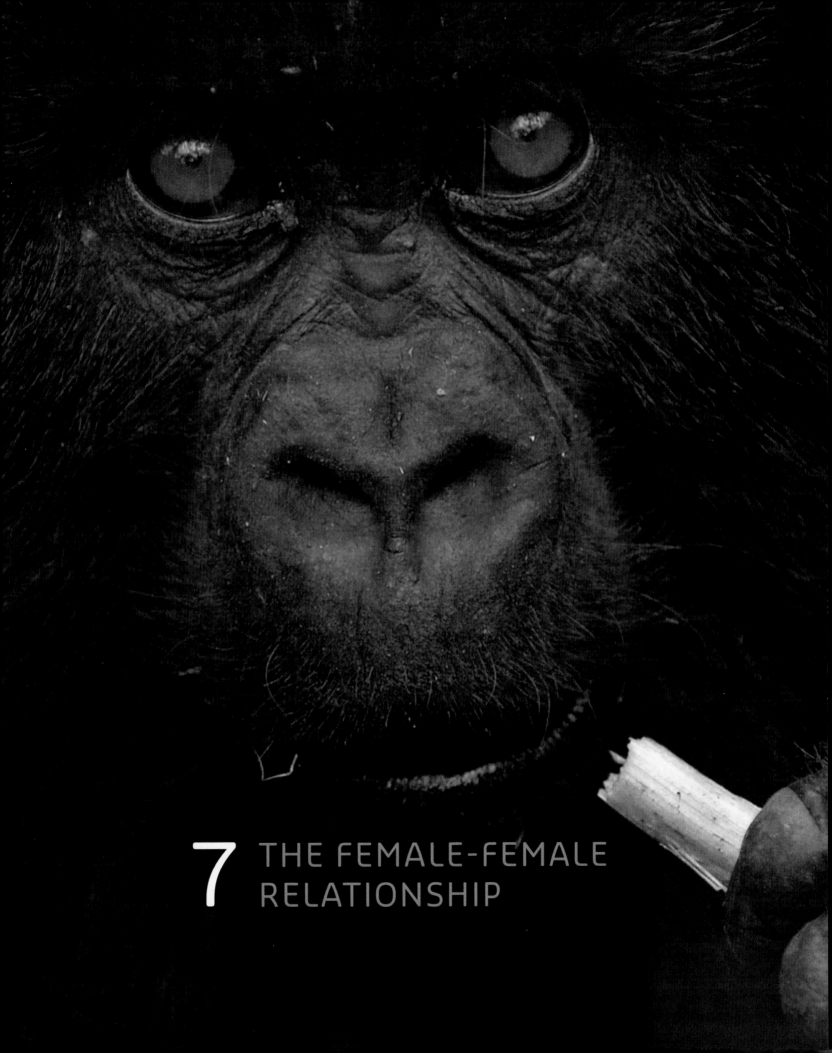

7 THE FEMALE-FEMALE
RELATIONSHIP

RELATIONSHIPS between adult female mountain gorillas generally take two forms: aggression and affiliative behavior. Affiliative or bonding interactions are more common than aggressive ones because of several factors, including group size. Fighting between females in large groups is more common than in small groups and has to do with the two primary causes for aggression between females: competition for food and access to male services such as protection.

Aggressive behavior in females is more often related to food competition, although food resources are rarely in short supply for mountain gorillas. Although competition over food is not a huge issue, ecological factors have a greater influence on females than on males because females have slower reproduction rates and a higher parental stake than their male counterparts. Foraging efficiency is vital for reproductive success and drives the feeding competition between females, which can be more intense in larger groups. The distribution of food and the variance in their diet can affect the type of feeding competition and its intensity. The potential for large gains or losses related to feeding competition between groups can also affect relationships in which higher-ranking females become more tolerant of subordinate females. The cost associated with leaving the group, including the potential loss of female allies, can be a motivating factor to stay in the group. In smaller groups where food competition is not as important, the dominance hierarchies between the females in the group can be weak or nonexistent. In those situations, aggressive encounters have more to do with individual issues such as fighting ability than access to food or protection. Agonistic behavior is almost always between two individuals. Others may join in coalition against another or intervene on another's behalf, but it always starts with individuals. Studies have shown a direct correlation between how often other females or coalitions between females would intervene or harass an

individual and how often that individual would intervene against or form coalitions against them. It would appear that gorillas, much like humans, remember other individuals who are confrontational to them.

Coalitions, often between related females, are formed to support each other in dealing with aggression from other females or males in the group. In some cases, high-ranking females will actually benefit from helping related females to achieve higher rank and status within the group. Most female coalitions between relatives, particularly maternal relatives, can involve support that one female gives to a relative who has initiated aggression against a nonrelated female. Females with no relatives in their group can face more opposition from coalitions than those with relatives, which makes the nature of their status in the group tenuous and stressed.

In many cases with larger groups, female immigrants will meet little resistance when they join the group. A notable exception occurred with Group 5, one of the Karisoke study groups during a three-month period in 1984 and 1985. Six females, including an adolescent, already resided in the group when five more females immigrated. Although the immigrating females stayed in the group for at least five years, there was sufficient harassment among them that two eventually emigrated out of the group. The resident females that did most of the harassing were neither pregnant nor lactating. Several factors may have caused the harassment, including reduced access to the dominant silverback because of the group's large size and the potential for feeding competition. Five of the resident females were natal to Group 5 and the sixth was the mother of all five females. These related females formed coalitions, often joining a sister who had initiated some form of aggression or harassment targeting one of the immigrating females. These acts of aggression resulted in bite wounds between combatants in the course of the fight. Because coalitions were involved in the attacks, the risks to the aggressors were minimized. The dominant silverback could not always intervene because the larger group size made it impossible to oversee all of the females at all times. Life was difficult for these immigrants because of the large number of related females in their new group.

Females have different types of social relationships, and relatedness is less important in the female-female relationships between mountain gorillas than other primates, perhaps because many mountain gorilla females often do not live with their relatives as a result of transferring to other groups when they reach maturity. Studies have shown that when they do live together they are more tolerant of the related females in their group than nonrelatives. Individuals with maternal relatedness generally show less agonistic behavior than those with paternal relatedness or other nonrelated females. Spending more time in close proximity to one another, these related females have also been observed grooming with other adult females, particularly those with whom they are related. Those without relatives will groom more with adult males and with their immature offspring.

Female aggression can also be related to access to male services such as protection. Protecting the female(s) is an affiliative behavior from males that could also

improve the males' chances of reproductive success by virtue of female choice. The competition between males for mates can influence the relationships between females and affects overall group composition in complex ways. Males will intervene more often than females when conflict arises between two females. Males will protect females by controlling female aggression and helping to limit the damage aggression can cause. In many cases, the female target of aggression will remain close to the male to prevent further harassment. Females will often take longer to reconcile after aggression from other females than they do after receiving aggression from males. The dominant male has a vested interest in controlling female aggression because this type of harassment from other females can be a motivating factor for them to emigrate, which in turn affects the male's chances of reproductive success.

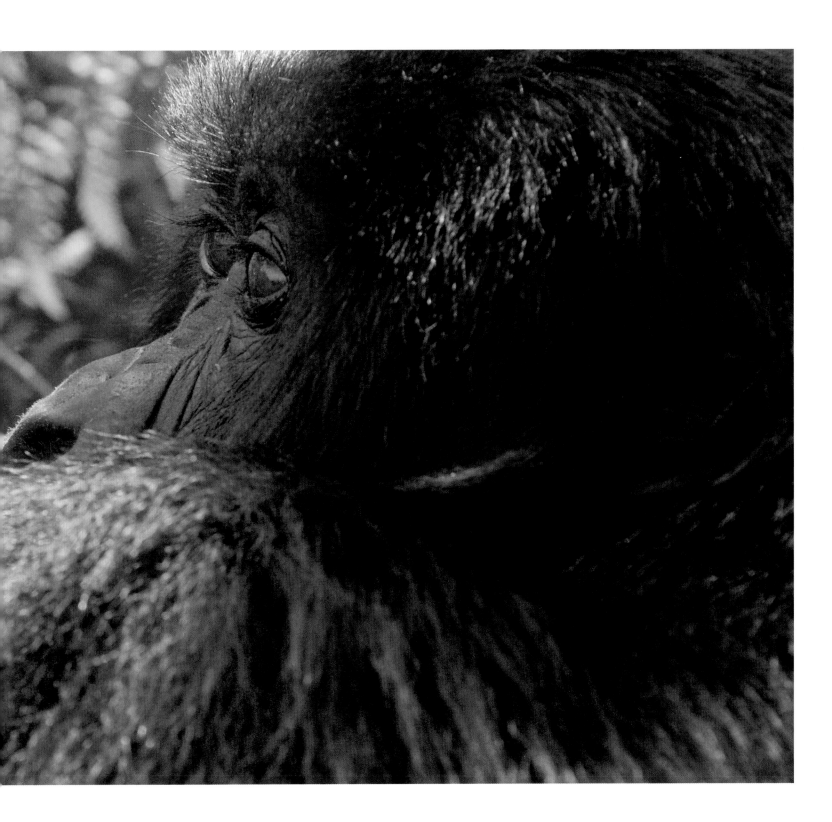

8 THE MALE-FEMALE RELATIONSHIP

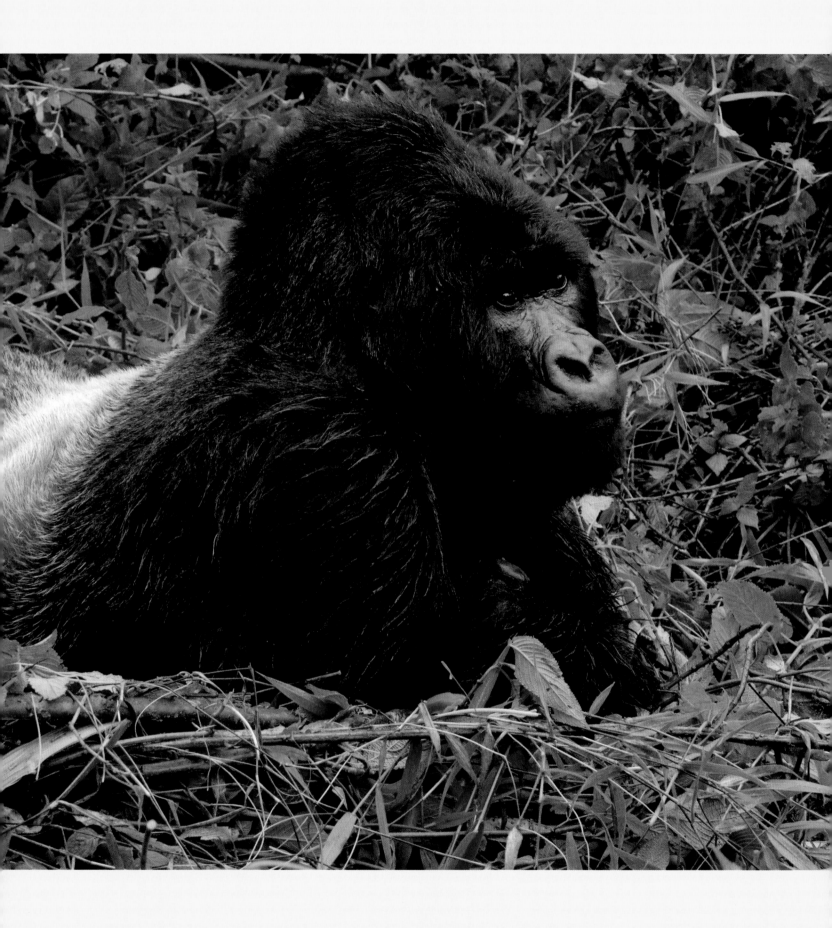

RELATIONSHIPS between male and female mountain gorillas are generally stronger than same-sex relationships (i.e., either male-male or female-female relationships). The reasons for this, like so many other social aspects of gorillas, have to do with access to mates and creating circumstances that afford the greatest opportunities for reproductive success. Many factors like aggression from other gorillas, male or female, can affect those opportunities. Because females can transfer several times in their life, it is likely that a female could find herself in a group with no relatives or established relationships and exposed to the aggression of other gorillas in the group. In this circumstance, relationships with males are important because males will often be their long-term social partners. These relationships are crucial to the interests of females by largely preventing the possibility of infanticide if one of them becomes the dominant silverback. It also helps to prevent harassment from other females inside the group and harassment from males both inside and outside the group. The primary interest for male gorillas is protecting the offspring and the retention and addition of new mates.

Although much study surrounding male-female relations has been done with the Karisoke gorillas, there is still much that is not known about these relationships as animals reach maturity. These relationships even have different dynamics in single-male groups and multimale groups. For example, in single-male groups during resting periods, females have been observed to remain in close proximity to the silverback and that closeness is maintained by the female. In multimale groups, however, the males have been observed to seek out proximity to proceptive females (females that are in estrus and ready to mate) rather than nonproceptive females. At times, subordinate silverbacks may even use grooming as a strategy to bond with and become closer to potential mates. The subtleties and true nature of how males and females interact with each other in regards to mating strategies had only begun

Previous page: Agashya, the silverback from Group 13 in Parc National des Volcans, Rwanda, relaxes, providing a nice view of the silver hairs on his back. Male gorillas are sexually mature and are referred to as "blackbacks" from age eight to twelve. Males do not reach full physical maturity until they are between ages thirteen and fifteen, when the hairs on their backs generally start to become silvery gray and they are called "silverbacks." These adult males are the largest primates in the world and by age twelve have a dramatic increase in size and shape. By the time they are thirteen to fifteen, they can easily reach twice the size of an adult female, standing over 5 feet tall and weighing up to 450 pounds.

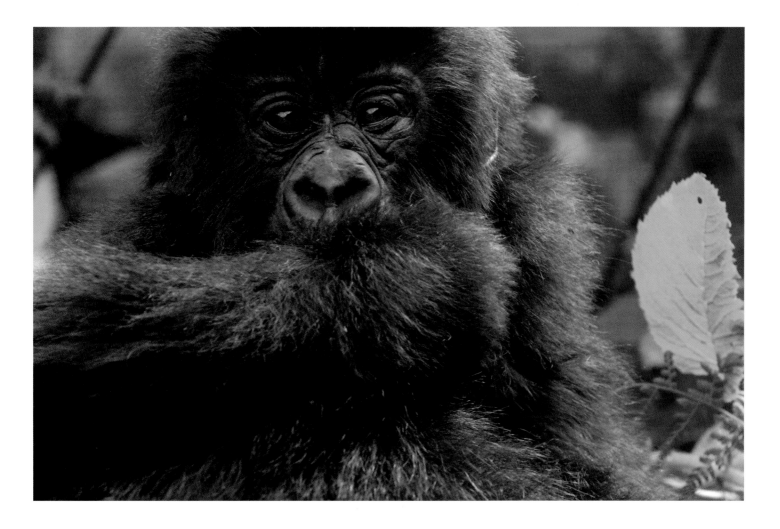

Inkundwa is part of Group 13 in Parc National des Volcans, Rwanda.

to become better understood as gorillas in the research groups began to mature, thus affecting group composition.

During the 1970s when most studies were conducted on single-male groups, the consensus was that mountain gorillas used a one-male mating system, in which the dominant silverback served as the sole mate to all of the females in that group. As long-term studies continued and the population dynamics of those groups changed, differing perspectives on the reproductive strategies of mountain gorillas emerged. Genetic studies have revealed that the dominant males sire most but not all of the offspring within a group. The second-ranking silverback in multimale groups, in some cases, will sire a small percentage of the group's offspring.

Competition between males for access to proceptive females is not new and has been observed both between and within groups. What is new in the historic sense is the concept of female choice relating to mates. Females have been observed mating with more than one male in multimale groups, which indicates the possibility that female choice is a factor in mating behavior. Studies have shown that females in multimale groups mate with males other than the dominant silverback; in some

instances, they mate with all of the males in the group. There are several theories about how and why this might occur. One theory is that females mate with multiple males to increase their chances of reproductive success and to guard against infanticide in the event that the dominant male is deposed or dies. As the theory goes, by mating with more than one male in a multimale group, even if the dominant male does not die, the females' actions create paternity uncertainty, which builds on the relationships between the female and other males making them less likely to commit infanticide. There is not enough data to provide certainty for this theory; however, the available data support it.

The second and more obvious indicator of a female's choice in mates is when she transfers between groups. Females can transfer from their natal group or from a secondary, or nonnatal group, to yet another group, which would tend to indicate that the avoidance of inbreeding or a lack of suitable males for mating are not the only motivating factors in a female's choice about whether to transfer.

Some of the potential external influences on a female's choice are harassment by other females from the group into which or from which the female is immigrating or emigrating and certain influencing behaviors from males. Dominant silverbacks will often intervene in conflicts between females, but they rarely take sides. The silverback's ultimate goal is to retain all of the females that might be involved in a conflict rather than aligning himself with just one female. Other types of influencing behavior from males can often be seen during group interactions and can include both affiliative and coercive behavior such as herding females. Herding is when a single male or multiple males will position themselves in a manner that physically prevents a female from transferring to the other group during an interaction. Casual observers may interpret subordinate males' apparent cooperation with a dominant male in herding females as supporting the dominant male or acting out of a sense of protection for the group. That behavior is more than likely rooted in the animals' own self-interest, as they too are ultimately interested in one day taking control of the group, including all of the females. For male mountain gorillas, these behaviors are geared toward the common theme of acquiring and retaining their own females.

Affiliative behavior is all about getting close to females and maintaining that closeness. Male gorillas will use a vocalization technique called "neighing," to negotiate physical proximity to a female and establish eye contact. This vocalization signals to the female that the male's intention is to stay close. Once the intention and physical closeness is established, the proximity can be maintained by the male or the female. This process targets females that are coming in and out of estrus, as opposed to pregnant or lactating females. Watching these interactions between males and females in the wild is fascinating for, in the end, it is the dynamics of male-female relationships in all their variation that are one of the causal factors in maintaining group integrity. They are also the same factors that can cause a group's integrity to change through the dynamic processes between males and females that influence group structure.

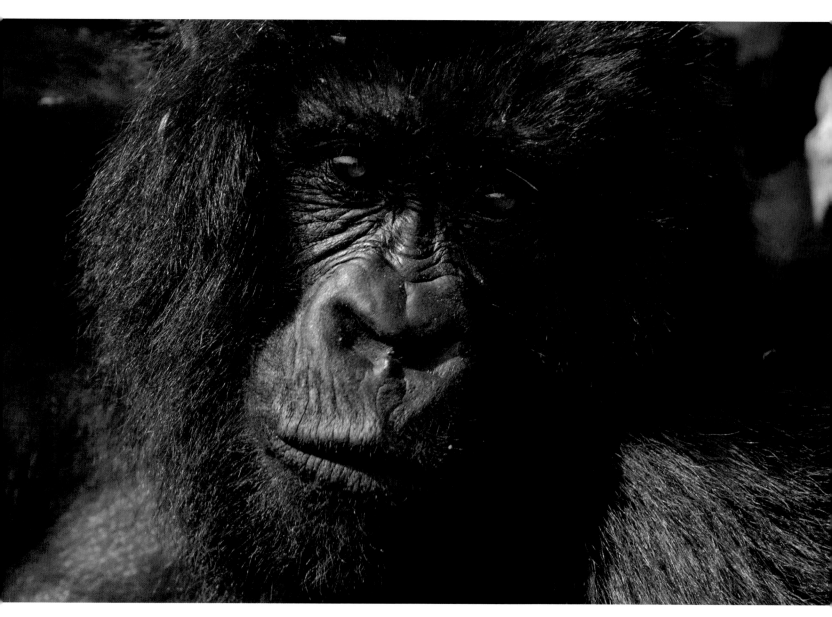

Gukunda is a member of the Sabyinyo group in Parc National des Volcans, Rwanda.

9 THE DAILY CYCLE

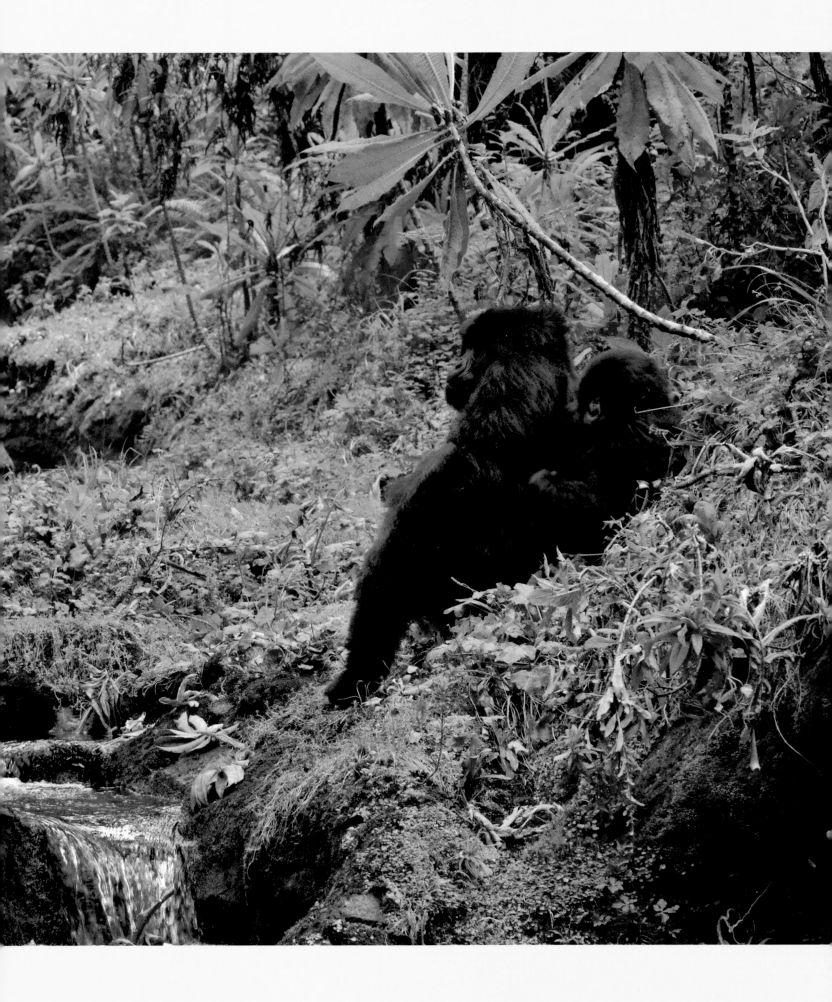

THE ACTIVITIES of mountain gorillas vary little from day to day. Diurnal or active during the day, gorillas typically rise at roughly the same time of the morning and lie down for the night at about the same time each evening. In their tropical environment, there is little variance in the times of sunrise and sunset or even the seasonal temperatures for that matter. Daylight occurs at around 6:00 a.m. and nightfall comes at about 6:00 p.m. with slight variances. They spend their nights in nests, and shortly after sunrise, various members of the group will start to rise and look about. They may stretch and yawn a bit, and just like humans, many will lie down again, resting for a few more minutes before beginning the day. At some point, the dominant silverback will wander from the nesting site and begin to feed, which signals the rest of the group to follow and begin the new day.

Gorillas' morning meal may last two hours or longer, roughly between 7:00 a.m. and 10:00 a.m. During this feeding period, the group slowly starts to spread out and the distance between group members increases. For short periods, individual animals may lose direct sight of each other because of the dense vegetation, but the group is still close enough that they could be called together quickly if the silverback senses danger or an interaction with another group should occur.

After consuming so much food, the animals will cease much of their activity as they slowly start to gather around the silverback for a midmorning resting period. The immature gorillas play with each other, while the older gorillas may sleep or just sit still and rest. This is also when grooming most often occurs between adults and mothers grooming their offspring. Grooming is not as common in mountain gorillas as it is in other primates, but it does occur with no clear pattern between the sexes in terms of who is grooming whom.

This is the time of day when tourist groups visit the gorillas, under the supervision of national parks guides and trackers. Because of their intense curiosity about one

Previous page: A mother and infant from the Beetsme group rest beside a stream in this pristine forest setting deep inside Parc National des Volcans, Rwanda.

Mapuwa, a silverback from the Mapuwa group in the Parc National des Virungas, Democratic Republic of Congo, grooms the female Kagofero. After consuming so much food, gorillas will cease much of their activity for a midday resting period. They may sleep or just sit still. Grooming often occurs during this time; adults groom one another, and mothers groom their offspring.

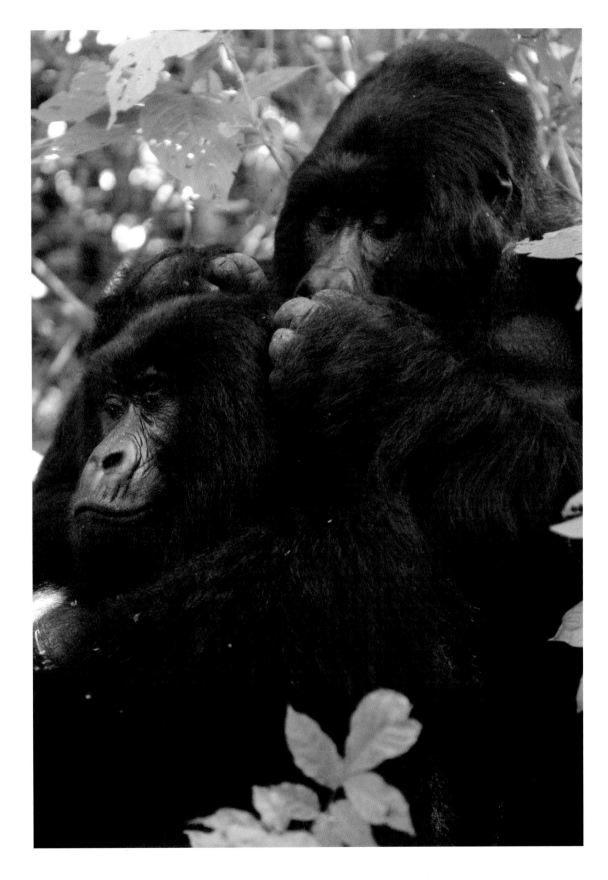

another, the younger gorillas and the tourists can keep the babies' mothers and the guides busy making sure babies and tourists stay apart. Left to their own devices, many of these infants would crawl right up to the tourists and sit next to them to see what all the commotion is about. Fortunately for everyone, however, their mothers keep them in check, while the guides manage the tourists.

Later in the afternoon, normally occurring between 2:00 p.m. and 5:00 p.m., another feeding period occurs. Such is the daily cycle of mountain gorillas; eating, playing, resting, investigating their surroundings, and then more eating, playing, and resting. They are highly adapted to their environment, with its abundant sources of food and trees and vines to play on; it is what they do.

As the day ends and the light begins to fade, the dominant silverback leads the group to a nesting site and begins to build his nest, signaling to the rest of the group that it is time to build their nests and bed down for the night. Sometimes gorillas build day nests in the trees or on the ground, but they always make a nest for the night. The percentage of nests found in trees or on the ground is largely a factor of the immediate environment and surrounding vegetation. In fact, the evidence would indicate that gorillas have no real preference for materials to be used in nest building but rather they go for whatever seems to be at hand and easy to muster. Gorillas build nests on the ground by folding branches and foliage into a springy circle around them. When a gorilla builds a nest, it will reach out, break off, bend, or otherwise pull in vegetation. Vines, leaves, or branches are then used to fashion a rim around the gorilla, or for padding underneath to form a big enough area to lie down in. These oval-shaped nests are constructed with more attention on the perimeter of the nest than the central area where the animal lies. The size of the nest is proportional to the size of the animal that built it. On average, these nests are built within a minute or two but can take as long as five minutes or as short as a few seconds.

Nests are almost always used for a single night. The animals move on the next day, and build a new nest the following night. There is no indication that gorillas leave their nests at night unless disturbed. It is common to find dung in the nests the next morning. By examining the dung found in the nests, scientists can determine the age, sex, and the number of gorillas that might have occupied a nest on any given night. For example, by measuring the size of the dung in the nest, they can estimate the age of the animal. The quantity and size of the dung indicate whether a female and her baby shared a nest during the night. An infant will always share a nest with its mother until it reaches about four years old; that is when the next infant is born. However, it is highly uncommon for the mature males to share a nest, with the exception of orphans who will often nest with the silverback. Silvery or white hairs indicate to scientists that a silverback made and slept in the nest. By examining all of the nests in a nesting site, the general composition of a group can be determined, and estimates on the overall number of animals in the group can be obtained. This is one of the core methods used for validating the population counts and demographic information gathered during gorilla censuses.

This is a typical night nest in Parc National des Volcans, Rwanda. The size of the dung found in the nest indicates the age and size of the gorilla that built and occupied it. When a gorilla starts to build a nest, it will reach out, break off, bend, or otherwise pull in vegetation. The gorilla uses vines, leaves, or branches to fashion a rim around the gorilla or to pad underneath, forming an area big enough to lie down in. These nests can be built within a minute or two or can take as long as five minutes or as short as a few seconds.

10 FEEDING HABITS

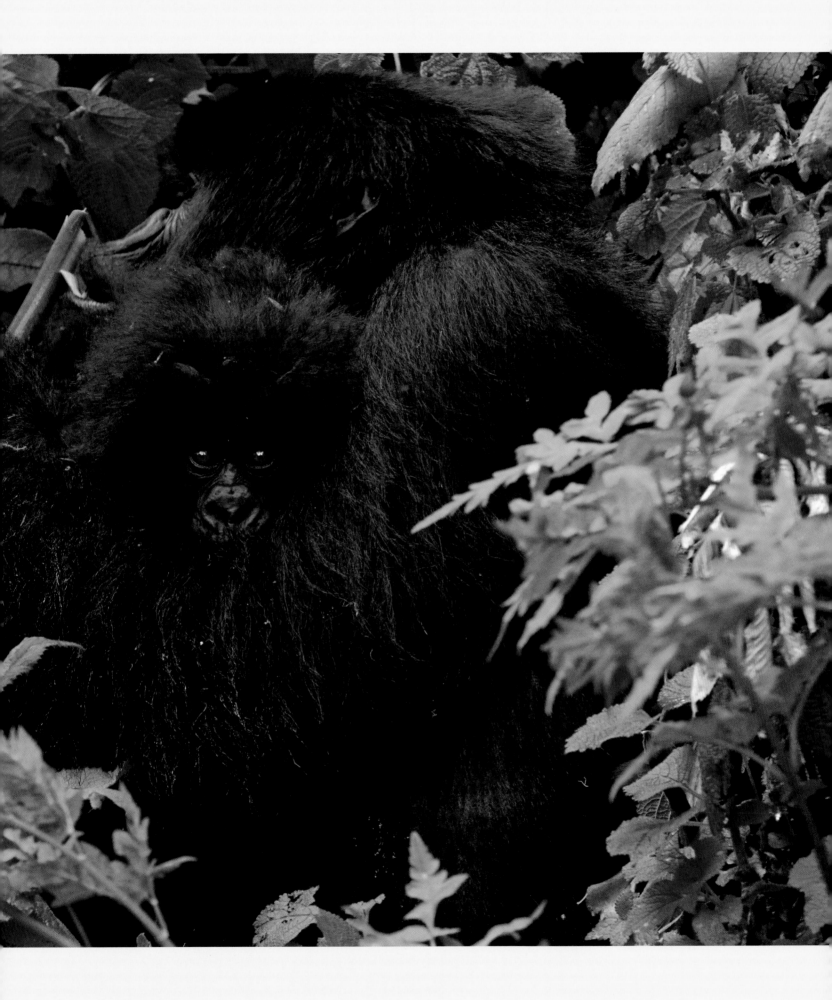

THE FEEDING ecology of mountain gorillas is a contributing factor to understanding so many aspects of gorilla behavior at larger levels. As an important variable in the ranging patterns of gorillas, feeding ecology relates to the availability of food in gorillas' habitat, which foods they choose to eat, and the ways they have adapted for processing that food. The feeding habits of mountain gorillas, a subspecies of the eastern gorillas, differ noticeably from those of the western gorilla species. Feeding habits even differ between mountain gorillas and other eastern gorilla subspecies, such as the Grauer's or eastern lowland gorillas (*Gorilla beringei graueri*). The habitats in which mountain gorillas live and feed dictate their feeding habits.

These habitats vary from group to group even within a particular environment such as the Virungas or Bwindi. The montane environments where these gorillas live differ significantly from the lower elevations where the western gorilla species live. Altitude affects the types of vegetation that grow in a given area. These variations are called "vegetation or habitat zones" and are detailed in chapter 11 of this book, "The Majestic Montane Rain Forests."

Gorillas' diet varies little from the dry season to the wet season; the particular location they are in on any given day has more of an effect. An exception is the bamboo zone, which is dominated by extensive stands of bamboo. There is a seasonal variance when the bamboo produces shoots, which are highly sought after by gorillas and constitute one of their main food sources during the rainy season.

At times, gorillas will move from one area or habitat zone to another in a given period, often in the same day, indicating that they are selecting foods from within their range to obtain the highest-quality, most nutrient-dense food sources available. This flexibility likely factors into gorillas' ability to range over different habitat zones throughout the Virungas. Research shows that mountain gorillas are effective

Previous page: Bukima, an adult female from the Beetsme group in Rwanda, holds her young male infant Ihumure close while she eats wild mountain celery and other food. The home range of the Beetsme group is in Parc National des Volcans, Rwanda.

FOOD PROCESSING AND TOOL USE

Although mountain gorillas have not been observed using tools to process food, unlike chimpanzees and orangutans, this is probably because they don't need tools to extract their food. In the lush forest environment they live in, food can easily be obtained with their hands.

Mountain gorillas will use manual skills to process various kinds of plants for food. This type of behavior is indicative of extensive learning and complex cognitive skills. Gorillas will make choices about plants that they eat for food. Those choices will weigh the benefit of a food in relation to the amount of energy required to obtain it. For many of the mountain gorilla groups, the abundance and easy availability of certain plant species makes them staples in the gorilla's diet. What makes these particular plants important

to note are the skills required by the gorillas to defeat the plants' natural defenses in order to eat them. Commonly eaten species such as galium, nettles, or thistles have natural defense mechanisms such as barbs and stinging needles. These natural defenses must be overcome before they can be consumed.

Because some of these plants can be a large part of a gorilla's diet, they must develop a repeatable method of processing them. How are these skills acquired? Research shows that the infants learn these complex manual processing skills primarily through observation and practice, a cognitive process called "program-level imitation." In program-level imitation, one gorilla will observe another as they perform an organized process, in this case processing food. That gorilla will in turn use that process in the future. The details of how a specific plant might be handled or manipulated to avoid its natural defenses are possibly learned and refined on a trial-and-error basis. Infants will likely observe their mothers and others in the group performing these complex manual food processing techniques. The finer details will be worked out by the infant over time as they repeat the process.

The way that mountain gorillas process stinging nettles, *Laportea alatipes*, is an excellent example of how these complex manual processes work. Stinging nettles are covered with stinging hairs that can be extremely painful. Certain parts of the plant must be removed, and the gorillas must eat the leaves in such a way that they won't be injured. Mountain gorillas have devised a very effective way of dealing with this. They place their hand near the base of the stem of the plant loosely wrapping their fingers around it. This allows them to strip many leaves off the stem in a single motion. Then they use the other hand to grab and twist the petioles that are protruding from one end of the hand until they come off and are discarded. The remaining leaves are then carefully folded over, regrasped, and then consumed in one large bite. This contains most of the stings in one exposed leaf's underside. Because the leaves are the least stinging part of the plant, it minimizes the pain involved and maximizes the yield by obtaining this high-quality food source. Gorillas will use similar techniques for different major food plants, with some variation to deal with the specific defenses or problems presented by a given plant species.

To view some of the plants more commonly eaten by gorillas in the Virungas and Bwindi, see appendix D, "Vegetation Documentation."

Gasindikira from Group 13 in Parc National des Volcans, Rwanda, stuffs a wad of *Carduus nyassanus* in his mouth. Commonly eaten species such as galium, nettles, or thistles have natural defense mechanisms such as barbs and stinging needles. These natural defenses must be overcome before they can be consumed. Given that these plants can comprise a high percentage of a gorilla's diet, a repeatable method of processing them for consumption is necessary. How these skills are acquired is the real question. Research shows that the infants learn these complex manual processing skills primarily through observation and practice.

TABLE 10.1 | HABITAT PREFERENCE RANKINGS

Group	Habitat Type	Rank	Food Density (g/m²)	Frequency of Food	Diversity of Foods
Group BM	Herbaceous	4	74.94	100	1.85
	Brush Ridge	3	17.36	80	1.83
	Hagenia	2	75.99	92	2.03
	Subalpine	1	37.68	58	1.67
Group 11	Mimulopsis	4	20.08	93	2.32
	Bamboo	3	4.21	28	1.19
	(with shoots)		6.32		1.43
	Herbaceous	2	74.94	100	1.85
	Hagenia	1	75.99	92	2.03

Source: McNeilage, Alastair. 2001. Diet and habitat use of two mountain gorilla groups in contrasting habitats in the Virungas. Chap. 10 in *Mountain Gorillas: Three Decades of Research at Karisoke*. Cambridge University Press, Cambridge.

Note: Habitat preference rankings (1 is lowest, 4 is highest) and habitat quality parameters for the habitat types within the home ranges of the two main study groups in the Virungas. The parameters are dry biomass of gorilla food available per m², frequency of food (the percentage of 1 m² plots containing herbaceous food), and diversity of foods. Certain parameters are given separately for bamboo during the period when shoots were present.

foragers because they use various habitat zones for their unique vegetative characteristics. By selecting areas with large amounts of high-quality food sources, the distances covered on any given day are shorter and the nutritional requirements of the gorillas can be met with less time spent searching for food. The availability of choice food sources is a prime motivator in how far a group will range on a given day or within a given time period. When sufficient food is present, a group might not venture more than 400 or 500 meters in a day in the Virungas or 800 to 1,000 meters a day in Bwindi. Once they find an acceptable food source, their need to move diminishes. There is no need to move for water either. Although an abundance of water sources are available, gorillas acquire the hydration they need from the plant matter they consume each day.

Historically, much of our knowledge on the feeding behavior of mountain gorillas came from studies at the Karisoke Research Center in Rwanda. There, herbaceous vegetation dominates the gorillas' diet, which led to the generally held belief that mountain gorillas were strict herbivores. Since the 1980s, a great deal of research has been done in the Bwindi Impenetrable National Park in Uganda and with western and eastern lowland gorillas in other parts of central Africa. These studies, combined with the information gleaned from the Karisoke studies, have greatly improved the understanding of the feeding behavior of gorillas in general and mountain gorillas in particular. Much of the variation in diet is dependent on habitat, altitude, and vegetation (availability of gorilla foods). For this reason, there are some similarities between the foods consumed by gorillas in Bwindi and those

TABLE 10.2 | FREQUENCY AND BIOMASS OF TOP 10 GORILLA FOOD SOURCES

Species	Part[a]	Frequency (%)[b]	Biomass (%)[c]
Group BM			
Galium spp.	ls	24.41	34.96
Carduus nyassanus	lf	16.72	19.94
Peucedanum linderi	st	15.8	18.54
Carduus nyassanus	st	16.81	10.72
Senecio johnstonii	pi	2.69	5.07
Carduus nyassanus	rt	1.50	4.31
Laportea alatipes	lf	8.21	1.39
Lobelia stuhlmanii	pi	1.44	1.28
Urtica massaica	st	1.44	1.14
Laportea alatipes	st	0.87	0.64
Group 11			
Galium spp.	ls	31.66	53.12
Carduus leptocanthus	rt	4.02	10.50
Vernonia auriculifera	pi	4.84	6.89
Basella alba	lf	16.06	5.07
Peucedanum linderi	st	4.42	4.87
Arundinaria alpina	lf	1.34	3.32
Arundinaria alpina	sh	8.60	2.99
Droguetia iners	lf	7.66	2.92
Carduus leptocanthus	lf	3.26	2.64
Rubus spp.	lf	0.76	2.04

Source: McNeilage, Alastair. 2001. Diet and habitat use of two mountain gorilla groups in contrasting habitats in the Virungas. Chap. 10 in *Mountain Gorillas: Three Decades of Research at Karisoke*. Cambridge University Press, Cambridge.

Note: The relative frequency and biomass of the top 10 foods recorded in the diet of Group BM and Group 11 in the Virungas.

[a]Plant parts are lf = leaf and stem eaten together, lb = leaf base, pi = pith from branches, rt = root, fl = flowers, dw = dead wood, tw = twigs, cu = cuticle of vine stems, ba = bark, sh = shoot, fr = fruit, and fu = fungus.

[b]Calculated from the number of feeding sites at which each food was eaten.

[c]Calculated where possible either from fecal analysis or from trail signs, as described in the text.

in the lower altitude zones of the Park National des Virungas in the Democratic Republic of Congo and even with the Grauer's gorillas in the Kahuzi Biega National Park farther south and west in the eastern Democratic Republic of Congo. There are large differences however in diet between the gorillas that range at higher elevations in the Virungas and the Bwindi gorillas whose range and habitat is at much lower elevations.

Gorillas are known to eat around 60 different species of plants in the Virungas and 140 in Bwindi. Of the herbaceous vegetation, a mountain gorilla's diet consists mostly of leaves, stems, pith, roots, and shoots. As few as two or three species can constitute 60 percent or more of the diet for the Virunga gorillas. In some circumstances, one species could constitute up to half of a gorilla's diet. Such a focus on

a single species is only possible when one of the most nutritious foods is available in great abundance. Because the overall plant diversity is not as high in the Virungas as in Bwindi, there is little reason to force them to vary their diet and include a greater proportion of other foods, or to search farther afield for other foods.

A second study conducted by the Max Planck Institute for Evolutionary Anthropology has increased our understanding of mountain gorilla feeding ecology by examining the dietary preferences in Bwindi. When the data from these two studies are analyzed and compared, the major differences in the diets of the Virunga gorillas and the Bwindi gorillas are clear. Because of a lack of consumable fruits in the high-altitude forest, fruit is not a regular feature of the Virunga gorillas' diet. The eating of fruit is not only typical of the Bwindi gorillas but also of the western lowland gorillas in the forests of west Africa. The Ugandan study revealed that the Bwindi gorillas eat fruit regularly, with seasonal spikes in the amount of fruit eaten as part of their diet. When they are available, gorillas readily seek and consume fruits. *Myrianthus holstii* is one of the most important fruit species consumed by both the Bwindi gorillas and the Grauer's (eastern lowland) gorillas in Kahuzi Biega National Park. The staple and largest part of the diet of the Bwindi gorillas still consists of fibrous foods (leaves, stems, and pith) like the Virunga gorillas. Largely related to differences in altitude, there are however, significant variations in the specific species of fibrous foods consumed by the gorillas in each of these locations.

These wide-scale variations in diet are believed to be a causal factor in ranging

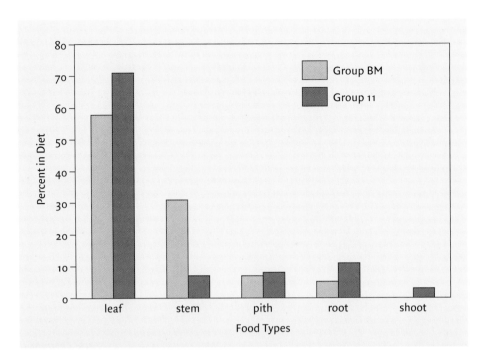

Above: This chart shows the percentage of the diet composed of different food types observed in the study of the Beetsme group (BM) and Group 11 in Rwanda. Gorillas may eat the leaves, stems, pith, root, or shoots of a given plant. *Source*: McNeilage, Alastair. 2001. Diet and Habitat Use of Two Mountain Gorilla Groups in Contrasting Habitats in the Virungas. Chap. 10 in *Mountain Gorillas: Three Decades of Research at Karisoke*. Cambridge University Press, Cambridge.

Below: *Myrianthus holstii* is one of the most important fruit species consumed by both the Bwindi gorillas in Bwindi Impenetrable National Park, Uganda, and Grauer's gorillas in Kahuzi Biega National Park, in the Democratic Republic of Congo.

DR. MARTHA ROBBINS is a Research Associate in the Department of Primatology from the Max Planck Institute for Evolutionary Anthropology (MPIEA), which is located in Leipzig, Germany. MPIEA is the primary organization conducting research on the Kyagurila group of mountain gorillas in Bwindi Impenetrable National Park (BINP) in Uganda. Dr. Robbins leads that research effort for MPIEA and is based at the Ruhija Research Institute located in the northeast section of BINP.

An American born in New Jersey, Martha received her bachelor's degree from the University of South Carolina, with a double major in biology and psychology. In 1990, after completing her bachelor's program, Martha made her first trip to Africa to work as a research assistant at the Karisoke Research Center collecting data for her master's and PhD. After returning to the states to complete her PhD program in zoology at the University of Wisconsin, Martha taught at the university for a year and at a small college in Minnesota for another year. Martha went to work for MPIEA in 1998 in Bwindi and has been working there ever since.

Dr. Robbins is interested in the evolution of sociality in animals, and trying to better understand the links between ecological conditions, behavioral patterns, and population dynamics. In addition to her interest from a scientific standpoint, she wants her work to have conservation implications. The data and analysis of the work that she and her staff produce function as key inputs to the conservation and management plans of BINP, which is a part of what she had hoped to accomplish with her work. She is also committed to the training and capacity building of Ugandans at all levels, ranging from field assistants to supervising PhD students.

Actively involved with other MPIEA projects involving great apes in Gabon and other central African countries, Dr. Robbins wants to look at gorillas comparatively across different ecological conditions to see how they vary, how that translates into differences in ranging and dietary patterns in different populations, and how that in turn translates into differences in social behavior, population dynamics, and grouping patterns.

Having worked in both the Virungas with the Karisoke research groups, and with the Bwindi research group, Dr. Robbins is recognized as a subject-matter expert on the behavior of mountain gorillas and has an extensive list of published material covering many different aspects of the ecology and behavior of mountain gorillas in addition to papers about subjects involving other great apes as well. Many of those papers can be found on the MPIEA, Department of Primatology web site. She is an editor for the Cambridge University Press book titled *Mountain Gorillas: Three Decades of Research at Karisoke* and *Feeding Ecology of Apes and Other Primates*, both from Cambridge University Press. She is also an author of several mountain gorilla censuses conducted in both the Bwindi and the Virunga forest environments, including the most recent censuses conducted in each protected area.

TABLE 10.3 | VARIETY IN CONSUMPTION OF FRUIT SPECIES IN BWINDI

Species	Year 1	Year 2	Year 3	Year 4	Year 5	Year 6	Six Years Combined	Genus Eaten in Kahuzi Biega[a]
Allophyllus sp.	0.81	0.70	1.22	3.26	5.23	1.11	2.19	+
Chrysophyllum sp.	8.87	11.58	0.91	17.51	7.99	13.06	10.05	
Drypetes gerrardii	0.00	5.26	0.00	0.00	10.74	0.00	2.81	
Ficus spp.	0.40	2.46	0.30	0.00	1.10	1.11	0.88	+
Maesa lanceolata	0.00	5.26	3.96	4.45	16.53	0.56	5.47	+
Myrianthus holstii	8.06	9.82	6.71	6.53	12.95	8.89	8.90	+
Mystroxylon aethiopicum	0.00	4.56	0.30	1.19	1.10	0.00	1.15	
Olea capensis	6.85	1.05	0.00	8.61	0.00	0.28	2.60	
Olinia usambarensis	0.40	4.56	0.30	0.30	0.28	10.00	2.76	
Podocarpus milinjianus	0.00	0.35	0.61	0.00	0.55	0.00	0.26	
Rapennea rhodrodendoroides	0.00	0.00	0.00	0.00	0.55	0.00	0.10	
Rhytinginia kigeziensis	0.00	0.00	0.00	0.00	2.20	0.00	0.42	
Strombosia sp.	0.00	0.00	0.30	0.00	0.00	0.00	0.05	+
Rubus apetalus								
Symphonia globulifera	0.40	0.00	0.00	0.00	0.55	0.00	0.16	+
Syzigium sp.	2.42	5.61	1.22	7.42	4.13	11.39	5.57	+
Teclea nobilis	0.40	11.23	0.00	0.59	5.51	0.00	2.86	
Xylamos monospora	0.00	1.40	0.61	1.48	0.28	0.00	0.62	+
Total % Fruit Days	23.80	43.20	15.60	42.3	53.04	40.28	37.06	

Source: Robbins, Martha M., John Bosco Nkurunungi, and Alastair McNeilage. Variability of the Feeding Ecology of Eastern Gorillas. 2006. In *Feeding Ecology in Apes and Other Primates.* Gottfried Hohmann, Martha M. Robbins, and Christophe Boesch, eds. Cambridge University Press, Cambridge. Variability in consumption of fruit species across the six years of observation. Values are the percentage of observation days that the species was consumed. The only species recorded as eaten in the Virunga Volcanoes is *Rubus apetalus.*
[a] "+" indicates the genus is consumed by Grauer's gorillas in Kahuzi Biega.

patterns and behavior. There is a positive correlation between the length and distance of a foraging activity and the degree of frugivory, thus making the role of fruit in the Bwindi gorillas' diet and the lack of it in the Virunga gorillas' diet significant. Generally high in sugars, fruit yields significant nutritional value and is a preferred food choice when available. Although herbaceous vegetation is spread quite widely throughout the habitat, gorillas will seek particularly nutritious foods, like fruit, when available. Because fruit trees are distributed in patches and are not all ripe at the same time, as the gorilla's diet becomes more frugivorous, the distance covered in a day increases proportionately.

From a conservation and management perspective, it is important to understand what exactly constitutes "good gorilla habitat." The information gained from the research conducted by the Karisoke team in Rwanda and the Max Planck team in Uganda helps conservation managers and planners in Rwanda, Uganda, and Democratic Republic of Congo to understand the feeding ecology that defines "good gorilla habitat" so that they can manage the protected areas accordingly.

TABLE 10.4 | FIBROUS FOODS CONSUMED IN BWINDI

Species	Plant Form	Part Consumed[a]	% Days Consumed across 3 Years	Correlation with Fruit Consumption R^2 values[b]	Genus Important in Kahuzi Biega	Genus Important in Virungas
Basella alba	Herb	l, st	46.2	0.192	+	+
Cardus sp.	Herb	l, st, fl	12.4	0.029		+
Epiphytes[c]	Herb	l, st, wp	7.5	0.010		
Ficus spp.[d]	Tree	b, l	5.7	0.001	+	
Ganoderma australe	Fungus	wp	7.5	0.066		
Ipomea sp.	Herb	b, l	46.6	0.070	+	
Mimulopsis arborescens	Herb	l, p	42.2	0.105		
Mimulopsis solmsii	Herb	b, l	45.9	0.051		
Momordica spp.[e]	Herb	b, l	71.1	0.092		
Myrianthus holstii	Tree	b, l	26	0.107	+	
Olea capensis	Tree	l, dw	8.5	0.006		
Piper capense	Herb	p	17.1	0.054	+	
Rubus sp.	Shrub	l	42.3	0.007		
Triumfetta sp.	Herb	l	60.3	0.436		
Urera hypselodendron	Herb	b, l	72.3	0.177	+	
Vernonia calongensis	Shrub	b, l	5.9	0.013	+	+

Source: Martha M. Robbins, John Bosco Nkurunungi, and Alastair McNeilage. 2006. Variability of the Feeding Ecology of Eastern Gorillas. Feeding Ecology in Apes and Other Primates. G. Hohmann, Martha M. Robbins, and C. Boesch, eds. Cambridge University Press, Cambridge.
Note: Important fibrous foods consumed (eaten on >5% of days), results of tests for seasonality in consumption of fibrous foods, and correlations between consumption of fibrous foods and overall fruit consumption.
[a]Plant parts: b = bark, l = leaves, st = stem, p = pith, wp = whole part, fl = flower, dw = wood from dead tree.
[b]R^2 values are for a correlation between consumption of each fibrous food species and fruit consumption using monthly percentages.
[c]Not identified to genera level. [d]Not identified to species level. [e]Includes three species: M. solmsii, M. calantha, and M. foetida.

Population	No. of Fruit Species in the Diet	Estimate of Fruit in Diet	Terrestrial Herbaceous Vegetation Density	Home Range Size	Core area size
Mountain Gorillas: Karisoke Research Center	1	<1% of feeding time spent eating fruit	8.8 stems/m²	3–15 km²	1.4–4km² 30–40% of annual home range
Mountain Gorillas: Bwindi Impenetrable	16	27% of observation days Approx. 11% of foraging time spent eating fruit	? (Nkurunungi, in prep)	21–40 km²	7–12 km²
Eastern Lowland Gorillas: Kahuzi Biega		Seasonal variation	Not calculated	23–31 km²	Not calculated
Highland (1,800–3,300 m)	20	96.5% of fecal samples contained fruit remains			
Lowland (600–1,300 m)	48	89% of fecal samples contained fruit remains			
Western Lowland Gorillas: Lopé, Mondika, and Bai Hokou	77–115	98% of fecal samples contained fruit remains Seasonal variation	0.78–1.87 stems/m²	7–23 km²	Not calculated

Source: Robbins, Martha M., and Alastair McNeilage. 2003. Home Range and Frugivory Patterns of Mountain Gorillas in Bwindi Impenetrable National Park, Uganda. International Journal of Primatology, Vol. 24, No. 3, June 2003.

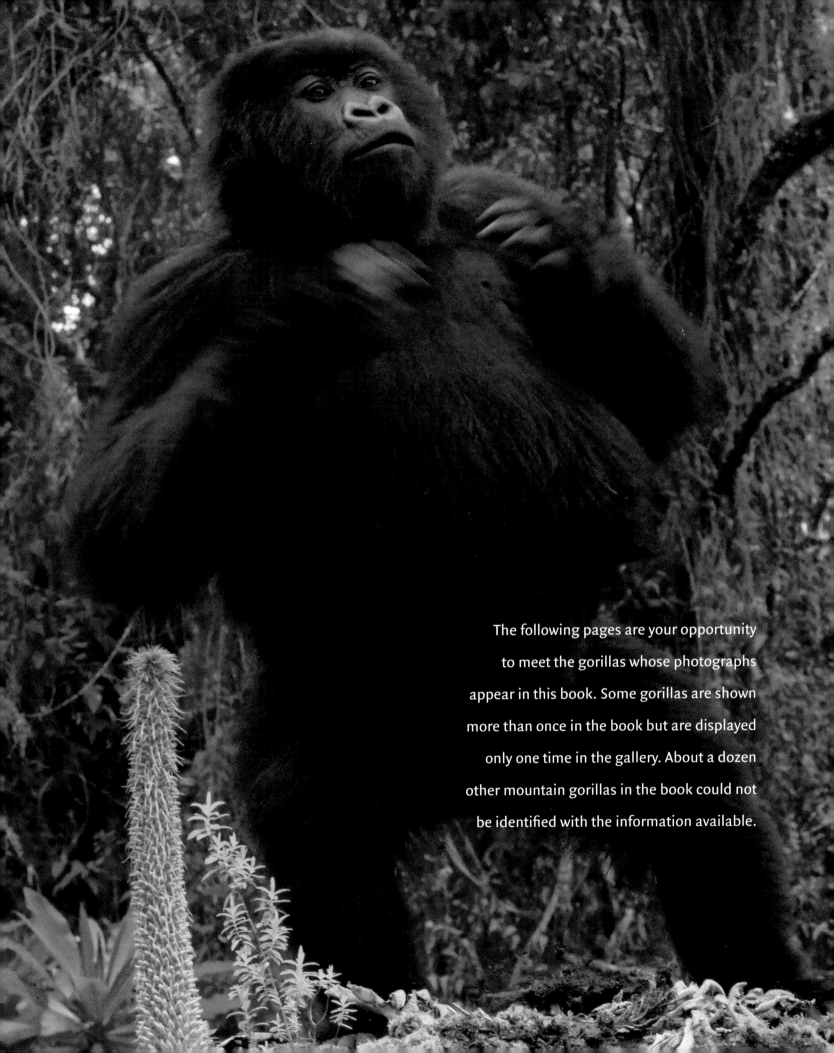

The following pages are your opportunity to meet the gorillas whose photographs appear in this book. Some gorillas are shown more than once in the book but are displayed only one time in the gallery. About a dozen other mountain gorillas in the book could not be identified with the information available.

Name: Gasindikira
Group: Group 13
Country: Rwanda

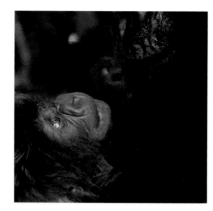

Name: Byishimo and Impano (twins)
Group: Susa
Country: Rwanda
Notes: Since their birth in 2004, the twins from the Susa group and their mother, Nyabatindore, have been the number one tourist attraction.

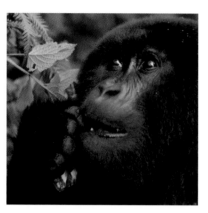

Name: Bunyenyeri
Group: Umubano
Country: Rwanda

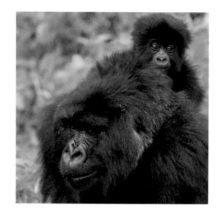

Name: Poppy and her infant, Ishyaka Laurentine
Group: Susa
Country: Rwanda
Notes: Poppy is one of the oldest and most successful females among the Virunga gorillas. She has raised many babies over the years contributing to the overall population.

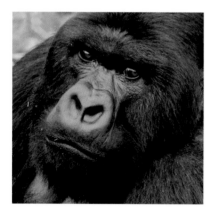

Name: Kwakane
Group: Susa
Country: Rwanda
Notes: Kwakane is one of three silverbacks in the Susa group.

Name: Muganga
Group: Susa
Country: Rwanda

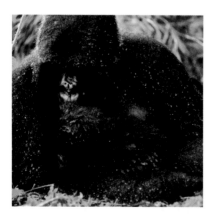

Name: Tuyishime and Kuramba
Group: Susa
Country: Rwanda

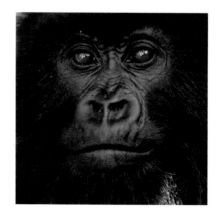

Name: Ishema
Group: Susa
Country: Rwanda

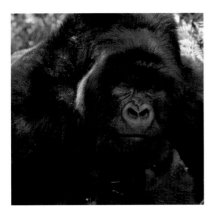

Name: Nyakakangaga
Group: Susa
Country: Rwanda
Notes: Nyakakangaga is one of three silverbacks in the Susa group.

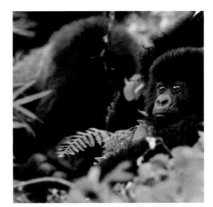

Name: Isonga
Group: Susa
Country: Rwanda
Notes: Little Isonga sits close by the silverback during the resting period. This behavior is a normal part of the relationship between the infants of the group and the silverback.

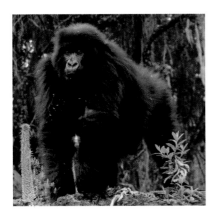

Name: Isaro
Group: Beetsme
Country: Rwanda

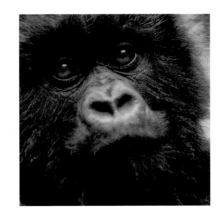

Name: Shirimpumu
Group: Sabyinyo
Country: Rwanda

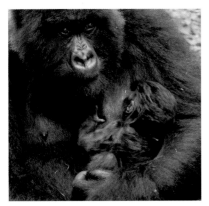

Name: Mbele and Agaseke
Group: Amahoro
Country: Rwanda
Notes: Mbele holds her young nursing infant named Agaseke.

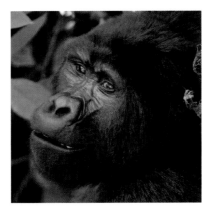

Name: Sikio
Group: Kyagurilo
Country: Uganda

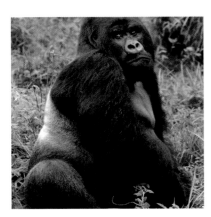

Name: Guhonda
Group: Sabyinyo
Country: Rwanda

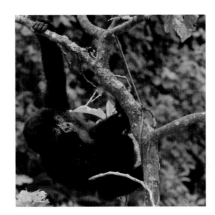

Name: Izuba
Group: Umubano
Country: Rwanda

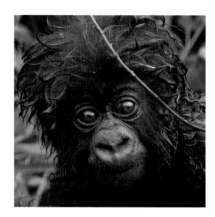

Name: Urumuli
Group: Group 13
Country: Rwanda

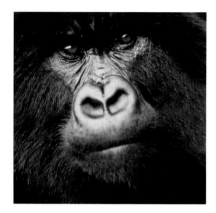

Name: Kampande
Group: Susa
Country: Rwanda

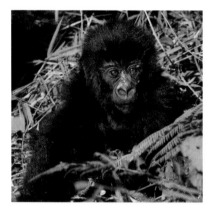

Name: Inkundwa
Group: Group 13
Country: Rwanda

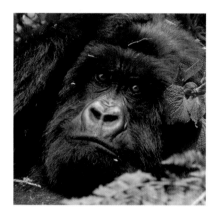

Name: Rugendo
Group: Group 13
Country: Rwanda

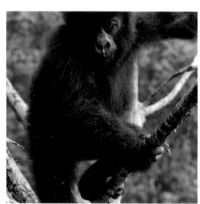

Name: Byiringiro
Group: Umubano
Country: Rwanda

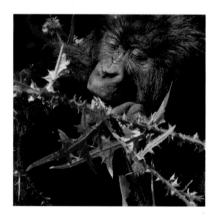

Name: Gukunda
Group: Sabyinyo
Country: Rwanda

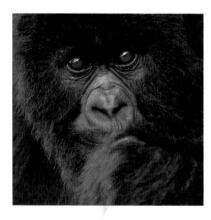

Name: Ibigwi
Group: Amahoro
Country: Rwanda

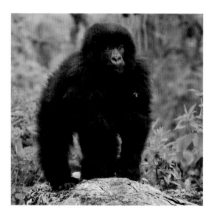

Name: Tetero
Group: Beetsme
Country: Rwanda

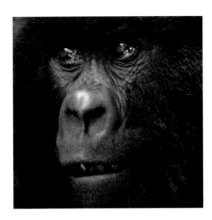

Name: Bushokoro
Group: Amahoro
Country: Rwanda

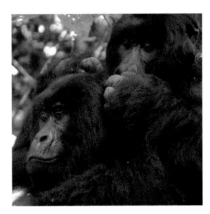

Name: Mapuwa and Kagofero
Group: Mapuwa
Country: Democratic Republic of Congo
Notes: The silverback Mapuwa grooms a female named Kagofero.

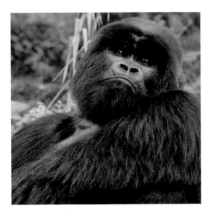

Name: Ubumwe
Group: Amahoro
Country: Rwanda

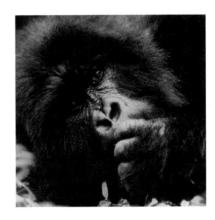

Name: Bikwi
Group: Susa
Country: Rwanda

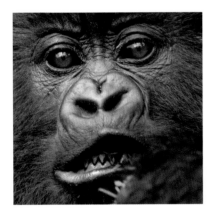

Name: Ikaze
Group: Beetsme
Country: Rwanda

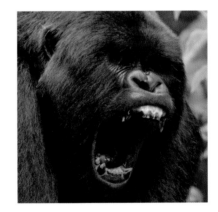

Name: Charles
Group: Umubano
Country: Rwanda

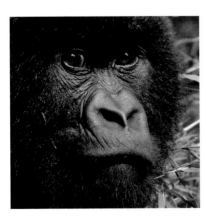

Name: Gihishamwotsi
Group: Sabyinyo
Country: Rwanda

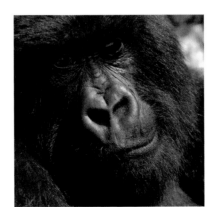

Name: Rugendo
Group: Group 13
Country: Rwanda

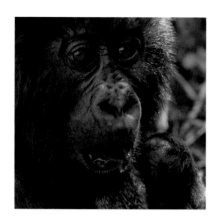

Name: Kalema
Group: Group 13
Country: Rwanda

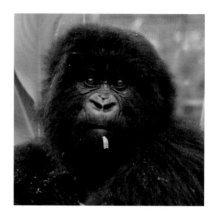

Name: Maisha
Group: Unknown
Country: Rwanda

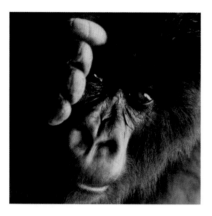

Name: RwandaRushya
Group: Susa
Country: Rwanda

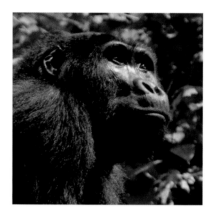

Name: Marembo
Group: Kyagurilo
Country: Uganda

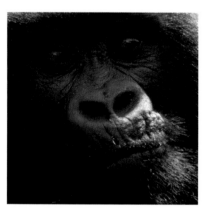

Name: Kabatwa
Group: Sabyinyo
Country: Rwanda

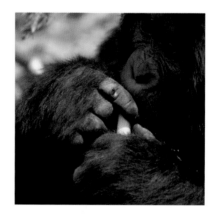

Name: Turiho
Group: Sabyinyo
Country: Rwanda

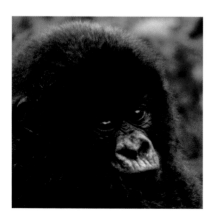

Name: Himbara
Group: Amahoro
Country: Rwanda

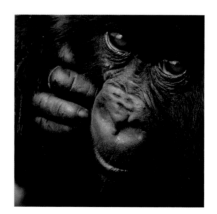

Name: Kubana
Group: Shinda
Country: Rwanda

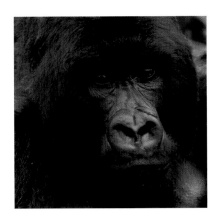

Name: Agashya
Group: Group 13
Country: Rwanda

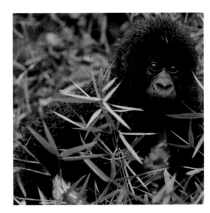

Name: Dusangire
Group: Group 13
Country: Rwanda

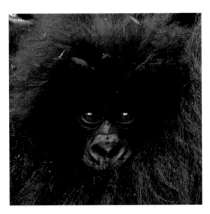

Name: Bukima and Ihumure
Group: Beetsme
Country: Rwanda
Notes: Bukima holds her young male infant, Ihumure.

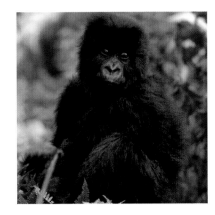

Name: Humura
Group: Susa
Country: Rwanda

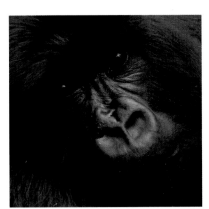

Name: Inziza
Group: Beetsme
Country: Rwanda

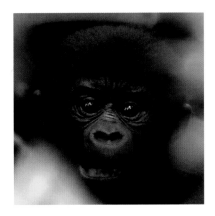

Name: Happy
Group: Kyagurilo
Country: Uganda

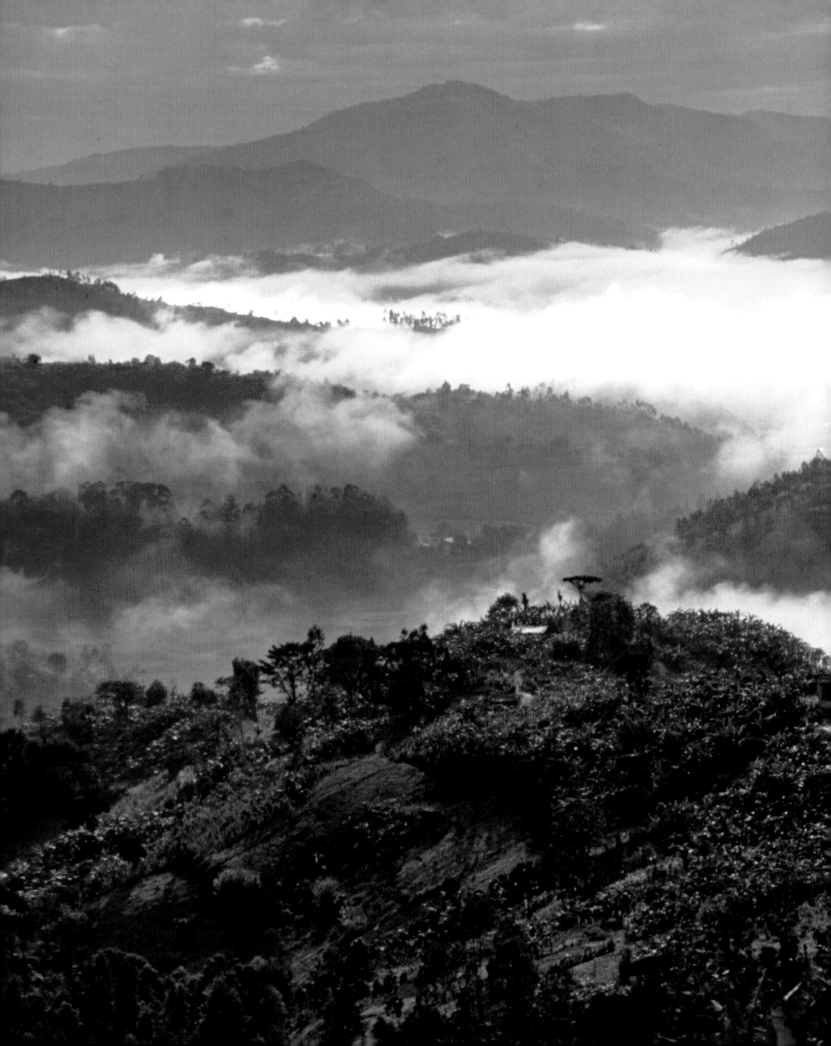

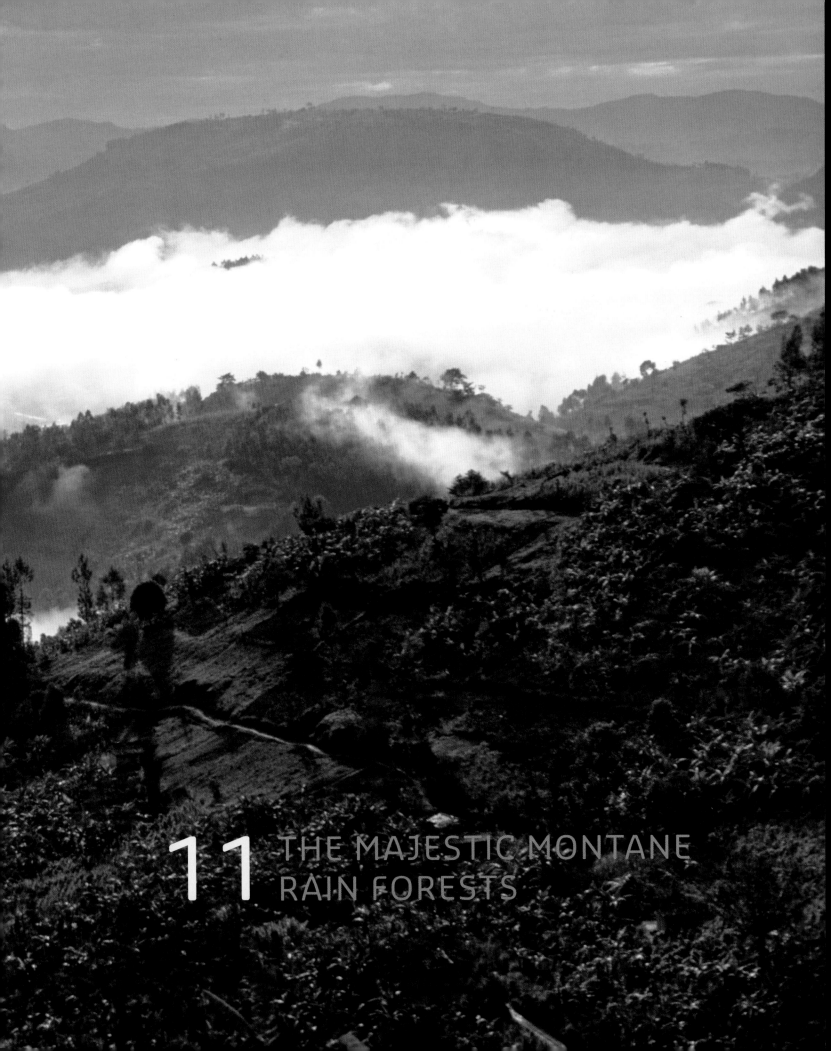

11 THE MAJESTIC MONTANE
RAIN FORESTS

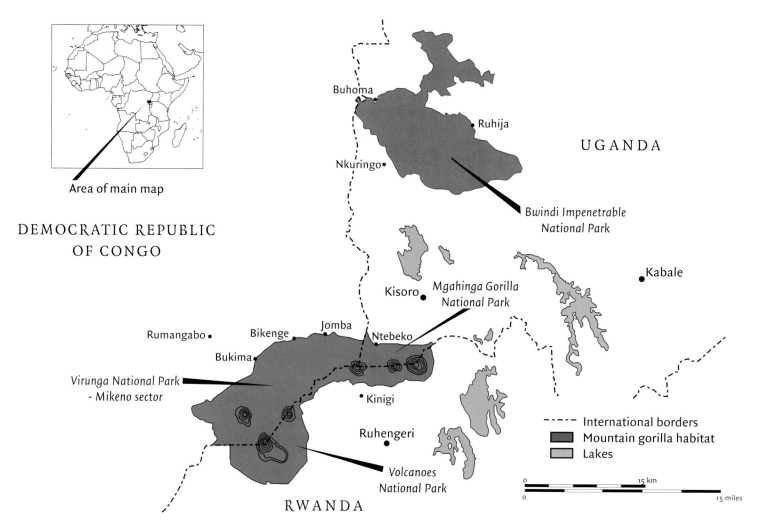

Area of main map

DEMOCRATIC REPUBLIC
OF CONGO

Buhoma

Nkuringo•

Ruhija•

UGANDA

Bwindi Impenetrable
National Park

Kabale•

Kisoro•

Mgahinga Gorilla
National Park

Rumangabo• Bikenge• Jomba• Ntebeko•

Bukima•

Virunga National Park
- Mikeno sector

•Kinigi

Ruhengeri•

Volcanoes
National Park

RWANDA

- - - - International borders
Mountain gorilla habitat
Lakes

0 15 km
0 15 miles

Evolution

Twenty million years ago, before the western arm of the Great Rift Valley came to
be, the Kigezi Highlands were formed. The Kigezi Highlands are a small range of
mountains located in the extreme southwestern corner of present-day Uganda,
approximately 25 km (about 15 miles) north to northeast of what would one day
become the border of Rwanda. This was the beginning of a series of geological
events that over time would forever change the landscape and create the spectacular
montane forest environments where mountain gorillas now live in central Africa.
Millions of years would go by before the next major events would occur.

 Almost half a million years ago, volcanic activity in the region began. As they were
born, the Virungas, or Bufumbiro chain of volcanoes, formed an arc along the Alber-
tine Rift Valley. Forming the western arm of the Great Rift Valley, the Albertine Rift
extends from the northern Democratic Republic of Congo along its eastern bound-
ary (northern tip of Lake Albert), to the southern tip of Lake Tanganyika, in Zambia.

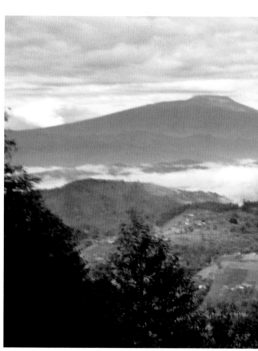

Previous spread: Steam and misty clouds in the morning rise and hang in the peaks and valleys of the volcanoes and the surrounding hills, reminding everyone of the pictures and movies that have drawn them to this most special place.

Opposite: Mountain gorillas are only found in the Virunga Volcanoes and the Bwindi Impenetrable National Park (BINP). The Virungas are a chain of eight volcanoes that straddle the confluence of the borders of Rwanda, Uganda, and the Democratic Republic of Congo. BINP is located in the Kigezi Highlands, a small range of mountains located in the extreme southwestern corner of Uganda approximately 25 kilometers (about 15 miles) north to northeast of the Virunga Volcano Conservation Area.
Although both areas contain lush montane rain forests, there are significant differences in elevation between the area surrounding the Virunga Volcanoes and the mountain forests of Bwindi. This difference in elevation affects both animals and plants. *Source:* IGCP.

Below: A dramatic panoramic view of the Virunga Volcanoes from a hillside above Ruhengeri, Rwanda. Of the eight volcanoes in the chain, only two are still active. From this vantage point, only six of the eight are visible. The other two volcanoes are located entirely within the Democratic Republic of Congo.

The Great Rift Valley is a massive, deep valley cutting through Africa from north to south with an eastern tract and a western tract. Several of the great lakes of Africa, including Lake Kivu, lie on the floor of the Great Rift Valley, which begins in northern Kenya and extends south to the great Zambezi Valley in Zimbabwe.

The first two volcanoes to be born were Mts. Mikeno and Sabyinyo. Sometime within the last one hundred thousand years, Mts. Karisimbi, Visoke, Gahinga, and Muhavura emerged. The word "virunga" in the local language means "high mountains reaching the clouds." These volcanoes became the dominant feature of the landscape in the area and could be seen for miles in all directions.

During the last fifty thousand years, significant climatic change was taking place throughout the planet. The changing size of the polar caps was dramatically affecting world climates. Although Europe and North America were affected by glaciation, Africa was overcome with long periods of cool, dry weather known as "interpluvials" and alternating shorter periods of warm, moist weather called "pluvials."

The Kageran, the Kamasian, and the Gamblian are the three main pluvials. During the Gamblian pluvial, the equatorial forest zone in this part of Africa would expand and return to its former state. The expanding and shrinking of forest habitats would have a major impact on both flora and fauna in other areas. The environments in this part of the Albertine Rift, however, remained stable during these periods and are believed to have functioned as a refugium during the Gamblian pluvial. A refugium is an environment that remains relatively stable, allowing various forms of plant and animal life to survive when they had perished elsewhere. This would in turn contribute to the tremendous biodiversity of the Albertine Rift, which includes both the Bwindi and Virunga forests.

The last two volcanoes, Mts. Nyiragongo and Nyamulagira, were created about twenty thousand years ago, completing the chain. Mt. Nyamulagira, which erupts

about every two years, and Mt. Nyiragongo, which is a little less frequent, are both continuously active, producing smoke and rumbling. Together, these two volcanoes are responsible for nearly two-fifths of Africa's historical volcanic eruptions.

Over time, the volcanoes would ultimately become covered and surrounded by high- and medium-altitude forest. As forests would shrink and separate, some species would evolve into different species or subspecies. When the forests eventually rejoined, the evolution had occurred at such a rate, in some cases, the different species could no longer interbreed. The survival of species within the refugia and the diversification of life adapting to the drier and colder conditions resulted in an increased biodiversity in the refugia and the areas immediately surrounding them. About ten thousand years ago, because of a warm and moist period, the forest at Bwindi flourished in the direction of the southeast. This would be its last major expansion.

TABLE 11.1 | VIRUNGA VOLCANO INFORMATION TABLE

Volcano	Altitude	Volcanic Status
Mt. Mikeno	14,553 ft or 4,436 m	Dormant
Mt. Sabyinyo	11,960 ft or 3,645 m	Dormant
Mt. Karisimbi	14,787 ft or 4,507 m	Dormant—last known eruption believed to be 8050 BC
Mt. Visoke	12,175 ft or 3,711 m	Dormant—last known eruption 1957
Mt. Gahinga	11,400 ft or 3,474 m	Dormant
Mt. Muhavura	13,540 ft or 4,127 m	Dormant
Mt. Nyiragongo	11,384 ft or 3,462 m	Active—eruptions recorded every few years from 1884 continuing through 2006
Mt. Nyamuragira	10,033 ft or 3,058 m	Active—eruptions recorded every few years from 1865 up to 2004

Source: Global Volcanism Program. www.volcano.si.edu/; Schaller, George B. 1963. *The Mountain Gorilla: Ecology and Behavior.* University of Chicago Press, Chicago.

The Environment Today

The Virungas are located between latitude 0° 25′ and 1° 35′ south and longitude 29° and 30° east, running along the top of the Congo-Nile crest, a north-south ridge similar to the continental divide in the United States. The rivers on the west side of the crest flow into the Congo River basin, while the rivers on the eastern side flow northward and empty into the Nile River. The Congo-Nile crest forms the eastern wall of the western part of the Great Rift Valley.

Spanning what would become the borders of the eastern Democratic Republic of Congo, northwestern Rwanda and southwestern Uganda, elevations in the Virungas range from around 6,068 feet (1,850 m) in the Mwaro Corridor of the Mikeno sector in the Democratic Republic of Congo all the way up to 14,870 feet (4,535 m) at the peak of Mt. Karisimbi, the highest in the chain. Towering over the farms and gardens that run up to the very edge of the park, the volcanoes and lush mountain forests that carpet their slopes stir the imagination and the soul. Seemingly infinite expanses of green spread out across the saddle areas between the volcanoes forming a veritable sea of endless vegetation.

Bwindi is located between latitude 0° 53′ to 1° 08′ north and longitude 29° 35′ to 29° 50′ east in southwestern Uganda. Like the Virungas to the south and west, it sits

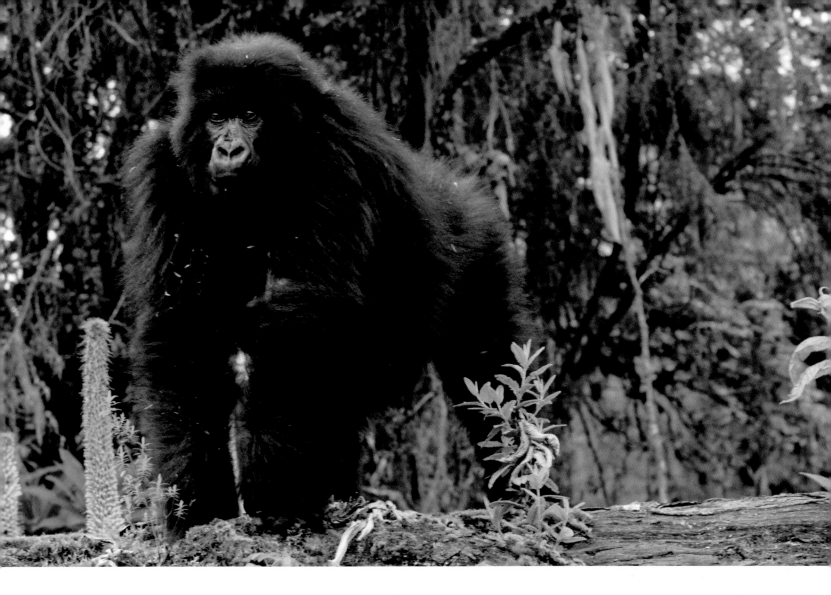

Isaro from the Beetsme group pauses on a log to look down and scrutinize the photographer below. Parc National des Volcans, Rwanda.

along the Western Rift Valley. Located in the Kigezi Highlands, the altitude in Bwindi ranges from around 3,805 feet (1,160 m) in the northern part of the park to 8,551 feet (2,607 m) in the southeast. Steep hills and valleys cover the entire area with few exceptions. The only flat areas in the park are the Mubwindi and Ngoto swamps. Rugged terrain and extremely dense vegetation cover almost the entire park. Significantly lower in altitude than most of the areas in the Virungas, this forest environment is very different from the protected areas in Rwanda, Congo, and even Mgahinga Gorilla National Park (MGNP) in southwestern Uganda.

Although both areas contain lush montane rain forests, there are significant differences in elevation between the area surrounding the Virunga Volcanoes and the mountain forests of Bwindi. This difference in elevation affects animals and plants alike. Some plant and tree species overlap; however, the difference in altitude makes Bwindi unique in respect to the overall plant and animal life of its forest compared with the forests of the Virunga Massif, particularly the higher-altitude sections of the Virunga forest.

These once contiguous forests are now isolated habitats, separated over time by

PARC NATIONAL DES VOLCANS

Parc National des Volcans (PNV) represents the Rwanda side of the Virungas. It is 160 km² in size and is situated between latitude 1° 21′ and 1° 35′ southern and between longitude 29° 22′ and 29° 44′ east. Originally part of Parc National Albert, the Governor of Ruanda-Urundi increased the area of the park in 1927. In 1974, the Rwandan Office of Tourism and National Parks (ORTPN) was charged with the management of the park, protection of its natural resources, and the promotion of research and tourism.

Seven thousand hectares (ha) of the park were cleared in 1959 and another 10,000 ha were cleared between 1969 and 1973 in a scheme to grow pyrethrum, a flower used in the manufacture of pesticide. The pyrethrum project was a European Community–funded project that failed, ironically, because of the drop in prices of pyrethrum immediately after the project was started. The original size of the park was 328 km². It has since been reduced by almost 50 percent to its current size of 160 km².

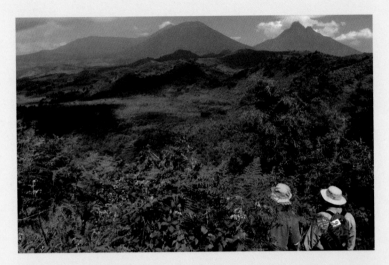

The Parc National des Volcans represents the Rwandan side of the Virungas. It is 160 km² in size. Originally part of Parc National Albert, the governor of Ruanda-Urundi increased the area of the park in 1927. In 1974, the Rwandan Office of Tourism and National Parks was charged with the management of the park, protection of its natural resources, and the promotion of research and tourism. These tourists pause in the middle of their gorilla trek to take in the spectacular view across the expanses of the park.

land clearing for agriculture. They are the only places in the world where mountain gorillas are found. Because of this separation of the forests, the gorilla populations have also become separated. When habitats become separated like this, physical changes and evolution can occur. Those changes, stimulated by the uniqueness of their isolated environments could be the first steps to the creation of new subspecies. In the case of the Virunga and Bwindi gorillas, observers familiar with both populations can notice subtle differences in their appearance, no doubt due to adaptations to their different environments. There is, however, an ongoing debate about the morphological differences between the two populations and whether they merit separation into two subspecies. Further study will be needed to resolve that debate definitively.

The Parks

Early in the twentieth century, the Belgian colonial government was in control of Congo, Rwanda, and Burundi (then Ruanda-Urundi). King Albert of Belgium, at the behest of Carl Akeley from the American Museum of Natural History, created the first national park in Africa in 1925. Parc National Albert was created to protect the gorillas in the area surrounding the Virunga Volcanoes. Today, the Virunga

PARC NATIONAL DES VIRUNGA

Parc National des Virunga (PNVi), designated as a World Heritage Site in 1979, represents the Congolese side of the Virungas and the largest part of the greater Virunga Conservation Area. The subsector (Mikeno) of the park that is home to mountain gorillas in the Virungas has a surface area of 240 km². The first reserve area was 20,000 ha located around Mt. Karisimbi, Mikeno, and Visoke. This was further extended to include the Rwindi Hunting Reserve and farms in the region totaling 350,000 ha. Another extension in 1939 expanded the park to more than 800,000 ha. With its massive size, the park is divided into four sections: northern, central, eastern, and southern. The southern sector is further subdivided into the Mikeno and Nyamulagira sectors.

MGAHINGA GORILLA NATIONAL PARK

Mgahinga Gorilla National Park (MGNP) is located in southwestern Uganda. It is the Ugandan sector of the Virunga Volcanoes covering the northern slopes of Mt. Muhavura, Mt. Gahinga, and the northeastern slope of Mt. Sabyinyo. Its coordinates are at latitude 1° 23′ south and longitude 29° 39′ east. The history of the park began during the British colonial administration in 1930. The Gorilla Game Sanctuary, with a size of 33.7 km², was established to protect the gorillas and other animals inhabiting the forest. At this time in Uganda, the forests and wild game had been managed by separate organizations within the colonial government. To protect the forest as well, the Mgahinga Forest Reserve was created in 1941. In 1951, the size of the forest reserve was reduced to 23.3 km² to provide more land for farmers. The boundary of the game sanctuary remained, although over the years, most of the vegetation outside the new boundary of the forest reserve was cleared, leaving little protection for wildlife. In 1963, the size of the forest reserve was increased to 27 km², while at the same time, the size of the game sanctuary was also increased to 47.5 km². The game sanctuary was renamed Gorilla Game Reserve. People had already settled in the areas covered by the expansion, however, and the new boundaries were never actually enforced. Under increasing pressure from the international community, the Gorilla Game Reserve Conservation Project was established as part of the Impenetrable Forest Conservation Project in 1989. With support from conservation organizations, the Forest and Game departments began to enforce laws and survey the wildlife living within the park. This is also when the tourism program was established. MGNP was officially gazetted in 1991 using the boundaries of the original game sanctuary providing protection for all of the flora and fauna and prohibiting human occupation and farming within its boundaries.

BWINDI IMPENETRABLE NATIONAL PARK

History of the Park

Two forest reserves totaling 207 km² were gazetted in 1932 by the colonial government with the intention of protecting the forest at Bwindi. Those reserves were combined in 1942 forming the Impenetrable Crown Forest Reserve with an increased total area of 298 km². It was designated a game reserve in addition to its forest reserve designation in 1961 when its surface area was increased to 321 km². The pressure to create a national park at Bwindi began in the 1970s in light of the overwhelming push for access to forest resources. The Impenetrable Forest Conservation Project was created in 1986 to more fully understand the biodiversity of the forest, to curb illegal activities within the forest reserve, and to plan for management of the protected area. Bwindi Impenetrable National Park (BINP) was created in August 1991, and habituation of two of the gorilla groups began almost immediately. Tourism programs would begin taking tourists to visit the gorillas in BINP in April 1993. In 1994, BINP was declared a Natural World Heritage Site under the provisions of UNESCO's World Convention Concerning the Protection of the World Cultural and Natural Heritage.

The boundary between Bwindi Impenetrable National Park in Uganda and "everything else" forms a stark line set against the adjacent farmland. The inherent challenges and pressures on both the park and people are caused by the encroachment of farmland and the potential for human/animal conflict.

Volcanoes are home to three different national parks: the Parc National des Volcans (PNV) in Rwanda; the Parc National des Virunga (PNVi) in the Democratic Republic of Congo; and the Mgahinga Gorilla National Park (MGNP) in Uganda. Dissected by the converging international borders of all three countries, together these three parks form a single, contiguous protected area with a total surface area of 447 km². The Bwindi Impenetrable Forest in Uganda, however, would not achieve national park status for almost seventy years after Parc National Albert was created.

Climate

Both the Virunga and Bwindi forests are located near the equator producing mild and consistent temperatures year round. Because Bwindi is closer to the equator and lower in altitude than the Virungas, the temperatures at Bwindi can be cooler.

Temperatures in the Virungas vary with altitude, but normal temperatures at the

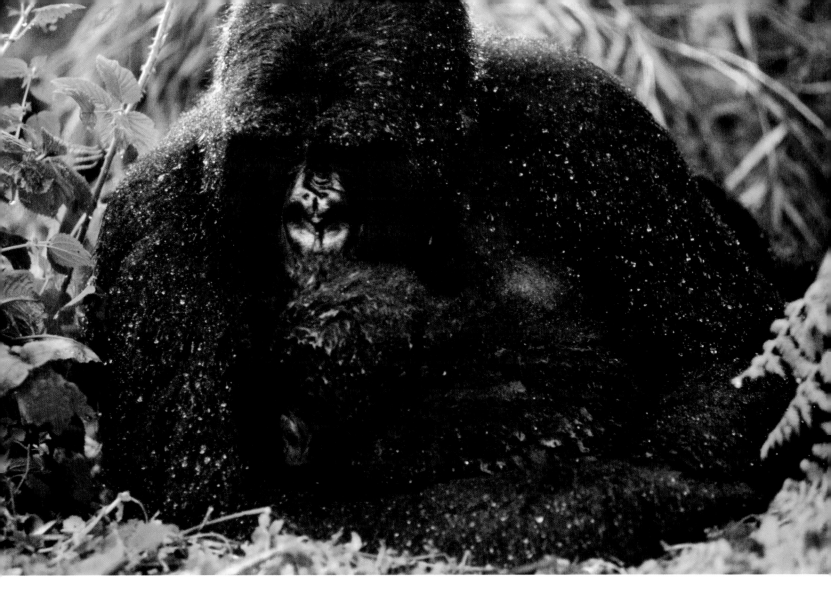

Tuyishime holds her baby, Kuramba, close to shelter it from the rain, keeping it safe and warm as possible. They are members of the Susa group in Parc National des Volcans, Rwanda.

lower altitudes range from lows of 10–15°C (50–60°F) at night to highs of 26–32°C (80–90°F) during the days. Morning temperatures are generally cooler and humid followed by warmer afternoons. The higher you go in the Virungas, the cooler it gets; temperatures can be reduced by as much as 1.6°C for every 300 m that you gain in elevation. The temperatures in Bwindi range from lows of around 7°C (45°F) at night to highs around 21°C (70°F) during the day.

Although both forests are classified as rain forests, there is a substantial difference in the amount of rainfall in the two different environments. The average annual rainfall in the Virungas is between 1,016 mm (40 inches) and 1,524 mm (60 inches) per year, with the highest rainfall along the high-elevation sections of the Congo-Nile crest. Rain typically comes to the Virungas during two wet seasons, the first of which is from around late February through early May and the second from around late October to early January. Some of this precipitation at the higher peaks even comes in the form of snow and hail. In Bwindi, rainfall can range from 1,130 mm (44.48 inches) to a significantly higher 2,390 mm (94.09 inches) per year. There are

ALASTAIR MCNEILAGE is British by birth but he has been working on the ground and calling Africa home since the late 1980s. His background and experience with gorillas and forests is extensive. Working as a research assistant at the Karisoke Research Center in Rwanda, Alastair's PhD project involved the study of mountain gorilla ecology, their habitat availability, quality, and utilization. He would go on to complete his PhD in Zoology at the University of Bristol in England, and then immediately return to Africa to study western lowland gorillas in the Dzanga-Ndoki National Park, located in the Central African Republic. His work would eventually lead him back to Uganda and Bwindi Impenetrable National Park where he would take a leadership role as the Director of the Institute for Tropical Forest Conservation (ITFC). Alastair believes that the ITFC is in a unique position. As a field-based research institute with a strongly applied focus and a close working relationship with the managers of protected areas in southwest Uganda, they also have the ability to carry out research of interest to the wider conservation and academic communities. He feels that their challenge in the future is to continue to improve the quality and impact of their work and to become better known on the international stage as a center of excellence in conservation research. At the same time, he feels it is important to keep a close working relationship with park managers, expanding their programs to include a broader range of forests in the Albertine Rift.

Much of Alastair's work has involved looking at the ecology of gorillas, the relationship with their environment, their diet, and their use of habitats. He has recently become more interested in the conservation challenges for the forests that support gorillas and other wildlife. This has led him to broaden his research interests to include the relationship between the forests and the surrounding human populations, and to better understand the effectiveness of different conservation strategies in ensuring the conservation of these forests. As the Director of ITFC, his involvement in a wide range of different projects from ecology of endangered species and ecological dynamics of the forest to socioeconomic work with the local communities allows him to have an impact in many areas.

Alastair, like many of his expatriate colleagues, is committed to the support, growth, and development of young Ugandan scientists. His work as Director of ITFC contributes greatly to facilitating the development and work of this next generation of young scientists.

two rainy seasons in Bwindi from March to May and from September to November. December to February and June to August are the dry seasons in Bwindi. Early mornings are always cooler and have higher humidity, but the forest will often dry and warm as the day progresses. The mist and fog, famous in photographs of the area, occurs in the early morning hours and after the rains. Cool air saturated with water collects in the valleys forming the misty fog.

TABLE 11.2 | CLASSIFICATION OF HABITAT ZONES FOR THE VIRUNGAS

Type	Altitude, Meters, and Feet	Characteristics
Alpine	Above 11,811 ft (3,600 m)	Areas above the limit of most herbaceous and woody plants, with low grass and mosses and occasional *Senecio johnstonii*. Bare rocky areas, especially on top of Mts. Mikeno and Sabyinyo were also included as Alpine.
Subalpine	10,826 ft (3,300 m) to 11,811 ft (3,600 m)	High-altitude vegetation, up to 4–5 m high, with abundant *Senecio johnstonii*, *Lobelia stuhlmanni*, and/or *L. wollostonii*, *Hypericum revolutum*, and *Rubus kirungensis*.
Brush Ridge	9,678 ft (2,950 m) to 10,826 ft (3,300 m)	Dense vegetation along the ridges and ravines on the sides of the volcanoes, with abundant *Hypericum revolutum* and shrubby growth of *Senecio mariettae*, reaching around 32 ft (10 m) high.
Herbaceous	9,186 ft (2,800 m) to 10,826 ft (3,300 m)	Open areas with low 3–7 ft (1–2 m), dense herbaceous vegetation, generally on the sides of volcanoes, with very few *Hagenia abyssinica* and *Hypericum revolutum* trees.
Hagenia	9,022 ft (2,750 m) to 10,826 ft (3,300 m)	Equivalent to the "Saddle" zone of previous authors, a variable canopy woodland dominated by *Hagenia abyssinica* and *Hypericum revolutum* trees reaching up to 65 ft (20 m), with a dense herbaceous or, less frequently, grassy understorey found in the saddles between certain volcanoes and on the less steep lower slopes.
Bamboo	8,366 ft (2,550 m) to 9,678 ft (2,950 m)	Areas dominated by often monospecific stands of bamboo (generally 16–40 ft [5–12 m] high), mixed with a few trees and vines at lower altitudes.
Mimulopsis	8,366 ft (2,550 m) to 9,186 ft (2,800 m)	Open herbaceous areas, differing from the Herbaceous zone in being found at lower altitudes, generally in the flat saddle between Visoke and Sabyinyo and often dominated by *Mimulopsis excellens*.
Meadow	7,217 ft (2,200 m) to 12,139 ft (3,700 m)	This term was used to describe open grassy areas at a variety of altitudes. These areas were often marshy and contained very little gorilla food. A large, dry, shrubby area on the east side of Muhavura, which burned extensively in 1989, was included here as Meadow.
Mixed Forest	6,561 ft (2,000 m) to 8,366 ft (2,550 m)	A mixed species montane forest, with abundant *Neobutonia macrocalyx* and *Dombeya goetzenii*. Other tree species include *Bersama abyssinica*, *Croton macrostachys*, *Clausena anisata*, *Maytenus heterophylla*, *Maesa lanceolata*, *Pygeum africanum*, and *Tabernaemontana johnstonii*. The open canopy reached up to 65 ft (20 m) high, and the understorey consisted of herbaceous vegetation, with dense patches of *Mimulopsis arborescens*.

Source: McNeilage, Alastair. 2001. Diet and habitat use of two mountain gorilla groups in contrasting habitats in the Virungas. Chap. 10 in *Mountain Gorillas: Three Decades of Research at Karisoke*. Cambridge University Press, Cambridge.

Flora

The rains that fall gently on the Bwindi and Virunga forests help to support the lush montane forest environments that mountain gorillas call home. Standing in the forests of Bwindi, there is no doubt that you are in "the jungle." All the classic elements that fill the wildest imagination are there: towering trees, giant ferns, dense undergrowth, and tangled vines create this complex forest environment. In the Virungas, the vast expanses of green stretch out for miles in the saddle areas between the volcanoes. At times, it seems like the forest goes on forever.

The primary differences in plant life in both forests are heavily influenced by extreme variations in altitude. Different plants exist in different areas and at differ-

TABLE 11.3 | CLASSIFICATION OF HABITAT TYPES FOR BWINDI

Type	Characteristics
Open forest	A colonizing forest with noncontinuous canopy and characterized by mixed herbaceous ground cover of herbs and vines. In some valleys and lower slopes, a woody herb, *Mimulopsis arborescens*, that grows into large woody trees is the dominant vegetation. When these plants die synchronously, it opens the understory, with more light to create wide areas of herbaceous plants and vines. Trees are few and form a noncontinuous canopy cover; gap specialists such as *Neoboutonia macrocalyx*, *Allophyllus albisinicus* (Ruhija), *Milletia dura*, and *Albizia gummifera* (Buhoma) may be present. In some places, it is characterized by gaps dominated by herbaceous vines, such as *Serioitachys scandens* and *Mimulopsis* spp. When on slopes there might be a mixture of bracken ferns, herbs, and trailing vines or gaps dominated with bracken fern. Areas that result from clearings made by elephants, tree falls, or landslides also fall into this category.
Mixed forest	A habitat dominated by both understory and canopy trees and shrubs, usually interspersed with lianas and woody vines, especially *Mimulopsis* spp. The canopy is discontinuous, open, or partially closed. When on slopes in the Ruhija area, this forest type usually forms a transition between open forest and mature forest and is often dominated with a terrestrial woody shrub, *Alchornea hirtella*. In the Buhoma area, the ground layer is dominated by *Asplenium* and *Pteris* fern species or herbs.
Mature forest	A habitat with large, tall canopy trees which often bear lianas. The trees form a continuous canopy and the undergrowth usually contains leaf litter and very scanty small herbs. In some places, the forest is stratified into tall canopy trees, a shrub layer with young trees whose diameter at breast height is <10 cm, and an herb layer with seedlings and saplings.
Swamp forest	A habitat with temporary or permanent streams found on lower slopes or valleys. In a few places, there may be some waterlogged open areas dominated by sedges. However, in most cases, it is composed of a mixture of herbs, vines, shrubs, and short trees usually found on the periphery of waterlogged swamp habitats. *Brillantaisia* spp. and *Mimulopsis arborescens* are often present.
Riverine forest	A habitat with permanent or temporal streams or rivers and a continuous or open canopy. Dominant herbs include *Palisota mannii* and *Aframomum* spp.; dominant shrubs include *Brillantaisia* spp. The tree fern *Cyathea manniana* is often found here as well.
Regenerating forest	A previously anthropogenically disturbed (logged) habitat that may have been burned. Dominant vegetation includes grasses such as *Pennisetum purpureum*, sedges such as *Cyperus* spp., and the ferns of *Pteridium* spp. There are also herbs, vines, shrubs, and a few colonizing tree species such as *Maesa lanceolata* and *Xymalos monospora*.

Source: Nkurunungi, John Bosco, Jessica Ganas, Martha M. Robbins, and Craig B. Stanford. 2004. A comparison of two mountain gorilla habitats in Bwindi Impenetrable National Park, Uganda. *African Journal of Ecology* 42:289–297.

ent elevations; these areas are referred to as "habitat zones." These habitat zones form various habitats as classified by the types of plant life that characterize those particular areas and elevations. Not restricted purely to specific elevations, the same habitat type may be found at different elevations throughout the Virungas or Bwindi for that matter. For example, in MGNP, the bamboo zone is found above the montane forest from Mt. Sabyinyo to Mt. Muhabura. The *Hagenia-Hypericum* zone can be found both above the bamboo zone on Mt. Sabyinyo and below it on Mt. Gahinga. Bwindi, however, is one of the few areas in Africa where lowland and montane vegetation communities meet, ranging from lower-altitude tropical moist forest to high-altitude afro-montane forest. As with the forest of the Virungas, the vegetation in Bwindi varies with altitude and terrain.

As you view a satellite map of the area, a dramatic topographic picture of the Virungas emerges. The outline of the park boundaries is the first thing that stands out. Next you are drawn to the volcanoes rising straight up to almost 15,000 feet at

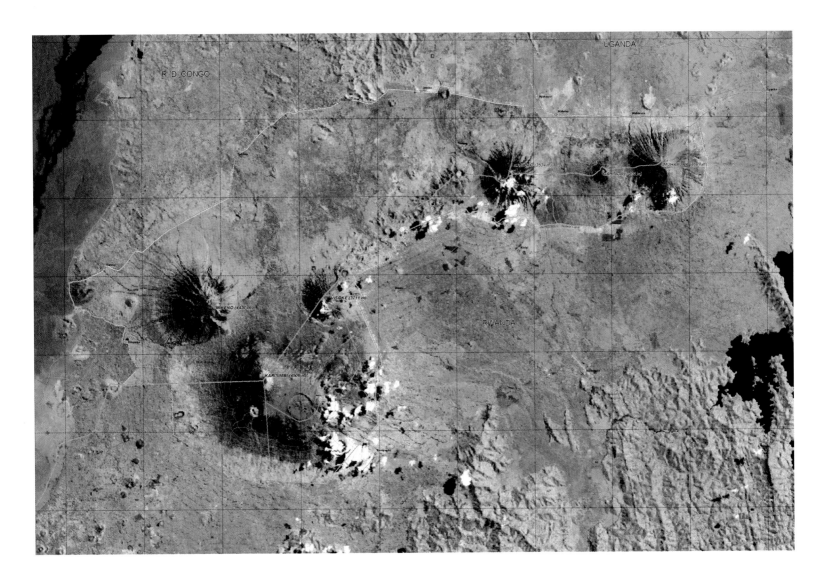

A dramatic image of the Virunga Volcanoes taken in 1987 from a NASA satellite. Notice the variation in altitude and the topographical changes. *Source: IGCP.*

the top of Mt. Karisimbi. The satellite image provides a unique perspective on the environment and shows just how wide the variation in elevation is throughout the Virungas. Looking at the vegetation map of the Virungas, you notice the patches and variation of habitats that blanket the parks in all three countries. If one were to overlay and compare this map with the satellite image, how the vegetation zones correspond to the variation in altitude becomes clear. In most places or locations, the vegetation is thick and dense, the inclines can become very steep, and the environment is nothing short of spectacular.

Scientists have been studying the many types of vegetation found in the Virunga Volcanoes and Bwindi for years. The list of plant species now known to occur within the Virunga Volcanoes stands at 1,265, of which 92 are endemic to the Albertine Rift and 7 of those are IUCN listed as endangered or threatened. Three hundred and forty-eight species that were not previously known to exist in the Virungas were added to this list in 2004, and twelve more species were recorded but could not be

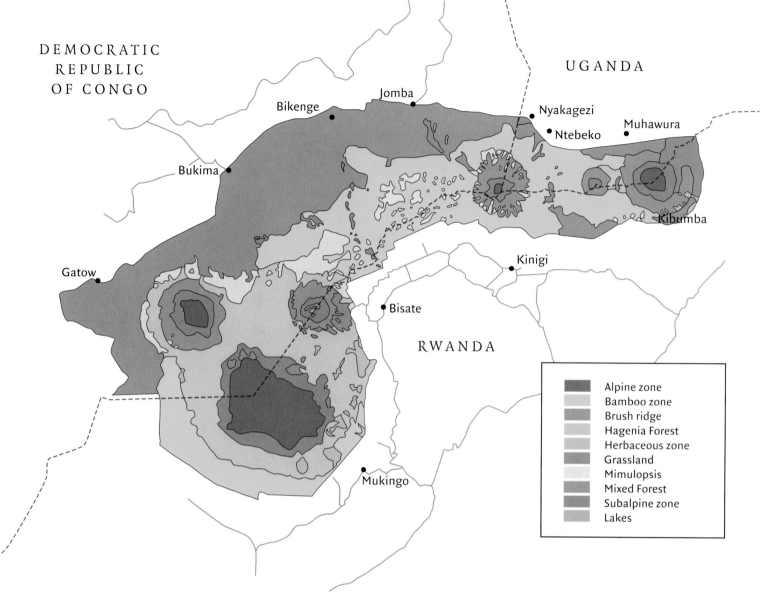

DEMOCRATIC
REPUBLIC
OF CONGO

UGANDA

Jomba

Bikenge Nyakagezi

 Muhawura
 Ntebeko

Bukima

 Kibumba

Gatow Kinigi

 Bisate

 RWANDA

Legend:
- Alpine zone
- Bamboo zone
- Brush ridge
- Hagenia Forest
- Herbaceous zone
- Grassland
- Mimulopsis
- Mixed Forest
- Subalpine zone
- Lakes

Mukingo

Virunga Massif Vegetation Map. Within the extreme variance in elevation of the Virungas, there are corresponding vegetation zones. The various habitat types found in the Virungas are documented in this vegetation map reproduced by permission from International Gorilla Conservation Programme and Dr. Alastair McNeilage. Overlay this map on the NASA satellite image on the previous page to see how vegetation zones correspond to the variance in altitude. *Source: IGCP and Alastair McNeilage.*

Opposite: Tourists hike into the seemingly never-ending forest in Parc National des Volcans, Rwanda. In most places or locations, the vegetation is thick and dense, the inclines can become very steep, and the environment is nothing short of spectacular.

identified. More extensive surveys in either of these forests would undoubtedly yield additional plant species, further evidence of the tremendous biodiversity contained in both forests. Because of the biodiversity in its plant life, Bwindi was recognized by the IUCN in a list of the twenty-nine African forests most important for conserving plant diversity.

In a 2004 survey conducted by Owiunji et al., the highest level of plant biodiversity was found to be in PNV with 624 species recorded. The lowest level was 313 species recorded in MGNP. Because the survey did not cover the entire area in all of the parks, it is probable that PNVi could have a greater number of plant species because it has the widest range of altitudes and habitats among all of the parks.

With herbs being the highest number of plants in all three of the parks, the area around Mt. Sabyinyo was found to be the richest area for plant biodiversity. Three hundred and fifty-eight species of plants were recorded on this volcano alone, the only one that includes all of the different habitat zones and vegetation types identified for this area contributing to its superior richness in overall biodiversity. The saddle areas between Mt. Sabyinyo and Mt. Visoke were equally rich with 346 species recorded. The areas of low-altitude forest between Mts. Sabyinyo and Visoke on the Democratic Republic of Congo side were found to have the fewest numbers of plants with only 161 species recorded.

The richness of plant species is also impacted by altitude. The greatest numbers of species are found in the lower altitudes, typically below 2,700 meters. The total number of plant species and the endemic species drops off in the higher elevations.

The types of plant life found in various areas of the parks in each country has changed over time, primarily as a direct result of human intervention. Parts of MGNP were destroyed by human encroachment during the 1950s and very little montane forest remains at the

base of Mt. Muhabura. The lower montane forest zone found between 1,600 meters and 2,600 meters is mostly gone in PNV, with only small patches still remaining in isolated areas. It is a constant battle to hold off encroachment in both forests.

Fauna

Part of the Albertine Rift, the montane forests of the Virungas and Bwindi, are home to many different species of birds, primates, and mammals. Understanding this tremendous biodiversity is crucial for properly managing the area and prioritizing research and conservation strategies.

Belgian scientists first began studying the wildlife in the Virunga Volcano Massif early in the twentieth century, and the international scientific community continues those studies to this day. Each study that is done expands the lists of species found in the area. A more recent inventory was performed in 2004 in a joint study involving the Wildlife Conservation Society, the Dian Fossey Gorilla Fund International, the International Gorilla Conservation Programme, and the three Protected Area Authorities in the range states: Office Rwandaise du Tourisme et des Parcs Nationaux, Uganda Wildlife Authority, and Institut Congolais pour la Conservacion de la Nature.

TABLE 11.4 | BIODIVERSITY RICHNESS

	Species Richness	Endemic Species	Threatened Species
Mammals	86 (21.3%)	18 (52.9%)	6 (16.7%)
Birds	258 (24.3%)	20 (57.1%)	4 (16.0%)
Reptiles	43 (24.6%)	7 (43.8%)	0 (0%)
Amphibians	47 (39.4%)	16 (47.1%)	9 (56.3%)
Plants	878 (15.2%)	124 (21.5%)	4 (10.0%)
Total	1,312	185	23

Source: Owiunji, D., D. Nkuutu, I. Kujirakwinja, I. Liengola, A. Plumptre, Nsanzurwimo, K. Fawcett, M. Gray, and A. McNeilage. 2004. *The Biodiversity of the Virunga Volcanoes.* WCS, DFGFI, ICCN, ORTPN, UWA, IGCP.
Note: The species richness, number of Albertine Rift endemic and IUCN threatened species for five taxa surveyed in the Virunga Volcanoes. Values in parentheses are the percentage of the total for the Albertine Rift.

As a result of that study, thirty-six new species of birds were added to the Virunga Volcanoes list of bird species. Eighteen of these species are endemic, and seventeen of these were recorded in MGNP. This brings the new total of recorded bird species in the Virungas to 294, with the highest number of 119 in PNV, followed closely with 109 species in PNVi and 88 in MGNP. Like most of the animals in the Virunga Volcanoes, the numbers and locations where bird species are found vary with the different habitat types. Because habitat types can be linked to elevation, the richness of bird species generally increases with elevation and then tapers off above 3,000 meters.

It is believed that up to ninety species of mammals occur within the Virunga Massif. Thirty-nine species of mammals alone have been recorded in MGNP. Other than mountain gorillas, some of the mammals found in different parts of the Virunga Massif include elephant (*Loxodonta africana*), buffalo (*Syncerus caffer*), bushbuck (*Tragelaphus scriptus*), black-fronted duikers (*Cephalophus nigrifrons*), giant forest hog (*Hylochoerus meinertzhageni*), leopard (*Panthera pardus*), spotted hyena (*Crocuta crocuta*), golden cat (*Profelis aurata*), African civet (*Civettictis civetta*), genet (*Genetta servalina*), and hyrax (*Dendrohyrax arboreus*). Four species of primates have also been found in addition to the mountain gorillas: golden monkeys (*Cercopithecus mitis kandti*), two

TABLE 11.5 | ALBERTINE RIFT ENDEMIC BIRD SPECIES

	Grass	Disturbed Woodland	Mixed Forest	Bamboo	Hagenia-Hypericum	Subalpine/Alpine	Swamp
Archer's ground robin	2.40	6.35	5.87	7.90	7.78	6.78	5.33
Blue-headed sunbird			0.98				
Collared apalis	6.00	3.13	6.90	4.18	1.14	0.52	5.33
Dusky crimson-wing			0.21				
Handsome francolin			0.05	0.08			
Kivu ground thrush			0.05	0.15	0.16		
Mountain masked apalis		1.04	3.66	1.47	0.97		9.33
Red-faced woodland warbler		1.57	5.05	6.12	1.62	1.04	
Red-throated alethe			0.26				
Regal sunbird		2.61	3.66	2.71	0.49	0.52	5.33
Rwenzori batis	1.20		2.11	2.55	2.11		
Rwenzori double-collared sunbird	4.80	6.26	1.91	2.63	27.57	8.35	1.33
Rwenzori turaco	2.40	4.70	1.65	2.63	2.92	3.13	2.67
Strange weaver	1.20		3.30	0.77	0.32		2.67
Stripe-breasted tit			0.21	0.23	3.08	1.57	
Total No. ARE	6	7	15	12	11	7	7
Total no. species	35	48	95	72	57	29	33

Source: Owiunji, D., D. Nkuutu, I. Kujirakwinja, I. Liengola, A. Plumptre, Nsanzurwimo, K. Fawcett, M. Gray, and A. McNeilage. 2004. *The Biodiversity of the Virunga Volcanoes.* WCS, DFGFI, ICCN, ORTPN, UWA, IGCP.

Note: The total number and encounter rates of Albertine Rift endemics recorded in the major habitat types.

additional subspecies of blue monkeys that have not been confirmed to be present in recent years (*Cercopithecus mitis dogetti* and *C. m. schoutedeni*), and the l'Hoest's monkey (*Cercopithecus l'hoesti*). Although the mountain gorillas receive the most attention from the world community, the golden monkey, which is endemic to the Virungas, is also endangered. As such, it is also a prime focus of conservation efforts in the Massif.

Part of the Albertine Rift, Bwindi, is one of the most biodiverse forests in East Africa, boasting 350 species of birds, 310 species of butterflies, 324 species of trees, and at least 120 species of mammals, among them 10 species of primates. Twenty-two of the twenty-seven endemic bird species in the country are found in Bwindi along with eight of the Albertine Rift endemic butterfly species making Bwindi the most important site in Africa for the conservation of montane butterflies. The International Council for Bird Preservation has also designated Bwindi as one of the critical "hot spots" for endemic birds. Altogether, nine globally threatened species are found in Bwindi. They include mountain gorillas, chimpanzees, l'Hoest's monkeys, African elephants, African green broadbills, Grauer's rush warblers, Chaplin's flycatchers, African giant swallowtails, and cream-banded swallowtails.

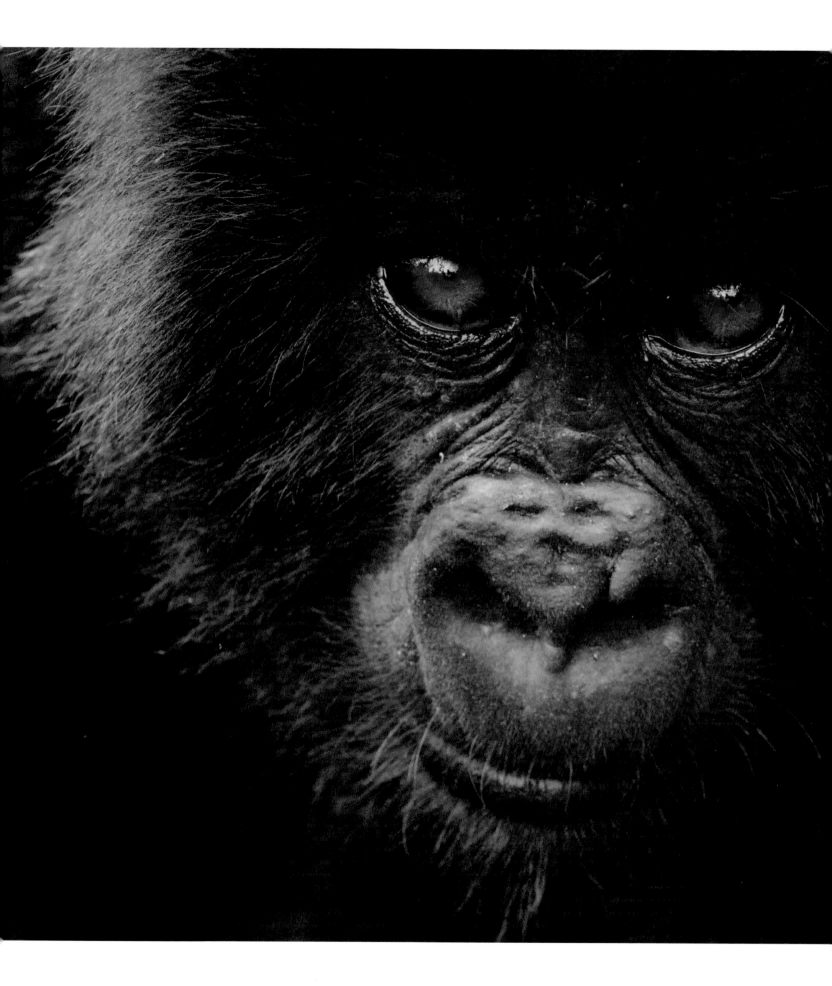

Greater Role in the Region

Everywhere in this part of Africa there seems to be competition for resources. Humans and animals are locked in a constant struggle. The gorillas and the people living around the boundaries of these forests are no exception. The reality is that the fate of the gorillas, the people, and the forests are inextricably linked. Although the forest is obviously critically important for the survival of the gorillas and the other wildlife, the role of the forest in helping to meet the resource needs of the people in that region is crucial. The Virungas and their spectacular forests function as a water catchment, providing critical retention, distribution, and availability of water for much of the region. Bwindi constitutes approximately 6 percent of the water catchment area for the entire country of Uganda. In fact, five major rivers, providing most of the runoff into Lake Edward, find their source in BINP. Because of the catchment, the various streams throughout the forest provide fresh and clean water to many local people surrounding the forest. Furthermore, the thin soil covering the volcanoes could easily wash away without the forest's vegetation taking hold and keeping the soil in place. The absorption of water by the forest and its soils protects the soils farther downhill from erosion as well. These soils are the basis for the agricultural lifestyle of the enormous human population in the valleys below. Soil erosion is a huge issue in these mountainous areas. Estimates in Rwanda, considered by some to be a gross underestimate of the real levels of erosion, are that 11 tons of soil per hectare are lost every year to erosion.

Forests of this magnitude have a significant effect on the weather of the region. Through the high levels of evapotranspiration typical of tropical forests, the precipitation in the surrounding area is

Young Kubana from the research group Shinda stares intensely in the Parc National des Volcans, Rwanda. Part of the Albertine Rift, the montane forests of the Virungas, are home to many different species of birds, primates, and mammals. Understanding this tremendous biodiversity is crucial to managing the area properly and prioritizing research and conservation strategies.

increased. Evapotranspiration is the process whereby the plants take the water from the ground, transfer it into the atmosphere, and contribute to the high levels of rainfall essential for the continued growth of the lush vegetation. This natural benefit of the forest to a region that is completely covered with farms is enormous.

For millennia these forests provided many other resources for their inhabitants and those living near the edge of the forest. For many generations, people have been collecting honey and other forest products. The duiker antelopes, forest hogs, and other animals have been hunted as long as humans have inhabited the area providing a constant source of protein. Much like the forests of Bwindi, plants of the Virunga forests have been used traditionally for medicinal purposes and its trees for building materials and fuel wood for fires to cook with. These forest resources are now all but limited to the protected areas, as everything outside the protected zones has been cut down.

Today, the ecological benefits of the forest are primarily the positive effect on the amount of rainfall in the region, control of soil erosion, and the provisioning through groundwater of year-round springs for clean water. If the forests in the Virungas were cleared for agriculture, all of these benefits would disappear with little to no alternative for providing these functions and benefits. The clearing of the entire forest on the Rwandan side of the Virungas would only accommodate the human population growth in that country for a few years at best. The benefits achieved from making the remaining park lands available to farming would simply not justify the costs associated with the disastrous impact that losing the forest would have on the region.

Opposite: Sikio is a member of the Kyagurilo group, which is reserved for research only in Bwindi Impenetrable National Park (BINP), Uganda. In 1994, BINP was declared a Natural World Heritage Site under the provisions of UNESCO's World Convention Concerning the Protection of the World Cultural and Natural Heritage.

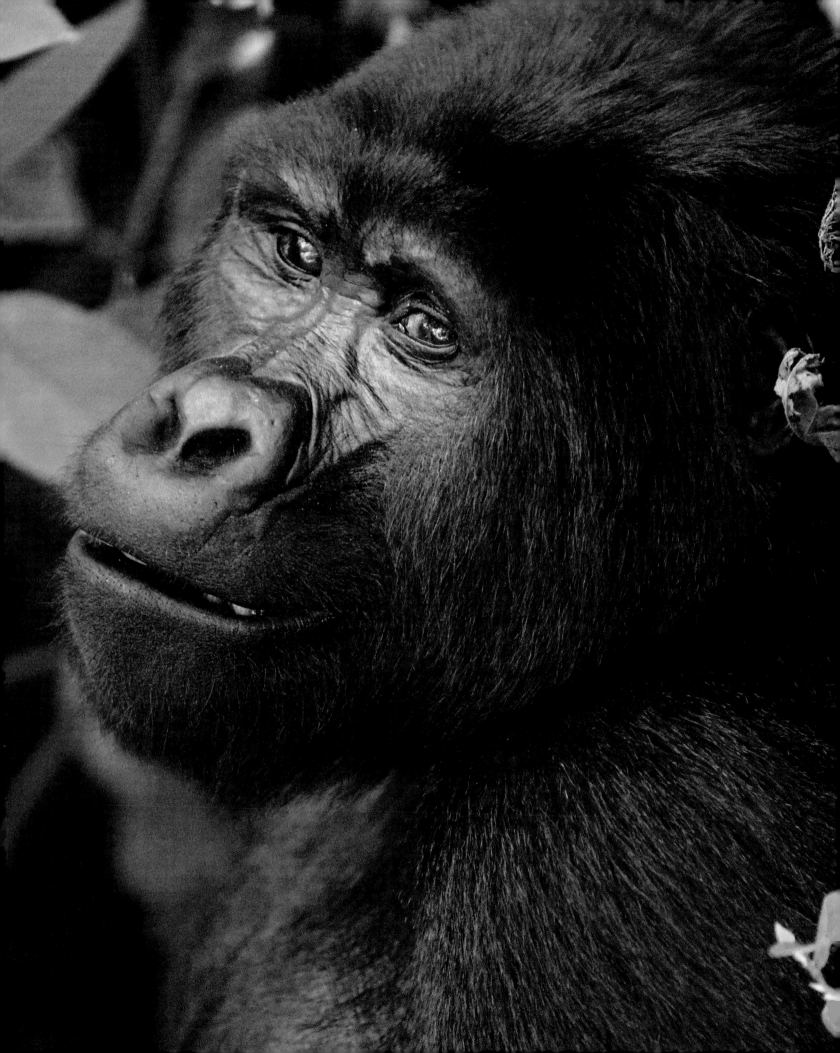

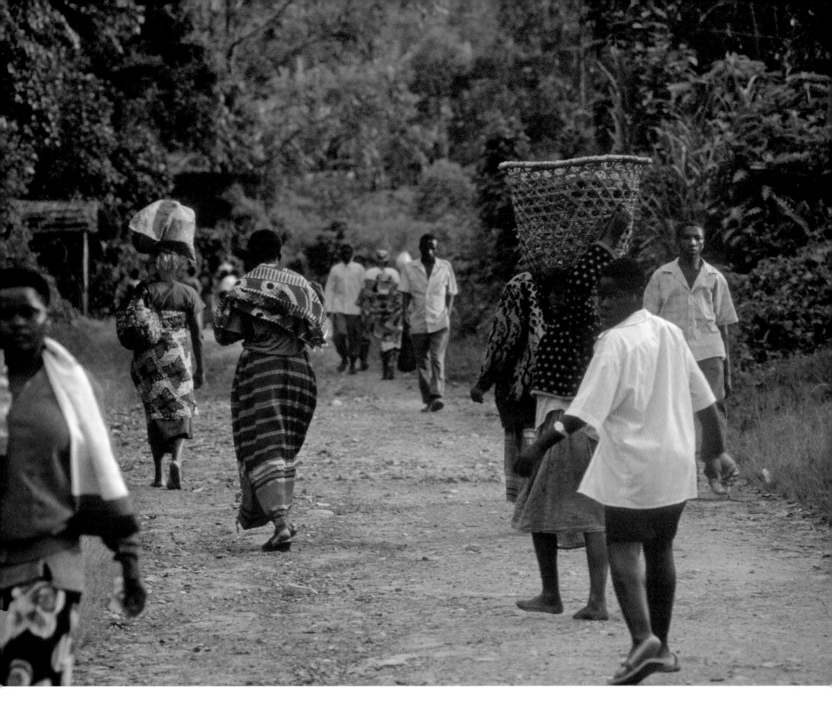

12 THE CLEARING OF THE FOREST

HUMANS had been settling throughout the fertile regions of Africa as they developed agriculture and as their populations grew. They constantly searched for more land on which to settle, and in order to settle, humans had to be able to consistently produce enough food to feed themselves. Through agriculture, people learned to manipulate the environment, exercising conscious control over the amount of available food production needed to sustain themselves. The societal success that came with greater food production led to greater population density, which leads to a need for greater food production, and a never-ending greater need for resources.

At one time, the forest in central Africa stretched from the west coast to the western wall of the Great Rift Valley. Groups of people settled here, attracted by the fertile, volcanic soils of the region. As the population grew, their need for land and resources increased. In the case of Rwanda, Uganda, and parts of Democratic Republic of Congo, the fertile lands and rich forests provided very adequate resources for that growing population.

Virtually all circumstances where animals become critically endangered species can be traced at a fundamental level to the loss of habitat. Mountain gorillas are no exception. Mountain gorillas are found in only two isolated forests, which were once contiguous but are now separated. These forests are surrounded by people whose agricultural nature continues to apply pressure to the remaining habitat.

This was not always the case in central Africa. A series of events occurred over time that ultimately changed the landscape forever and changed the face of the people living in the areas, which are home to the last remaining mountain gorilla populations on earth. It began when man made the initial transition from existing as a hunter-gatherer to living as a farmer and continued with the explosion of the Bantu migration across Africa. Everything would change. The transition from a hunting

Previous page: People are everywhere. Until the last 100 years, many of these areas were largely unpopulated. In Uganda, for example, the population in Kabale near Bwindi Impenetrable National Park increased by 90 percent between the late 1940s and 1980. A population census in 1991 showed populations in the districts in southwestern Uganda to vary from 125 people/km² to over 600 people/km² in the Gisozi Parish near MGNP. The Housing and Population Census of 2002 showed further increases in population density. Activities on this road near Bwindi, Uganda, pick up as people go about their day.

With each evolution of technology and increased capability for man to manipulate his environment, it became easier for the people inhabiting and expanding through central Africa to "tame" the forest. The birth of the agricultural revolution had begun. Agriculture and pastoralism would change everything.

People tend their cattle as they graze in fields at the very boundary of the Parc National des Volcans, Rwanda. A large cattle project was one of the major threats to the integrity of the park when the Mountain Gorilla Project was formed. The MGP staff were able to present a sufficient alternative for producing revenue through tourism that they were able to stop the cattle project before more of the forest was cleared.

and gathering way of life to agriculture was one of the most significant events in human evolution and set the course for the future of Africa and all life on Earth.

The Transition

The origins of agriculture and pastoralism as a means of food production came about roughly ten thousand to twelve thousand years ago, depending on what part of the world you are referencing. The transition would not be quick. During the Late Stone Age, people were still living largely as hunter-gatherers. Agriculture was not widespread; instead, the produce of wild plants was gathered. Many native plants in central Africa produced vegetables that were readily harvested, and fish and game from the hunt supplemented the rest of the diet. This was the way of life, which continued from about 15,000 BC to about 4,000 years ago. These two economic forms of existence—agriculture and hunting and gathering—supplemented each other, although over time the former slowly replaced the latter.

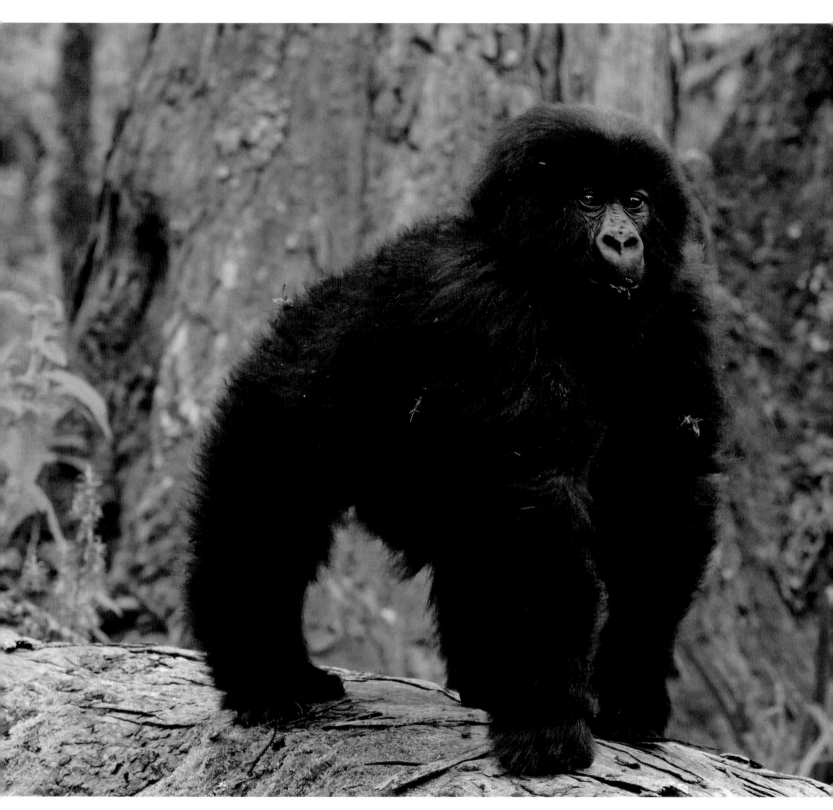

Tetero, a young juvenile from the Beetsme group, knuckle-walks along a large fallen tree in Parc National des Volcans, Rwanda. On the ground, gorillas walk on all fours, resting on the knuckles of the hands rather than on the bottoms or palms of the hands.

These methods of food production are at the very heart of the issues affecting both gorillas and people. This was a defining point in human evolution, not only in terms of how we acquire food but also in how our societies and technologies would develop, driving certain people to migrate from place to place or even disappear all together. Settlements replaced wandering as the ability to domesticate and control food production was achieved. With the advent of technologies related to farming, divisions of labor came about, and men were freed to pursue political and military ambitions, while farming chores were reserved for women, children, and slaves. As men focused time and effort on politics and military campaigns, new levels of aggression and expansionism emerged, along with a greater need for resources to support these efforts. The clearing of forests that had existed in one state or another for millions of years had begun. Within short order, in large part due to the Bantu migration, much of these incredible majestic forests would be all but gone.

The Bantu Migration

The origins of the Bantu are traced to West Africa in the regions of Nigeria and Cameroon. Bantu refers to a group of languages that represent approximately half of the Niger-Congo language family. Over time, Bantu would be used by some to classify entire groups of peoples in regards to their culture and origins. These are the people that eventually inhabited (and still do) most of central Africa and much of southern Africa. Many different tribes and cultures are represented within the Bantu language classification. For our purposes, we refer to the Bantu as a group. This allows us to speak specifically about the effect that their human expansion would have over the course of a thousand years or more throughout equatorial Africa and beyond.

At the same time that the Bantu peoples of West Africa were slowly spreading across equatorial Africa, the making and use of tools (eventually iron tools) was spreading with them. The Bantu tools became more specialized over time. Some maintain that the use of iron tools was a key factor in the expansion of the Bantu throughout the region.

Moving gradually from the north to the south, they would follow the river systems as they worked their way through the forest, resulting in the slow destruction of primary forest by the agricultural populations. The use of iron tools would contribute to this significantly by yielding an increased capability to manipulate the environment, making it easier for the people inhabiting and expanding through central Africa to "tame" the forest.

Initially, as the Bantu spread across the region, they had wet-climate crops from West Africa and cattle but were not yet using iron tools. They were in effect living a hybrid lifestyle as they transitioned from hunting and gathering to agriculture and pastoralism. As they progressed through the Congo Basin, a veritable squeeze play was happening to the Twa, or forest people, forcing them deep into the forest. By

THE TWA

Prior to the Bantu expansion, the people that occupied much of the rain forests of central Africa were the Twa (previously also known as Pygmies and "forest people"). With a current population of approximately two hundred thousand, the Twa, also referred to as Batwa, were the original forest inhabitants throughout this region. These people were true hunter-gatherers living entirely off the bounty of the forest. During the first thousand years of the Christian era, many of the forest-dwelling people (mostly Twa) essentially lost their social and cultural uniqueness as well as their language. This was a direct result of living near their new agricultural neighbors—being assimilated into their culture and adopting their language or being displaced altogether. As a result of the Bantu expansion, the few remaining Twa populations were scattered among the Bantu peoples. This would turn out to be a significant contributing factor in the fate of the Twa in modern times and ultimately in determining their greater role in society within the region.

Their role in the communities surrounding the parks in all three countries and their relationship with the forest are unique. Intimately bound to the forest over time, the Batwa were connected in all ways to the forest—culturally, physically, emotionally, and spiritually. Creating a life from what lies in the forest is what they knew. When the first restrictions to the forest at Bwindi occurred in the early 1930s, the Twa were still able to spend much time collecting honey, gathering fruit, and hunting game inside the forest with little real ecological impact to the environment. Although no Batwa were living in the area at the time that Bwindi Impenetrable National Park and Mgahinga Gorilla National Park became national parks, those forests could no longer be used by the Batwa as they had been before. The Batwa owned no land and had severely restricted options. As a consequence, many continued their activities within the forest illegally, exchanging forest products for agricultural products.

In Uganda, capacity-building efforts have been targeted specifically toward the Batwa and improving their condition. Organizations like the Mgahinga and Bwindi Impenetrable Forest Conservation Trust, now called the Bwindi Mgahinga Conservation Trust, have purchased land from the community and given it to the Batwa to resettle and build homes. Throughout all of their history, the Twa have never been farmers. Expecting them to make this transition quickly or easily is unrealistic at best. There are multiple use zones established in Bwindi where traditional activities like the controlled harvesting of honey and other non-timber forest products are still allowed. In Rwanda, however, there are no multiple use areas, and access to the forest is completely restricted leaving the Twa living in very poor circumstances, highly marginalized by the greater society at large, and with very little hope of improving their condition.

CALEB NGAMBANEZA: *A Distinguished Career in Conservation, Guiding and Supporting Researchers*

CALEB NGAMBANEZA has spent most of his life in the forest. Born in the village of Buremba in the Kanunugu district in Uganda near the boundary of the forest, Caleb is one of the forest people known as the Twa. In fact, he has memories of his great-grandfather living in the forest. By the time that the forest was gazetted as a national park, they were living on the boundaries of the forest and interacting with the local people. Early on in Caleb's life, and before the forest became a national park, he would go into the forest to look for medicinal plants, wild honey, bushmeat, and forest products to make handicrafts. As a young boy, Caleb remembers working with his father, assisting Jonathan Kingdon, the world-renowned author of *The Kingdon Field Guide to African Mammals*.

Despite not having a formal education, Caleb has had a long and distinguished career in conservation, guiding and supporting the research community. He started working for the Game Department of Uganda in 1987 and moved into his current position as a Senior Field Assistant for the Institute for Tropical Forest Conservation (ITFC) in 1994, where he has worked for the past twelve years. As an expert on all flora and fauna in the forest, Caleb wields an incredible intuition for understanding the location and movements of animals in the forest. His knowledge of the local plants, the geography of the forest, and his tracking skills are so extensive that he has trained many of the staff in the ITFC, the Ugandan Wildlife Authority (UWA), various researchers, guides, and trackers. An incredibly valuable asset, his work, guidance, and support in the field can make the difference between a day's success or failure for many researchers and others that work in the forest. Caleb loves the gorillas and feels most comfortable when he is in or near the forest. Along with many of the Twa, Caleb did not believe early on that the gorillas could be habituated. Even now, he says that there are still some people that do not believe that the gorillas have actually been habituated. Having participated on the team that habituated the Kyagurila research group of gorillas currently being studied at the Ruhija Research Institute, Caleb is now a believer!

Although he is very supportive of conservation projects and initiatives, Caleb recognizes that there are things that people still need from the park and that some people feel deprived because they cannot go into the park to collect various forest products. This is why he supports the practice of multiple use zones; designated areas where specific activities such as controlled harvesting of certain plants for medicinal purposes or other activities such as bee keeping are allowed within the protected forest area. He also recognizes that the money generated from gorilla tourism does not necessarily benefit all of the people living near the park equally, but rather it is the people living near the tourist centers that generally see a greater amount of the benefit. He hopes to see that benefit more evenly distributed in the future.

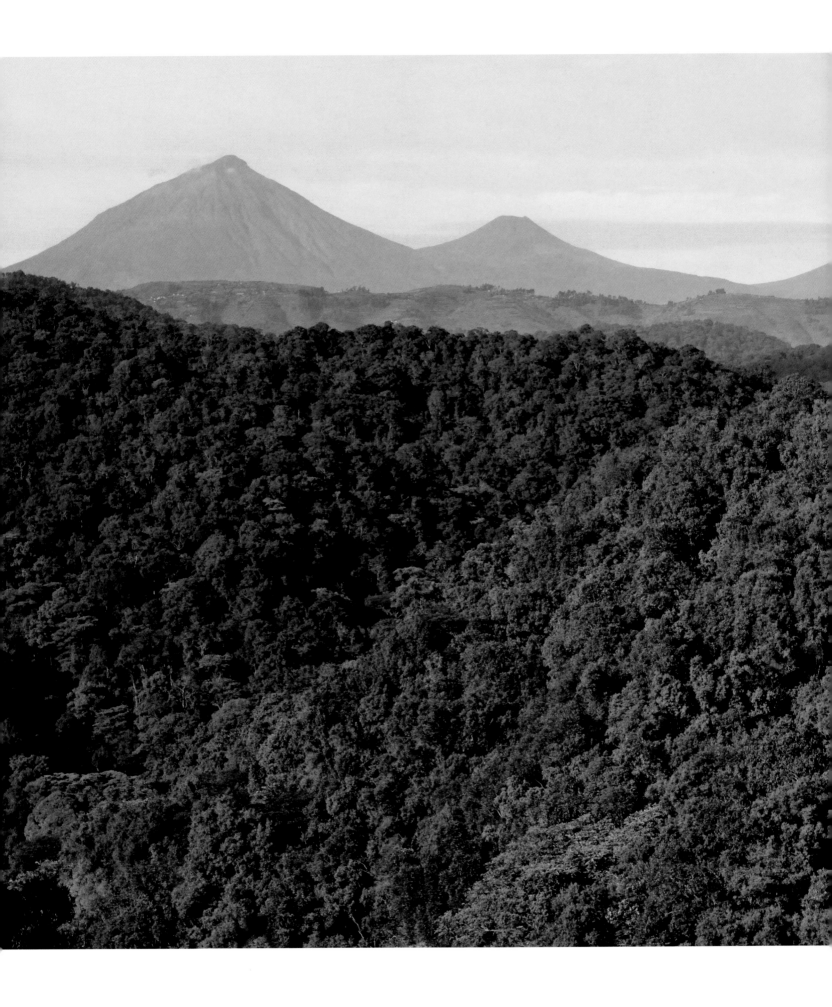

around 1,000 BC, the Bantu had made their way through the forest and into the open areas of the Rift Valley and the Great Lakes.

Afro-Asiatic and Nilo-Saharan farmers exposed the Bantu to millet and sorghum production as well as raising livestock. The introduction to iron came shortly thereafter. With all of their experience from West Africa, enhanced crop-raising knowledge from East Africa, and the technology advance of iron tools, the Bantu were unstoppable. There was existing competition in East Africa, but to the south lay thousands of miles of territory that was lacking in iron technology and crops. In the wake of their migration paths, entire peoples, species, and habitats were eradicated or displaced, land was cleared, communities were formed, crops were planted, domesticated animals were raised, and human populations flourished. By around 1500, most of the human migrations had taken place with almost all of equatorial and subequatorial Africa dominated by Bantu peoples, as it remains to this day. The full weight of the agricultural revolution was becoming realized throughout the region and beyond. The most significant land clearing had occurred within the last five hundred to a thousand years, permanently separating the forests of the Virungas and Bwindi.

Patterns and trends began to evolve whereby the populations that inhabited the lakeshores slowly moved progressively higher into the uplands, which required felling trees for food and fuel production. This trend, coupled with the very fertile land capable of producing food, is why these rural areas have some of the highest population densities in all of Africa. As a result of an ever-present slow drift of people toward the uplands, the forests were continuing to disappear at an alarming rate.

From the Ruhija Research Station looking out across the forest in Bwindi Impenetrable National Park toward the Virunga Volcanoes in neighboring Rwanda and the Democractic Republic of Congo, the impact of land clearing is visible in the stretch of farmland in the middle of the photo. The most significant land clearing has occurred within the last five hundred to a thousand years and ultimately led to a permanent separation between the once contiguous forests of Bwindi and the Virungas.

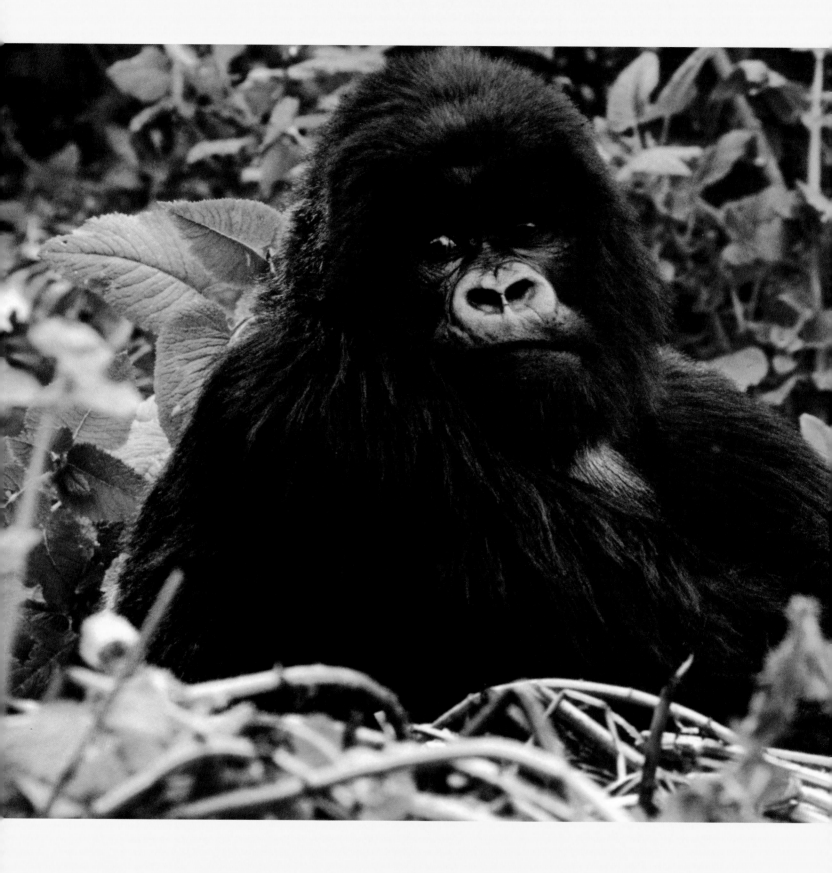

13 THE IMPACT OF COLONIALISM

ENTIRE BOOKS have been written about the impact of colonialism in Africa. However, we will only take a brief look at how colonial powers came to control the range states, and then we will explore three areas in which colonialism directly affected, and continues to affect, mountain gorillas and the people who live near them. First, colonialism exploited the natural environment and the people. Second, we examine the colonial powers' scientific discovery of mountain gorillas and the subsequent creation of protected areas. Last, we look at how colonialism contributed to and set the stage for war and conflict in the region, which gives us a context for some of the threats that mountain gorillas and people face today.

The Establishment of Colonialism in Central Africa

European interest in Africa intensified around the end of the eighteenth century as the power base in the various countries and kingdoms of the region became more centralized. With well-defined trade circuits beginning to develop in the Great Lakes region and west into the Virungas, reconnaissance expeditions were put in place to gather information about everything from the physical topography of the land to population dynamics and industrial trends. European explorers were all over the continent. Despite the flurry of outside interest in Africa's people and resources, the drive for change and improvement was coming largely from within. The irony is that despite this internal (African) push for improvement and exploitation of the foreign interest, it would in turn be Africa that came to be exploited by the foreign interests: Germans, British, Belgians, and French. Africa had developed intellectually and politically, but the lack of economic and technological development in agriculture

Previous page: The silverback Ubumwe oversees everything occurring with the Amahoro group in Parc National des Volcans, Rwanda.

Opposite: Kampande from the Susa group stares intently at the visitors that have entered his realm in the Parc National des Volcans, Rwanda.

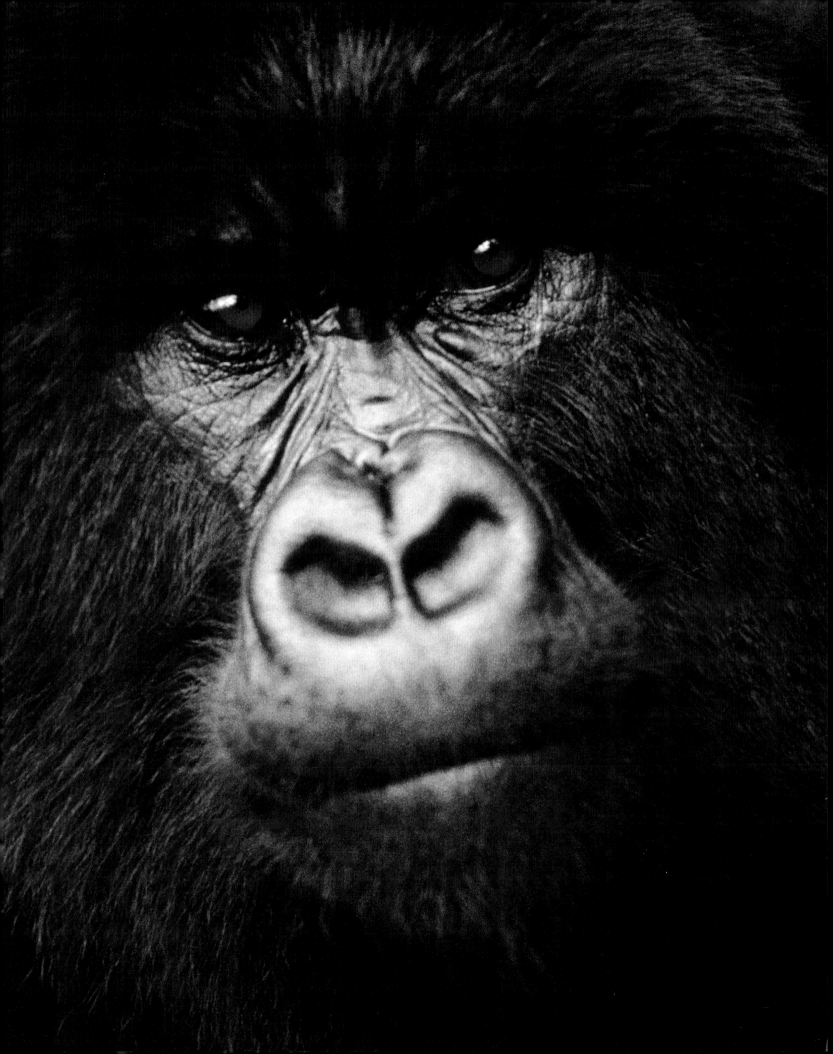

ultimately prevented them from being able to withstand the wave of European colonial domination that loomed in the near future.

Europeans were quietly acquiring control of the land, animal, and mineral resources that formed the economic power base in Africa. Once in control of the economic power, use of higher technology, guns, and weapons assured a change in the overall balance of power and whose hands that power would ultimately reside in. The slow erosion of the indigenous cultures and assimilation to a modern world had begun.

The time between 1880 and the middle of the twentieth century were extremely turbulent years for Africa. The most significant changes took place between 1880 and 1910, when, in a stunningly short period of time, European powers came to control all of Africa, except Ethiopia and Liberia. During the Berlin West Africa Conference in 1884–85, the powers that be gathered in Berlin to discuss the disposition of the African states as they all scrambled for control of the interior of Africa. In the end, Great Britain would control Uganda, King Leopold (and later Belgium) would have the Democratic Republic of Congo (Belgian Congo), and the Ruanda-Urundi kingdom would become part of the German East Africa protectorate. New maps and boundaries were drawn without regard for already established African rule, culture, history, or existing relationships with different peoples.

The primary goal of these conquests and acquisitions was the exploitation of Africa's vast natural resources, more specifically, its land, animals, and people for the purposes of enriching the occupying country's own interests or agendas. The colonial powers did develop infrastructure within these countries. Sadly, that infrastructure was not designed to empower the overall economic development of the country but rather to facilitate the direct exploitation of their natural resources. Specifically, transportation and communication infrastructure was designed to move product whether it was cash crops or mineral products from central gathering points to points of departure, typically on the coasts.

Colonialism had taken its hold in the region. Very early in the twentieth century, the occupation and subsequent domination of Africa had been completed. Although Africa would reclaim herself eventually, colonialism was a direct assault on the way of life for the people and a dark period for all of Africa.

The Pressure to Produce

As colonial governments solidified their power over the African people and the administration of their countries, the pressure to produce was everywhere. When prices were lowered, the method of compensation was to produce more. When all of the available land was in use, more land was cleared to boost production further reducing the forests. When coffee production needed to be expanded in Uganda, they looked to Ruanda-Urundi.

The British and Belgian administrators would often retain the African rulers as part of their administration to perform the dirty work of acquiring forced labor and collecting taxes or tributes. Controlling everything, the compulsory cultivation of crops, government-sanctioned use of nonpaid labor, and heavy taxation only served to highlight the colonial administration's exploitation of Africa's land, animals, and people.

By 1930, the Great Depression had firmly taken hold, and with the subsequent crash of the stock market in the United States, the economies of the European stakeholders were affected as were their African colonies. A methodical system was put into place whereby the Africans were not allowed to grow food for their own consumption but rather were forced to grow cash crops and deliver raw materials to be exported. In turn, many of the items required for local consumption had to be imported from their European counterparts. As the depression took hold, the price paid for exports was cut dramatically, while the cost paid for imported goods and taxes remained the same. The only choice was to produce more products to generate enough money to cover the cost of their personal consumption and to pay their taxes to the colonial government. Again, this would mean more land clearing for farming.

The Colonial Contribution to Conservation

Despite the many negative impacts of colonialism to the people and lands of Africa, one of the positive impacts was the contribution that colonial powers made to conservation. It was, in fact, a colonial dispatch traveling in Rwanda that made the scientific discovery of mountain gorillas that would ultimately lead to King Albert of Belgium creating the first national park in Africa to protect the gorillas and the forests that they live in.

The first protected area created by King Albert would encompass the Virunga Volcanoes Conservation area and one day be divided into the three national parks that exist today. The British would follow suit and create forest reserves in Uganda, continuing to increase the size of these reserves and expanding their purpose to protect the gorillas by making them game reserves. The national parks would not be gazetted until after independence, but this first step of making the forest at Bwindi and Mgahinga protected areas was crucial to the long-term conservation and protection of the mountain gorillas in these areas.

The Road to Independence and the Prelude to War

During World War I, Africans saw the weaknesses in the occupying colonial powers that tried to maintain a front in Europe and tried to defeat insurrections in their colonies abroad. The international communities' view of colonialism in Africa was

starting to take a more opposing stance as well. During the Versailles Peace Conference (1919–1920), the colonial record of Germany came under particular scrutiny, and the general consensus was unfavorable. All German colonies were surrendered as League of Nations mandates, including Ruanda-Urundi, which would come under Belgian rule.

Between World War I and World War II, a shift in attitudes started to occur. After years of suffering at the hands of their colonial administrators, African people felt tremendous negativity, anger, and frustration. People who had conducted their own affairs were subjected to forced labor, conspiratorial taxation, physical torture, abuse, and loss of self-determination. A building wave of nationalism and the desire for self-control and determination by the Africans began to gain unstoppable momentum.

By the end of World War II, anticolonial sentiment was peaking, and by the early 1950s, the process of decolonization had begun. In April 1958 in Ghana, the Accra conference hosted the Conference of Independent African States. This conference was sponsored by the free African states at the time and was focused on the eradication of colonialism and establishment of self-determination for all of Africa. April 15 was declared African Freedom Day, a special day that would later be moved to May 25 and renamed African Liberation Day. The fever of independence was in full swing. In 1960, Zaire (ex-Belgian Congo) gained its independence from Belgium, which affected George Schaller's pioneering study of mountain gorillas as well as Dian Fossey, who followed in Schaller's footsteps. Rwanda would soon follow suit in 1962. Great Britain would grant independence to Uganda in 1962 as well.

Unfortunately, the wars that brought about independence in the range states were not the final word on conflict for this area. Although the wars for independence were violent and affected the human population in significant ways, the impact on the forests and the gorillas was nothing compared with what was to come. Colonialism would exacerbate existing ethnic tensions and set the stage for a catastrophic eruption. The Rwandan civil war in the 1990s and the various conflicts in the eastern Democratic Republic of Congo would be devastating to the people, the forests, and the mountain gorillas of this troubled region.

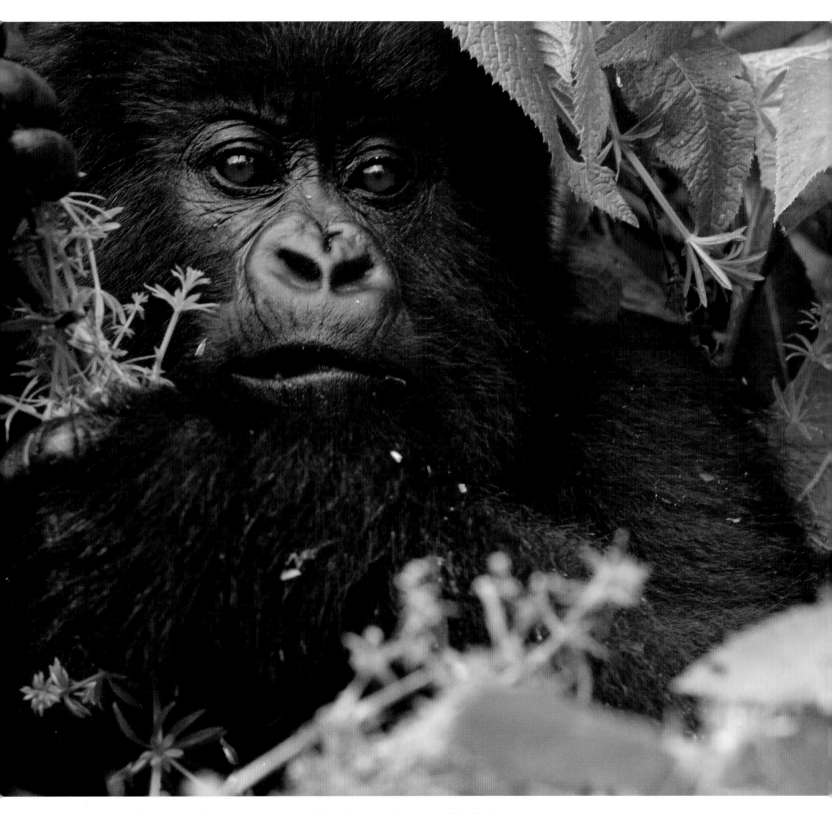

A young female named Ikaze from the Beetsme group grabs handfuls of Galium. Galium is one of the foods most commonly eaten by mountain gorillas in Parc National des Volcans, Rwanda.

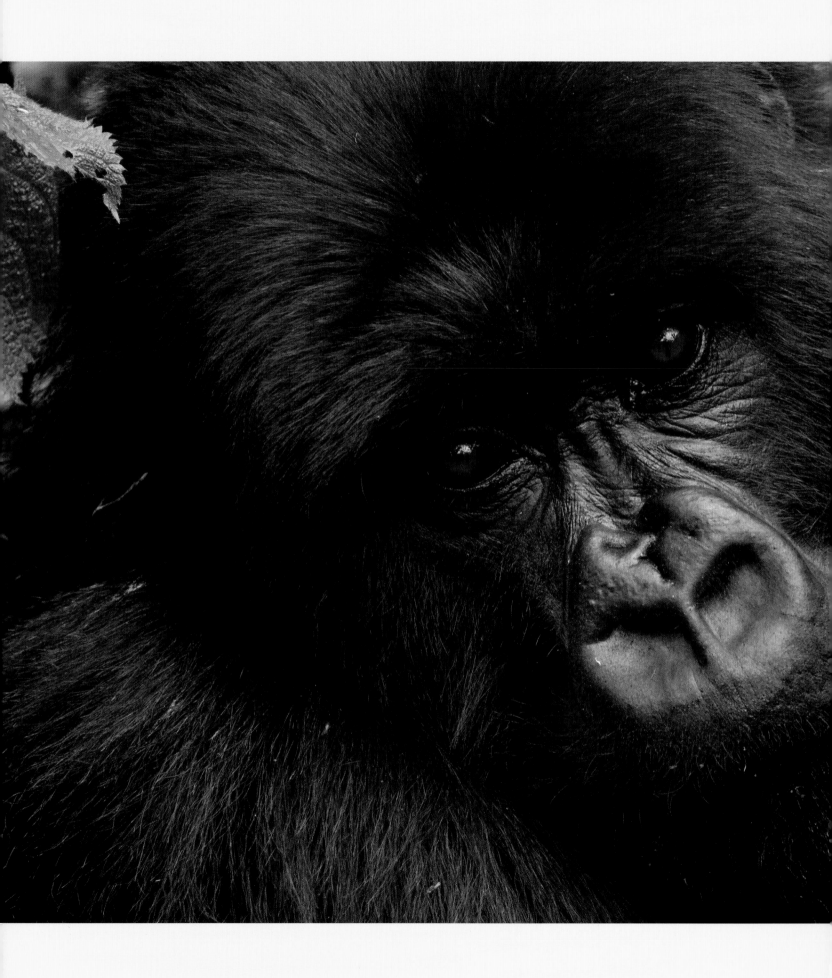

14 LIFE IN A WAR ZONE

SECURITY in Uganda and Rwanda has improved in recent years. Still the people of the Democratic Republic of Congo (DRC) face tremendous struggles that not only affect their daily lives but also substantially impact gorilla tourism in the DRC. These problems sometimes spill over into Rwanda and Uganda. War and conflict often manifest themselves in border areas. Throughout the world, international borders have been commonly drawn along natural divisions, such as mountain ranges, rivers, and lakes. These same features provided the biological justification for establishing many of the protected areas along national borders, as in the Virungas. The convergence of these factors has meant that many of the recent wars and civil conflicts in the transboundary area, which is home to the mountain gorillas and the people living near them, have been fought near or in the protected areas.

In many cases, violence against civilians in war or civil conflict is a deliberate strategy, not an accidental side effect of war. This kind of violence can have a devastating impact on the people living near these protected areas and the work of conservation inside the protected areas. The percentage of civilian casualties in wars around the world is currently around 80 percent, a high proportion of which are made up of women and children. This region is no exception. In this chapter, we examine how conflict and insecurity impact people and conservation to better understand the context under which the existence of mountain gorillas and people are threatened.

Civil War and Genocide

Many people around the world remember the war and the resulting genocide that occurred in Rwanda from 1990 to 1994 (it ended in July 1994). Some may not be aware

Previous page: The conflicts along the borders between the Democratic Republic of Congo, Rwanda, and Uganda have not been fully resolved. Interahamwe militias still roam in the forests in the DRC and rebel groups based in the DRC still threaten Rwanda and Uganda. Clashes within the DRC, between different groups, continue to destabilize the country, which is why gorilla tourism was closed for so many years in the DRC and struggles to reestablish itself to this day. The fact that gorillas like Inziza and the rest of the Beetsme group in Parc National des Volcans have survived at all is amazing.

of the earlier genocide in the 1960s, the series of wars in the DRC, the specifics of how and why these conflicts and events occurred, or that they continue to occur. The true impact of those events on the environment, the animals, or the people in the surrounding areas (other countries) was devastating for those immediately affected on the ground. Truly understanding the nature of conflict in Africa is difficult at best, because so often many agendas are at play in any given situation. This region has suffered from the hardships and effects of war and conflict throughout much of modern history, with some of the worst of it occurring in the past 150 years.

Examining the Rwandan civil war helps us to better understand the impact of how living in a conflict area can affect the environment, the gorillas, and the people of all three countries. To understand the dynamics and effects of this conflict, the intimate nature of the geography in the region must be considered. The Virungas are at the confluence of the borders of Rwanda, Uganda, and the Democratic Republic of Congo. The borders are buried deep within a forest that from a military perspective is strategically very important. Because the Virungas cross all three countries, the opportunities for rebel and militia groups to move between the three countries with impunity are greatly enhanced. The dense ground cover carpets the entire Virunga Volcano Conservation area providing an excellent staging ground for combatants to hide, to establish operational bases for insurgency activities, and to launch attacks. This area was a prime staging area for the Rwandan Patriotic Front during the civil war and an escape route for perpetrators of genocide as well as civilians fleeing in the aftermath of the genocide.

During the Rwandan genocide, about eight hundred thousand people were killed during the 100-day period from April to July in 1994. In July, after the Rwandan Patriotic Front had taken the capital city of Kigali, there was a mass exodus, as nearly 2 million people fled the country. This wave of humanity fled largely into the northern and southern Kivu districts of the DRC and into Uganda and Tanzania as well. As they fled into Congo, most of them would flee directly through the forests of the Virungas. No one was prepared for the sheer numbers of people that would flood the area. With a significant refugee population in the southern part of the Kivu province at Bukavu and a much larger population in the north at Goma, the impact on the area, the people, and the environment would prove to be devastating.

With the rule of law largely absent, the ensuing chaos was unimaginable. Armed groups of soldiers, militia, and assorted rebels were everywhere. This contributed to the lawlessness and desperation of everyone involved. Local economies were devastated. Political implications were seen whether or not they existed in virtually everything, including the work of park management and protection. The neutrality of park staff was questioned by the rival armies, as they accused them of their activities in the forest benefiting one or the other side in the conflict. Displaced persons and militia alike took up residence wherever they saw fit, often in the park or within the areas immediately bordering the park. Many forest areas were cleared for security reasons. Land mines, traps, and combat made travel through the forest extremely

JEAN BOSCO BIZUMUREMYI: *His Work Helped Karisoke to Continue during the War Years*

This profile is based on a 2000 article by Liz Williamson and Andrew Plumptre called "Local Hero at Karisoke: Jean Bosco Bizumuremyi," which appeared in the *Dian Fossey Gorilla Journal*, Summer: 16–17, and input from Dr. Katie Fawcett, the Director of the Karisoke Research Center.

JEAN BOSCO BIZUMUREMYI was born in Kinigi, Rwanda, near the headquarters of the Parc National des Volcans (PNV) and has lived there all of his life. He works for the Karisoke Research Center (KRC) as the Field Operations Coordinator and has worked at Karisoke for over twenty years. As a young boy, Jean Bosco grew up listening to stories of gorillas and the forest from his father who had also worked with Dian Fossey. These stories fired his imagination and interest to work with the gorillas too. He started at Karisoke volunteering during his school holidays to help around the camp until he was taken on full time at the age of sixteen as research assistant for a student studying buffalo. He was subsequently hired by Karisoke to collect the meteorological data when Karisoke was still based in the forest. Over the course of time, Jean Bosco has held many positions at Karisoke, eventually becoming a tracker, then a member of the antipoaching patrol until his current position of Field Operations Coordinator.

His appointment as Field Operations Coordinator was natural and developed during the insecurity of the 1990s. His detailed knowledge of the field operations and conservation was critical as government security personnel around the park changed frequently; Jean Bosco played a lead role in introducing conservation issues to the new incumbents and to negotiating military escorts for Karisoke trackers to check on the gorillas or conduct antipoaching patrols. Similarly, his calm strength and honesty inspired confidence in the other Karisoke trackers at a time when their morale was at its lowest ebb.

In his position as Field Operations Coordinator, he is responsible for the daily management of all of the field teams of Karisoke staff and the activities that they conduct within the forest. This includes the three teams of trackers working with the research groups Beetsme, Pablo, and Shinda, the Karisoke antipoaching patrol staff, the team tracking the lone silverbacks, as well as the golden monkey trackers. In addition, Jean Bosco coordinates the field activities of all of the Karisoke research staff and students working with gorillas and other biodiversity in the Volcanoes National Park. He continues to personally lead and train the Karisoke antipoaching teams. Jean Bosco coordinates patrols and other field operations with Office Rwandaise du Tourisme et des Parcs Nationaux (including the collection of forest food for the confiscated gorilla named Maisha) in addition to coordinating KRC field staff for Mountain Gorilla Veterinary Project when they need additional support for immobilizations. He also supports the KRC Education program activities with Bisate Primary School, where he is a member of the Parent Teachers Association facilitating their work and encouraging both parents and pupils to take their education seriously. Individuals of this caliber are rare and such dedication from one individual has proved to be indispensable for gorilla conservation, particularly during times of conflict; mountain gorillas are fortunate to have him fighting for their cause.

Jean Bosco is a courageous and intelligent young man who has made an enormous contribution to conservation throughout Rwanda's most turbulent times, largely through his own drive and personal conviction. During nearly a decade of political unrest in the region, Jean Bosco has overcome numerous personal hardships and risen to a position of leadership among his colleagues. Just thirty-two years old, he has united and inspired Karisoke's antipoaching rangers and gorilla trackers to continue their work in the most difficult circumstances and in the face of personal tragedy. Having suffered through attempts on his life, threats to his family, and having his home burned to the ground, Jean Bosco's selflessness and courage throughout the war years made it possible for the Karisoke project to continue, including monitoring and protecting the gorillas. He stands as a shining example to his fellow nationals and conservationists the world over of the significant positive impact of one person's dedication.

This child, who lives near Bwindi Impenetrable National Park, fetches water for his mother. What do you suppose this child thinks as he sees tourists come past his home every day on their way to see the gorillas? How will his daily life and the challenges his family faces shape his opinions about the national park and conservation in general?

dangerous. Hundreds of park staff throughout the Virunga National Park were killed either by mines or as a result of the conflict. Rangers were often disarmed, prevented from patrolling the park, or killed outright. Researchers, conservationists, park staff, and the local people were all living under the constant threat of violence.

Combatants and refugees alike required the same staples for survival. Among those are the most basic needs: water, food, fuel, and shelter. These requirements immediately impacted the forest habitat in a catastrophic fashion. The amount of fuel wood alone taken from Virunga National Park every day from August to December 1994 was estimated by the United Nations High Commission for Refugees at 7,000–10,000 m³. In addition to the fuel wood and wood consumed for construction purposes, a burgeoning commercial business developed where wood and charcoal were harvested and sold to other refugees or to the local population. The bamboo

The civil war that had begun in Rwanda in 1990 and the political unrest in the Democratic Republic of Congo in 1992 erupted in a catastrophic series of events in 1994 resulting in a genocide that would ultimately claim the lives of an estimated eight hundred thousand people. After the Rwandan Patriotic Front (RPF) launched their initial invasion into Rwanda from their base of operations in Uganda, they maintained a presence in the Virunga Volcanoes between January 1991 and 1994.

When the RPF took control of the country and declared an end to the war in July 1994, between 1.7 and 2.0 million people had fled the country in a mass exodus for fear of retribution, spilling over into the neighboring countries of the Democratic Republic of Congo, Burundi, Uganda, and Tanzania. Hundreds of thousands of refugees crossed into the Democratic Republic of Congo, settling around the town of Goma, where they found what they were desperately seeking: water, firewood, and food, all provided by Virunga National Park (PNVi) and its immediate surroundings. On one day alone that month, over five hundred thousand refugees arrived. Within a few days, another three hundred thousand had joined them. During July, three camps (Kibumba, Mugunga, and Katale) emerged where the refugees had stopped. To accommodate the continuing influx of refugees and to decongest some of the initial refugee locations, two additional camps, Lac Vert and Kahindo, were developed in late 1994 and early 1995. In late 1994, the population of the refugees was estimated at around seven hundred and fifty thousand.

During the more than two years that the refugees remained in the Goma area, large tracts of forest were systematically destroyed, especially in the southern sector of PNVi. The forests closest to the Kibumba camp (which held 190,000 refugees) suffered severe and extensive deforestation during the first year. The prominent ecological value of these forests motivated considerable efforts to protect this sector of the park during the second year. Further damage was practically halted in 1996. In the zone of the Mugunga and Lac Vert camps, where some two hundred thousand refugees were located, extensive areas were stripped of vegetation. In the other camps, these activities were more effectively controlled and deforestation gradually decreased.

The provision of fuel wood to refugees depleted the tree plantations in the area, thereby expending the reserves of wood previously available for use by the local population. The region was already experiencing a shortage of fuel wood, and the arrival of the refugees put an unbearable strain on the region's ability to provide sufficient supplies. Most importantly, this increased pressure on the forests jeopardized the long-term sustainability of the local population's energy resources.

Refugees, primarily from the Kibumba camp, were involved in commercial enterprises that required bamboo collected from inside the park. The commercial demand for bamboo caused extensive damage to the limited bamboo zone inside the park, where it is an important seasonal food source for a number of different species of wildlife, including mountain gorillas.

Refugees were also heavily involved in poaching, primarily for food. They used traditional snares as well as the firearms smuggled into the camps. Poaching quickly became a commercial activity and a significant threat to wildlife populations. The movement of tens of thousands of Rwandan refugees through the forest also caused a great deal of damage and disturbance to the forest. The damage was especially intense when the refugees brought along their herds of livestock.

The regular movement of insurgents through the park and the presence of refugees greatly intensified the risk of disease transmission to wildlife. One significant health threat posed to the wild ungulate populations (Buffalo [*Syncerus caffer*], Duiker [*Cephalophus* spp.] and Bushbuck [*Tragelaphus* spp.]) in PNVi-south was the periodic presence and passage of thousands of cows, goats, and sheep.

The impact of the war and resulting genocide on the economy of Rwanda and the Democratic Republic of Congo was devastating. In addition to the disruption to the daily lives of people in the region—their inability to work and to get crops and products to markets—income from gorilla tourism would come to a virtual stand still. Before the genocide, tourism was one of the largest sources of revenue for the government of Rwanda. At the time, direct annual revenues from gate fees were as high as USD $1 million, and indirect revenue associated with tourism such as food, transportation, and accommodations were estimated between USD $3 million and USD $5 million annually. The number of tourists visiting Rwanda to trek for gorillas began a rapid decline in 1990 and bottomed out in 1994 and again in 1997 and 1998. Only after the country had begun to stabilize in 1999 would the numbers start increasing again.

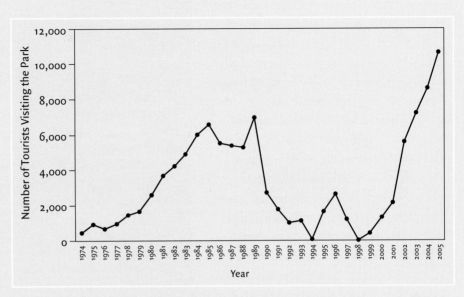

The dramatic drop-offs in 1994 and a few years later in 1998 directly correlate to the security situation on the ground and the periods of civil war in Rwanda. The program was built up to a respectable level and peaked in 1989 and then went steadily down until it bottomed out in 1994. A short rise and then it bottomed completely in 1998. The program has returned to and surpassed its prior peak levels and continues to grow each year. Source: *Volcano National Park Tourist Statistics, 1974–2005*, Office Rwandaise du Tourisme et des Parcs Nationaux.

In addition to the loss of direct and indirect revenues from gorilla tourism, many foreign assistance projects would be closed as well. U.S. Agency for International Development ceased its funding of all projects in the Parc National des Volcans (PNV) and other protected areas in Rwanda in 1990, which represented a loss of expected support of USD $1.5 million in the years between 1990 and 1994. Additional funding from the French, Belgian, and Swiss governments as well as the World Bank were all stopped permanently. Development agencies would slowly return to Rwanda after the genocide, but their focus would shift from conservation-related activities to humanitarian relief. During times of conflict such as this, the role of conservation NGOs (nongovernmental organizations) with funding from private donors and individuals becomes very important to help continue financial support when government funding mechanisms (internal or external) cease to function.

zone inside the park was damaged extensively as well. By 1996, much of the deforestation had been curbed; however, other conflict-related problems would persist for years.

The lack of fresh water and the health effects of the crisis were overwhelming. Because of the numbers of people involved and the locations of the camps, there were no provisions for dealing with human waste or properly disposing of the dead. People were ill and exhausted and often defecated near human habitation or water sources. Bodies could not be disposed of in a timely fashion. Thousands died within

weeks from cholera and dysentery epidemics, which contributed significantly to the risk of disease transmission between humans and from humans to animals. Not only the gorillas were at risk, but also many of the other animals in the park. The large ungulate species were particularly susceptible to diseases from livestock brought into the area by refugee populations.

The food requirements for a population of this order of magnitude are enormous. This led directly to the harvesting of food-related resources (i.e., plants and animals) from the forest. In addition to the large amount of poaching of smaller game for food, eighteen gorillas were killed between 1995 and 1998 as a result of the violence. Despite this, the small gorilla population held on tenaciously. The fact that the gorillas survived through this period of intense human occupation of the forest and the associated violence is testimony to their resilience.

The economies of all three countries would be severely affected by the Rwandan genocide and again in just a few years as the lingering effects of the genocide would bring violence to the Bwindi Impenetrable National Park in Uganda.

The Attacks in Bwindi

The violence and effects of this devastating series of events would directly and indirectly spill over into Uganda and the DRC, as it did when war in eastern Congo drove refugees into Uganda, Rwanda, and Burundi. This spillover gained international attention on March 1, 1999, when a group of Interahamwe militia (Rwandan extremists) crossed over the border from Congo into Uganda, kidnapped a number of British, American, and New Zealand tourists from various tourist camps near the park headquarters in Bwindi, and subsequently murdered eight of them. The original conflict was in Rwanda; the Interahamwe who perpetrated the genocide fled into exile in Congo and then conducted illegal operations in Uganda. This is a perfect example of how events in one country can spill over into other countries within the region and have devastat-

TOURISTS ARE ATTACKED IN BWINDI

Early on the morning of March 1, 1999, there was an attack in Bwindi Impenetrable National Park (BINP). A large group of militia, believed to be Interahamwe, crossed over the border from the Democratic Republic of Congo where they had been living in exile from Rwanda and basing their operations since the genocide in 1994. After looting their way through the village of Buhoma, these men passed through the gates into the park and moved on to the park headquarters. The warden of BINP was the first person to be killed. The militia group proceeded to gather tourists from the camp located across from the park headquarters and separate them based on nationality and language. A group including Americans, New Zealanders, Canadians, and British tourists, was taken hostage and forced to march back into the forest with the militia group as they headed back into the Democratic Republic of Congo. Eight of those tourists would be killed on that trek.

The impact of this single event would be enormous and would be felt in all three countries: Rwanda, Uganda, and the Democratic Republic of Congo. Gorilla tourism would be affected for years. The immediate question on everyone's mind was whether it was safe to visit the gorillas. The government of Uganda took immediate steps to improve the security surrounding the communities near the park and for the tourists visiting the gorillas. It started at the grassroots level by sensitizing the local communities to the need for reporting unusual behavior or strangers to the local community leaders. Stronger relationships and tighter communications were developed between the community leaders, the park staff, and the military. Communications infrastructure was put into place linking them all together, creating a large communications and intelligence-gathering network. With an early warning capacity in the region, tensions eased and eventually tourists returned to Bwindi. Uganda's tourism program would be severely impacted for years as would tourism programs in Rwanda and the Democratic Republic of Congo, which, in turn would directly affect the people living in the areas around the park where these programs are based. It was in response to this event that the policy of military escorts for all tourist groups entering the forest was instituted in all three countries.

MBAKE SIVHA, a forty-two year-old Congolese, has worked for many years in one of the most troubled parts of the continent—eastern Democratic Republic of Congo (DRC). For seven years, Mbake worked as a Programme Officer for a joint initiative between GTZ (German Technical Co-operation) and the Institut Congolais pour la Conservation de la Nature (ICCN—the Protected Area Authority in DRC) in the conservation of Kahuzi-Biega National Park, a World Heritage Site and the home of the eastern lowland gorilla. Following that, Mbake joined as the DRC Programme Officer for the International Gorilla Conservation Programme, a transboundary initiative between the Democratic Republic of Congo, Uganda, and Rwanda, focusing on the conservation of the mountain gorilla and its afro-montane habitat. Mbake managed the DRC component of that program in the Virunga National Park from the nearby town of Goma. During these years, Mbake worked against terrible odds caused by the war and civil instability that has raged in this part of DRC for over a decade but was one of a few key personalities to ensure that conservation efforts for these parks continued regardless of the obstacles. In 2004, however, Mbake had to flee the DRC for her stand against encroachment and destruction of the Virunga National Park by rebel militia. Since then, Mbake has worked in the Garamba National Park, on the DRC border with southern Sudan, to develop community-

based conservation strategies and engage the local population in conservation and park management. The relationships that Mbake, as a woman, as a strong leader, and as a gentle and kind human, has built, have contributed enormously to conservation. The three parks where Mbake has worked are all World Heritage Sites, classed as sites of outstanding natural value for the world. The survival of the eastern lowland gorilla, the mountain gorilla, and the northern white rhinoceros are all dependent on the continued conservation and protection of these parks. Without the dedicated work of Congolese conservationists like Mbake, this will never be possible.

ing results. The transboundary area where all of these countries converge has been dealing with the effects of this war for many years. It is as tightly linked as the forest is to both the gorillas and the people. The real question is what happens next?

The Impact of Conflict and Insecurity on People and Conservation

The conflicts along the borders between the DRC, Rwanda, and Uganda have not been fully resolved. Interahamwe militias still roam in the forests in the DRC, and rebel groups based in the DRC still present a potential threat to Rwanda and Uganda. Clashes within the DRC, between different groups, continue to destabilize

the country. The conflict between the Rwandan- and Ugandan-backed rebels in the eastern DRC and President Kabila's forces in the west ensured that political and military objectives were at the forefront of the government's agenda. The wars in Sudan, Somalia, and elsewhere in the region have also affected the border areas with Congo and Uganda, increasing the availability of small arms and light weapons and the presence of refugees, militias, and rebel groups in all of these countries. In the region around the Virunga Volcanoes range, numerous clashes among different groups have led to population displacement across the borders, which explains why gorilla tourism was closed for many years in the DRC and struggles to reestablish itself to this day.

Insecurity can manifest itself in the form of robbery, kidnapping, rape, torture, coercion, and murder. Insecurity can lead to famine by preventing people from working their fields, traveling to markets, or otherwise producing income, thereby affecting families, communities, and entire regions. Likewise, the restriction of emergency aid and the deviation of humanitarian support by armed groups can further exacerbate hunger and lead people to seek refuge and resources anywhere they can find them, which can include the forests of the protected areas.

When people affected by conflict seek refuge in or near protected areas, the impact on conservation is immediate and substantial. Crop raiding of people's fields by park wildlife is one of the conservation problems that the Protected Area Authorities in the DRC are currently facing in Parc National des Virunga. This is a perfect example of how insecurity at the regional level affects people, the environment, and the animals directly. The crop raiding in the Mikeno sector of the park is believed to be due to insecurity in the adjacent Nyamulagira sector. Normally, there is a small forest corridor between these two sectors where elephant and buffalo would cross back and forth between the two sectors. Currently, militia groups are located throughout parts of the Nyamulagira sector. Some of these militia have been living there in exile since their exodus from Rwanda following the genocide in 1994. Because of the large number of people and high levels of poaching in that sector in addition to deforestation through the narrow corridor connecting Mikeno with Nyamulagira, the animals in the Mikeno sector have nowhere to go. The amount of forest habitat available to them is too limited for the large herbivores, and they leave the park to raid crops from fields around the forest for lack of other options. It is imperative that the government resolve the security problem in the Nyamulagira sector so that the integrity of the park can be restored and the dynamics of the animal population can return to normal, which should aid in minimizing the problems introduced by crop raiding in the Mikeno sector of the park.

As long as war and conflict plague the transboundary region, the people will undoubtedly continue to suffer, and the work of conservation will be substantially impacted. It is vital that the park authorities and the nongovernmental organizations maintain a presence during times of insecurity and conflict as evidenced during the

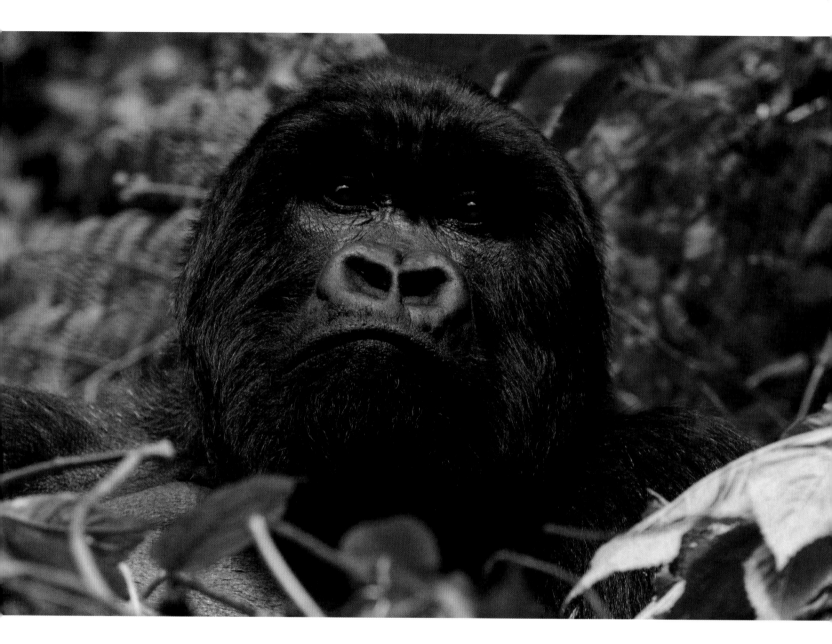

It is vital for the Protected Area Authorities and the nongovernmental organizations to maintain a presence during times of insecurity and conflict. It is during these times of conflict that the PAAs have paid a heavy price in the loss of human life. To date, more than 200 members of the PAA staff across Uganda, Rwanda, and the Democratic Republic of Congo have lost their lives in the line of duty protecting their countries' national parks and the gorillas that inhabit them. The killing of Congolese park rangers, who have suffered the greatest toll, continues to this day. These Rwandans, Ugandans, and Congolese park rangers have sacrificed and others continue to do their jobs, at times under very real threat to their own personal safety.

Rwandan civil war in the 1990s. It is during these times of conflict that the park staff has paid a heavy price in the loss of human life. More than 200 members of the park staff across all three countries have lost their lives in the line of duty protecting their countries' national parks. The killing of park rangers in Congo, who have suffered by far the greatest toll, continues to this day. These Rwandans, Ugandans, and Congolese made the ultimate sacrifice, and others continue to do their jobs, at times under very real threat to their own personal safety. That is a tremendous testament to their ownership of the parks, and their commitment and dedication to the service of their people and their countries.

These are the people who live near the parks and are affected by mountain gorilla conservation. In the areas surrounding Bwindi Impenetrable National Park in Uganda, pastoralists, farmers, and traditional hunter-gatherers (Twa) make their living. Some of the dominant people in the region are agriculturalists but combine this lifestyle with some livestock. Years before the forests became national parks, these people traditionally leveraged the forests by logging/pitsawing, hunting, and mining. Their culture indicates a traditional dependence on the forest for agriculture, medicinal resources, and the making of implements. Beekeepers, traditional healers, and craftspeople still have ties to the forest and are allowed limited access in multiple use areas of the forest.

15 MAKING A LIVING

AS LONG AS people have occupied the area in the range states, they have had to deal with the question of how to make a living. Over time, how people sustained themselves changed. Part of their livelihood or their culture still came from the forest, even after they transitioned from hunting and gathering to agriculture. Their relationship with the forest changed as the idea of creating national parks took hold and the forests became protected areas. Those changes have altered the conditions under which people living near the protected areas survive and how they provide for their families. Coming full circle, those people and their condition, originally impacted by park management have in turn affected conservation, the protected areas, and the gorillas.

Poverty is the common denominator in the lives of the people of this region, and the fact that so many of them survive through subsistence farming are underlying themes affecting all aspects of conservation. All farmers living near the forest are affected by conservation in one way or another, including the impacts of crop raiding by animals from within the forest, in some cases mountain gorillas. The economic challenges are complicated by lack of education, the bushmeat trade, and harvesting legal and illegal forest products. In this chapter, we explore these challenges in greater detail to better understand how conservation and people living near the protected areas affect one another every day.

ECONOMIC CHALLENGES

The economic challenges facing the people living near the parks in Uganda, Rwanda, and the Democratic Republic of Congo are formidable. For the people living at the edge of the forest, the challenges become even greater. Because of the remoteness where these people live, infrastructure and services can be nonexistent, making their options for change severely constrained.

For some like the Batwa, the primary obstacle to making money is a lack of land. Without land in a place where most people farm for a living, the Batwa are disadvantaged from the very start. In the areas around Bwindi, land has been purchased for the Batwa to help alleviate this problem. Even in the circumstances where they have been given land, they are still challenged in that they have no money for supplies to develop the land. A few credit schemes exist for people to purchase land, livestock, improve their farming methods or to start businesses; however, some like the Batwa cannot meet the qualifications to participate in the loan programs. In cases like this, the unavailability or severely limited supply of credit can work against people's ability to create wealth and improve their condition.

For others living near the forests, lack of access to markets to sell surplus products is the challenge. Markets in general tend to be located farther away from the people living nearest to the forest boundaries. Lack of infrastructure like roads and transport to those markets can place the possibility of making extra money beyond the reach of many of those most in need. In Rwanda, a new paved road will extend from Ruhengeri all the way to and just beyond the national parks headquarters in Kinigi. This one additional piece of infrastructure will make a difference for thousands of people in their ability to access markets and increase their income.

EDUCATION

Education has a major impact on the livelihood strategies of people anywhere in the world and central Africa is no exception. For families living throughout the range states where mountain gorillas are found, education is the exception rather than the rule, and for families living near the forest, it can be even more elusive. People with primary education are the largest group of educated people living near the parks in Rwanda, Uganda, and the Democratic Republic of Congo. The percentage of people with a primary education is highest around Bwindi, which is probably because primary education is free in Uganda. In Rwanda, the government has recently made primary education free for all people; however, secondary school is not free. In the Democratic Republic of Congo, education is not free. When faced with the costs of educating their children, most parents are forced to choose either one child in the family to educate or not to educate any children. The numbers of people in all three countries with a secondary education drops dramatically and becomes almost nonexistent at the university level. For the Batwa, the only area reporting education levels above primary were around Parc National des Volcans in Rwanda. The lack of education plays directly into the socioeconomic equation for people living near the parks. Lack of education alone severely limits employment opportunities, and in areas where unemployment ranges from 20 percent to more than 66 percent, lack of education can determine one's destiny.

TABLE 15.1 | EDUCATION LEVELS

	Percentage with Primary Education	Percentage with Secondary Education	University Educated
Batwa Bwindi	37.37	0.00	0.00
Batwa DRC	12.50	0.00	0.00
Batwa Mgahinga	47.52	0.00	0.00
Batwa PNV	30.30	7.07	1.01
Bwindi	60.20	13.74	1.58
Mgahinga	44.78	17.05	0.72
PNV	54.07	6.75	0.19
Virunga	40.16	9.35	0.24

Source: Plumptre, A. J., A. Kayitare, H. Rainer, M. Gray, I. Munanura, N. Barakabuye, S. Asuma, M. Sivha, and A. Namara. 2004. The Socio-economic Status of People Living Near Protected Areas in the Central Albertine Rift. Albertine Rift Technical Reports 4. 127 pp.

Note: The percentage of household members with only primary education, with some form of secondary education (post primary), or university education. DRC = Democratic Republic of Congo, PNV = Parc National des Volcans.

The areas surrounding the Virunga Volcanoes and the forest in Bwindi are home to large numbers of people living subsistence lifestyles, well below the internationally established poverty line. The average annual income in Rwanda in 1998 was USD $251 per year, and in Uganda, many of the people that do earn income are making less than USD $1 a day. Because of the constant state of instability and civil war in the Democratic Republic of Congo (DRC), getting accurate information about the income of people living near the park and how they make their living is difficult, at best. The lives of these people living near the parks are often characterized by lack of adequate land, transportation, and education; shortages of food, water, and other necessary resources; and lack of access to infrastructure, such as health care, schools, and markets. Some of the most vulnerable among these people are the widows and orphans who have lost their family members to war and genocide, forcing many of them to eke out a living by whatever means possible.

Dealing with basic survival strategies, many of these people have limited options to improve their situations. They often cannot even participate in local programs such as credit schemes and cooperatives because they cannot meet the basic requirements for membership. As such, they are not able to benefit from many of the programs implemented by various nongovernmental organizations (NGOs) to help people in their circumstance. This creates a situation in

HARVESTING OF FOREST PRODUCTS

The harvesting of both timber and non-timber forest products (NTFPs) has occurred in Bwindi and the Virungas as long as man has lived in and near the forests. Once traditional ways of making a living became illegal activities when the forests were designated as protected areas. For people living in poverty with limited options for income, the bounty of the forest represents a variety of resources to be used for food, building materials, and the promise of selling forest products, both timber and non-timber, for money.

Many by-products are produced from the items harvested in the forest. For example, from bamboo, people make many items as diverse as baskets, beds, bows, building poles, chairs, granaries, mats, ropes, and winnowing trays. From honey, alcohol, candles, and medicine are made. Wood is used for beds, chairs, doors, and planks.

These men are pitsawing outside the park in Parc National des Volcans, Rwanda. This type of processing timber has a long history in the Virungas and in Bwindi.

Out of the many items harvested from the forest, however, wood is a resource in constant demand by all people living near the parks in Uganda, Rwanda, and the Democratic Republic of Congo. Wood is used for everything, from construction material to fuel wood, handles, walking sticks, and stakes used to cultivate beans and bananas. With wood being a high-demand resource, in Uganda alone the estimated consumption of firewood in the area around Bwindi is 140,000 m³/year. More than 95 percent of the people living around the parks rely on wood or charcoal as their only source of heating or energy for cooking.

To combat the harvesting of wood from the forest, fast-growing eucalyptus trees have been planted in Rwanda, as well as eucalyptus and black wattle in Uganda. Although there were compulsory tree planting programs imposed by the colonial government in Uganda early in the twentieth century to help address the need for wood, they were not embraced by the local people. Subsequent interventions by other organizations over the years have helped this program to be embraced, and southwestern Uganda now has more planted woodlots than any other area in the country. Most of the local population in Rwanda, however, do not have access to plantations for wood and are forced to seek those resources elsewhere. Different forest products, both timber and non-timber, are harvested with differing levels of frequency in each forest area. For some areas, medicinal plants are harvested, in others it is bamboo and water, each in accordance to the resource needs and availability of the immediate area. The challenge for conservation managers and planners is to find ways like the tree plantations and beekeeping projects that will turn illegal harvesting activities within the forest into legal activities outside the forest or within carefully managed multiple use zones.

The sun shines warmly on the smiling face of this Rwandan man. He lives near the park headquarters in Kinigi, Rwanda. Like so many others in the area, he watches tourists as they walk through the fields and gardens every day making their way to the edge of the forest to trek for gorillas.

Conditions for some of the people around the immediate tourist areas in the parks have improved dramatically as a direct result of tourism. There is a huge disparity however between the benefits that people living in areas like Buhoma in Uganda and Kinigi in Rwanda where the park headquarters and tourist operations are located and the communities in other areas bordering the parks that do not have access to the tourists and the revenue that they bring with them. Finding ways to smooth the distribution of benefit to all people living near the park will be key to improving the condition of the local people and their attitudes and perceptions toward the protected areas, the authorities, and the gorillas.

which the people most affected by poverty, most in need of assistance, and most dependent on forest products for their livelihood or income cannot get aid and also suffer the greatest hardships and burdens created by restricted or no access to the protected areas and forests. This in turn leads to encroachment, illegal activities inside and outside the park, and negative attitudes by many local people toward the protected areas and the Protected Area Authorities, all of which have a direct or indirect effect on mountain gorillas. As a consequence, the people of the Virunga and Bwindi regions are, and must continue to be, a targeted area of focus by the governments and the NGO communities if they are indeed to benefit from intervention, development, and education programs designed for the greater community at large.

DEMOGRAPHICS

In the areas surrounding Bwindi Impenetrable National Park in Uganda, various groups of people can be categorized as pastoralists, farmers, and traditional hunter-gatherers (Twa). Some of the dominant people in the region are agriculturalists but combine this lifestyle with small numbers of livestock. Years before the forests became national parks, these people traditionally leveraged the forests by logging/pitsawing, hunting, and mining. Their culture indicates a traditional dependence on the forest for agriculture, medicine, and implements. Beekeepers, traditional healers, and craftspeople still have ties to the forest and are allowed limited access in multiple use areas of the forest at Bwindi.

In Rwanda, 84 percent of the population are farmers and about 15 percent are pastoralists raising cattle. Only a small minority, estimated at 1 percent, are Batwa. Both of these larger groups and their daily activities have significantly impacted the forests of the Virungas over time. Much like the people living near Bwindi, they have historically gone to the forest for raw building materials, to hunt, or to gather honey. There are currently no multiple use areas in the Virungas.

POPULATION DENSITY

The region surrounding the common borders of Rwanda, Uganda, and the Democratic Republic of Congo where mountain gorillas are found contain some of the highest population densities in Africa. Rwanda is the most densely populated country in Africa. High human population densities are not in and of themselves a problem. If land is managed completely effectively, as has been done successfully in many parts of the world, the highly fertile land could support high human population densities. When issues such as land tenure, fertilizers, erosion control, rotation of crops, and a balance of mixed crops are not handled effectively enough (or at all), high population densities like those found in this region can be a catalyst to bigger problems, often wrongly taking the blame for being the root cause. When combined with other challenges facing the region, high population density can exacerbate problems in such a way that can prevent the land from being managed in a sustainable way, without degradation or environmental impact. Traditional methods used when population densities were lower were actually very effective and emphasized crop rotation and using organic material for fertilization and soil conservation. The challenge for conservation managers, planners, and development projects is to understand how human needs and sustainable management practices are linked. Once the linkages are understood, the challenge becomes how to turn that understanding into effective, long-term sustainable policy and action.

Farming

With most of the forests outside the parks cleared, agriculture is the primary economic activity in all three of the range states. Most farming is done for the purpose of subsistence; however, when surpluses are available, they can be and are sold for cash, with a small percentage of the population supplementing their crops with livestock.

In Uganda, the primary food crop grown below 1,800 meters is bananas, which are a perennial crop. Tea and coffee are grown as cash crops. A commercial tea factory near Kayonza employs approximately 500 people with another 4,555 independent tea farmers selling their tea to the factory as well. The factory has been a contributing factor in the improvement of the roads in the area. Annual crops such as sorghum, sweet potatoes, Irish potatoes, wheat, millet, and peas are grown above 1,800 meters. Pyrethrum, grown in Rwanda for years, at times is grown in Uganda as a cash crop.

Cultivated fields in Parc National des Volcans, Rwanda, take advantage of every available space right up to the very edge of the park. Cultivating crops up to the edge of the forest occurs in all three countries where mountain gorillas live.

The primary cash crop surrounding Parc National des Volcans (PNV) in Rwanda, pyrethrum, is grown along the entire length of the western half of PNV. Wheat, sorghum, potatoes, beans, peas, and maize are grown for food. Even though more than 90 percent of the population is involved in agriculture, there is still not enough food produced to meet the needs of all the people in this region.

Farming on the Democratic Republic of Congo side of the park produces beans, maize, potatoes, sorghum, banana trees, sweet potatoes, peas, cassava, wheat, taro, cabbage, onions, spinach, leeks, garlic, celery, artichokes, radishes, fennel, parsley, rhubarb, and marrow. When market routes were open, this area of eastern DRC produced most of the fresh vegetables consumed in Kinshasa, far to the west.

Raising crops and cattle can be a challenge for people as they try to provide for their families. In the Mikeno sector of Parc National des Virunga in the Democratic Republic of Congo, the productivity for farmers and cattle breeders has been significantly impacted by displaced peoples, the lack of stability and resources for

With the Bwindi Impenetrable National Park boundary visible in the background, these residents in Uganda are replanting the morning after elephants came out of the forest at night and destroyed their crops. Crop raiding like this can devastate people living near the park. Strategies like the HuGo (Human Gorilla Conflict) program and the buffer zone project at Nkuringo were created to address this problem and the impact on the local communities.

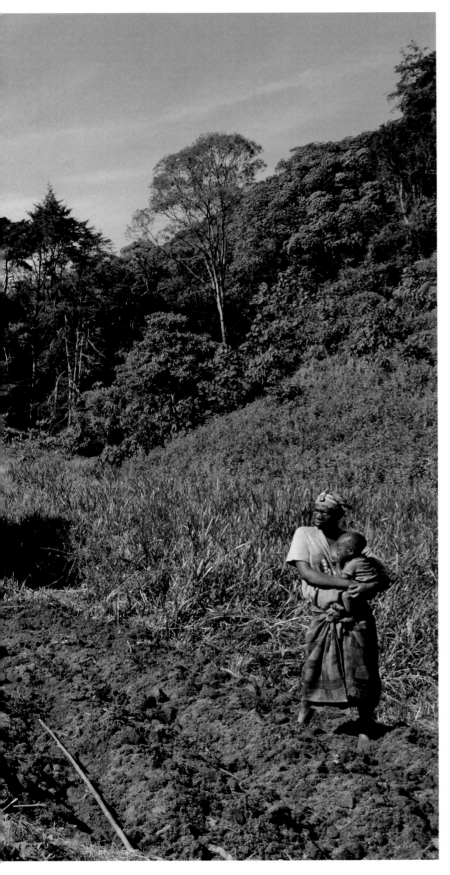

those trying to escape the violence and insecurity, theft, and the general lack of infrastructure brought about by decades of war. Because of the instability, there is little to no investment in the region, poor to nonexistent infrastructure, and constant disruption of people's daily lives. The lack of infrastructure is a problem that manifests itself in many ways and often can cause a problem to become compounded. For example, shortages of clean water complicate farming and raising cattle and can contribute to health problems, such as skin diseases, worms, dysentery, cholera, and diarrhea. These problems require money or additional access to resources to resolve; however, resources are already in short supply. The poor infrastructure and lack of security impact the ability to both acquire supplies from outside the area and to transport potential surplus to other markets for consumption.

The problems presented by the lack of infrastructure and insecurity are further complicated in all three countries. When the land is not properly managed in a holistic way, there is simply not enough land to support the existing populations, let alone the increased population each year. Consequently, people are constantly putting pressure on the land to produce more food, leading to depletion of the soil nutrients and degradation of the soil. In the best case, this leads to low yields. In the worst case, it causes the land to become infertile pushing people further into poverty. It is a vicious cycle with no easy answers.

The people of the Kibumba region around the Virungas use terracing in an effort to prevent erosion and make the most use out of every square kilometer of land, including all the hills and valleys. In the valleys, they have developed a technique that involves raised mounds of soil. The furrows separating the mounds collect stems from the last crops grown, which function similar to using manure for fertilizer, therefore helping to reduce soil infertility. Even when the land is managed effectively, however, there is still potential for human/animal conflict with so many people living and farming near the edge of the forest.

Crop Raiding

When a family is living by subsistence farming on a piece of land that is not sufficient to provide them with enough food to begin with, the loss of any part of their crops can be devastating. Crop raiding by wild animals affects people's sources of food but also has a significant social impact as well. Where problems with raiding animals exist, people, often children, must stand guard over the crops to ensure their protection, which can be physically dangerous to the person guarding the crops. In circumstances in which the losses are too significant for a family to bear, they could be driven to relocate elsewhere or to go into the forest searching for food. In the case of animals that raid during the night, the older men in the household will stand guard in the fields near the bush so that the women and children remain safe in their villages. But for families that have no male head of the household because of war or genocide, the women are left with limited options in combating the problem animals.

An average of 46 percent of homes surveyed surrounding the parks across all of the range states reported crop loss due to raiding animals, with most of those animals coming from the forest. Although gorillas raid crops, the most common crop-raiding animals are elephants, buffalo, bushpigs, and baboons. In the areas surrounding Mgahinga Gorilla National Park, buffalo (*Syncerus caffer*) and porcupines (*Hystrix africaeaustralis*) are the primary culprits. In this area, as has been done in PNV, a wall has been constructed at the boundary of the park to contain the buffalo. In both areas, this has proven to be very effective at containing the buffalo and contributed significantly to public perception about the Protected Area Authorities' willingness to address the problems raised by crop-raiding animals.

Near Bwindi Impenetrable National Park (BINP), the more common problem animals are baboons (*Papio anubis*), elephants (*Loxodanta africana cyclotis*), and bushpigs (*Potamochoerus porcus*), with baboons reported as causing 84.9 percent of crop-raiding incidents. The crops being raided near BINP include millet, sorghum, sweet potatoes, Irish potatoes, cassava, peas, beans, bananas, coffee, yams, cabbages, passion fruits, ground nuts, tobacco, wheat, sugarcane, pumpkins, pineapples, and sunflowers. Although there are reports around Bwindi of raiding by chimpanzees (*Pan troglodytes*), l'Hoest monkeys (*Cercopithecus l'hoesti*), and gorillas (*Gorilla beringei beringei*), these incidents are much more infrequent than the incidents involving baboons or the elephants and bushpigs.

TABLE 15.2 | CROP RAIDING BY WILD ANIMALS

	Suffer Crop Loss	Forest	Plantations	Nearby/Fields
Batwa Bwindi	53.33	51.67	0.00	0.00
Batwa DRC	66.67	44.44	0.00	22.22
Batwa Mgahinga	0.00	0.00	0.00	0.00
Batwa PNV	36.84	36.84	0.00	0.00
Bwindi	51.80	47.77	1.58	1.73
Mgahinga	74.80	74.80	0.00	0.00
PNV	34.91	19.92	3.41	11.35
Virunga	49.89	44.07	1.79	4.03

Source: Plumptre, A. J., A. Kayitare, H. Rainer, M. Gray, I. Munanura, N. Barakabuye, S. Asuma, M. Sivha, and A. Namara. 2004. The Socio-economic Status of People Living Near Protected Areas in the Central Albertine Rift. Albertine Rift Technical Reports, 4. 127 pp.

Note: The percentage of households that suffer crop loss to wild animals and the responses about where the animals come from. DRC = Democratic Republic of Congo, PNV = Parc National des Volcans.

STEPHEN ASUMA is the Country Program Officer in Uganda for the International Gorilla Conservation Programme (IGCP). He was born in the Arua district of northernwestern Uganda and attended primary and secondary school in the same region. Stephen attended Makerere University in Kampala, Uganda, and obtained a bachelor's degree in science in 1989 with a major in wildlife ecology, applied parasitology, and entomology. He also has a separate postgraduate diploma in education and is currently working on his master's degree in protected landscape management.

After completing his work at the university, he joined the Ugandan Game Department in 1990, as a warden until 1995. In this position, he was responsible for managing wildlife outside the different parks in Uganda. In 1996, the Ugandan Game Department was merged with the Uganda National Parks (UNP) to form the Ugandan Wildlife Authority (UWA). Stephen then continued to work for UWA in several areas, including Queen Elizabeth National Park in western Uganda and Karamoja in northeastern Uganda. His last post was in Bwindi Impenetrable National Park (BINP) in southwestern Uganda where he served until 1999. Stephen was working in BINP, as a warden in charge of tourism development during the infamous attack by Interahamwe militia that had crossed over the border from the Democratic Republic of Congo on March 1, 1999. One of the wardens, along with eight tourists were killed during that attack. Stephen narrowly escaped with his life.

In September 1999, Stephen went to work for the IGCP as a Field Officer. In 2003, he was promoted to Country Program Officer based in Kampala, the capital of Uganda. Stephen's years of experience in the field working for the Ugandan Game Department and later for UWA gave him valuable experience and insight that would serve him well in his work with the IGCP. His knowledge of the inner workings of conservation and natural resource management programs on the ground both in and around BINP, Mgahinga Gorilla National Park (MGNP), and the central Albertine Rift is extensive. Stephen has a passion for understanding the root causes and drivers of the problems facing BINP, other protected areas in the Albertine Rift, and the people that live near them. Stephen actively seeks to update his knowledge with global conservation issues and approaches to help broaden the scope of solutions that can contribute to alleviating the conservation challenges around protected areas and furthering the development of best practices in natural resource management. He understands the value of having the correct data available and analyzed properly to help policy makers and conservation planners to make better informed decisions. He is committed to continued process improvement to yield better and more accurate data to facilitate making better informed decisions.

In the gardens surrounding PNV in Rwanda, 91.2 percent of all respondents surveyed reported problems with crop-raiding animals, and 71.3 percent identified buffalo as the worst offender with bushbuck coming in second, as reported by 40.3 percent of survey respondents.

One of the problems for conservation managers and planners in developing solutions for crop raiding is the accuracy of the information provided by the people living near the park. Often, people will exaggerate claims with the hope of receiving some kind of compensation for damages. Although this would assist them in offsetting the devastating impact of crop raiding, without dedicated and long-term sources of funding for such support, such a compensation scheme would not be economically feasible. Properly identifying the animals that are damaging crops is also crucial to developing solutions. People tend to emphasize larger animals like elephants and baboons when birds and rodents are the more likely the culprits.

The Protected Area Authorities in all three countries have developed mechanisms to control and prevent crop raiding in some of the worst-affected areas. Together with the local communities and supported by conservation programs, groups consisting of both rangers and farmers patrol these areas and make loud noises to herd animals out of the fields and back into the forest when they approach crops. These groups are called HuGo rangers, named for the Human Gorilla Conflict Program. Although the program is impossible to conduct around the entire boundary of

HUNTING AND BUSHMEAT

The hunting of wild animals outside the park is often the result of crop raiding. Animals wander out of the park and into farmer's gardens to forage for food, which leads to irate farmers, and in some cases, the killing of animals in the fields. Some people actually hunt illegally within the forest as their families and ancestors have done for hundreds or in some cases thousands of years. In addition to the animals killed for personal consumption, there is still an active bushmeat trade in the region. Fortunately, gorillas are not on the menu in the areas surrounding the Virungas and BINP, however, when surveyed, people living near all of the parks indicated that they do kill animals in their fields as well as buying bushmeat and hunting within the forest.

Hunting in the forest is illegal, but the larger problem presented by the bushmeat trade and hunting in general is that of collateral damage. Hunters enter the forest and set snares for duikers or other small animals, but their unintended victims can be gorillas. When a gorilla becomes caught in a snare and either loses a hand or dies as a result of an infection from the wound, it doesn't really matter what the hunters original intentions were. Often, the people hunting animals in their fields and even hunting within the park are those that are most affected by crop raiding and conservation because of their proximity to the park boundary. These are some of the poorest people in the region, and hunting provides a means of acquiring food at little to no monetary cost providing they are not caught. Many households with some income (e.g., from employment but with little or no livestock) often purchased bushmeat. Consequently, as economic conditions improve, it will be important to monitor the situation for potential increases in the bushmeat trade.

TABLE 15.3 | HOUSEHOLDS KILLING ANIMALS, BUYING BUSHMEAT, AND HUNTING IN THE FOREST

	Kill in Fields	Buy Bushmeat	Hunt in Forest
Batwa Bwindi	36.67	10.00	15.00
Batwa DRC	11.11	11.11	0.00
Batwa Mgahinga	0.00	0.00	0.00
Batwa PNV	33.33	4.76	4.76
Bwindi	9.50	3.45	19.57
Mgahinga	14.63	3.23	2.42
PNV	5.04	7.50	8.02
Virunga	6.04	9.17	6.49

Source: Plumptre, A. J., A. Kayitare, H. Rainer, M. Gray, I. Munanura, N. Barakabuye, S. Asuma, M. Sivha, and A. Namara, A. 2004 The Socio-economic Status of People Living Near Protected Areas in the Central Albertine Rift. Albertine Rift Technical Reports 4. 127 pp.
Note: The percentage of households that admitted to killing animals they found in their fields, the percentage that admitted that people near them bought bushmeat, and the percentage that stated that people living near them hunted in the forest. DRC = Democratic Republic of Congo, PNV = Parc National des Volcans.

LEGAL INCOME FROM THE FOREST

One of the great success stories of mountain gorilla conservation are some of the ways that people can now make money legally from the forest as a direct result of conservation, development projects, and their related activities. Because of mountain gorilla conservation, jobs have been created within the park such as tourist guides, guards and rangers, porters, trackers, and administrative staff. In Buhoma, Uganda, located at Bwindi next to the park headquarters where tourists stay when trekking for gorillas, as many as 80 percent of the households interviewed responded that either someone from the household or a relative was employed in support of the tourism at Bwindi. The Institute for Tropical Forest Conservation located just inside the eastern boundary of the Bwindi forest at Ruhija also employs many people in support of their research activities.

The importance of these ways and means to generate income legally from the forest cannot be overstated. The money earned by people supporting research, conservation, and the tourism industry infuses much-needed money into the local economies and improves the attitudes of the local people toward the gorillas, the protected areas, and conservation in general.

Beekeeping also generates much-needed income. When the parks were established, beekeeping and collecting honey within the boundaries of the parks became an illegal activity. Although it remains illegal in the Democratic Republic of Congo and in Rwanda, a multiple use zone has been established in Bwindi, which allows for beekeeping within that zone of the forest. According to the beekeepers, the honey yield is higher when the bees are kept within the forest because of the greater proliferation of flowers for the bees. In both Rwanda and the Democratic Republic of Congo, the beekeepers working together with the nongovernmental organization community have set aside new areas for their hives that are as close to the forest as possible so that the bees may benefit from the richness of flowers.

the parks, it has made a significant difference to some of the most vulnerable communities. In addition, the dry-stone wall built around much of the Virunga forest has involved local communities, park staff, and conservation NGOs working together helping to prevent elephant, buffalo, and bushpigs from coming out. Such barriers will not prevent the primates from climbing over them, but they have made a difference to many of the communities.

Different approaches have been tried near Bwindi, including alternative control measures such as creating live fencing by planting *Ceasalpinia decapetala* or nonpalatable crops such as tea or *Artemisia annua*. This, however, like other methods, requires the involvement of the local communities to maintain these barriers and deterrents. The local communities feel that the Protected Area Authorities or the government at large should bear the costs associated with building and maintaining these control measures. They also feel that they should receive compensation for the damage inflicted by animals from the forest.

In all of these circumstances, the involvement of the affected communities in the decision-making process is and will continue to be vital to the effectiveness of the animal control programs. It will also influence the attitudes of the local people toward the animals, the parks, and the Protected Area Authorities. Properly setting expectations for these programs and the involvement of all stakeholders in the implementation of animal control programs is very important to long-term success. When the community members most affected by these problems are directly involved in the decision-making process and deal with the challenges in implementing sustainable solutions, they better understand the complexity of solving these problems in ways that work for all of the affected parties.

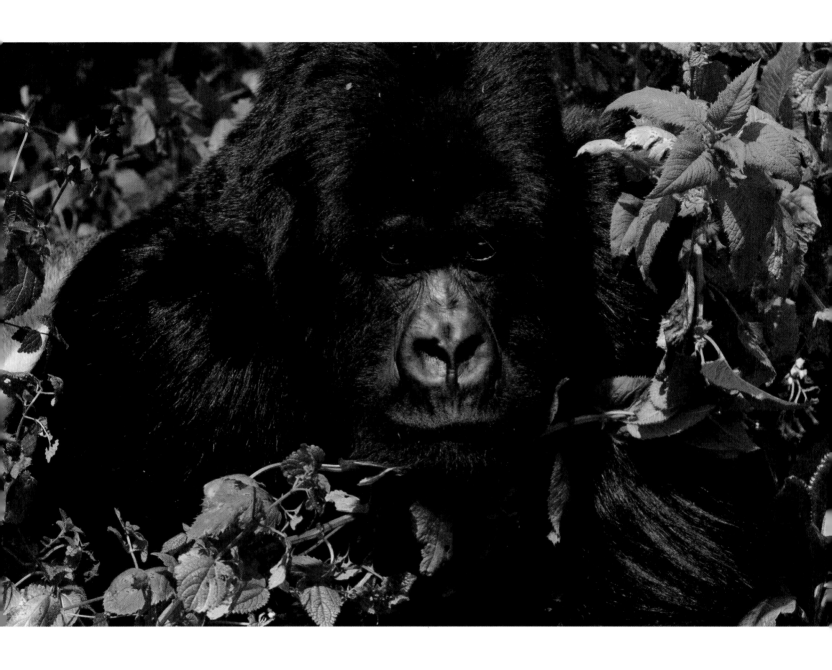

16 THE BUSINESS OF MOUNTAIN GORILLAS

MOUNTAIN GORILLAS mean business. In Rwanda, for example, tourism is the third largest source of revenue for the country. Initially, the funding for mountain gorilla research came from a combination of philanthropists and organizations like the National Geographic Society, the New York Zoological Society, and the Frankfurt Zoological Society. After worldwide exposure to mountain gorillas by the National Geographic Society and the subsequent publicizing of several disastrous poaching events in the 1970s, private funds were established in the United States and in Europe solely for mountain gorilla conservation. People from around the world continue to donate money to save the mountain gorillas and their forest homes.

As conservation methodologies evolved and expanded, the tourism programs were conceived and implemented by the Mountain Gorilla Project and later by the Protected Area Authorities, with support from the International Gorilla Conservation Programme (which evolved out of the Mountain Gorilla Project). While private donations continued to support the nongovernmental organization (NGO) community, the money generated by tourism would be recognized in many different ways and in many places.

In this chapter, we look at the economic value of the forests in the Virungas and in Bwindi and where the money comes from as we examine how the benefits from those dollars are being distributed. We also attempt to explain the differences between conservation money, development money, the new and different models of financing, and what that means for the future of mountain gorilla conservation.

Previous page: Mountain gorillas like Guhonda from Sabyinyo group in Parc National des Volcans, Rwanda, have been thrust into the popular world-view by Dian Fossey and others. As a result, money has flowed in to save mountain gorillas ever since. The challenge is to understand how best to leverage money to benefit not only the gorillas but also the people living near the protected areas.

CONSERVATION MONEY

Historically, conservation organizations have received their funding from private sources. Concerned individuals and philanthropic organizations would provide the bulk of the budget for NGOs with a focus on conservation. Later, the funding would come from various sources, ranging from private to public and from individual to corporate to government. Those monies would be used for conservation-related activities, such as antipoaching, monitoring, and education, and development of the tourism program; livelihood and development-related activities, such as conservation-based enterprise; and alternative income-generating activities.

DEVELOPMENT MONEY

Development money is different from traditional conservation money in several ways. Development funding generally comes from some taxpayer-based source, such as national government agencies and international organizations. Multilateral organizations like the European Union, U.N. Development Program (UNDP), International Monetary Fund (IMF), and World Bank as well as bilateral (government) donors, such as United States Agency for International Development and the U.K. Department for International Development, provide funding for various types of development projects largely centered around poverty alleviation and economic growth strategies. In many cases, the poverty alleviation strategies have either a direct impact on conservation efforts or are dependant on and tied to conservation efforts in the same areas. The amount of money these organizations make available for different types of development activities typically far surpasses the amount of money available for traditional conservation activities. The models by which rural development program funds are dispersed and implemented are very different than the models for traditional conservation funding. Because of increased reporting and auditing costs, the administrative costs of involvement with development sources of funding is typically much higher than what is required for managing traditional types of conservation funding.

The IMF and World Bank developed a "poverty reduction strategy process" in which Poverty Reduction Strategy Papers (PRSP) function as a template for the coordination and management of development efforts. Countries that receive funds from the IMF, World Bank, UNDP, or most other large development donors must be engaged in the PRSP process. The idea is to help countries develop more effective poverty reduction strategies through participation and including the country's own strategies as a baseline for the PRSP. It's a way to try to get all of the stakeholders involved in different development activities to develop plans regarding what needs

to be done and the allocation of responsibilities for completing the work. When the framework for a sector is complete, the Ministry of Finance will take all of the sectoral plans and budgets and compile them into the national budget framework for the country to prioritize national expenditures accordingly.

MONEY FROM TOURISM

The tourism program is a cornerstone of the mountain gorilla conservation strategy. The money generated from mountain gorilla tourism is substantial and takes many forms, the most obvious and direct form is permits for gorilla viewing. When the tourism program was in its infancy in Rwanda, gorilla trekking permits cost USD $25. Today, they are USD $500 and millions of dollars are generated every year from permits alone. In addition to gorilla trekking permits, there are park entry fees, tips for national parks guides and porters, souvenirs, transportation and accommodation, and private guides. All of these direct and indirect sources of revenue from tourism add up to a substantial amount of money.

These revenues were vital when the tourism program was conceived and developed by the Mountain Gorilla Project. Coming at a time when the Virungas were in very real danger and threatened on several occasions with cattle projects and resettlement schemes, the money produced from tourism provided the economic alternative to using the land as an agricultural or pastoral resource.

Distribution of Costs and Benefits

Understanding all of the costs and benefits of a forest and how those costs and benefits are distributed is important for sustainability and to achieve a more equitable distribution of benefits. Some studies have been done, but further study is needed to better understand these valuations, their dynamics, and how the balance between cost and benefit can be more fairly distributed.

In 2003, a report carried out by the International Gorilla Conservation Programme was submitted to the governments of Rwanda, Uganda, and the Democratic Republic of Congo outlining the data from a study on the economic value of the Virunga and Bwindi protected forests. That study had three objectives: (1) to determine a more accurate estimate of the true value of the forests by conducting a valuation of forest benefits and costs; (2) to identify and explore important economic drivers within local livelihoods; and (3) to examine the distribution of forest benefits and costs between international, national, and local levels. The primary outputs for the study were forest benefits, forest costs, and the distribution of those benefits and costs.

To understand forest benefits, three metrics were evaluated. *Direct use value* is the benefit derived from the direct use of forest products, such as logging, hunting, or

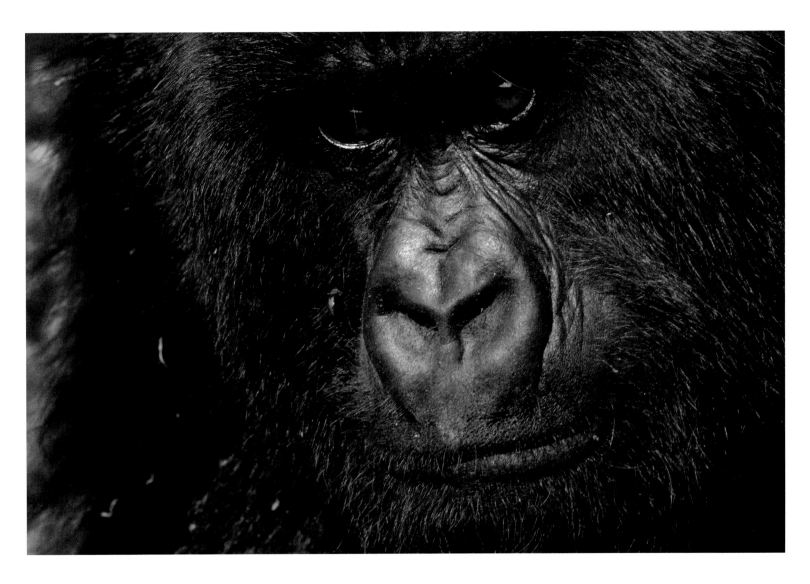

Rugendo from Group 13 in Parc National des Volcans, Rwanda.

the harvesting of plants. *Indirect use value* is the value that is achieved through the indirect use of elements of the forest, such as mountain gorilla tourism. These uses do not represent a significant negative impact to the forest, yet yield benefit and value nonetheless. *Non-use value* is the value of a forest that is represented by the ecological service value, such as watershed protection, soil conservation, carbon sequestration (one of the most rapidly growing global political agendas that could yield some benefit for conservation), and the biodiversity of a forest.

The investigation of direct use value did not yield reliable data as people are often reluctant to be forthcoming when discussing illegal activities in the forest. Because the forest is largely park, any direct harvesting of resources is illegal. Consequently, this is an area that clearly needs more study to be fully understood.

The information and data available for indirect use value was abundant. The expenditures associated with gorilla viewing between 2000 and 2001 totaled approximately USD $7.75 million, $2.78 million of that coming from gorilla trekking permit fees alone. (This period had relatively low tourism numbers because of the

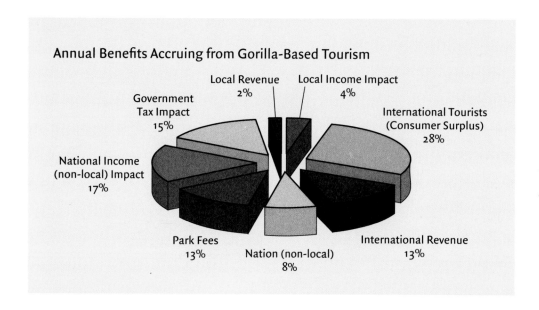

Annual Benefits Accruing from Gorilla-Based Tourism

Local Revenue 2%
Local Income Impact 4%
Government Tax Impact 15%
National Income (non-local) Impact 17%
International Tourists (Consumer Surplus) 28%
Park Fees 13%
Nation (non-local) 8%
International Revenue 13%

The amount of benefit being realized from gorilla-based tourism at the local level is the smallest piece of the pie. One of the challenges for planners and conservationists is to figure out ways to increase the level of benefits that are realized at the local level where the greatest burdens and costs associated with conservation are being experienced. *Source:* Hatfield, Richard, and Delphine Malleret-King. 2003. The Economic Value of the Bwindi and Virunga Gorilla Mountain Forests, A report submitted to the International Gorilla Conservation Programme (IGCP), Nairobi.

war. The figures prewar and in 2004–2005 are much higher.) These monies constituted on average 31 percent of tourists total safari expenditure. An additional USD $4.48 million was identified as secondary income generated within the economy and USD $3.10 million more in generated taxes.

For the year used in the study, it was determined that gorilla tourism generated an indirect use value of USD $20.6 million overall. Fifty-three percent of that was accrued at the national level with 41 percent being realized at the international level and 6 percent going to the local level. The local gains from both direct and indirect benefits were the smallest proportion of benefits received. When you consider that during the year measured by this study, the gorilla trekking was operating at only 41 percent of full capacity, the potential for increased revenues based on the available capacity is estimated at a maximum attainable value per year of USD $51.7 million.

The non-use value of the forests was estimated based on four communities of interest: (1) local residents surrounding the forests, (2) national citizens, (3) international citizens (non-gorilla tourists), and (4) the ecological service values to agriculture such as water supply, clean air, erosion control, and so on. This valuation was based on the experiences of the now deforested Gishwati forest in Rwanda. The study determined that the non-use value to local residents was USD $200,000 and USD $1.0 million for the national citizens. The local ecological services had an estimated worth of USD $200,000 annually and an additional value of USD $700,000 annually was attributed to the value gained from carbon sequestration. International citizens non-use value resulted in an annual estimate of USD $186.5 million, which was motivated primarily by ethical and existence values. This was another area in which the sample size was limited and further, more sensitive, analysis is indicated.

When examining the costs associated with the forests, there are two primary costs to be understood: (1) damage by wildlife to the land, crops, infrastructure, and

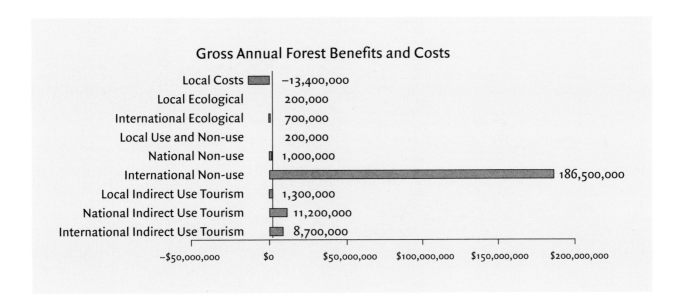

Gross Annual Forest Benefits and Costs

Local Costs	−13,400,000
Local Ecological	200,000
International Ecological	700,000
Local Use and Non-use	200,000
National Non-use	1,000,000
International Non-use	186,500,000
Local Indirect Use Tourism	1,300,000
National Indirect Use Tourism	11,200,000
International Indirect Use Tourism	8,700,000

−$50,000,000 $0 $50,000,000 $100,000,000 $150,000,000 $200,000,000

This chart depicts the gross annual forest benefits and costs relating to the economic value of the Virunga and Bwindi forests. *Source:* Hatfield, Richard, and Delphine Malleret-King. 2003. The Economic Value of the Bwindi and Virunga Gorilla Mountain Forests, A report submitted to the International Gorilla Conservation Programme (IGCP), Nairobi.

people and (2) the opportunity cost, which is the value of lost opportunities due to the existence of the forest: using the forest for one purpose, such as a national park, as opposed to another purpose, such as clearing the land for agriculture. A critical assumption was made in the study that the forest opportunity cost is borne by local residents, more specifically that those local residents would be the beneficiaries of forest conversion to agricultural land. This assumption is oversimplified as this land was gazetted as a park in 1925 (Democratic Republic of Congo and Rwanda), when the land was much less densely populated. The local people have not had the opportunity to cultivate the land for more than eighty years; therefore, the opportunity cost is hypothetical.

Accurately qualifying the amount of loss attributable to wildlife damage and crop depredation proved to be problematic at best. Some of the respondents surveyed claimed damage levels that were significantly over the claimed production levels; consequently, the data for this metric were unreliable and require further study to fully qualify.

Based on an assumption that 50 percent of the existing park areas could be cultivated and an average net income per hectare of USD $436 per year, it was estimated that there was an annual (opportunity) cost of USD $15 million based on the forgone agricultural potential due to the existence of the forests.

When the total gross economic value of the forests were aggregated based on the gross benefits less the local forest costs, a total annual value for the combined Virunga-Bwindi forests was estimated at USD $196.4 million. Ninety percent of this total is derived from the non-use value of mountain gorilla habitat to the international community. When the remaining benefits are scrutinized, 91 percent of those benefits can be accounted for with gorilla tourism with the important distinction being made that the benefits of the mountain gorilla tourism are tangible in nature

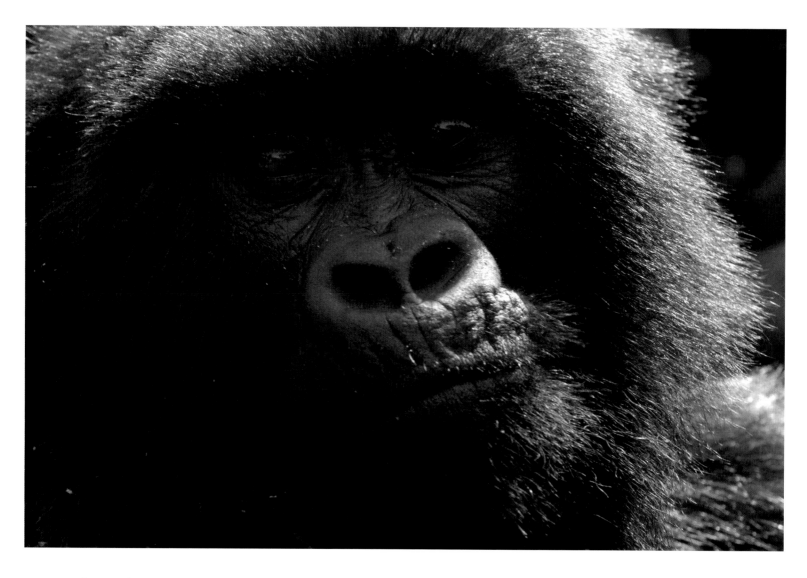

where as the non-use value to the international community is not nearly as tangible.

The study arrived at five main conclusions: (1) The Virunga and Bwindi forests should continue to be protected because, from an economic standpoint, they are generating significant benefits above and beyond the costs that are being borne. (2) Given that tourism is the driving force behind the most tangible benefits that come from the forests, it is important to maximize the potential revenue while maintaining the quality of the experience and, more importantly, the sensitivity of the industry with respect to the very fragile resources on which it is based. (3) The international community is the major beneficiary of forest protection. (4) Assuming that the opportunity costs of the forests are borne by the local communities—this assumption is not a given, as stated earlier—significant tangible benefits are being realized at the national level and local communities experience the losses at a similar magnitude level. Alternatively, the assumption is held that if the opportunity costs of small-holder agriculture are borne at the national level, then meager tangible and nontangible benefits are being realized at the national and community levels.

Kabatwa is a member of the Sabyinyo group in Parc National des Volcans, Rwanda.

(5) When the potential scenarios for change are examined, even if there was a significant increase in the share of tourism benefits at the local level while combined with a sustained growth in tourism, the net effect would only improve rather than sustain the livelihoods of people living near the forests. Investing in the further development of the main local livelihood, which is agriculture and small industry, was more likely to have a lasting effect on development, the condition of people living near the protected areas, and subsequently on sustainable forest conservation.

New Directions and Strategies for Financing the Future

When one considers the changes in approach and methodology used in conservation of the Virunga and Bwindi forests today as opposed to thirty years ago, the differences are substantial. The approach to conservation has become much more interdisciplinary, which is a result of necessity, creative thinking, and lessons learned over time on the ground. In the same way that the operational strategies on the ground have evolved and become more sophisticated, so too have the sources of money. Whereas private individuals and organizations have been the sources for conservation funding in the past, the NGOs are getting funding from much more diverse sources today. Funding now also comes to NGOs from large bilateral and multinational donors. The challenges presented in the future for the way that funding sources are channeled are complex and will affect the future of NGOs.

As conservation strategies and methodologies evolved, conservation organizations became more involved in projects targeting income generation and rural development activities to help people develop wealth, which is a fundamental aspect of many integrated conservation development programs. There are essentially two methods that are used to achieve this objective. First, you have income substitution, that is, giving people another activity to do, which brings them money, and secures their livelihood, which doesn't require them to use the parks or the natural resources inside the parks at all. The second option is collaborative management arrangements such as trying to find ways of getting people to work together with the parks for a more sustainable use of the available resources. In reality, many of these activities are in effect rural development activities, particularly those focused on income substitution. The challenge is that conservation money is being used on some of these projects when they could conceivably be funded through more ample development funds. That could potentially free up the conservation money to be used for more traditional types of conservation activities. Effectively coordinating this would require cooperation and strategic planning between many different organizations. That same level of coordination and cooperation is reflected in an emerging trend in the financing of development efforts called "basket funding." Instead of bilateral and multinational donors setting up their own projects with a parallel infrastructure to the governments, donors are looking at the governments' national priorities as

stated in their PRSPs and in the medium term expenditure frameworks. Then they give the money directly to the government for implementation rather than managing it all independently through a consultancy or NGO. The intent is to empower national governments to be able to manage their own development efforts and establish priorities. The challenge for the NGO communities and conservationists will be in how they can effectively participate and contribute in the new models for financing while continuing to support the primary missions and objectives of their respective organizations. If the protection and management of the forests and national parks are not represented in the countries' national economic plans, the importance of these activities will continue to be undervalued and overlooked, and the work of conservation may suffer as a result. Conservation strategies will need to be aligned with other national economic policies on development and the environment. Conversely, development agencies are becoming increasingly involved in sustainable management of natural resources. They are pulling in environmental approaches and conservation principles and tying them to rural development and poverty reduction programs. By participating in the PRSP and playing a part in the greater strategic framework of national governments, the impact of conservation can be strengthened and benefit greatly from the synergy created by coordinating with rural development efforts. This trend will enable some conservation funds to be redirected to more specific activities focusing on threats reduction and sound ecological management. Without this type of integrated approach, sustaining the funding at the level necessary to support conservation efforts well into the future may become increasingly more difficult.

The Issue of Sustainability

One of the important questions that needs to be asked regarding the business of mountain gorillas is whether the tourism programs are sustainable at current and projected growth levels. From a purely management and revenue-based perspective, there is always a desire to increase the amount of revenues that are currently being derived from mountain gorilla tourism. That can be done only a few ways. Permit fees can be raised, more groups can be habituated for tourism, or the creation of focused programs that enable tourists to either spend more money in gorilla tourism areas (i.e., purchasing souvenirs, guided nature and cultural walks) or to visit other parks in that country. This last option is being done to a certain extent. Permit fees have continually been raised over the years, which raises two issues: (1) fees will reach their limit at some point; and (2) rising permit prices places the experience of visiting gorillas beyond the financial reach of many people who arguably have as much right to visit the gorillas as those that can afford the higher prices. The remaining option of habituating more gorilla groups for tourism has been debated.

Opposite: This headshot of Agashya, a silverback from Group 13, clearly shows the large sagital crest that plays such an important role in the appearance of these spectacular animals.

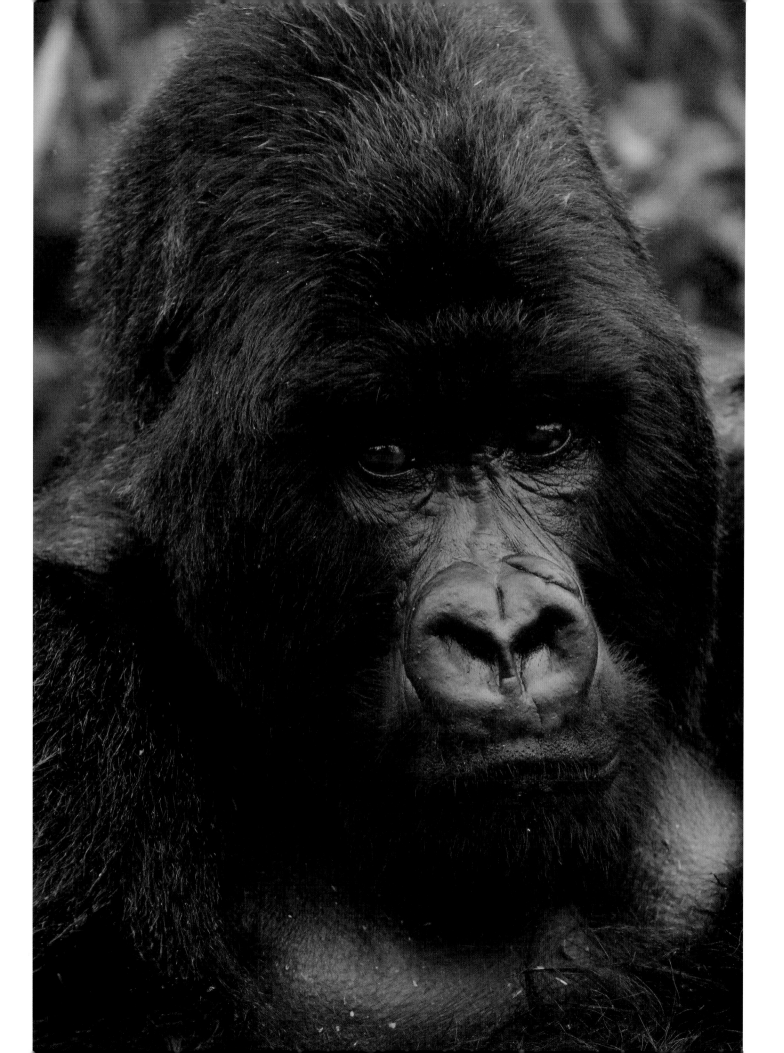

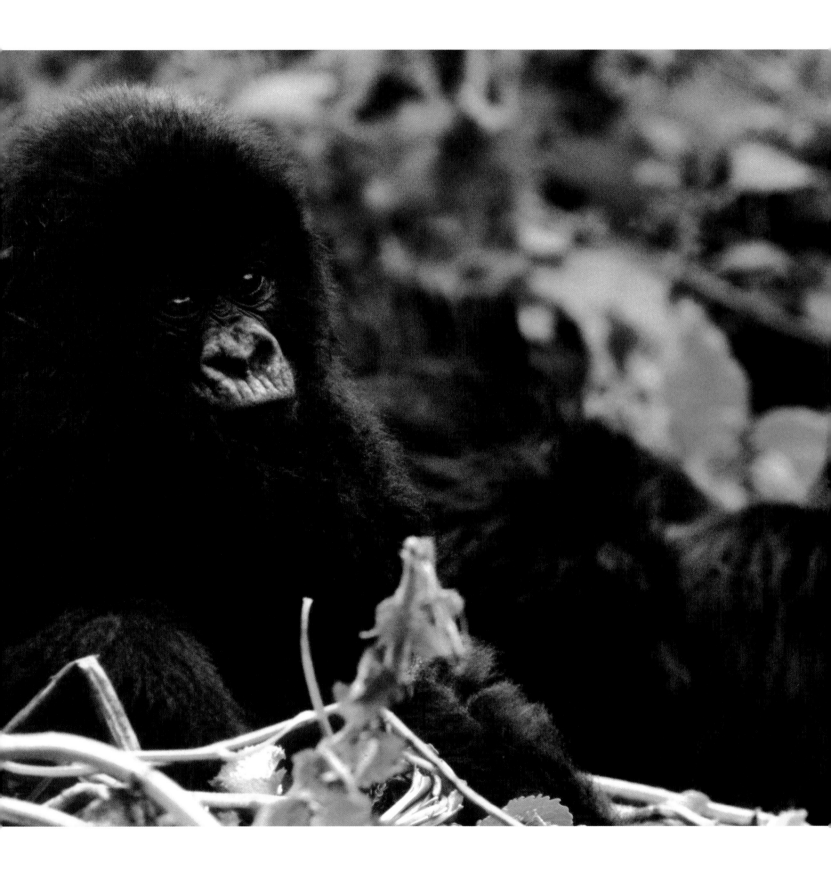

These discussions have included the park authorities, conservationists, and tourism development experts. The consensus from the discussions has been that it is preferable to keep a significant proportion of the gorilla population free of tourism or scientific study to minimize their exposure to humans. As a consequence, it was agreed that no additional groups of gorillas would be habituated for either tourism or behavioral research. Behavioral impact studies have shown that, in addition to the threats posed by disease transmission, tourism visits also affect gorillas, which is why the rules and structure of the tourism program were created in the first place. The outcome of that impact on the long-term welfare of the gorillas is not known. At current levels, the effect is probably controlled; however, continued long-term research will be able to demonstrate the true effect over time.

Consideration should also be given to the vulnerability of tourism and conservation efforts in a region that has historically been challenged with insecurity and the fickleness of world tourism markets. The attack and subsequent killing of tourists in Bwindi in 1999 had an immediate impact on gorilla tourism at Bwindi as well as tourism throughout Uganda, and the entire region took years to recover to preincident levels. The war and subsequent instability immediately following in Rwanda caused gorilla tourism to be virtually eliminated in 1994 and totally eliminated in 1998. The insecurity in the Democratic Republic of Congo caused gorilla tourism to be stopped for years; it has only resumed operations in 2003. They are still recovering even today. The terror attacks in the United States in 2001 resulted in many U.S. tourists immediately canceling all holiday-related travel in Africa and other parts of the world. It has taken years to recover to preincident levels. The U.S. market constitutes one of the largest constituencies of gorilla tourism. A single unrelated event 10,000 miles away from the gorillas could have a huge impact on gorilla tourism, which in turn heavily impacts the local, regional, and national economies of the countries in the range states. Recessions in Europe and the United States could limit the ability of private citizens to donate money to conservation organizations. It could also have an impact at a much greater level if donor countries are not able to afford bilaterally funded development/conservation programs.

What role could trust funds play in this equation? The Mgahinga Bwindi Impenetrable Forest Conservation Trust was created with a model designed to provide

Himbara, an infant from the Amahoro group in Parc National des Volcans, Rwanda, carries on unaware of the controversy and challenges that face mountain gorillas. The viability and growth of mountain gorilla tourism raises difficult questions. There are biological limits to the revenue generated from gorilla tourism that cannot be ignored. Many global factors will have a direct effect on tourism. Many direct use benefits people derive from the parks are illegal and largely uncontrolled. How can we find the right combination of incentives to promote income substitution and meaningful deterrents to illegal or unsustainable practices in the parks? How can stakeholders achieve balance between the short-term and long-term interests of the economy, society, and the environment? As long as these questions remain unanswered, the sustainability of gorilla tourism and conservation will remain in jeopardy.

THE BWINDI MGAHINGA CONSERVATION TRUST

In 1995, something new was created in southwestern Uganda. The first forest conservation trust fund in Africa was established by a Trust Deed under the Uganda Trust Act. It would be called the Mgahinga Bwindi Impenetrable Forest Conservation Trust (MBIFCT). Many years later, the Trust would become the Bwindi Mgahinga Conservation Trust (BMCT). The purpose of the Trust was to support conservation activities and the biodiversity of the ecosystems in Bwindi Impenetrable National Park and Mgahinga Gorilla National Park. The initial funding for the Trust came from donations from the World Bank Global Environmental Facility, U.S. Agency for International Development, and the Royal Netherlands government.

One of the goals of the Trust was reducing the local communities' dependence on forest resources for basic economic needs. They sought to increase the awareness within the local communities of the value of conservation and the ecological value of the forests. That in turn should help to improve relations between the park and the communities, increasing the Uganda Wildlife Authority's capacity for managing the two parks and ensuring the sustained financial viability of the Trust moving forward.

The Trust set out to develop strategic partnerships between the Ugandan government, the local communities, and donors. To that end, a Local Community Steering Committee (LCSC) was created with elected representatives of the communities, representatives of the Batwa (forest people), local government representatives, and NGOs that were active in conservation work in and around the parks. The LCSC is the vital link between the communities and the Trust. They are responsible for preselecting community projects, approving small project grants, and making recommendations for larger ones to the Trust Management Board.

Mandated by the Trust Deed with the Ugandan government, the annual budget of the MBIFCT must be allocated to certain activities. Sixty percent of the income is designated for community development projects and activities proposed by the LCSC. These are designed to be activities that have a positive effect on the conservation of the parks and that demonstrate nonconsumptive utilization of the forests such as ecotourism. Twenty percent of the funds are for research-related activities, primarily ecological and socioeconomic study, that can provide critical data to be used as an input for improving the management of the parks and community relations. The remaining 20 percent take the form of grants to the UWA to subsidize the costs of implementation of the management plans for both parks. With the largest share of the Trust going to community development projects, there are real and tangible benefits that make it back into the local communities, which take the form of projects that benefit the broader community, such as primary school classrooms, health units, and road construction. On a more personal and individual level, the Trust has purchased land for many of the Batwa and helped to develop income-generating activities that include fish farming, beekeeping, and other agricultural-based activities. These activities are intended to address the needs that have been previously provided for by obtaining resources from within the protected area forests.

perpetual funding for conservation by taking the seed money provided by donor organizations and investing it, only spending money from the proceeds and leaving the initial capital to continue earning money in perpetuity. This was a good idea in theory, but it fell prey to outside factors beyond the Trust's control. Market fluctuations caused a significant loss in the value of the fund shortly after the Trust was created.

These are difficult questions with no easy answers. There are biological limits to the tourism revenue generated from visiting gorillas that cannot be ignored. There are myriad factors on the global stage that can and will have a direct effect on tourism. Those factors cannot be changed either. Many of the direct use benefits that people are deriving from the parks are illegal and largely uncontrolled. How can we find the right combination of incentives to promote income substitution and meaningful deterrents to illegal or unsustainable practices in the parks? Furthermore, how can all of the stakeholders in the range states achieve a balance between the short-term and long-term interests of the economy, society, and the environment? As long as these questions remain unanswered, the sustainability of gorilla tourism and conservation will remain in jeopardy.

17

CONSERVATION

The Early Years

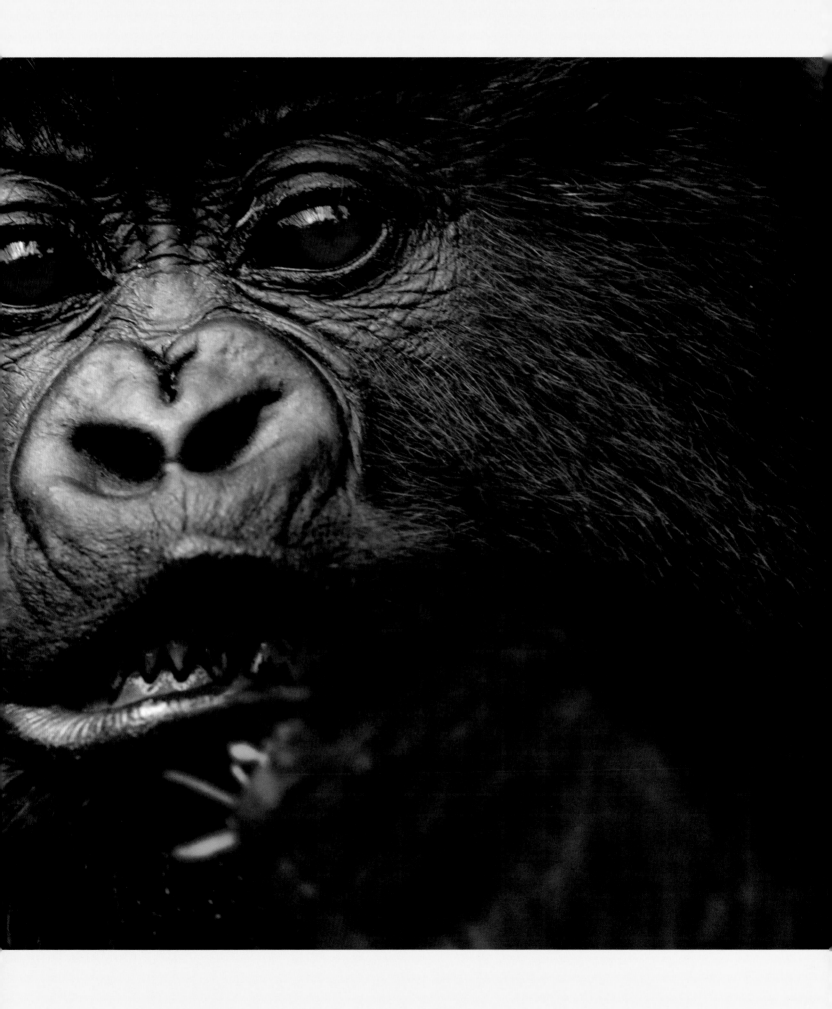

THE COLLECTIVE knowledge base of information that exists on mountain gorillas is unique in the world of primatology. The work done at the Karisoke Research Center in Rwanda represents one of the longest continual studies of free-living primates in the world. In fact, our knowledge of mountain gorillas constitutes the majority of what we know about the behavioral ecology of the entire gorilla genus. That research and scientific understanding are the fundamental inputs to conservation strategies, management planning, monitoring, and the evaluation of success in conservation initiatives.

The interdisciplinary approach to conservation that exists in the range states today produces behavioral data, environmental and ecological data, veterinary services, and a better understanding of the socioeconomic conditions of the people living near the parks. These combined efforts have thus far saved the mountain gorillas from extinction and helped to improve the lives and condition of the people living near them. That comprehensive style and approach was nonexistent in the early years of conservation and concern for mountain gorillas. It came about over time because of the hard work of many people and an evolving school of thought in terms of how to approach the conservation of mountain gorillas. By examining the early years of mountain gorilla conservation, we can see how we arrived in the present and most importantly where we are headed.

Early in the twentieth century, one of the first critical junctures for mountain gorillas involved an American named Carl Akeley. Akeley, a natural historian, had designed and created the Akeley Hall of African Mammals for the American Museum of Natural History in New York City. He was the first non-African and thus known key player in the conservation picture for the mountain gorilla and the first man with the intent of studying them in the wild. Akeley's interest in all African mammals was

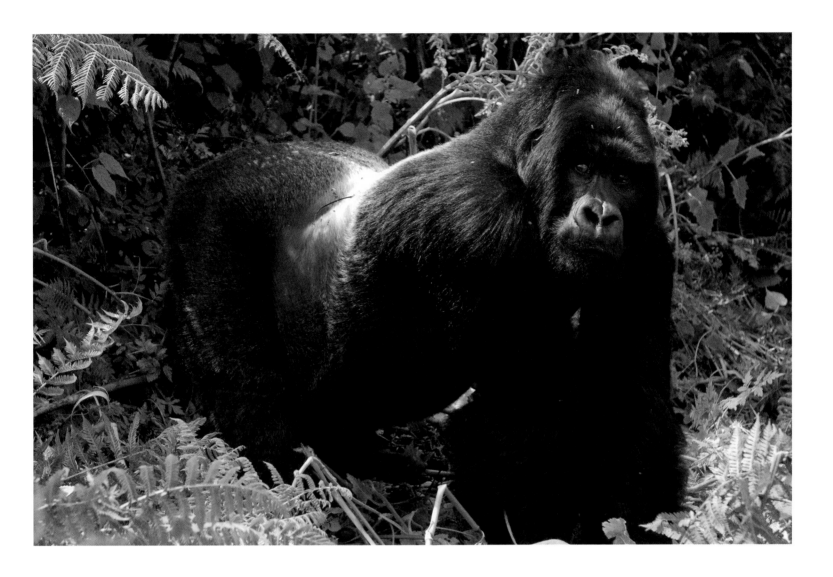

Agashya, the silverback from Group 13, has just come crashing through the bushes in Parc National des Volcans, Rwanda.

clear and the educational benefit gained by the millions of people that would tour the Hall at the museum cannot be denied. At the time, the idea of adding mountain gorillas to the exhibit was well intended. It is also likely that the potential impact on gorillas from those actions was secondary to the educational benefits. Virtually nothing was known about mountain gorillas, and the world was thirsty for any exposure to them, even if they were stuffed and mounted in a museum. During this time, many mountain gorillas were killed for museum exhibits, including Akeley's exhibit, or for private collections.

After killing and "collecting" five gorillas for his display at the American Museum of Natural History, Akeley was moved to take action to protect the gorillas. At the time, the entire area surrounding the Virungas was under Belgian control. Akeley managed to gain an audience with King Albert of Belgium. In 1925, had Akeley not convinced King Albert to designate the area surrounding the Virungas as a protected

area and the gorillas as a protected species, there is little doubt that the mountain gorilla would have gone extinct by now, if for no other reason than loss of habitat. The establishment of Albert National Park, the first national park in Africa, was a milestone event for mountain gorillas and for all of Africa. It would help to pave the way for scientists and researchers that would come to study mountain gorillas. The irony for Carl Akeley is that he died unexpectedly after returning to the Belgian Congo (now Democratic Republic of Congo) to study the mountain gorilla in the wild, never being able to truly pursue his aim. He was buried at Kabara Meadow in the Mikeno sector of the Virungas, a site that would later host two other prominent figures in mountain gorilla history. Thirty years later Kabara Meadow would become a base of operations for George Schaller.

The Absence of Information

Before George Schaller's work on the Africa Primate Expedition, research on mountain gorillas was minimal, and long-term research on free-living mountain gorillas was practically nonexistent. It was this absence of information that would be the underlying driver for the project. For many years after the scientific discovery of the gorilla in the nineteenth century, accurate reports about the behavior and interactions with wild gorillas were simply not avail-

Charles, a silverback from the Umubano group in Parc National des Volcans, Rwanda, stretches and yawns. For many years after the scientific discovery of the gorilla in the nineteenth century, accurate reports about the behavior and interactions with wild gorillas were not available. Often, initial reports were embellished for publication and portrayed gorillas as ferocious. That reputation would stay with the gorilla for many years to come and in some people's minds, it still exists today. The reputation combined with the extreme nature of the environment where gorillas are found, were considered prohibitive to an in-depth behavioral study of free-living gorillas. George Schaller's work would change all of that and the very nature of our understanding of gorillas in general and mountain gorillas in particular.

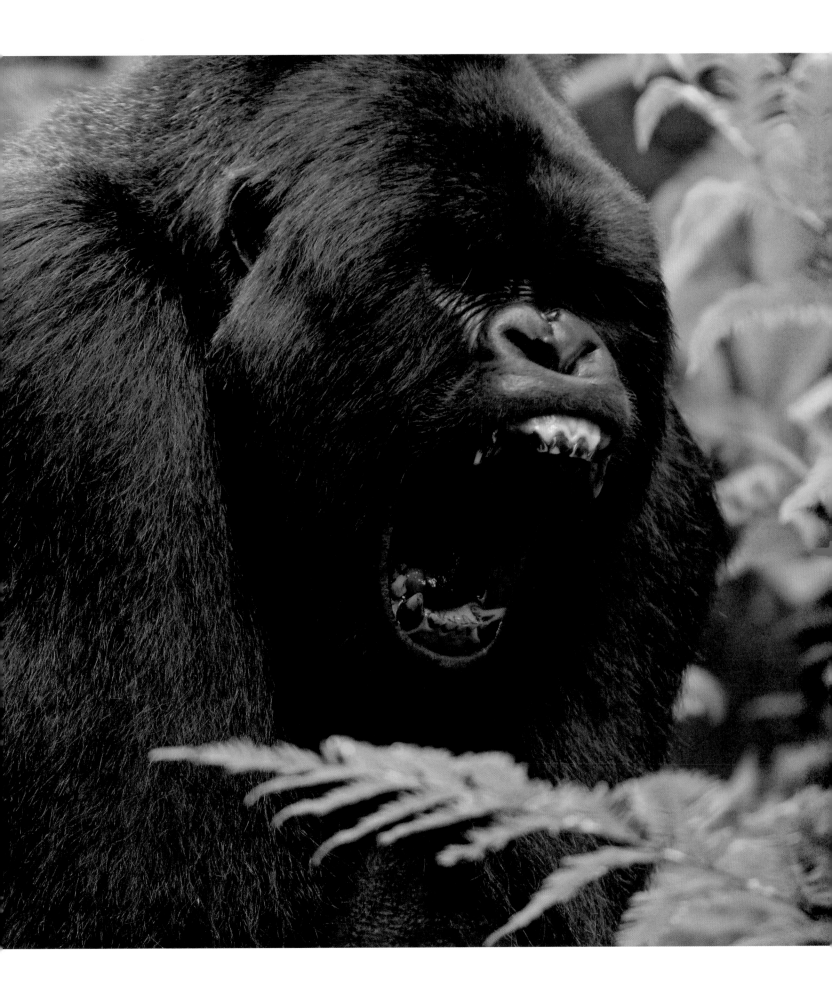

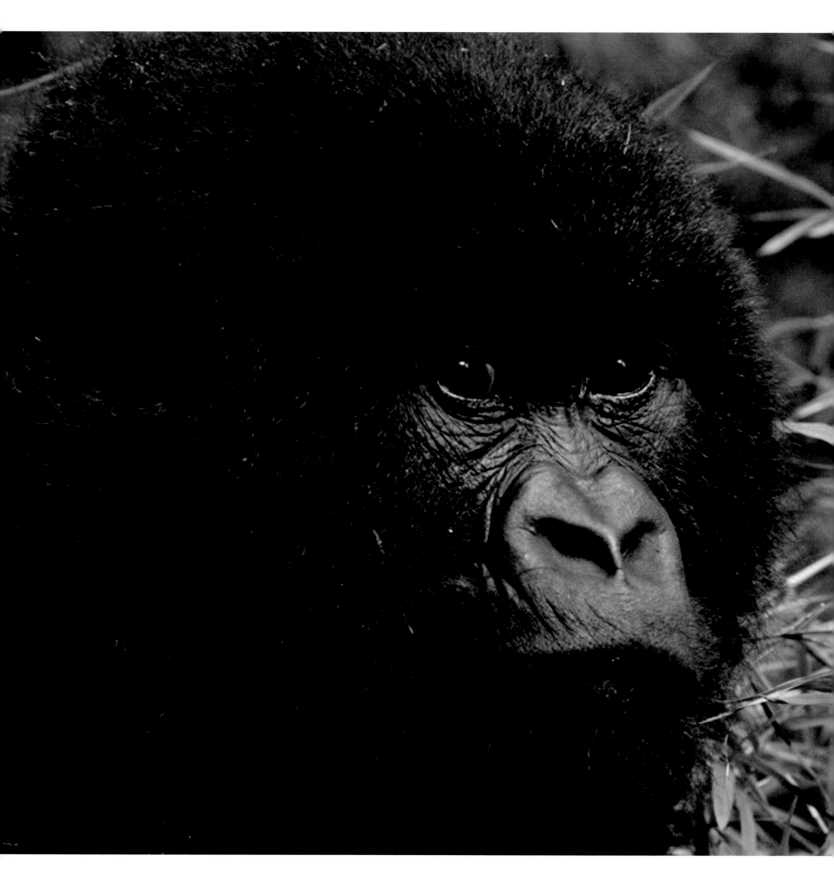

Dian Fossey, who had no training in primatology and no experience doing fieldwork, was the last person anyone would have expected to spend the rest of her life living on the side of a mountain in Africa studying gorillas. The emotional connection and seeds for her future work were firmly planted while she observed the gorillas near Kabara on her first trip to Africa in 1963. It's easy to understand this strong connection after seeing gorillas like Gihishamwotsi from the Sabyinyo group in Parc National des Volcans.

able. Often, initial reports would be embellished for publication and would typically lean toward the "ferocious nature of the mighty beast." That reputation would stay with the gorilla for many years, and in some people's minds, it still persists today. The reputation combined with the extreme nature of the gorilla's environment were considered to be prohibitive to an in-depth behavioral study of free-living gorillas. Schaller's work would change all of that and the very nature of our understanding of gorillas in general and mountain gorillas in particular. A few came before and many scientists came after Schaller, but his work was the foundation of the focused scientific research that would be conducted over time with free-living mountain gorillas.

The African Primate Expedition, or A.P.E., was primarily funded by the National Science Foundation and sponsored by the New York Zoological Society (later known as the Wildlife Conservation Society). The study was started in February 1959 by John Emlen and George Schaller. The fieldwork would be completed in September 1960. Emlen was a professor of zoology at the University of Wisconsin providing leadership and direction for the project. Schaller had studied at the University of Wisconsin and would conduct the extensive study of mountain gorillas in a single area. With several key objectives for the expedition, the team would spend six months performing a survey of the mountain gorilla range in the eastern part of Congo (as it was known then), the state of Ruanda-Urundi, and the western part of Uganda. The primary goal of the survey was to understand the distribution of the mountain gorillas, the ecological diversity, and to determine the most favorable sites for a longer-term behavioral study. Once the study site was determined, Schaller would spend a year of continuous observation studying the life history of the mountain gorilla.

After six months, they decided to perform their long-term study at the Kabara Meadow site in the Mikeno sector of the Virunga Volcanoes in eastern Democratic Republic of Congo, the site of Carl Akeley's burial thirty years earlier. From August 1959 through September 1960, Schaller and his wife Kay spent most of their time studying the gorillas around Kabara. The information gleaned from this field study would be reported in several publications; however, the primary report was produced in Schaller's 1963 book entitled, *The Mountain Gorilla: Ecology and Behavior*. At the time, this would be the most complete field study ever made on free-living primates and would define standards and methodologies that in many cases are still used today. Schaller detailed every aspect of ecology and behavior, including distribution, group dynamics, daily activities, social behavior, how the gorillas interacted with their environment, and the first census ever conducted of mountain gorillas. His report would serve as a fundamental knowledge base and reference for many years to come. It was the "gorilla bible" with which another person would begin her field study and continue the legacy of Schaller's pioneering work. Her name was Dian Fossey.

Dian Fossey is without question the most recognized name and personality in the world when it comes to gorillas, even now, more than twenty years after her death. She is also one of the most controversial individuals ever associated with mountain gorillas.

With no training in primatology and no experience with fieldwork, she was the last person anyone would have expected to spend much of the rest of her life living on the side of a mountain in Africa studying gorillas. Early on, Fossey was fascinated with Africa and took out a loan to realize her dreams of traveling there. In 1963, she visited the world-renowned anthropologist Louis Leakey at the Olduvai Gorge archaeological site in Tanzania. Leakey was enthusiastic about Fossey's plan to head for Kabara Meadow in the Congo to see the gorillas. He mentioned the fantastic work that Jane Goodall was doing with chimpanzees at the Gombe Stream Research Center and the need for similar long-term studies to be conducted on the mountain gorillas. As she observed the gorillas near Kabara, the emotional connection for Fossey and the seeds for her future work were firmly planted.

As fortune would have it, three years later Leakey was visiting Kentucky where Fossey was living at the time. After brief discussions, he proposed that Fossey conduct the study of the mountain gorillas. In 1966, at the urging of Leakey, the same philanthropist that funded Goodall's chimpanzee research consented to fund the gorilla study. After flying to Nairobi, Fossey acquired supplies and began her trek to Kabara in the Belgian Congo. She stopped for two days at Gombe at the invitation of Jane Goodall for an orientation on how to set up camp and to learn about data collection methodology.

Fossey would continue on and establish a camp at Kabara Meadow as George Schaller had done nine years before her. Because Fossey had no skills in the art and science of gorilla tracking, the going was rough at first. After six months, in July 1967, her work would come to an abrupt halt as she was escorted down the mountain by soldiers of the Zaire military. Zaire (formerly the Belgian Congo) was in a state of civil war, struggling with their newly gained independence, and dealing with rebellion in the Kivu province where Kabara was located. After being taken into custody by the military and detained for about a week, Fossey escaped to Kisoro in Uganda, taking refuge at Walter Baumgartel's hotel, the now famous Traveler's Rest. From there, she went back to Nairobi to meet with Louis Leakey, where it was decided that she would make a go of it on the Rwandan side of the Virungas.

After scouting the region, she decided to set up camp in the saddle area between two of the volcanoes, Mt. Karisimbi and Mt. Visoke. And on September 24, 1967, combining the names of the two mountains, the Karisoke Research Center was born. With the exception of a break to complete her PhD at Cambridge University, Fossey would spend much of the next eighteen years at Karisoke. Over the ensuing

years, a rotating crew of scientists, various students working on their PhDs, and other assorted individuals motivated to be involved with the cause would supplement her Rwandan staff. Fossey's work would expand on what was learned from Schaller's seminal study, shedding new light on the lives of mountain gorillas and the challenges they faced.

As fate would have it, Fossey would have her own challenges to face as well and would eventually suffer a violent death. She was murdered as she slept in her cabin at Karisoke eighteen years later, in December 1985. To date, her murder remains unsolved. The Rwandan government charged Rwelekana, one of the Karisoke trackers, and an American student who had worked at Karisoke with her murder. The student had already fled the country, and Rwelekana refused to confess and died in prison, presumably beaten to death by his interrogators. The general opinion of the people who worked with these men and with Fossey at the time believed the accusations were a farce and that poachers committed the crime.

It is easy to understand how Fossey's complicated life and methods could be questioned. It is not easy, particularly for foreigners, to understand the context and complexities of working on the ground in the bush in Africa in the 1970s (or even today), and why unconventional methods or approaches might be required. Most important is the positive effect that she had in the greater equation for mountain gorillas. Between the founding of the Karisoke Research Center, her book entitled *Gorillas in the Mist*, and the movie of the same name, Fossey and her legacy have done more to raise public awareness of the plight of mountain gorillas worldwide than any other person or organization in the world. For that, Fossey deserves credit. That has significant importance for fund-raising to support the continuing work of Karisoke and efforts by other organizations to raise funds for mountain gorilla research and conservation. It has also served to inspire countless tourists to visit the gorillas as well, a key factor in their survival. The unfortunate irony is that much of the far-reaching publicity and awareness generated by Fossey's work came about through the creation of the Digit Fund, a movement born out of the most grisly of circumstances.

The Digit Fund

In the late 1970s, a series of tragic events occurred, ultimately decimating one of the Karisoke gorilla research groups known as Group 4. On December 31, 1977, the silverback Fossey had named Digit was killed and mutilated by poachers. A tracker failed to locate the group the next day, and on the following morning, a staff member found Digit where he had been killed—decapitated and with his hands cut off. Digit was one of Fossey's favorite gorillas. She and the staff at Karisoke were devastated. Struggling with how to respond to Digit's death, several options were debated. One option was to publicize the events to generate support and establish a conservation fund. Another reason for publicizing the events was to increase pressure on

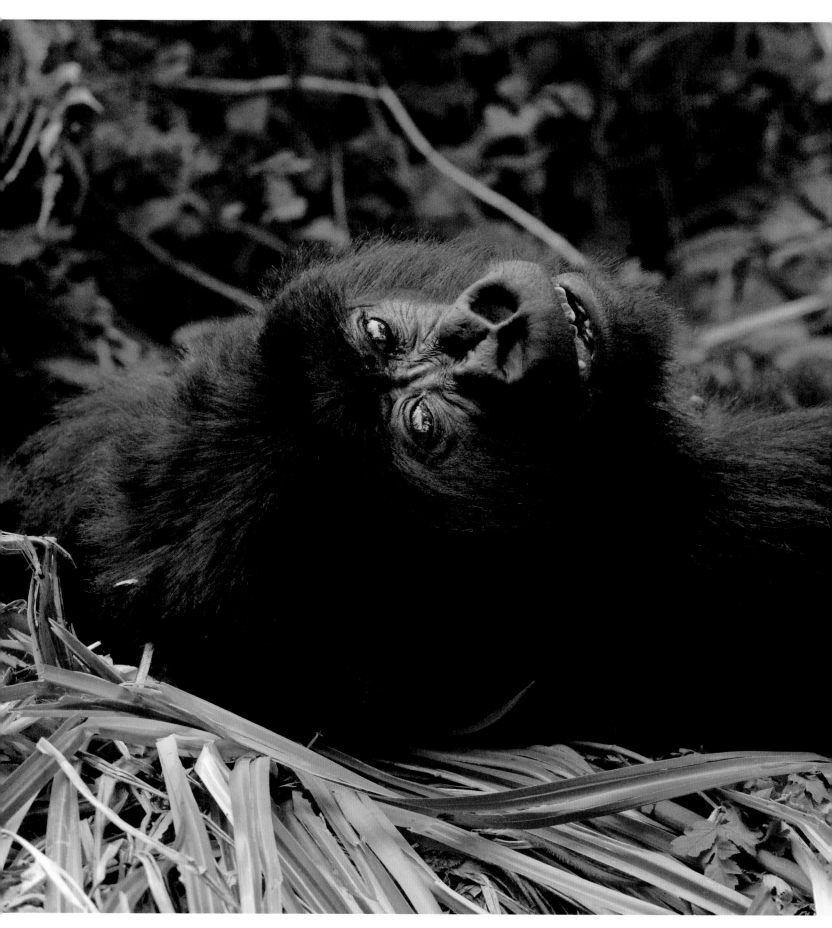

Completely at home and relaxed within her environment, Inziza from the Beetsme group lazily looks over
her shoulder as researchers collect data in Parc National des Volcans, Rwanda.

the Rwandan government to stiffen the penalties for poaching and to raise public awareness. Fossey's purpose for publicizing Digit's death was to create funding for increased antipoaching patrols. She had recently lost the financial support of the National Geographic Society and was in desperate need of funding. She established the Digit Fund in his memory in 1978 and money poured in. In 1992, the fund would be renamed to the Dian Fossey Gorilla Fund International (DFGF-I) to emphasize the purpose and direction established by its founder.

Now funded by DFGF-I, the work of the Karisoke Research Center continues today. The staff and visiting scientists of Karisoke have closely studied three or more of the habituated gorilla groups on the Rwandan side of the Virungas for forty years. Their work has covered many aspects and variations of social behavior, such as group structure, dispersal patterns, female mate choice, social relationships, reproductive strategies, and social development. They have also facilitated studies of the vegetation of the Virunga massif, the greater environment, and how that could affect the feeding ecology and ranging behavior of the gorillas. Many of those studies and resulting publications were the primary sources for the environment and ecology chapters of this book and most books published about mountain gorillas. The knowledge gained over the first twelve years of operation at Karisoke increased our overall knowledge of the ecology and behavior of mountain gorillas. During this period, despite the antipoaching patrols, the overall number of gorillas had declined since Schaller's first census underscoring the need for more comprehensive conservation measures. The expanded knowledge base gained from research was yielding a greater understanding of the threats facing mountain gorillas and the forest habitats in which they live. New ideas about how to approach conservation were in the air and the climate was ripe for change.

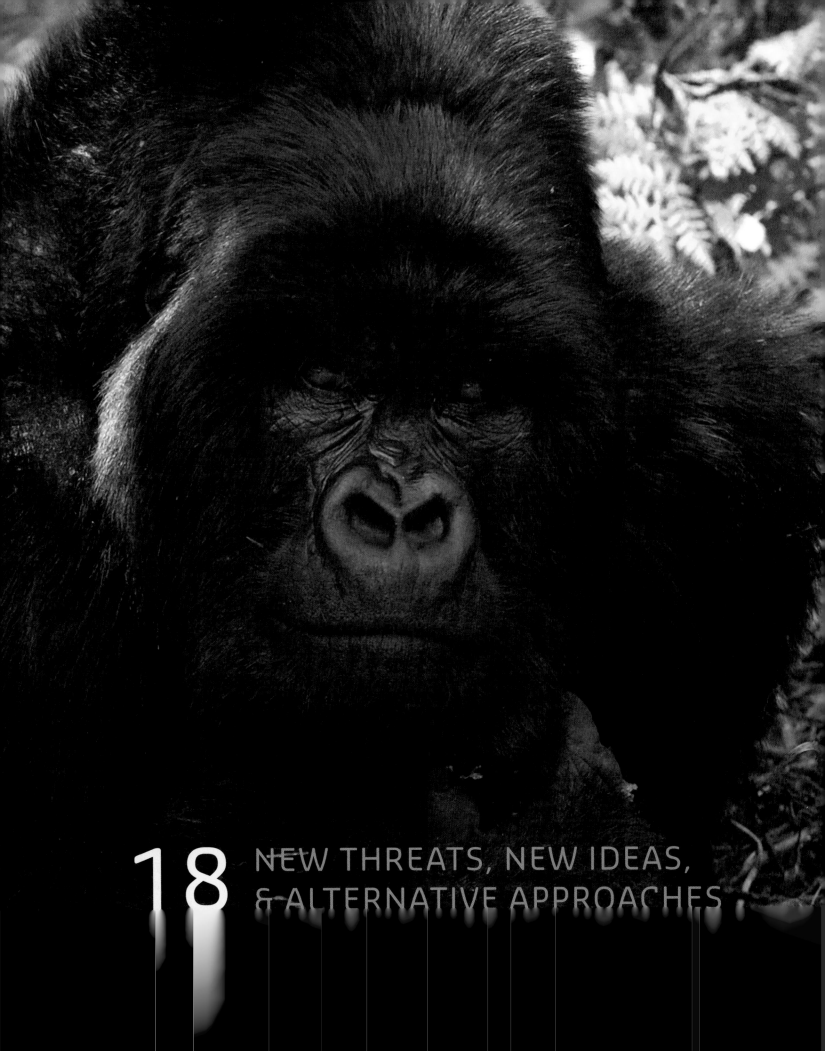

18 NEW THREATS, NEW IDEAS, & ALTERNATIVE APPROACHES

THE PARC NATIONAL DES VOLCANS (PNV) had suffered the loss and reduction of nearly half of the forest by 1958. In the years that followed, park managers, conservationists, researchers at Karisoke, and other scientists would see continued pressure from encroachment by the people living near the park. They would also have to deal with the increased threat of poachers. In 1979, a new threat emerged in Rwanda that would potentially dwarf the problems with poachers. The Ministry of Agriculture had proposed a European Community–funded cattle-raising project that involved the clearing and permanent deforestation of 12,500 acres of the park, including much of the bamboo zone and saddle areas. This action would have reduced by one-third what remained of PNV. The people of the area living near the park faced overwhelming poverty, which was difficult to dispute, and the proposed cattle project anticipated revenue of USD $70,000 annually through a combination of milk production and the sale of animals—direct income that would be a crucial factor in making a real difference in their lives.

During the early years of conservation, PNV was bringing in less than USD $7,000 in annual revenue, which offered no real alternative to other uses of the land, such as growing crops or raising cattle. At that time, virtually all of the benefits from mountain gorillas and the protected area were realized by scientific research institutions and individuals outside the country. Organizations such as the National Geographic Society would come to film Dian Fossey and the gorillas, generating sales for their magazines and films; however, the people who lived near the park—who bore the greatest cost of conservation and who were most in need—rarely benefited. There had to be a way to extend benefit to the local communities and help to alleviate some of the economic pressures these people were facing. The bottom line was money and an alternative solution that would provide ongoing revenue was the only thing that

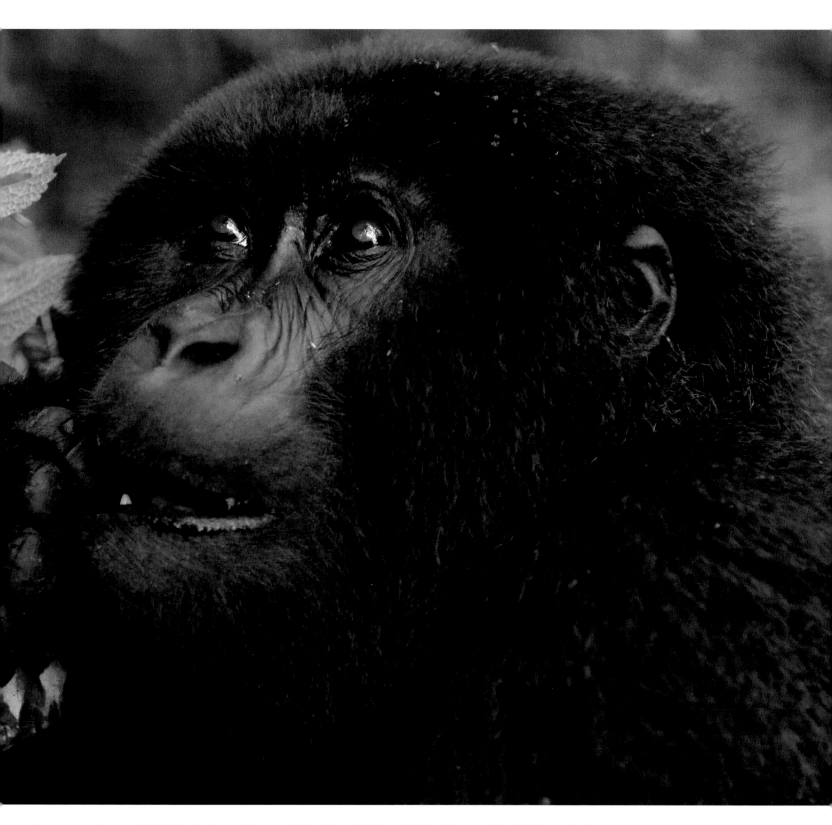

In 1979, a meeting was held at Karisoke Research Center with Dian Fossey, Robinson McIlvaine from the African Wildlife Foundation, Diana McMeeken, Bill Weber, Amy Vedder, Craig Sholley, and others to discuss the future of mountain gorilla conservation. Although there had been some attempts at gorilla tourism previously, the ideas that were being circulated at the time were to combine protection and education with a full-blown, carefully structured tourism program. The Mountain Gorilla Project was conceived. These events proved to be pivotal for the future of conservation for mountain gorillas like Bunyenyeri from the Umubano group in Parc National des Volcans, Rwanda.

could stop the impending threat of the cattle project. It was time for new ideas and alternative approaches.

Although the research and antipoaching efforts conducted by the Karisoke staff during Dian Fossey's tenure were crucial efforts at a critical juncture, they focused on a small subset of the overall population of mountain gorillas and a very small part of the Volcanoes National Park. Their efforts were the beginning of what would be a continuing evolution in thinking about how to protect the gorillas. The experience and lessons learned from their research highlighted to many the burgeoning need for a more comprehensive look at the broader issues of conservation in the larger context of the park. The broader issues included addressing the needs of the people. It had become clear that the future of the forest and the gorillas was tied directly to the conditions of the people living around the park. Different ideas about the approach to conservation were evolving and taking shape in Rwanda and other parts of the world. The seeds of these ideas and alternative approaches would ultimately form the model for the broader conservation efforts of today.

In 1979, a meeting was held at Karisoke with Dian Fossey, Robinson McIlvaine from the African Wildlife Foundation (AWF), Diana McMeeken, Bill Weber, Amy Vedder, Craig Sholley, and others to discuss various issues and options for the future of mountain gorilla conservation. Although there had been some attempts at gorilla tourism previously, the ideas circulated at the time involved combining protection and education with a full-blown, carefully structured tourism program. The tourism program represented an alternative source of income that could potentially stop the cattle project. Those discussions and the exchange of ideas were the genesis of what would become the Mountain Gorilla Project.

The Mountain Gorilla Project

At the same time that Fossey established the Digit Fund, the British-based Fauna and Flora Preservation Society (now Fauna and Flora International) established another fund called the Mountain Gorilla Preservation Fund (MGPF) to raise money for gorilla conservation in the Virungas. The Fauna and Flora Preservation Society was a very established conservation organization, employed major media in their campaign, and raised more money than the Digit Fund. The MGPF was designed specifically to work with Rwandan institutions to help Rwandans better manage their own parks and protect their natural resources. This was a sore point for Fossey because MGPF was working with people and organizations in Rwanda that Fossey had previously alienated, and those organizations were engaging fully with MGPF. To determine the most effective way to address conservation issues, the MGPF sent Sandy Harcourt, a former scientist from the Karisoke Research Center, and Swedish zoologist Kai Curry-Lindahl to Rwanda to try and devise a plan, secure local participation, and ink an agreement so that work could move forward. Fossey's support and international renown was considered crucial to any project's success.

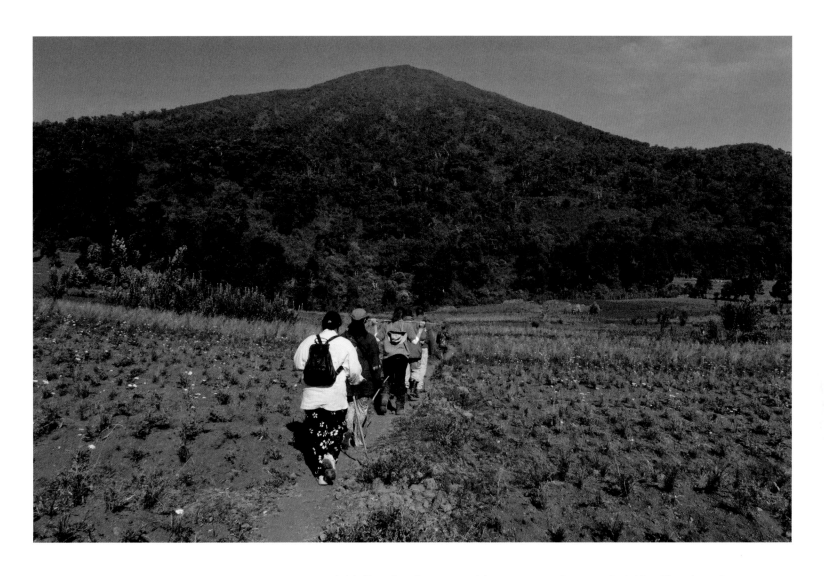

The Mountain Gorilla Project made the case for the tourism program to the Director of the Rwandan National Parks organization, Office Rwandaise du Tourisme et des Parcs Nationaux. They were finally allowed to proceed. The term *ecotourism* did not exist yet. It was 1979, and there was much at stake. This was a crucial turning point in the future of mountain gorillas, not only in Rwanda but in the greater transboundary region as well. The work being done here would create the model for the rest of the region and would ultimately be one of the significant determining factors in the attempts to secure the future of the mountain gorilla. In 2004, these tourists hiked up to the edge of the forest in Parc National des Volcans, Rwanda.

Fossey initially refused to meet with Harcourt and Curry-Lindahl. Bill Weber who was working at Karisoke at the time traveled to Kigali to meet with Harcourt and Curry-Lindahl to share the ideas that had been previously discussed for a more comprehensive approach to the region. Various people made several attempts to convince Fossey to meet with the team from the United Kingdom. Finally, she conceded to meet with Curry-Lindahl only. After a private meeting in her cabin, Fossey agreed to lend her support, with the condition that Rob McIlvaine and the African Wildlife Foundation be involved. The decision was made that the Mountain Gorilla Project (MGP) would be a three-tiered approach supporting antipoaching efforts, education, and a carefully managed tourism program. Jean-Pierre von der Becke, a Belgian, would be the first Director for the Mountain Gorilla Project. Von der Becke's paramilitary background made him a natural choice for training the antipoaching and protection teams. Weber, Vedder, Conrad, and Rosalind Aveling would be in charge of the tourism and education programs. With the combined efforts and support of many people in multiple organizations, the MGP was off the ground and running.

The Office Rwandaise du Tourisme et des Parcs Nationaux (ORTPN) had gotten a new Director named Benda Lema. Faced with the possibility of degazetting more of the park for the cattle project, Lema had to be convinced that there was a better alternative for creating revenue to support the local communities. The MGP made the case for tourism to Lema, and after some convincing by the team, they were allowed to proceed. The term *ecotourism* did not exist yet. It was 1979, and there was much at stake. This was a crucial turning point in the future of mountain gorillas not only in Rwanda but also in the greater transboundary region. The work that was being done would create the model for the rest of the region and ultimately be one of the major determining factors in the attempts to secure the future of the mountain gorilla. The tourism program simply had to work; failure was not an option.

Gorillas had to be habituated to the presence of humans before tourism could begin. The habituation process in Rwanda was initiated by several members of the Mountain Gorilla Project. ORTPN became more involved as the process continued. Groups 13 and 11 were the first to be successfully habituated. As the habituation process was starting to work, the teams would take additional people along to visit the gorillas. The TransAfrica overlanders, groups of people who travel together in large trucks across Africa to reduce their costs, would be the first groups of nonresident tourists to visit the gorillas. Early in 1980, limits on the numbers of tourists allowed to visit with the gorillas was set at six, which was eventually increased to eight; those limits, relative to the size of the gorilla group, remain to this day. A reservation system was put in place to assure tourists that they would be able to visit after traveling all the way to the park in Rwanda. Encouraged by the reservation system, tour operators in Europe and the United States warmed to the idea of sending people to visit the gorillas, and the tourism program in Rwanda, though in its infancy, saw a ray of hope. Now it was time to convince the people on the ground.

It wouldn't matter how much the conservationists knew or understood about the threats facing mountain gorillas if the Rwandans didn't buy into the plans to address them. Education and sensitization were fundamental elements of the MGP program. This component cannot be overlooked, nor its importance overstated. The secondary schools held the key to the future leaders of the country. Only a very small percentage of the local population would make it through secondary school, for a variety of reasons, and the ones that did would undoubtedly become the military, government, and business leaders that would one day rule the country, determining the disposition of the park and its resources. Educating these future leaders and the people living near the parks would be key to securing their support and cooperation for protecting the forests and the gorillas.

The local populations, which included farmers surrounding the Virungas, were vital because they represented the most immediate threat—land clearing for farming. They also bore the greatest costs because of the forest's designation as a protected area, which restricted their access. Few if any of these people at the time understood the forest's valuable role in helping to create rain, in functioning as a water catch-

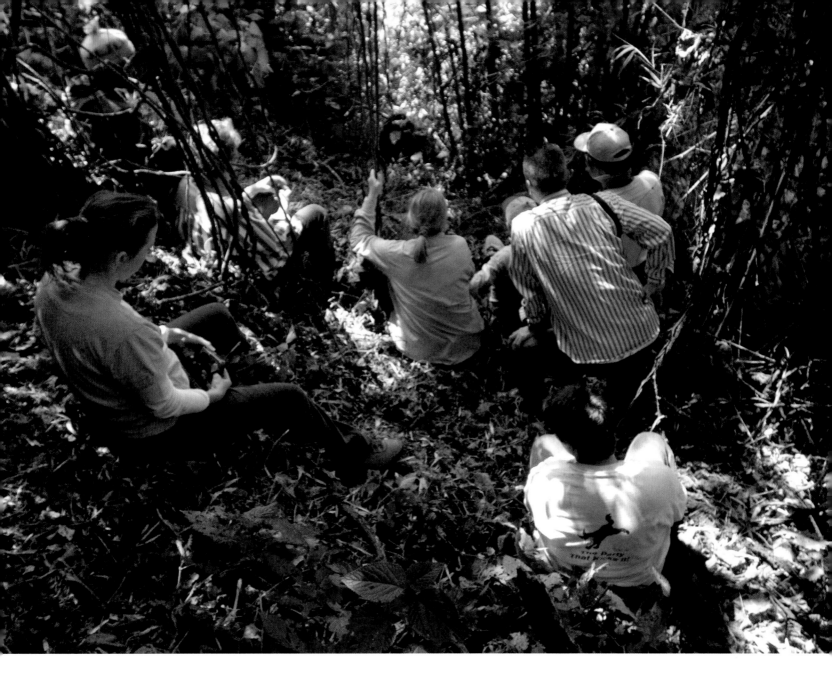

The gorillas would have to be habituated to human presence for the tourism program to work. Several members of the Mountain Gorilla Project in Rwanda initiated the habituation process. In 1980, the number of tourists that could visit the gorillas was limited to six. This limit was eventually increased to eight and those limits, relative to the size of the gorilla group, remain to this day. This tourist group watches a gorilla in Parc National des Volcans, Rwanda.

ment, and in preventing erosion and the subsequent flooding of their farmlands. By educating the population about these issues, as people came to understand how they were affected by them, they might be inclined to change their thinking about the land and the way that they live their daily lives.

The education and sensitization programs were slowly starting to affect people's attitudes about the forest and the need to protect it. The tourism program provided alternative income for the people of the region, and the proposed cattle project in the Virungas was finally dropped. Antipoaching, education, tourism, and the idea of direct benefit to the local communities were all making great strides. The Mountain Gorilla Project was succeeding in Rwanda albeit a tenuous and fragile success, but what about the gorillas in Uganda?

THE TOURISM PROGRAM

The tourism program for gorilla trekking is essentially the same in all three countries. Originally developed in Rwanda as part of the Mountain Gorilla Project, the model would later be duplicated in Uganda and the Democratic Republic of Congo (DRC). In the morning, tourists are required to report to the park headquarters for the area in which they are trekking for gorillas. In Uganda, there are park offices for Bwindi Impenetrable National Park in Buhoma and Nkuringo. The office for Mgahinga Gorilla National Park is located in Kisoro. In Rwanda, all of the tourists must report to the park headquarters in Kinigi. In the DRC, there are three locations from which trekking is conducted: Djomba, Bikenge, and Bukima.

Once the tourists have arrived at the park headquarters, the park staff will assign groups of tourists and guides to a given group of gorillas for the day's trek. There is a short assembly with the group for a briefing by the park guides with some basic information about the history of the park and the gorillas. After the briefing, the groups of tourists leave for their various starting points to begin their trek. For most of the groups, tourists are driven to a drop-off point and hike the rest of the way in. Depending on the group of gorillas they are visiting and which park they are trekking in, the group may leave directly from the park headquarters and walk straight up into the forest. Regardless of the group, the hike up will generally be through farmland until they arrive at the edge of the forest. When the edge of the forest is finally reached, the group will stop, and the guide will brief them about how to behave in the presence of the gorillas.

When the group reaches the gorillas, tourists are allowed to spend a maximum of one hour with the gorillas before they must back away and return down the mountain. The rules for visiting the gorillas are essentially the same in Uganda, Rwanda, and the DRC and agreed upon by the Protected Area Authorities:

- Keep a minimum of 7 meters (21 feet) from the gorillas. This is mostly to protect them from catching human diseases but also to minimize behavioral disturbance.
- Visitors must stay in a tight group when they are near the gorillas to ensure the silverback can see all people at all times and to help the guides maintain control of the group.
- Keep voices down at all times. However, it is OK to ask the guide questions.
- Spitting in the park is strictly prohibited to minimize the risk of disease transmission.
- Should the need to cough or sneeze arise, cover the mouth and turn away from the gorillas.
- DO NOT touch the gorillas under any circumstances. It is very tempting, and they may come close enough in passing. As relaxed as they may be, they are wild animals and should be respected as such.
- DO NOT eat or drink while near the gorillas. Eating or drinking inevitably will increase the risk of bits of food or drink falling to the ground and coming in contact with the gorillas. This represents another risk of transmission of diseases.
- Try not to make rapid movements that may frighten the gorillas and do not point fingers at them.
- If a gorilla should charge or vocalize, do not be alarmed, stand still, look away from the gorilla and follow the guide's directions.
 Do NOT try to take pictures and do not run under any circumstances.
- Do not litter.
- The maximum time tourists can spend with the gorillas is one hour although the guide can finish the visit early if he feels the animals are agitated or nervous.
- No flash photography is allowed.

As the MGP made progress in Rwanda, other efforts were under way to the north in Uganda. Makerere University and the World Wide Fund for Nature (WWF) were teaming up to address issues in the Impenetrable Crown Forest Reserve at Bwindi. The Bwindi forest was facing tremendous challenges, including damage to the vegetation and watershed. Those challenges were further complicated by the theft of fuel wood, timber, bamboo, and poles; illegal grazing; smuggling of cattle, lumber, and gold; agricultural encroachment; and poaching. This kind of illegal activity would not only impact the gorillas but also the habitat and many of the other animals within the forest. In 1986, the pressure was on to make the forest reserve into a national park. Tom Butynski would take the lead as the director of the newly formed Impenetrable Forest Conservation Project (IFCP). Butynski was a key player during this crucial period of development for research and conservation in the Bwindi forest. His efforts, and the studies that he and his staff published, would be an important part of the push for the forests at Bwindi and Mgahinga to be gazetted, eventually becoming national parks. After conducting a survey of the forest, its large animals and human activity, the establishment of a permanent research station in Bwindi was recommended. A research station was established at Ruhija in 1987, inside the northeastern boundary of the reserve. The IFCP would help three Ugandan students to receive their master's degrees in science as part of their work at this research station. The project staff would also publish twenty-five scientific papers adding much-needed information to the knowledge about the Bwindi forest, the gorillas, and the people living near them. The establishment of the IFCP and the research station at Ruhija would also help facilitate a very important partnership that reflected the new cross-disciplinary approach to conservation and development.

A close program of collaboration was established with CARE by the creation of the Development Through Conservation project (DTC). The DTC trained and placed fifty-five conservation extension assistants to function as a link between the local communities and the project providing conservation education and agroforestry information to the communities living around the park. Tree nurseries and wood lots were built to help reduce wood collecting inside the park. The project started to collect baseline data on the status and needs of the local communities and their agricultural practices around the forest. The thought process and approach to conservation in Uganda was expanding with new information and new ideas. The knowledge gained both by this collaboration and the experience with the MGP in Rwanda showed clear linkages between conservation, poverty alleviation, improved livelihoods, and education. It was time to turn this knowledge into action.

The Impenetrable Forest Conservation Project worked closely with national parks in the years after its inception to eliminate the illegal activities taking place within the Bwindi forest. Several dozen rangers and three wardens were assigned to work in

the forest. Over the next seven years, illegal activity in the forest, including the poaching of elephants and poaching-related incidents with gorillas would be significantly reduced. Although incidents of illegal activity and poaching still occur at some level, the work of the IFCP and its subsequent effects in reducing those activities came at a very critical time when intensive conservation and protection were very much needed in this Ugandan forest.

Despite all the progress with conservation practices in Uganda and Rwanda, there was still a huge gaping hole that was not being addressed. Although antipoaching patrols were expanded as part of the new programs in both forests, there was no solution for dealing with gorillas injured by the poachers' snares.

Dealing with Sick and Injured Gorillas

Poaching, one of the biggest threats facing mountain gorillas, can take the form of kidnapping, murdering other gorillas, usually in the course of kidnapping, or injuries and complications from being caught in snares. People enter the forest illegally to lay snares to capture bushbuck or duiker; rarely are snares set for gorillas. A gorilla moving through the forest might place its hand or foot in the snare and become entangled, with no means of escaping. Gorillas typically break snares to get away but are left with the snares encircling their hands or feet.

The pressure to make the forest reserve at Bwindi in Uganda a national park was on. In 1986, Tom Butynski would take the lead as the director of the Impenetrable Forest Conservation Project. Butynski was a key player during this crucial period of development for research and conservation in the Bwindi forest. His efforts, and the studies that he and his staff published, would be an important part of the push for the forests at Bwindi and Mgahinga to be gazetted and eventually become national parks. After conducting a survey of the forest, its large animals, and human activity, a recommendation was made to establish a permanent research station there, which was established at Ruhija in 1987 just inside the northeastern boundary of the reserve. Sikio is a member of the Kyagurilo group. This group is only visited by the researchers from Ruhija.

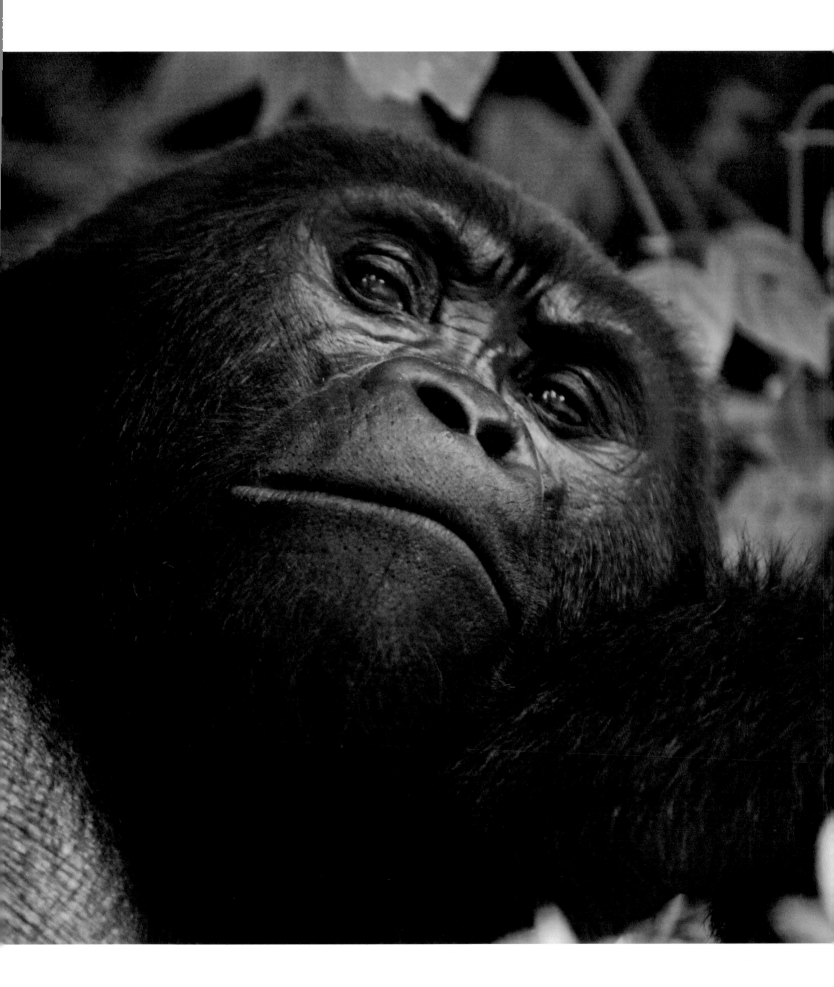

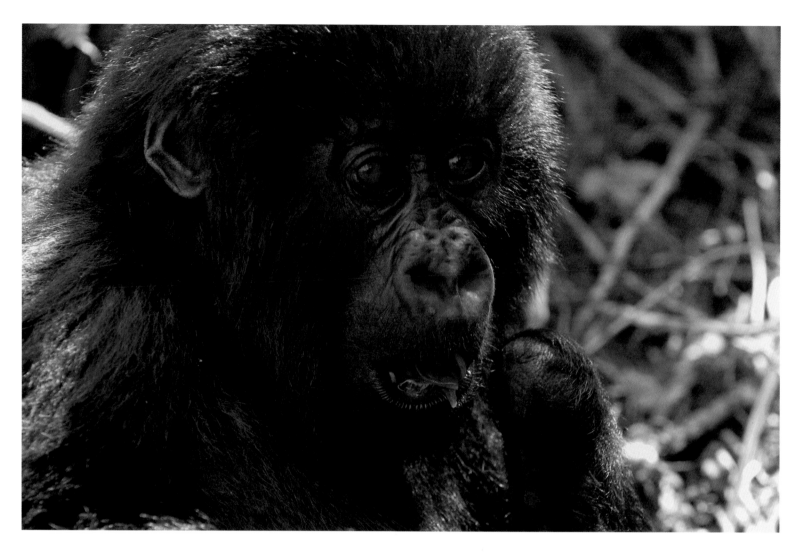

Many gorillas have suffered from snare injuries because of infection and have lost hands, feet, or digits. There are numerous accounts of gorillas dying, either because of injuries from snares that could not be removed or by not being treated for other types of problems. This issue has been a significant challenge historically in the fight to preserve and protect mountain gorillas from extinction. The need for veterinary intervention was clear and would make a huge difference in addressing this problem.

At the request of Dian Fossey, the Morris Animal Foundation (MAF) created the Mountain Gorilla Veterinary Project (MGVP) in 1986 to help deal with sick and injured gorillas. Fossey had solicited help from Ruth Keesling, daughter of Mark Morris, founder of the Morris Animal Foundation. With funding from MAF, the Volcano Veterinary Center was established by James Foster in Kinigi, Rwanda, in 1986, which later became the Mountain Gorilla Veterinary Project. The project proved to be a constant and an invaluable partner in the overall conservation equation. One more tool had been added to the conservation toolbox as there was now a capacity for dealing in the field with injuries resulting from poachers' snares and other human-caused problems.

One of the biggest problems facing mountain gorillas is the risk of poaching. Poaching can take different forms, one of which can result in complications from being caught in snares. Poachers enter the forest illegally to lay snares to capture bushbuck or duiker. Rarely are snares set for gorillas. Yet, they often encounter them as they move through the forest. Gorillas will typically break the snares to get away but are left with the snares encircling theirs hands or feet. Many gorillas have suffered from snare injuries because of infection or have lost hands, feet, or digits. Kalema, from Group 13 in Parc National des Volcans, Rwanda, has lost a hand.

MOUNTAIN GORILLA VETERINARY PROJECT

The primary functions of the Mountain Gorilla Veterinary Project (MGVP) are providing proper health care to the gorillas and conducting health-related research in support of the park authorities in Uganda, Rwanda, and the Democratic Republic of Congo. MGVP works in partnership with other nongovernmental organizations such as the Karisoke Research Center (researchers in the Virungas), the Max Planck Institute for Evolutionary Anthropology (researchers in Bwindi), the International Gorilla Conservation Program, and the three Protected Area Authorities. The MGVP provides highly specialized expertise and support to these organizations in all three countries of the mountain gorilla range. Providing vital care and intervention resources that were simply not available before their arrival, the level of cooperation between the MGVP and these organizations makes critical interventions possible when necessary and provides for the proactive health monitoring of the gorillas.

MGVP is regularly involved in treating snare wounds and skin and respiratory diseases and addresses a number of health problems affecting gorillas that are of human origin. They see mild injuries (cuts, wounds, etc.) about once a week. Illnesses such as respiratory problems (coughing, snotty noses, etc.) are seen every few months. Other illnesses (e.g., severe scratching, scabies, diarrhea) are seen much less often. Snare incidents are running around two to four per year in all four parks, but that number will likely go up as security and monitoring improve in the Democratic Republic of Congo and more incidents are detected. Since 2001, MGVP has done sixty-six gorilla treatments without immobilizations (e.g., given antibiotic or antiparasitic drugs via darts without anesthetizing gorillas), thirty-one full immobilizations of forty gorillas (six moms had babies that were worked on and/or partially sedated), and thirty-six necropsies/autopsies.

This photograph provided by Dr. Chris Whittier of an intervention with the Kwitonda group in the Democratic Republic of Congo shows the level of cooperation between organizations. *Clockwise from left,* Dr. Jacques Iyanya, Mountain Gorilla Veterinary Project (MGVP) field veterinarian for the Democratic Republic of Congo, takes a blood sample. Jean-Bosco Bizumuremyi from the Karisoke Research Center is sitting. Standing in green is Bararuha Evariste from Institut Congolais pour la Conservacion de la Nature. Standing center is François Bigirimana from Office Rwandaise du Tourisme et des Parcs Nationaux, Rwanda, one of the most experienced members of the intervention teams. Kneeling, *lower right,* is Dr. Innocent Rwego, MGVP field veterinarian for Uganda. Bending over is Dr. Jean-Felix Kinani, MGVP field veterinarian for Rwanda.

When gorilla immobilizations occur, the veterinarians are now allowed to collect biological samples, which could include blood, urine, feces, hair, biopsies, and culture swabs. This information is of enormous importance to further the understanding of the health status of gorillas in the wild like little Kalema from Group 13 in Rwanda. These samples are used in the physiological study of the mountain gorillas and in monitoring for disease or other potential health problems.

When it is determined that an intervention is necessary, the MGVP field veterinarians are engaged regularly enlisting the assistance of experienced Protected Area Authority guides, trackers, Karisoke staff, and national parks veterinarians or veterinary assistants. The policy for interventions and immobilizations state that veterinary intervention is only allowed when the identified problems are human induced or life threatening. An example would be an injury caused by a snare or a respiratory epidemic that has or could claim the life of a mountain gorilla. An animal will only be immobilized if there is a real risk that it will die or if its illness is caused by man. Any full immobilization carries with it a certain risk, so they are only done if absolutely necessary. In the event that an immobilization does occur, the veterinarians are now allowed to collect biological samples, which could include blood, urine, feces, hair, biopsies, and culture swabs. This information is of enormous importance to further understanding the health status of gorillas in the wild. These samples are used in the physiological study of the mountain gorillas and in monitoring for disease or other potential health problems. Samples are now being taken in duplicate so that one of the samples can be deposited at bio-banks being established by the park authority's veterinary services departments in addition to any analysis by other organizations abroad.

Although the work and published research of MGVP scientists is not as visible as other organizations, it is a critically important part of mountain gorilla conservation.

FELICIA NUTTER: *She Cares for Sick and Injured Gorillas*

FELICIA NUTTER was born in West Virginia in the United States. She grew up on a family farm surrounded by animals, mostly dogs, cats, chickens, and horses. Felicia remembers her mother telling her about a time when Felicia was just four years old and she informed her mother that she was going to be a veterinarian! Growing up in a farm environment with lots of woods around, there was a constant arrival of little orphaned wildlife with various broken things that needed fixing. Her mother had somewhat of a background as a kind of country doctor/nurse and would do her best to fix them up, but it didn't always work out. Felicia remembers always having a strong desire to fix them, knowing that there had to be somewhere to go to school and someone who could teach her how to fix them. Growing up in the golden age of *National Geographic* and Mutual of Omaha's *Wild Kingdom*, there were always people on TV that were out in the field and doing things with animals. The TV specials on Jane Goodall and Dian Fossey were a big part of her childhood. Felicia was inspired by these strong female role models, women who went out in the middle of Africa to study animals and made these incredible discoveries.

As fate would have it, Felicia didn't know it yet, but she was on a converging career path with another up-and-coming veterinarian named Chris Whittier. As it turned out, they both wanted the same job, Regional Field Veterinarian with the Mountain Gorilla Veterinary Project (MGVP) treating sick and injured mountain gorillas in the wild. Chris Whittier was returning from a trip working at the Jane Goodall Institute at Gombe in Tanzania. On his way back to the states, Chris ventured through Rwanda and met Dr. Liz Macfie, the MGVP field veterinarian at the time. Ironically enough, Felicia had also returned from Gombe after completing one of several working trips to the Jane Goodall Institute as a Consulting Veterinarian and a Fulbright Scholar. She had read about the open position with MGVP upon returning to the university in the United States. After returning to the United States, Chris applied to Tufts University School of Veterinary Medicine. One of the academic advisors at Tufts noticed that Chris had just returned from Tanzania and knew that Felicia had also just gotten back from Gombe as well. She told Felicia that she and Chris should talk, and they did. They talked so much they wound up married! Chris would ultimately return to Rwanda to work for the MGVP as a Regional Field Veterinarian and Felicia joined him there in the same capacity full time in 2002 where they have been fortunate enough to work together running the ground operations for the MGVP. In the course of her work with the MGVP, Felicia has published numerous articles and publications on various topics involving mountain gorillas and the health issues of people living near and working with mountain gorillas.

The role of Regional Field Veterinarian requires Felicia to wear many hats in addition to treating sick and injured gorillas. Her role as a field vet includes research, publication, revisiting and redefining operational protocols, functioning as a liaison between nongovernmental organizations and the Protected Area Authorities, and most importantly providing training for new Rwandan, Ugandan, and Congolese vets. Felicia strongly believes in the work of the Project training the next generation of local scientists and wants to help the MGVP country veterinarians more fully realize their potential as they become world-class wildlife veterinarians.

Felicia was profiled in 2005 in a book titled *Gorilla Doctors* (Houghton Mifflin). She and her husband, Dr. Chris Whittier, are based in Ruhengeri, Rwanda, and work with mountain gorillas in Uganda, Rwanda, and Democratic Republic of Congo.

In addition to helping deal with the threats of poaching, a central focus of the MGVP is better understanding the cross-transmission of diseases, another major threat to mountain gorillas. Much of the wildlife, especially the primates, are susceptible to human diseases. Diseases that can be transmitted from humans to gorillas include respiratory diseases (e.g., measles, tuberculosis, and influenza) and diseases contracted through fecal-oral or physical contact routes (e.g., shigellosis, hepatitis, herpes, scabies, intestinal worms, and polio). In 1988, they would face one of their biggest challenges when an unusually high number of gorillas displayed signs of a common infection, combined with an unusually high morbidity rate. Experts speculated that the viral outbreak could have been measles. After discussions with wildlife veterinarians from the United States, the United Kingdom, and Australia, a vaccination program and plan was presented to the Rwandan government. Once approved, the program was implemented beginning with a trial group in June 1988. Sixty-five gorillas were inoculated. Although the cause of this epidemic was unclear, there were no further signs of respiratory disease after the vaccination campaign, and the illness did not spread to other groups. Left untreated this one incident could have potentially wiped out the entire population.

The transmission of disease between gorillas and humans is real; it does happen, and it is as serious a threat to the future of the gorillas as any threat they face. The work of MGVP is fundamental in understanding how diseases can be cross-transmitted between gorillas and humans. The implications of that threat in regards to tourism, researchers, and all the other workers that come into daily contact with the gorillas are key inputs to conservation planning. This is also why the work of field veterinarians, medical support, and health monitoring for the mountain gorillas is such an important piece of the broader conservation equation.

When viewed from a historical perspective, addressing this need was part of the natural evolution in thought that was taking place in both forest environments. The benefits of a more comprehensive cross-disciplinary approach to conservation were becoming more and more obvious.

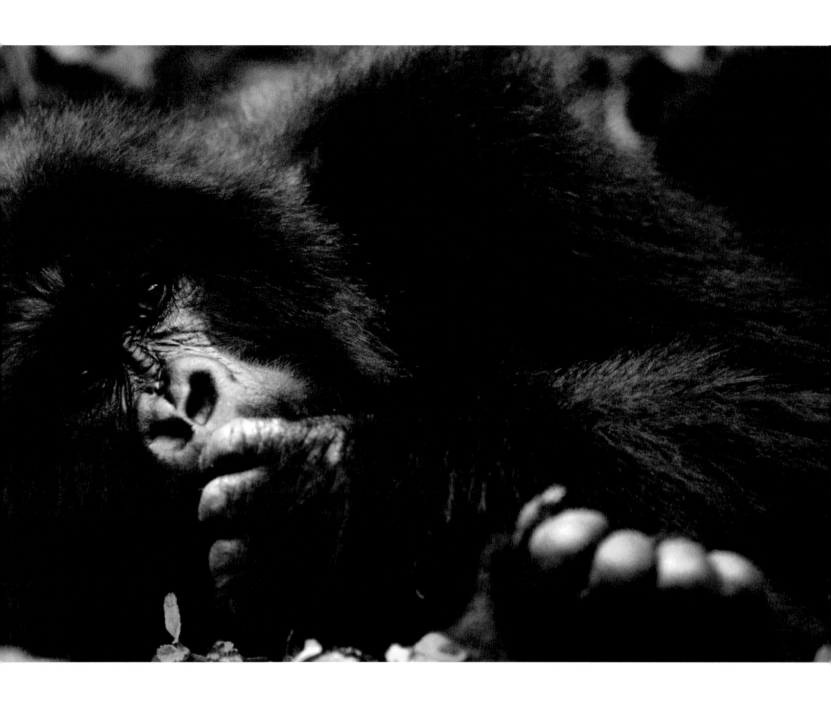

19 A NATURAL EVOLUTION TO A REGIONAL APPROACH

THE EARLY 1990s was a busy time for mountain gorilla conservation. Many threats had been abated or minimized while new ones had surfaced. The Mountain Gorilla Project (MGP) had been in existence for over a decade, making tremendous progress with their new programs; however, civil war was raging in Rwanda and the Virungas were crawling with members of the Rwandan Patriotic Front. Rwanda's tourism program grew phenomenally in the 1980s only to see the record numbers of tourists visiting the park spiral into oblivion because of the war. In Uganda, the Impenetrable Forest Conservation Project had made significant progress through their partnership with CARE in the Development Through Conservation project. The push for making the Impenetrable Forest Crown Reserve at Bwindi and the Gorilla Game Reserve at Mgahinga national parks was about to be realized.

So much had been learned in the previous decade about the context in which gorillas live and how that relates to conservation. As the scope of the research being done in all three countries expanded, the types of projects that the nongovernmental organizations were taking on and their role in those projects were expanding too. The level of collaboration between organizations and across borders was also increasing. As more information became available through research, an even greater and more sophisticated understanding of the threats facing mountain gorillas was emerging. By this point, it was generally accepted that the conservation of mountain gorillas and their habitat was tied directly to the condition of the people living near the parks. Applied research and development projects were beginning to address those needs, but it was time for a more regional approach that went beyond borders and transcended the traditional limitations of organizational boundaries. This was a time of fundamental change as a natural evolution in thought was occurring on many fronts within the region.

Previous page: Bikwi closely studies the visitors that have come to see the Susa group on this December morning in Parc National des Volcans, Rwanda.

In Rwanda, the Office Rwandaise du Tourisme et des Parcs Nationaux (ORTPN) had been growing and gaining strength as an institution. They were starting to take a stronger position and role in the management and ownership of their national park. The role of the park authorities in research, conservation, and the protection of the gorillas was changing as they took on more of the daily responsibilities on the ground. The partnerships between the park authorities, the NGOs, and the local communities were also evolving as the links between conservation of the gorillas and the daily lives of the people were better understood. Greater knowledge and understanding of the issues led to many collaborative projects that by their very nature required stronger partnerships between all stakeholders. It was time for ORTPN to take the lead.

A meeting to determine how to proceed with ORTPN was held in Nairobi with ORTPN and all the stakeholders in the MGP. Everyone agreed that ORTPN would take the lead, but ORTPN still wanted technical support and funding from MGP to assist them when needed with management strategies for the park. At the same time, the NGO coalition supporting MGP saw a clear need to take a broader focus on all three countries, which would include continued support for ORTPN. Timing is everything and this was a convergence of opportunities for the NGO community and the park authorities. ORTPN would step up and the MGP would ultimately evolve into another program, the International Gorilla Conservation Programme (IGCP).

By 1991, the MGP had naturally evolved into the IGCP with the formation of a formal coalition of several international conservation organizations. The IGCP formalized the existing collaboration between the three international conservation organizations and three Protected Area Authorities: the African Wildlife Foundation, Fauna & Flora International, and the World Wide Fund for Nature; the Institut Congolais pour la Conservacion de la Nature; the Office Rwandais de Tourisme et des Parcs Nationaux; and the Uganda Wildlife Authority.

With a desire to broaden the scope and operate regionally in the overall landscape, IGCP focused on critical conservation initiatives working with many different stakeholders. The park authorities had the mandate and the legal authority for action in all three countries making them strategic partners in any plan. Together, IGCP and the park authorities would work with members of the local communities, their leaders, the military, and the regional governments. All of these people and organizations had an impact on the forest and ultimately on the gorillas. With an expanded focus, the IGCP identified strategic objectives to support the goal of preserving the regional afro-montane habitats of the mountain gorillas.

First and foremost, there had to be effective and financially sustainable management of the forests. Everything that had been learned over the previous decade indicated that collaborative regional conservation efforts would be key to the effectiveness of ground operations. Widespread support for conservation of mountain

OFFICE RWANDAISE DU TOURISME ET DES PARCS NATIONAUX

The Office Rwandaise du Tourisme et des Parcs Nationaux (ORTPN) was created by presidential decree in June 1973 with responsibility for tourism and all of the national parks in Rwanda. The men and women of ORTPN are responsible for the work of protection day in and day out in Rwanda. This is also the organization from which you must acquire your permits for gorilla trekking in Rwanda. Permits can be purchased directly from ORTPN at their office in Kigali or Ruhengeri. The permits at the time of this writing are USD $500 each.

There are seven habituated groups currently being visited at this time by tourists in Rwanda: Susa, Amahoro, Sabyinyo, Umubano, Group 13, Hirwa, and Kwitonda (visiting from the Democratic Republic of Congo). Each gorilla group is allowed one group of visitors a day. That group consists of eight tourists (six for smaller groups of gorillas), one or two ORTPN guides, and one tracker. Other trackers, porters, and the military escort for security are part of the group but do not directly approach the gorillas within 200 meters.

The guides, most of the trackers, and most of the antipoaching patrols with the exception of the Karisoke Research Center staff, all work for ORTPN. The guides are very knowledgeable and, in most cases, have been working in the forest for years, some for more than twenty years. Their knowledge and experience of the forest is an enormous source of information for tourists.

In Rwanda, the Protected Area Authority is the Office Rwandaise du Tourisme et des Parcs Nationaux (ORTPN), which was created by presidential decree in June of 1973. ORTPN is responsible for tourism and all of the national parks in Rwanda. These are the people that are doing the work of protection day in and day out in Rwanda. The guides, most of the trackers, and most of the antipoaching patrols, with the exception of the Karisoke Research Center staff, work for ORTPN. The ORTPN park headquarters for Parc National des Volcans is located in Kinigi, Rwanda.

FRANÇOIS BIGIRIMANA: *His Commitment to Conservation Knows No Boundaries*

EVERY TIME A TOURIST COMES to Parc National de Volcans (PNV) to visit the mountain gorillas, they will be placed with an ORTPN national parks guide for the day. After spending all that money and traveling around the world to get there, that guide can make all the difference in a tourist's experience when visiting the gorillas and in the stories they tell when they go home. François Bigirimana has been one of those guides for almost thirty years, starting in 1980. François is one of the most popular guides in Rwanda and has guided literally tens of thousands of visitors and tourists over the years to see the gorillas, including prominent VIPs such as the President H. E. Paul Kagame of Rwanda, the King of Swaziland, Bill Gates, and many other visiting celebrities and dignitaries. Spending much time in the forest as a boy, François's knowledge of the forest began at an early age. When he first started working in PNV, François was assisting some of the researchers from the Karisoke Research Center and members of the MGP staff that had started the habituation process in Rwanda. François participated in the habituation of Group 13 and Group 9.

Because of the wealth of experience and dedication that François brings to any effort involving mountain gorillas, not to mention his comfort and lack of fear around gorillas, he is a critical component of the gorilla immobilization team and has been requested and has assisted in most of the immobilizations of sick and injured gorillas performed by the Mountain Gorilla Veterinary Project (MGVP), which includes immobilizations in all three countries of the range states. When asked about the many different tasks that he performs in his position as a national parks guide for ORTPN, François stated that it doesn't matter to him whether it's guiding tourists, training new guides, helping with immobilizations or participating in antipoaching patrols and Ranger Based Monitoring; as far as he is concerned, it's all about gorilla conservation. Even during the war when certain parts of PNV were a virtual no-man's land and François continued to work in the park, his comments about how difficult it was to work under those circumstances were simply, "No problem." His can-do attitude, which is shared by many of his colleagues, speaks of a commitment to mountain gorilla conservation that does not know political or organizational boundaries. It is that kind of attitude and collaboration that has helped to enable the mountain gorillas to survive through extremely challenging times and circumstances.

When asked about his very long tenure as a guide, François tells people that he still enjoys going into the forest every day and seeing the gorillas. Every day is different for him, and he plans to continue doing this as long as he is able.

INSTITUT CONGOLAIS POUR LA CONSERVACION DE LA NATURE

The Institut Congolais pour la Conservacion de la Nature (ICCN) is the Protected Area Authority for the Democratic Republic of Congo (DRC). Its origins began with the creation of Albert National Park in 1925, the first national park in Africa. It has undergone many name changes over the years, reflecting the complex changes in government and administration within the DRC. In 1934, in anticipation of new parks that were about to be created and that would have to be managed, the name was changed to the Institute of the National Parks of Belgian Congo. When the country became the République du Zaire in 1975, the organization again changed its name to the Zairean Institute for the Nature Conservation, and when the government changed the name of the country to the Democratic Republic of Congo in 1997, the Institute was renamed the Institut Congolais pour la Conservacion de la Nature, which is the name it continues to operate under today.

The Institut Congolais pour la Conservacion de la Nature is headquartered in Kinshasa, with a regional headquarters in Goma, North Kivu. From there, the park staff manage the entire Virunga National Park, spanning from the Ruwenzori Mountains in the north to Lake Kivu in the south. The park staff, like their counterparts in Rwanda and Uganda, manage the network of protected areas and the tourism programs in the national parks. There are three locations in the DRC where gorilla trekking is organized to start from: Djomba, Bikenge, and Bukima. There are currently six habituated groups in the DRC, one of which crossed over into Rwanda in October 2004 and has not returned since. The tourist groups that can be visited in the DRC are Mapuwa, Kabirizi, Kwitonda (now ranging in Rwanda), Rugendo, Humba, and Munyaga.

UGANDAN WILDLIFE AUTHORITY

The Ugandan Wildlife Authority (UWA) was created by the Uganda Wildlife Statute in 1996 as a result of merging the Uganda National Parks department and the Game Department. Governed by a board of trustees, the UWA has responsibility for the management of ten national parks, twelve wildlife reserves, fourteen wildlife sanctuaries, and provides guidance for five community wildlife areas spread across the country. Their mission is to conserve and manage the wildlife and protected areas of Uganda in a sustainable way by partnering with the neighboring communities and other stakeholders.

Like their counterparts in Rwanda, they are also responsible for the management of the parks that host the mountain gorillas and the tourism programs in Bwindi Impenetrable National Park and Mgahinga Gorilla National Park. There are four groups that are habituated for tourism in Bwindi Impenetrable National Park: Mubare, Habinyanja, Rushegura, which resulted from a split in the Habinyanja group, and Nkuringo, the newest

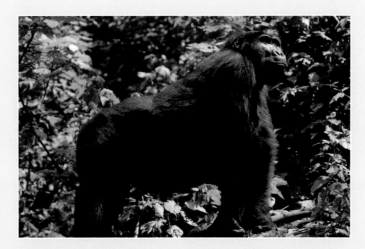

Four groups are habituated for tourism in Bwindi Impenetrable National Park (BINP), Mubare, Habinyanja, Rushegura, which resulted from a split in the Habinyanja group, and Nkuringo, the newest group. One group (Kyagurilo) is habituated and only accessed for research. Marembo, from the Kyagurilo group, is reserved for research only in Bwindi Impenetrable National Park, Uganda.

group. One group (the Kyagurilo group) is habituated and only accessed for research. In Mgahinga Gorilla National Park, there is one group (the Nyakagezi group) habituated for tourism and no groups for research. As recently as 2006, the Nyakagezi group had wandered over to the Rwandan side of the border where they have been monitored but not visited by tourists. Eight people are permitted per group per day to visit the gorillas in Bwindi and Mgahinga. The limit was increased to eight as in Rwanda and the Democratic Republic of Congo, but it was done against the advice of conservationists.

gorillas and the forests among interest groups and the public was needed to generate funding but also for the programs to be embraced. One key difference at this juncture was to have a core focus on the development of compatible policy and legislation supportive of the conservation of mountain gorillas and forests in each country.

Expanding the Focus

At the same time that the MGP was expanding their focus as the IGCP, the Impenetrable Forest Conservation Project was evolving too. In Uganda, the Impenetrable Forest Conservation Project was now the Institute for Tropical Forest Conservation (ITFC), with Tom Butynski continuing on as its first director. The ITFC functioned as a research institute of the Mbarara University of Science and Technology and as a base of operations for visiting scientists, similar to the Karisoke Research Center on the Rwandan side of the Virungas. This was an important time in the development of conservation at Bwindi. As the forest became a national park, many changes were occurring that would impact the forest, the gorillas, and the people living near them for years to come. The ITFC expanded its focus beyond mountain gorillas to include the systematic inventory of fauna and flora and the initiation of conservation programs. This led to a new dynamic in the relationship between the conservationists and the Ugandan Wildlife Authority. Armed with new information from applied research and ecological monitoring, the ITFC was now well positioned to advise Uganda National Parks as they were making management decisions regarding the park. Those decisions would in turn affect the gorillas and the people living near the park.

What was being discovered as a result of the collaboration between stakeholders is that many of the operational issues being faced in one country existed to one extent or another in all three countries. By encouraging a high level of cooperation and collaboration among the all of the affected parties in each country, several benefits were realized. Our knowledge and the broader understanding of the common issues were greatly expanding. That knowledge could then be leveraged by sharing and pooling resources so they could be used in a more organized fashion, yielding greater benefits. With the strength, synergy, and increased knowledge that come from collaboration, an intense focus could be applied to action in ways that would make a meaningful difference for the people most in need.

A strong emphasis was placed on capacity building. The operational capacity of national and local authorities in addition to the local stakeholders would be vital to the long-term sustainability of conservation and protection. For the local communities in all three countries, capacity building would be key to the development of livelihood strategies that were compatible with conservation objectives. There was a huge need to provide economic alternatives to subsistence farmers living around the forests.

One way of achieving this involved initiating the development of sustainable and controlled gorilla tourism in Uganda. Tourism had shown real benefits in the past

Opposite: If there was ever a question about whether gorillas climb trees, Rukina, the silverback from the Kyagurilo group in Bwindi would remove all doubt. Something that would no doubt only be seen in Bwindi Impenetrable National Park in Uganda. A large silverback weighing more than 300 pounds nibbles fruit from the branches high up in a tree.

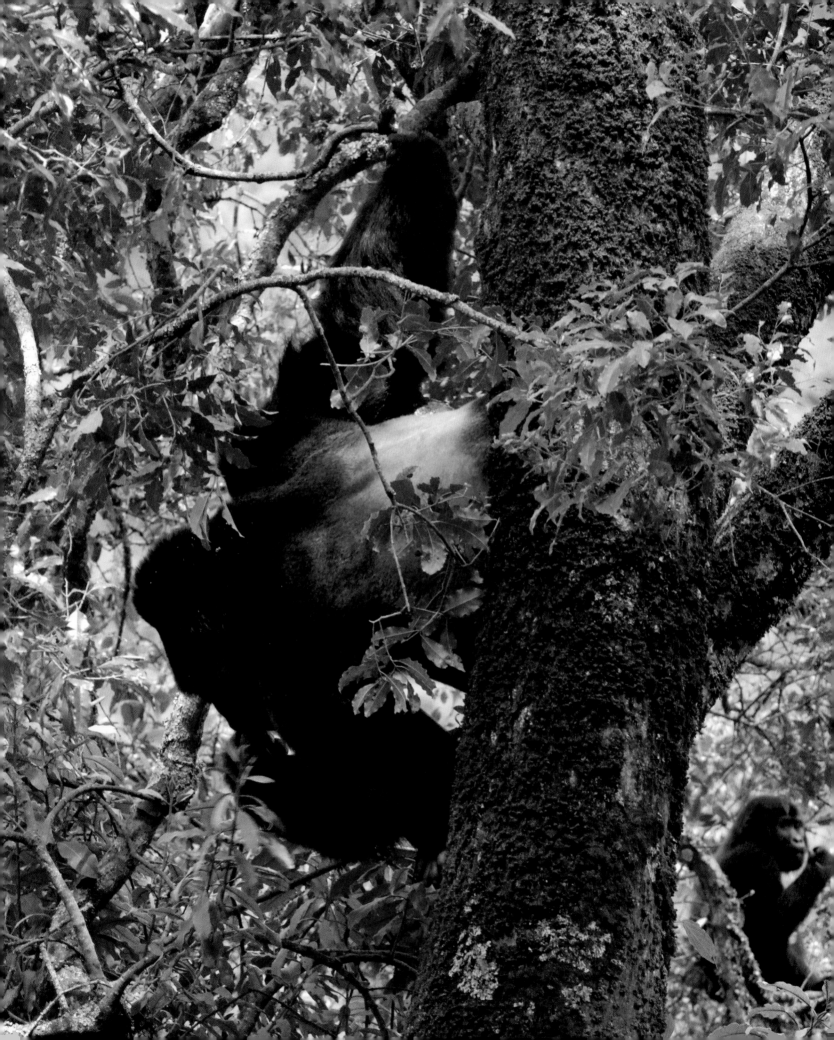

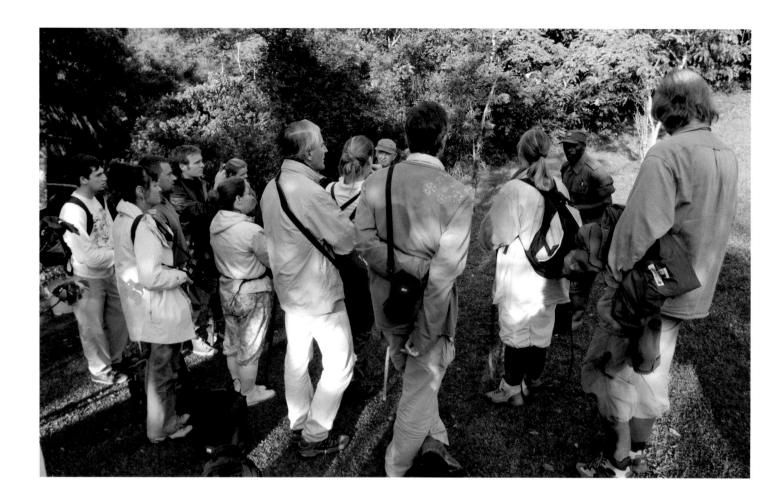

for Rwanda and the push was on for tourism to be developed in Bwindi Impenetrable National Park. The Impenetrable Forest Conservation Project had identified gorilla groups to be targeted for habituation and tourism. IGCP started working with the Ugandan Game Department's rangers to begin the habituation process in 1991. The first group to be habituated was the Mubare group. By working closely with the park authorities in Bwindi, the park was opened for non-gorilla tourism in January 1993, and the first gorilla visits were to the Mubare group in April of the same year. Another group called the Kyagurilo group was also habituated and used as a research group by the ITFC, the Max Planck Institute for Evolutionary Anthropology, and other visiting scientists.

The tourism programs would continue to be strengthened and supported in Uganda, Rwanda, and the Democratic Republic of Congo. To ensure that tourism served as a tool for conservation and was controlled effectively, NGOs such as the International Gorilla Conservation Programme, the Institute for Tropical Forest Conservation, and others worked with the three park authorities to develop ecological, socioeconomic, and law enforcement monitoring throughout the entire mountain gorilla range (Virunga and Bwindi populations). These efforts were supported by joint training programs at a national and regional level. The partnership between the NGOs and the park authorities to develop tourism had been effective in creating perpetual rev-

One of the results of the Impenetrable Forest Conservation Project surveys in the early 1990s was the identification of gorilla groups to be targeted for habituation and tourism. Bwindi Impenetrable National Park was created in August 1991, and habituation of two gorilla groups began soon after. Tourism had shown real benefits in the past for Rwanda, and the push was on for tourism to be developed in Bwindi Impenetrable National Park (BINP). Tourism programs in the BINP began in April 1993. These tourists in 2006 are receiving the morning briefing before gorilla trekking at park headquarters in Buhoma, Bwindi Impenetrable National Park, Uganda.

enue streams in all three countries. Some of that money was used to support the work of the park authorities, and some would be channeled back into community development projects to better share the benefits of tourism with the people most impacted by it. The idea of combining conservation and development activities began in the 1980s. In the 1990s, the fruits of those efforts had started to grow.

The ITFC continued the work that had begun in the 1980s with CARE in the Development Through Conservation (DTC) project. By researching the economic needs of the communities surrounding the park over time, this long-term project would provide valuable information and insight into the effectiveness of combining conservation and development efforts. The lessons learned fueled much of the change occurring in Uganda and contributed to changing perspectives in Rwanda and the Democratic Republic of Congo. Additional projects were developed because of what was being learned from the DTC project in Uganda and the applied research being done in Rwanda.

Looking Back

From a historical perspective, the evolution in thought was clear. The absence of knowledge drove the original projects. George Schaller's work with the African Primate Expedition was pure research and provided the baseline by which all future scientific work with mountain gorillas would be measured and evaluated. Although much more has been learned about mountain gorillas over the past forty years, scientists today are amazed about how much Schaller got right with just one year of study and observation. The Karisoke Research Center would continue the legacy of research and establish one of the longest-running primate studies in the world. The continuing work of Karisoke and the Digit Fund led to a better understanding of what the issues threatening gorillas were. It became evident that to protect gorillas the needs of the people had to be addressed, which led to the creation of the Mountain Gorilla Project. The school of thought had moved from doing pure research toward threat abatement to understanding the context in which the gorillas live and trying to make that context supportive of the gorillas' survival. That knowledge in turn led to an understanding that Uganda and the Democratic Republic of Congo needed to be a part of the overall strategy, which included regional needs like veterinary services to care for sick and injured gorillas. All of this fueled the creation of the Impenetrable Forest Conservation Project, the Mountain Gorilla Veterinary Project, the creation of the national parks in Uganda, and the establishment of gorilla tourism in Bwindi. Understanding the regional context to the problems led to the fully regional programs involving conservation organizations like MGVP and IGCP with a focus on the park authorities. Mountain gorilla conservation had not only evolved but had weathered the storms of encroachment, poaching, war, and conflict. The seeds of hope and change that had been planted for thirty years across the region were bearing fruit and the promise of the future.

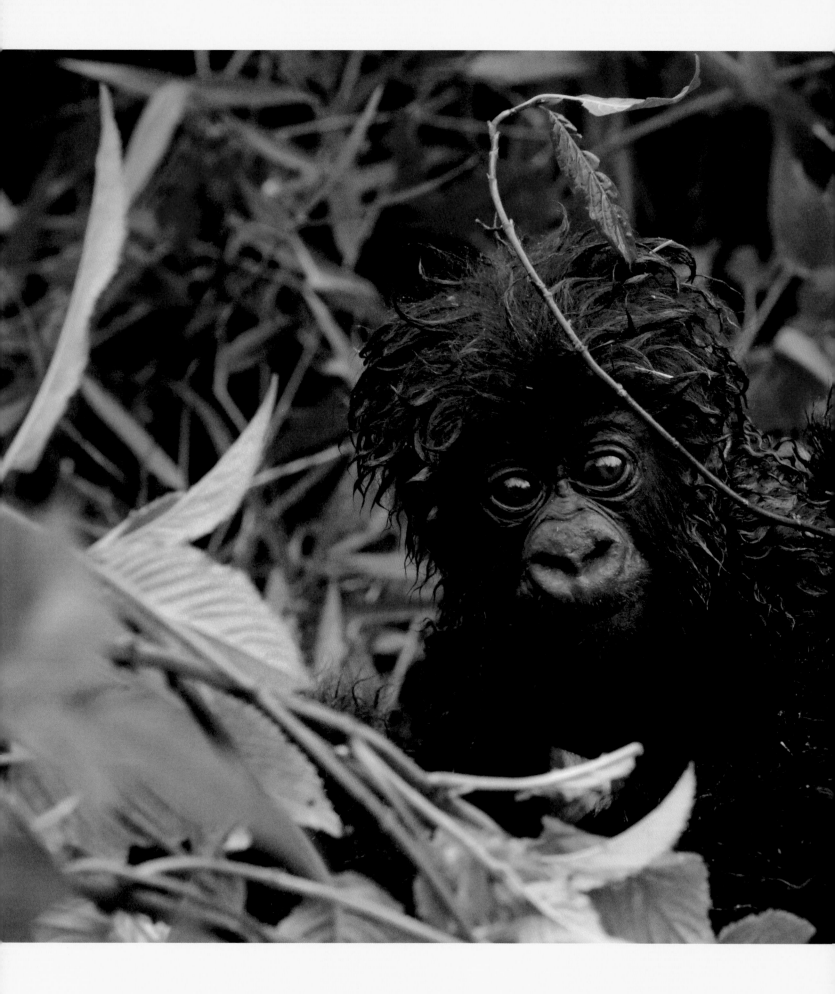

20

PARTNERS IN CONSERVATION— BUILDING FOR THE FUTURE

AS WE HAVE WATCHED the mountain gorilla conservation movement grow and evolve, we've learned that one of the most important dynamics in mountain gorilla conservation is the importance of the roles that the nongovernmental organizations (NGOs), the park authorities, and the community play as partners in conservation. The park authorities are charged with the protection and conservation of the parks and the gorillas. Nothing can happen in the forest without their involvement and support. The NGOs bring technical expertise and much-needed funds to the table. Their work in research and development provide the critical information that is often the impetus for many programs. The local communities who bear the greatest costs of conservation have a vested interest in the development of solutions to their problems. It is when all of these players come together as partners that they can make the collective difference at the end of the day. In this chapter, we examine some specific examples of how these partnerships benefit conservation and the people that are most impacted by it.

Research to Support the Park Authorities

We have learned from the past that research is the means through which greater knowledge and understanding are achieved. Research gave us our basic understanding of gorillas and how they live. Research helped us understand the connection between the gorillas and the people who live near the edge of the forest, and it is research that continues to help shape the management strategies of the parks and their wildlife, including mountain gorillas.

Through programs like the ITFC's Ecological Monitoring Program (EMP) in

Previous page: Young Urumuli from Group 13 emerges after a rain. Rain has a wonderful effect on the babies' hair, making it stand out in all directions. Parc National des Volcans, Rwanda.

DENNIS BABAASA is the coordinator for the Ecological Monitoring Program (EMP) that is managed by the Institute for Tropical Forest Conservation (ITFC). Born in the Kabale district of Uganda, Dennis works at the Ruhija-based Research Institute located in the northeast sector of the Bwindi Impenetrable National Park (BINP) in Uganda. Currently employed by the ITFC, Dennis is one of those people who has worked and contributed quietly in the background for years. After coming to Bwindi in 1989, his first job was working as a biologist for the Game Department of Uganda. There was a strong push to gazette the Bwindi forest and make it a national park. This effort was being led by the Impenetrable Forest Conservation Project, the organization that would evolve into the ITFC.

Dennis earned his bachelor's degree in zoology and botany from Makerere University located in Kampala, the capital of Uganda. He continued his studies obtaining his master's degree in zoology, specializing in wildlife management, which would bring him back to Bwindi to do his research for his master's. He then went back to work for the Game Department prior to that organization's evolution into the Ugandan Wildlife Authority (UWA). At the time, he was part of the team that was surveying all of the protected areas in Uganda to assess their status and levels of human encroachment before being taken over by UWA. When UWA took over the Game Department, Dennis went to work for the ITFC in 1998 and has worked for ITFC for the past eight years.

As part of his work with the EMP, Dennis is the lead on a project using aerial photographs, satellite images and Geographic Information Systems (GIS) data to produce a vegetation map of

the Bwindi forest at this time. Once the map is complete, it can be used for a baseline for virtually any study. With this map as a tool, researchers and conservation planners could eventually map things like presence or absence of groups of gorillas and then correlate that with their environment. This would help us understand in detail the impacts of factors like the level of human activities, the location of favored food plants and other habitat requirements on gorilla behavior and population size and ultimately determine if there is room for the population to grow. The types of analysis made possible by tools and monitoring programs like the EMP are key inputs to conservation planning. People like Dennis Babaasa are a vital part of making those programs work and making that data analysis possible.

Uganda, scientists take a broader look at what is happening in the ecosystem through careful monitoring. The EMP monitors things like slow growth and high demand plants that are vulnerable to overexploitation in multiple use zones. That information helps guide management decisions regarding the multiple use zones so that the access to resources in these areas can be managed in a sustainable way. By looking at things like the invertebrates in the rivers that are sensitive to changes in water quality, they can tell what is going on in the catchment. For example, sites on rivers that are in areas disturbed by past logging, mining, and agricultural encroachment have water that is not transparent compared to water in areas that are not disturbed. Sites in disturbed areas will have a lower diversity of water invertebrates,

while sites with many different water invertebrates indicate a "healthy" forest. Comparing sites with different disturbance histories shows differences that reflect the state of forest recovery. Therefore, when scientists understand the dynamics of what is happening in river water, they can then advise park authorities about corrective actions. In the areas that have been encroached, they can accelerate restoration plans and efforts as necessary. By partnering with the Institute for Tropical Forest Conservation (ITFC) and leveraging information from the Ecological Monitoring Program, the park authorities can proactively implement policy in and around the forest.

Likewise, the Max Planck Institute for Evolutionary Anthropology conducts the long-term research on the gorillas in Bwindi and the Dian Fossey Gorilla Fund International (DFGF-I) conducts the long-term research at the Karisoke Research Center in Parc National des Volcans in Rwanda. These organizations provide additional data that are crucial to the management and planning processes of the three park authorities. The long-term monitoring of known individual gorillas provides useful information for understanding normal patterns of behavior, life history dynamics such as how often females have babies, patterns of growth and mortality, and patterns of how social groups may change over time. The information gained from these long-term studies changed our understanding of mountain gorillas in the 1970s, again in the 1980s, and in the 1990s and will continue to change our understanding into the twenty-first century. This information and other monitoring tools such as the Ranger Based Monitoring Program developed by the International Gorilla Conservation Programme (IGCP) provide information on gorilla groups not monitored by researchers. That information helps park staff to make more informed decisions regarding day-to-day management of the parks in all three countries.

RANGER BASED MONITORING

The Ranger Based Monitoring Program (RBM) was created in response to a need for more information about the demographics and ranging patterns of the tourist groups of gorillas. There was also a need to better understand the nature of illegal activities within the park. The program is a tool for ecosystem surveillance and management of those ecosystems by park staff. Although a tremendous amount of information was available on the research groups of gorillas monitored by the Karisoke staff, little was known about most of the gorillas ranging throughout the forests. Very little information about those groups was available for management of the forest by park staff. The International Gorilla Conservation Programme worked with the park authorities in Uganda, Rwanda, and the Democratic Republic of Congo (Uganda Wildlife Authority, Office Rwandaise du Tourisme et des Parcs Nationaux, Institut Congolais pour la Conservation de la Nature) and developed a set of protocols for collecting data using low-tech methods that could be used by park staff conducting daily patrols. This data would then help guide the authorities in their management strategies for the parks.

Relying heavily on the presence of the park staff in the forest, data collection using the RBM techniques started in 1997 in the Democratic Republic of Congo and was quickly followed up in Uganda in 1998 and Rwanda in 1999. Currently, between the tourist groups and the research groups in Rwanda and Uganda, sixteen habituated gorilla groups are being monitored under the RBM program. Each animal in every group is identified individually and photographed along with records of nose prints and any other distinguishing physical characteristics. Given that an estimated 70 percent of the mountain gorilla population is habituated in either tourist groups or research groups, the information provided by the RBM program is vital to understanding the population dynamics of the habituated gorillas. That information in turn is important comparatively in understanding the dynamics of the unhabituated groups of gorillas. In 2000, the information from RBM was used in the Virunga census effort where actual counts from the field could not be obtained because of security problems within the park. Based on information gained from the full census conducted in 2003, the information on gorilla distribution and numbers gathered from RBM did not vary significantly from that of the actual census conducted one year later, when the situation had stabilized. RBM continues to be an effective and essential tool for conservation and management practices in all three countries.

One of the biggest challenges for mountain gorilla conservation has been gaining the support of the people living near the parks. The attitudes of the people toward the gorillas, the parks, and the park authorities can make the difference between success and failure for some programs. Involving the community in the planning and development of solutions fosters a sense of community ownership. It also supports the perception that the park authorities care about the problems conservation and protected areas present for people living on the park boundaries. An immediate local concern is crop raiding.

The problems associated with crop raiding go beyond the financial or food loss to the farmers. Crop raiding increases the risk for cross transmission of disease between humans and gorillas because of their prolonged contact during these incidents. People could be hurt by animals and the animals could also be in danger of being killed or physically harmed by angry farmers, making the safety of both people and the mountain gorillas a paramount concern. Understanding the impact that crop raiding and human/animal conflict has on people in all three countries, the park authorities had to find solutions the local communities would embrace.

In some instances, countermeasures such as the buffalo wall in the Virungas have been very effective. Buffalo were causing lots of problems in all three countries. CARE conceived of and built a wall to contain them within the park in Mgahinga. They worked closely with the park authorities and the local communities to develop a plan that would be effective. A plan was devised that would use existing natural resources for building materials and community involvement for labor to build and maintain the wall.

The buffalo wall is a simple construction of volcanic rocks collected from the area around the park to form a barrier approximately 1.5 meters high and 1 meter wide. The wall would later be extended around most of the forest in Rwanda and the Democratic Republic of Congo by IGCP, the Frankfurt Zoological Society, Office Rwandaise du Tourisme et des Parcs Nationaux (ORTPN), and Institut Congolais pour la Conservacion de la Nature. Although the wall was originally intended to keep the wild buffalo in the park to prevent them from venturing into the farmers' gardens, a secondary benefit of the wall has been its function as a semipermanent demarcation of the park boundary, making natural encroachment difficult and less likely to occur. The wall was very effective with buffalo in the Virungas, but it would not stop a gorilla or other primate from leaving the forest. Alternative measures would be needed to deal with gorillas.

The HuGo program (Human Gorilla Conflict Program) in Uganda was another approach to the problems of human/animal conflict that would require the partnership between the conservationists and the communities to be successful. Originally created in 1998, the program has been expanded to include forty-two gorilla monitoring

In 1998, a workshop was held in Uganda with key stakeholders to discuss the problems that people living around Bwindi Impenetrable National Park (BINP) were suffering because of crop raiding from wild animals. Small forest patches outside the park boundaries and the growing of crops like bananas could easily attract gorillas outside the park for a tasty meal. The local people whose crops were being raided felt they should be compensated because of the money the government was making from gorilla tourism. Compensation programs had been implemented, but they were plagued with a variety of issues and ultimately failed as a response to the problem. Another solution was needed.

Responding to the collapse of the compensation scheme, the International Gorilla Conservation Programme (IGCP) worked in coordination with the Ugandan Wildlife Authority (UWA) and the local communities to develop the HuGo program (Human Gorilla Conflict Program). As a result of the workshop, several solutions were proposed, including options for education, chasing the

Members of the International Gorilla Conservation Programme staff meet with a Human Gorilla Conflict Program (HuGo) team member at Nkuringo near the edge of Bwindi Impenetrable National Park (BINP), Uganda. The HuGo program instituted pilot programs for several solutions to human/animal conflict in Uganda and in the Democratic Republic of Congo. In Rwanda, crop raiding by gorillas is much less frequently a problem. In September 1998, the implementation of these programs began in Uganda by creating Gorilla Monitoring and Response Teams in two parishes surrounding BINP. These teams are trained to follow gorillas when they wander outside of the park boundaries and to gently chase them out of the fields and back into the forest by ringing bells, whistling, shouting, and herding. The development of this program required cooperation between the local communities, the Uganda Wildlife Authority, and nongovernmental organizations.

animals away, creating a "problem animal levy," hiring gorilla monitor response teams, and purchasing land on the edge of the forest to create a buffer zone. The HuGo program instituted pilot programs for several of these solutions in Uganda and in Democratic Republic of Congo.

The implementation of these programs began in Uganda by creating Gorilla Monitoring and Response Teams (GMRTs) in two parishes surrounding BINP. The GMRTs were selected by the local communities because of their responsibility, personal character, and commitment to developing a solution to the problem. By design, these teams were trained to follow gorillas when they wander outside of the park boundaries and gently chase them out of the fields and back into the forest using a variety of methods like ringing bells, whistling, shouting, and herding. The UWA and the IGCP worked together to provide equipment, including rain gear, boots, machetes (pangas), and Global Positioning System devices to make the work of the GMRTs more effective and comfortable. UWA also provided food rations to the GMRTs whenever they were actively on duty. Keeping the gorilla monitoring and response teams motivated and their morale high was paramount to the success of the program.

An incentive was created to help compensate the all-volunteer GMRTs for the time spent away, preventing them from working their own fields. Four hundred thousand Ugandan shillings in grants were provided to each of the GMRT members to be used for business ventures. Many members used this grant money to purchase sheep, goats, pigs, or cattle, which not only provided food for their families but also provided a means of perpetually generating income or increased wealth. The HuGo program continues today as part of the broader conservation strategy, including the Virungas.

Left, A man weaves Mauritius thorn in the buffer zone at the edge of Bwindi Impenetrable National Park, Uganda. *Right*, Growing strands of Mauritius thorn hedges and weaving them together creates a physical barrier animals cannot penetrate. Ecological deterrents and the removal of palatable exotic plants from the buffer zone may help to impede crop-raiding animals near the boundaries of the park. Nkuringo, at the edge of Bwindi Impenetrable National Park, Uganda.

and response teams in nine villages surrounding BINP. These community players come together biannually in meetings facilitated by IGCP and the Ugandan Wildlife Authority to share information about their work, to discuss the challenges they face, and to strategize about the best practices for moving forward in the next six months. The HuGo program involved several strategies for dealing with crop raiding. One of those solutions near Nkuringo in the Nteko parish involved purchasing land on the park's edge to create a buffer zone as a pilot project.

The Nkuringo buffer zone is a piece of land 350 meters wide that stretches along 12 kilometers of the park boundary in the Nteko parish. The width of the buffer zone is divided into two sections. The first stretch, which is approximately 200 meters

wide (2.4 km²), is the part directly bordering the park boundary that will remain intact and be allowed to regenerate. The second part, which is approximately 150 meters wide (1.8 km²), is designed to be used by the communities to grow crops unpalatable to gorillas and other problem animals. One such crop is *Artemisia annua*, an annual crop cultivated for one of the active ingredients used to manufacture antimalarial drugs. Special varieties of wheat not eaten by birds are also being tried as well. The crops' effectiveness as a deterrent is still being assessed by the Institute for Tropical Forest Conservation. This program is designed to serve two purposes; first to provide an ecological deterrent for crop-raiding animals and, second, to use those deterrent crops and activities to generate income or produce for the families and communities that are required to invest themselves in the maintenance of the buffer zone.

These approaches are combined with techniques such as growing strands of Mauritius thorn hedges to create physical barriers. The ecological deterrents and the removal of the exotic plants favored by gorillas from the buffer zone should offer the greatest chances of success in dealing with the problems created by crop-raiding animals in these areas.

The technical expertise of the NGOs makes a huge difference as they partner with local communities and park authorities to develop creative, ecofriendly solutions to problems like crop raiding. Helping to develop that technical knowledge and capacity is a core focus for many of the NGOs in their role as partners in conservation.

Capacity Building through Education and Training

Capacity building by the NGOs through education and training takes three forms when it comes to mountain gorilla conservation: (1) the development of the national parks staff; (2) the training and development of young scientists that will support the park authorities through their research; (3) work with the local communities to help develop their capacity to manage the land sustainably, while benefiting economically from conservation.

Many organizations will collaborate to generate both funds and support for their training programs by pooling their resources and expertise. For example, the joint training of the national parks guides, antipoaching patrols, and Ranger Based Monitoring rangers supported by IGCP, DFGFI, and MGVP. This partnership has been in place for years and has proven to be very effective in further developing the capacity of the park authorities to constantly improve their management techniques and strategies for the parks. By providing this training, young people are empowered to move into the roles of leadership as they look toward the future.

The Karisoke Research Center (KRC) and the IGCP currently conduct training courses on the biodiversity and conservation of the Parc National des Volcans for the Rwandan national parks guides and trackers. The purpose of this training is

Dr. Chris Whittier (*left*) supervises staff members of the Mountain Gorilla Veterinary Project (MGVP), Karisoke Research Center, and Office Rwandaise du Tourisme et des Parcs Nationaux during an autopsy of a golden monkey. As regional field veterinarian for MGVP, Dr. Whittier trains the veterinary staff. MGVP lab in Ruhengeri, Rwanda.

to ensure that the tourist guides and other park staff are kept current with relevant information and the latest research on the park's flora and fauna. The training includes field and classroom exercises and covers detailed information on the behavior of gorillas and golden monkeys. With the addition of several scientists to the Karisoke staff specializing in botany and ornithology, detailed courses are planned on birds and plants. Supporting the growth and development of scientists that can continue to provide training for the park authorities is vital for future generations in both protected areas.

Working closely with the National University at Butare, KRC has developed a program to recruit and train Rwandan scientists. When the current director took her position, only two scientists were working at KRC, Katie Fawcett (Director of the KRC) and Prosper Uwingeli who has since become the Research Warden for ORTPN. The staff at Karisoke has now been expanded and has five additional Rwandan scientists in different specialties and an ever-growing group of students working in internships in the office and in the park. The addition of these scientists has expanded both the research and training capacity of KRC to include botany, ornithology, and

ELISABETH NYIRAKARAGIRE was born in Kinigi, Rwanda, near the park headquarters for Parc National des Volcans (PNV). She continues to live and work there to this day. In her role as a Veterinary Warden for the Office Rwandaise du Tourisme et des Parcs Nationaux (ORTPN), Elisabeth is in the forest working with mountain gorillas in Rwanda most days. She also participates at times in other veterinary activities in support of her colleagues in Uganda and the Democratic Republic of Congo as well. Elisabeth was trained at the Veterinary Training Center of Rubilizi in Rwanda and is one of a very few women working in a field position in ORTPN. She worked in PNV for seven years prior to the war. Daily operations for veterinary staff were shut down for several years during the war due to high levels of insecurity in the park. It was during the war years from 1991 to 1993 that Elisabeth went to Cameroon to complete her training at Garoua, a specialty school with a focus on fauna and flora. She was finally able to return to work in 1999.

Working in partnership with the Mountain Gorilla Veterinary Project, the MGVP Regional Field Veterinarians have given Elisabeth additional training in data collection techniques for the field, gorilla anesthesia and monitoring, and postmortem examination techniques at the MGVP lab in Ruhengeri. Elisabeth is part of the MGVP-led intervention team that performs immobilizations of sick and injured gorillas in the field. Highly committed to her work in PNV, the years of experience that Elisabeth has on the ground working with gorillas brings with it a sizeable, long-running experience and knowledge base, earning her the respect of her colleagues and peers. Elisabeth has worked for ORTPN since 1987. Many members of the veterinary staff in all three countries and within MGVP have worked on the ground for several years but very few have remained to provide this most critical service for more than a decade. Elisabeth wants to go to Makerere University in Uganda to continue her studies and complete a doctorate in veterinary medicine.

golden monkeys. The training of Rwandan scientists is intended to build capacity within the national scientific community and make the center's data available to a broader audience. The goal is to ultimately make the Karisoke Research Center a Rwandan research center enabling Rwandan scientists to participate in the scientific community at an international level.

The same type of training is taking place in Uganda where the ITFC is also heavily invested in the development of young Ugandan scientists and researchers. In addition to the fieldwork that students are allowed to conduct at Ruhija, the ITFC has supported approximately twenty-five students in gaining their master's degrees in science. Several of their PhD candidates have gone on to occupy key positions in conservation throughout Uganda.

The MGVP regional field veterinarians work closely with the field veterinarians in all three countries, providing training for complex operations like immobilizations, field surgical techniques, data collection, and health monitoring. In a region where

JOHN BOSCO NIZEYI: *Training Future Generations of Veterinarians*

JOHN BOSCO NIZEYI is a Ugandan veterinarian based in Kampala, Uganda. John is the Uganda Coordinator for the Mountain Gorilla Veterinary Project (MGVP). He is also a member of the faculty of Veterinary Medicine at Makerere University in Kampala. Having received his Bachelor of Veterinary Medicine from Makerere University in 1988, John Bosco went to work for MGVP and the Office of Rwandaise du Tourisme et des Parcs Nationaux (ORTPN) the following year in 1989. In the early 1990s, he came to the United States to further his studies by earning a Master of Science degree specializing in Recreational Resources and Protected Areas Management from Colorado State University. After returning from the United States, John Bosco went back to work for MGVP in 1996 and continues to work with them to this day, making him the longest-serving staff member for the project. John Bosco or "JBN," as he is often referred to, earned his PhD in Veterinary Medicine from Makerere University and is currently an Honorary Lecturer with the Department of Wildlife and Animal Resources Management at the same university. Dr. Nizeyi has been a joint author for numerous published papers on subjects ranging from fecal bacterial and parasite studies to infections in habitats of free-ranging human-habituated gorillas. Every year he takes a couple of students into the field for specialized training in wildlife management, the collecting of biological samples, and the immobilization of wild animals.

John Bosco feels that the work that they are doing with the Makerere University training the young Ugandan veterinarians is a fulfillment of the dream and vision of Dr. James Foster (the first veterinarian at the Volcano Veterinary Center, which would become the Mountain Gorilla Veterinary Project when the MGVP was started in 1986). Part of MGVP's mission has always been to assist in building and supporting the capacity of the local country veterinarians to provide world-class health care for mountain gorillas. John Bosco's work with the MGVP and Makerere University helps to fulfill that dream and vision in Uganda as they continue to train the next generations of young scientists.

most veterinary training is focused on livestock, the highly specialized training provided by the MGVP is key to developing the capacity to care for sick and injured gorillas. The training is not only done in the field but also in the laboratory in Ruhengeri where MGVP veterinarians and national parks staff perform analysis of biological samples taken from the field, necropsies, and other procedures.

The country field veterinarians also receive training abroad and have participated in a six-week intensive training session in the United States. John Bosco Nizeyi, a veterinarian employed by MGVP in Uganda, also serves as a professor at Makerere University in Kampala. Nizeyi was the first Rwandan field veterinarian for the MGVP, and he is now training new students in veterinary medicine who represent the future of health care for the gorillas.

By providing scholarships for some of the wardens and support for students, these NGOs are committed to reinforcing the African ownership of their parks, natural resources, and the scientific knowledge base.

Generating Income in Sustainable Ways

The Development Through Conservation (DTC) project in Uganda, and other community-based conservation programs, have focused much attention on understanding the interplay between the human and natural environments. A full socioeconomic survey was conducted in the region to better understand the circumstances in which people are living. Based on the results of that survey and a thorough evaluation of the fifteen years of experience from the DTC project, other projects have been developed to address the human needs of a poor and almost entirely agrarian population. Developing alternative activities to those that pose threats to the natural resources and developing projects that generate revenue from sustainable use of the forest resources have had significant success in the region. The NGOs work with leaders in different communities to identify issues people are facing and how they could best be helped through development projects. The beekeeping project at Kinigi is one such project.

Historically, people have collected honey from within the forest, an activity that

The president and officers of the Kinigi Beekeeping Association are on site with their hives at a remote edge of the park in Parc National des Volcans, Rwanda. The Kinigi Beekeeping Association alone employs approximately 280 people and that only represents nineteen of the sixty-eight associations served by the honey processing plant outside Ruhengeri.

This shop for tourists is located next to the park headquarters at Parc National des Volcans in Rwanda. Projects like this help to put money from tourism back into the local communities most affected by the presence of the parks and conservation activities.

has now become illegal with the designation of the forests as protected areas. Their families and ancestors collected honey for hundreds of years, in some cases even longer. With access into the park now prohibited, the Kinigi Beekeepers Association had set up hives on the buffalo wall where the edge of the park meets the farmland. Bees attacked the cattle, which caused problems for the farmers. There was nothing to keep the cattle from roaming near the hives; consequently, one accidental bump into a hive and the bees would go crazy. IGCP helped the association to acquire land along the edge of the park, separate from the cattle. Working together with association members, the site is in the process of being properly secured with fences and tree lines. This will reduce conflicts with farmers and allow space for additional hives, which will increase the overall production of honey and its by-products.

The honey is harvested and taken to a processing plant nearby that services approximately sixty-eight associations. There the raw honey is refined and processed into jars for sale locally and for distribution. The beeswax, a by-product of the refinement process, is also made into candles for resale. Very little is wasted or not used in the process.

The Kinigi Beekeeping Associations employs about 280 people, which only represents nineteen of the sixty-eight associations served by the processing plant. Production estimates for the hives of the Kinigi Beekeepers Association alone project the potential for harvesting 1,400 to 1,600 kilos of honey a year. At 700 Rwandan francs per kilo, that's over 1 million francs annually. These operations are staffed and managed entirely by Rwandans. By working together, they have taken an illegal activity inside of the park and turned it into a sustainable, legal, revenue-producing activity outside the park.

Other projects are designed to capitalize on tourism, such as the community gift shop built in Kinigi next to the park headquarters. This operation enables members of the local communities to sell handicrafts and curios bringing much-needed money back into their pockets. These types of projects provide direct, tangible benefits from gorilla tourism to the local communities and are facilitated through the partnership between the NGOs, the park authorities, and the local community.

Infrastructure to Change People's Lives

NGOs provide critical sources of funding and technical support on many different development projects in the pursuit of conservation. Often, outside money is spent on research projects, protection projects, and revenue-generating projects designed to infuse monetary benefit back into the communities surrounding the park. Although these are important components of conservation strategies, for most people living near the protected areas, the lack of infrastructure and basic services is an overwhelming problem and a contributing factor to the condition of their daily lives. These projects include things as diverse as clean water projects, schools, and health care.

When something as simple as the water project at Buhoma is put in place, the impact and bottom-line benefit to the communities surrounding the area can be huge. Water projects provide much-needed clean water to the communities with minimal investment. Clean water affects every area of people's lives, particularly the lives of the women and children whose job it is to procure water for the family's daily needs. The vast majority of people living near the park have no running water, electricity, or plumbing in their homes. Given that most women in these areas work all day in the fields and gardens, reducing the extra time and labor required to walk to obtain water makes their daily burden much easier. Beyond making access to the water less work, the health and sanitation aspects of readily available clean water are significant. When people are exposed to or drink contaminated water, the risk of parasitic infection is high, which can cause diarrhea and dehydration and which, left untreated, in extreme cases can cause death. The water scheme developed by CARE and IGCP in the village of Buhoma at the edge of the Bwindi forest gathers water from a catchment high on a hill above the village and then captures that water in a series of reservoir tanks. The water is then channeled through 9 kilometers of pipeline

Opposite, top: Members of the Water Project Committee in Buhoma, Uganda, inspect the catchment area, the source where water is captured for the water project near the edge of Bwindi Impenetrable National Park, Uganda. *Inset,* A woman collects water from a community tap that is part of the water project at Buhoma, which provides clean water to 6,000 people through a 9 kilometer pipeline. Near Bwindi Impenetrable National Park, Uganda.

Opposite, bottom: These children attend school in Buhoma near the edge of Bwindi Impenetrable National Park, Uganda. A new school building was built and partially funded by money generated from the Buhoma Community Campground Project. Supporting projects like the community campground can benefit the local communities in many ways such as contributing to the construction of new schools.

along two different channels through the immediate surrounding area and community, providing fresh water to approximately six thousand people.

For many of those people living near the parks, the lack of education is a huge problem but progress is being made. The distance children must travel to schools and families' ability to pay for books and uniforms can impact a parent's ability to educate their children. Many of those parents also need their children to work. NGOs, working in partnership with the communities, are involved in helping to develop some of this infrastructure in areas located near the parks. The Buhoma Community Orphan's School is an example where adequate facilities and classrooms were simply not available. Classes were being held without a proper building or classrooms. Teachers taught classes under a roofed structure, but the school had virtually no books to begin with. A new building was constructed using money donated from tourists that had come to Buhoma to visit the gorillas and funds from the Buhoma Community Campground Project. In addition to a new building with proper classrooms, a library was created and stocked with book donations from tourists. In circumstances like this, great wins for people impacted by conservation can be achieved because NGOs offer a channel for contributions to flow from tourists directly to the communities. Various NGOs continue to work with the community leaders to identify the needs, coordinate sources of private funding, and assist with the development and capacity-building plans to enhance this critical component of the community's infrastructure.

Twa children at the new schoolhouse in Buhoma sneak a break in to have a look at the stranger with the camera. According to a 2004 survey, only 37 percent of the Batwa living near Bwindi had a primary education. At the secondary school level, it drops to zero percent for the Batwa. Education is a critical challenge for people living near the parks in Uganda, Rwanda, and the Democratic Republic of Congo. The governments of Uganda and Rwanda are pursuing universal primary education programs. Even if school is free, many parents cannot afford books and uniforms for all of their children. In some circumstances children are simply not able to attend school; often parents must choose which of their children will be educated because they cannot afford to educate them all.

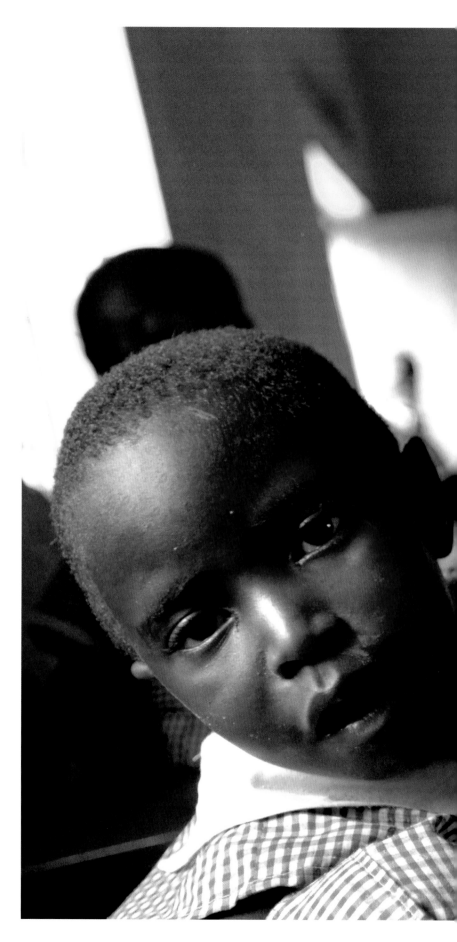

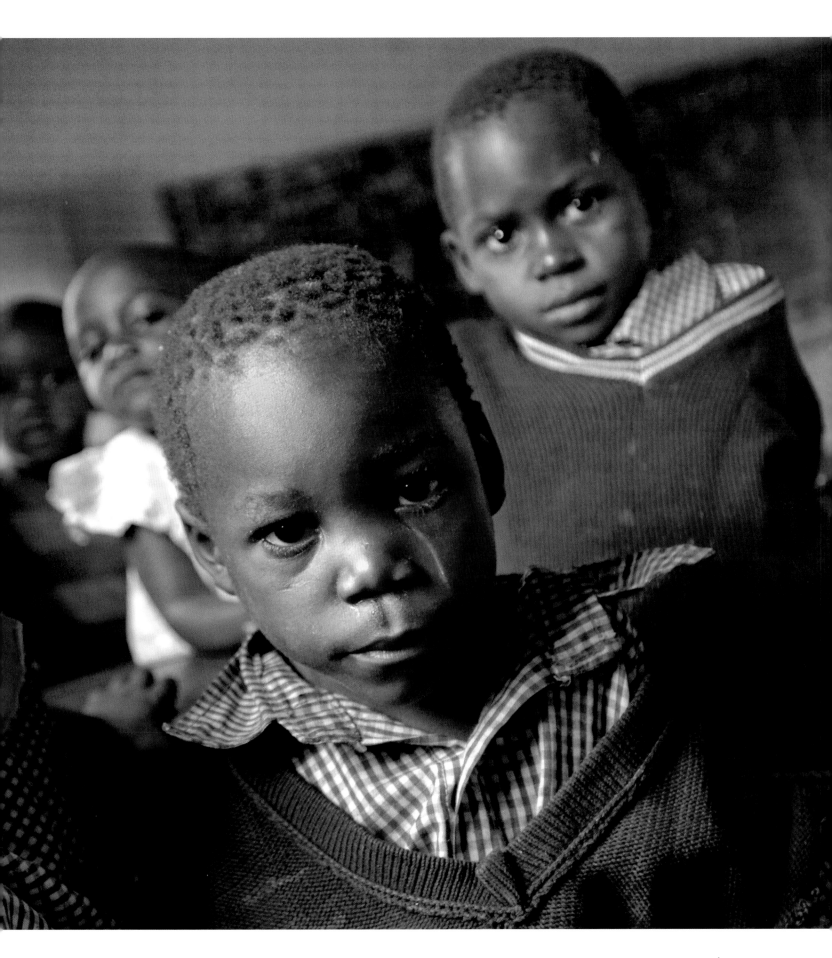

The Buhoma Community Hospital Project was initially set up for the Batwa living near Bwindi because they could not afford basic health care. Dr. Scott Kellerman, an American, came up with the idea for this project. The Twa do not pay for health care at this facility. They used to travel 17 kilometers to the nearest health facility, about a four-hour walk. Now they have access to health care in their community. Near Bwindi Impenetrable National Park, Uganda.

With the risk of disease transmission being one of the greatest threats facing mountain gorillas, the role and importance of health care in conservation cannot be overstated. While the veterinary teams monitor and address the health care issues of the gorillas, health care in all three countries for the staff that work with the gorillas every day and for the people living near the park is an issue of paramount concern. It is debatable whether the tourists pose a greater risk than the locals considering that the vast majority of tourists that come to visit the gorillas are from the United States, Britain, Germany, and Australia. These countries provide a standard of health care that far surpasses anything available to the general population living near the forests that are home to the mountain gorillas. In the past, the health status of the local staff for the park authorities and the NGOs have more likely presented as great or perhaps a greater risk for disease transmission to the gorillas because of this imbalance in health care, coupled with their more frequent exposure to the gorillas. Several programs have been developed to address this issue.

MGVP created and administers a program in Rwanda and the Democratic Republic of Congo called the Employee Health Program, a free service that they provide for all the staff that work directly with or near the gorillas regardless of organizational affiliations. Regular monitoring and necessary health care significantly reduce the risk of cross transmission of disease from these workers who have daily contact with the gorillas. When people are not able to afford basic health care, the risk of illness for those people is higher and the possibility of disease transmission to the gorillas increases substantially. The Employee Health Program not only contributes positively to the protection and conservation of the gorillas but also improves the condition of the employees that participate by identifying health problems early on and treating them.

DFGFI's Ecosystem Health Program was designed to better understand and help stop the transmission of parasites between humans and gorillas. The program has four phases: (1) collecting samples of gorilla dung, (2) collecting samples of human feces, (3) medical treatment for the human population, and (4) monitoring after the fact to determine the success of the program. Fecal samples were analyzed from people living near the park boundary, gorillas living within the park (near the human populations), and gorillas living deeper in the forest having much less contact with humans. There were common parasites found in both the human populations and the gorillas living closest to those people at the edge of the park. It was further discovered that there were fewer parasites found in the dung samples from the gorillas living deeper in the forest. Through the assistance of Pfizer Pharmaceuticals in the form of donated drugs, more than seventy thousand people had been treated for parasitic infections in the Rwanda program by the end of 2005. The medical activi-

ties of the Ecosystem Health Program are supported with education initiatives to help the local people understand why this is an issue, how they become infected, and ways to reduce or eliminate the possibility of reinfection.

In Uganda, the Conservation Through Public Health (CTPH) program was founded by Dr. Gladys Kalema-Zikusoka in 2002. CTPH is a grassroots NGO working with the Uganda Wildlife Authority and the local community in Buhoma to prevent and control disease transmission where wildlife, domestic animals, and people meet. Their mission is to promote conservation and public health by improving the primary health care to people and animals in and around the protected areas. CTPH maintains a permanent presence within the community at Buhoma providing much-needed health care, information, and public awareness campaigns to these people living at the edge of the park.

Because of the Employee Health Program, the Ecosystem Health Program, and Conservation Through Public Health, people better understand the potential impact of human health care and sanitation to the health of the gorillas. They also provide a valuable service to the community, enhancing the personal health of all the people that are treated in these programs.

Access to general health care and hospitals is something that is still not available to many people living near the parks. For the Batwa people, who live near Buhoma, however, an American named Scott Kellerman has helped to change that equation. For the Batwa, the cost of health care alone was prohibitive. In addition to the cost, the nearest health care facility to Buhoma was about 17 kilometers away, about a four-hour walk. Kellerman is an American physician who orchestrated and coordinated funding to establish a hospital and clinic in Buhoma. Kellerman now lives in Uganda and runs the hospital. Providing free medical services to the Batwa and services at reduced cost to the rest of the community, the impact to the local community has been life saving. In an area where infant mortality is high and life expectancy can be low because of malnutrition, malaria, disease, and poverty, access to local, immediate, and free medical services can make the difference every single day in whether many of the people in need live or die. At some point, it becomes that simple.

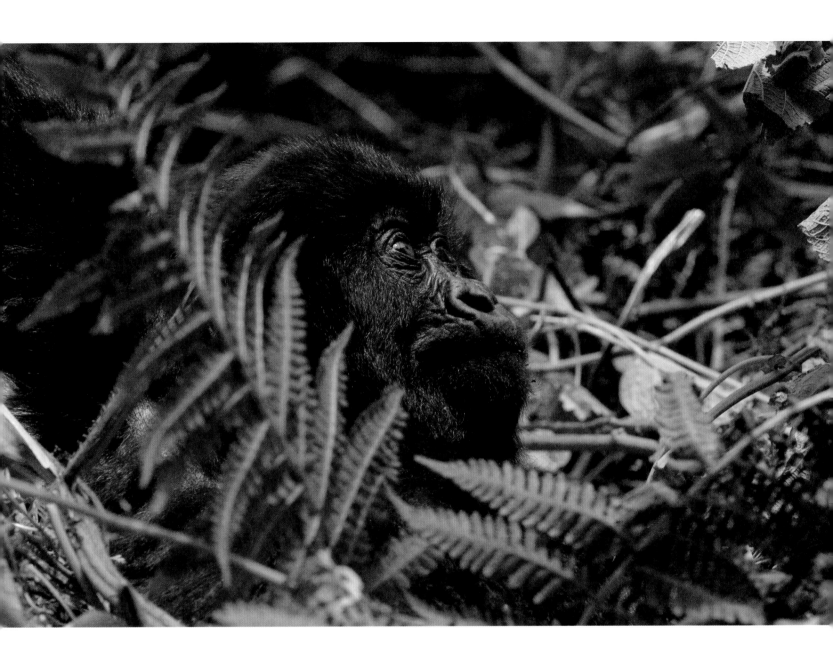

21 MORNING OF HOPE

THE DAWN OF THE twenty-first century heralded a new consciousness of the importance of healthy natural ecosystems. The first seven years of this century would see many events full of promise and hope for the future. Gorilla tourism returned to the Democratic Republic of Congo in 2003 after being shut down because of security problems for nearly fifteen years. In Rwanda, the return of tourism surpassed its previous records before the civil war and genocide of the 1990s. The census for the Virungas in 2003 and for Bwindi in 2006 both indicated continued growth in the populations of mountain gorillas, a positive sign of success. Nongovernmental organizations are taking a more regional approach to conservation as they work closely with one another and the park authorities in all three countries as the governments take steps to formalize the transboundary collaboration between each of their Protected Area Authorities. New strategies for reintroducing orphaned gorillas to the wild are being developed, and hopes are high for a successful reintroduction attempt. For the past three years, two of the brightest stars in mountain gorilla conservation have slowly and quietly been gaining strength deep in the forest, high up on the side of Mt. Karisimbi.

The Return of Tourism in the Aftermath of Conflict

Although the tourism program in the Democratic Republic of Congo was officially closed in 1989 because of security problems in the area, the guards and rangers of the Institut Congolais pour la Conservacion de la Nature (ICCN) continued to work for years under extremely difficult conditions. They in fact worked without pay for much of that time. The commitment and sacrifice of human life that they endured

The road to Bikenge, one of the locations for gorilla trekking in the Democratic Republic of Congo (DRC) winds through gentle hills, sculpted and covered with fields near Parc National des Virungas (PNVi). Although the tourism program in the DRC was officially closed in 1989 because of security problems, the guards and rangers of the Institut Congolais pour la Conservacion de la Nature continued to work for years under extremely difficult conditions and worked without pay for much of that time. The commitment and sacrifice of human life that their organization endured in an effort to try to maintain some level of monitoring of the park and the gorillas is in a word, unimaginable. In 2003, tourism to mountain gorillas was officially reopened in the DRC, and tourists again began visiting the gorillas in PNVi.

in an effort to maintain some level of monitoring of the park and the gorillas was in a word, unimaginable. In 2003, tourism to visit mountain gorillas was officially reopened in the Democratic Republic of Congo and tourists again began visiting the gorillas in Parc National des Virunga (PNVi). An observer, an expatriate NGO employee who worked with these rangers, described the first morning when tourists returned, "The rangers and guides were all lined up standing at attention and saluting as the flag was raised. They were so proud of their country and took such pride in their jobs." Working with these rangers as an expatriate NGO worker, she had tears in her eyes knowing what they had been through. Seeing them once again taking tourists to see the gorillas was a bright moment in a very dark period for eastern Congo.

Although security problems persist in varying sectors of the park on the Congo side of the Virungas, operations continue as the government works to further secure the area. The loss of tourism in the Democratic Republic of Congo for most of the 1990s through 2003 was significant. The loss of income and revenue generated for the local people by tourists, while significant, pales in comparison to the loss of

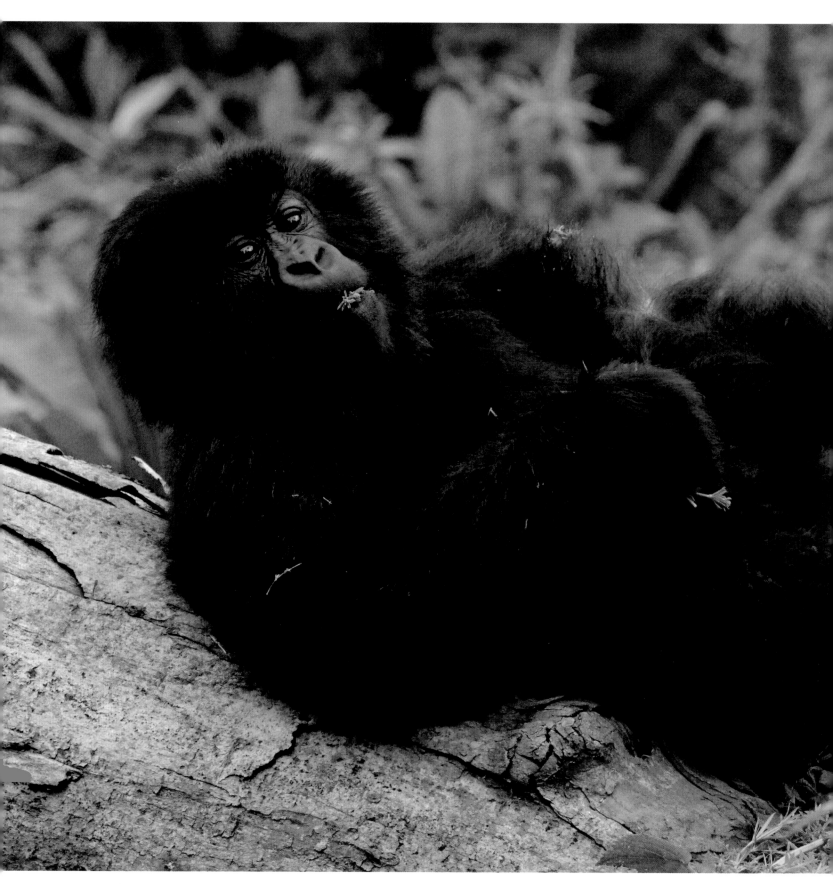

Tetero from the Beetsme group relaxes on a log in Parc National des Volcans, Rwanda.

human lives, both in terms of the park staff and civilian casualties. The volume of tourists in the Democratic Republic of Congo does not come close to the numbers that visit the Rwandan side of the Virungas or Bwindi because of the continued security problems. However, the potential for rebuilding the program is high with gorilla trekking operations for five groups of gorillas being conducted in three locations.

The meteoric comeback of tourism in Rwanda is evidence of how things in this region rebound from the most tragic of circumstances to realize great victories and accomplishments. After the genocide, tourism plummeted to zero; eventually, the numbers of tourists visiting the gorillas skyrocketed, exceeding 10,600 in 2005. The comeback of tourism is realizing itself in many ways for the areas around Kinigi, where the park headquarters is located. New guest lodges and hotels have been built, which improve the quality of the experience for many tourists and bring jobs to more people in the region. A new paved road is being built connecting the town of Ruhengeri with the area surrounding Kinigi. This road was previously a dirt road that filled with ruts when it rained and made for a slow, bumpy ride to the park at times. The new road will make access to the park easier for tourists but will also provide much easier access to markets for the people living near the edge of the park. With improved access to markets, the ability of people to make money by selling excess produce will now be a realistic possibility. More jobs and better access to markets and infrastructure will continue to improve the lives and conditions of these people.

A Stepping Stone To Peace

In a region where conflict and political agendas can cause divisiveness, suspicion, and breakdowns in communications, moments of opportunity can arise for people to come together. Rwanda, Uganda, and Democratic Republic of Congo were often in very strained relations over the past ten years, as rebel militias and military crossed borders and destabilized the region. In 2004, after years of conflict, the three governments came together to engage in a very different way. With the assistance of the International Gorilla Conservation Programme, Rwanda, Uganda, and the Democratic Republic of Congo have

TRANSBOUNDARY MEMORANDUM OF UNDERSTANDING

A historic agreement was signed between the governments of the Democratic Republic of Congo, Rwanda, and Uganda to collaboratively manage the protected areas of the Central Albertine Rift in 2006. A ten-year "transboundary" strategic plan was agreed to that allows the wildlife conservation authorities of the three countries to work together in managing the rich and diverse ecosystems that lie across their borders. It also allows them to share the revenue from gorilla tourism that is generated from the transboundary tourist groups of gorillas (e.g., gorillas that were habituated in one country and moved to another one). The International Gorilla Conservation Programme has been working in a regional capacity with the three Protected Area Authorities since 1991 to develop a basis of trust and collaboration between the three countries, despite the years of conflict and political challenges between them. That work resulted in a tripartite declaration for collaboration signed in 2001, with the following objectives:

- Cooperative conservation of biodiversity and other natural and cultural values across boundaries.
- Promoting landscape-level ecosystem management through integrated bioregional land-use planning and management.
- Peace building.
- Establishment of a common vision for transboundary collaboration.
- Building trust, understanding, reconciliation, and cooperation among governments, nongovernmental organizations, communities, users, and other stakeholders.
- Sharing of biodiversity and cultural resource management skills and experience.
- Greater effectiveness and efficiency of cooperative management programs.
- Access to and equitable and sustainable use of natural resources, consistent with national sovereignty.
- Enhancing the benefits of conservation and promoting benefit sharing across boundaries among stakeholders.
- Cooperative research and information management programs.
- Increasing revenue and reducing costs of conservation and conservation-related enterprise activities.

Further work resulted in the development and agreement to a Transboundary Strategic Plan, coordinated by the Transboundary Secretariat, to manage protected areas straddling the borders. The agreement included a Memorandum of Understanding on how tourism revenue for gorilla groups that were habituated in one country but moved to another country can be shared between the countries involved.

recognized and seized one of those moments to formalize transboundary collaboration. On January 4, 2004, a Trilateral Memorandum of Understanding (MOU) brokered by International Gorilla Conservation Programme (IGCP) was signed by the park authorities in all three countries. The MOU was designed to address the collaborative conservation of the Central Albertine Rift Transfrontier Protected Area Network, a network of eight national parks that includes the four parks where mountain gorillas are found. Recognizing the need for coordinated and collaborative management of the parks in the transboundary area, the MOU stated, "The parties hereby agree to recognize these efforts and further pledge to continue to implement, and formalize the transboundary collaboration in the areas of conservation, research, monitoring, community-based conservation and eco-tourism to ensure sustainable biodiversity conservation." This agreement was strengthened in 2006 with the signature of a further MOU agreeing to the Transboundary Strategic

Plan for the region and the establishment of a Transboundary Secretariat, involving representatives from each of the three authorities.

In reality, the park authorities had already been cooperating informally with each other in all four parks that are home to mountain gorillas. Sharing information and collaborating on strategies, even during times of war, the wardens would meet, share information, and conduct joint patrols. This agreement and the cooperation that it represents, is not only vital to the successful conservation of the protected areas, it is also viewed as a symbol of the hope for peace and a precedent for international relations. The work for the conservation of mountain gorillas has the real potential to be a stepping stone for peace in the region.

A New Answer to an Old Problem

It is unfortunate that in 2006, almost forty years after Dian Fossey started antipoaching operations at the Karisoke Research Center, the problem of poaching and what to do with orphaned gorillas still exists. One recent poaching attempt occurred when poachers were encountered and arrested near the Pablo and Susa groups in Rwanda in June 2006. Although that attempt was thwarted, it does underscore that the problem still exists today. Fortunately, mountain gorillas are generally not hunted for food in this region, and the pressures of bushmeat are much less than in regions where gorillas are hunted for food. Currently, two mountain gorillas (*Gorilla berengei berengei*) await reintroduction, including a young female called Maisha, two more mountain gorilla orphans are awaiting their disposition in the Democratic Republic of Congo, and six more Graueri's gorillas confiscated from poachers also await their disposition. To date, all attempts to reintroduce confiscated mountain gorilla orphans into nonnatal groups in the wild have ultimately failed and ended with the death of the reintroduced gorilla; the most recent attempt was in 2002–2003. It was time for a new answer to an old problem.

Maisha, a female infant mountain gorilla, was confiscated from poachers in Rwanda on December 18, 2004. Three poachers had kept her tied in a sack in a cave for two weeks, only letting her out occasionally to eat. What group she came from or where she was captured is unknown, but it has been verified that she did not come from any of the habituated groups in any of the three countries. The poachers, who were caught and arrested, claim that she was captured near Bukima in PNVi in Congo. Although this is possible, it is unsubstantiated information. Numerous patrols by ICCN in that area have not only accounted for all of the known individuals in the habituated groups but also failed to turn up any evidence of dead gorillas or poaching at the time.

After her confiscation from the poachers, Maisha was in a serious state of emotional, physical, and psychological trauma. Maisha was turned over to the Mountain Gorilla Veterinary Project (MGVP) regional field veterinarians who, with the help of

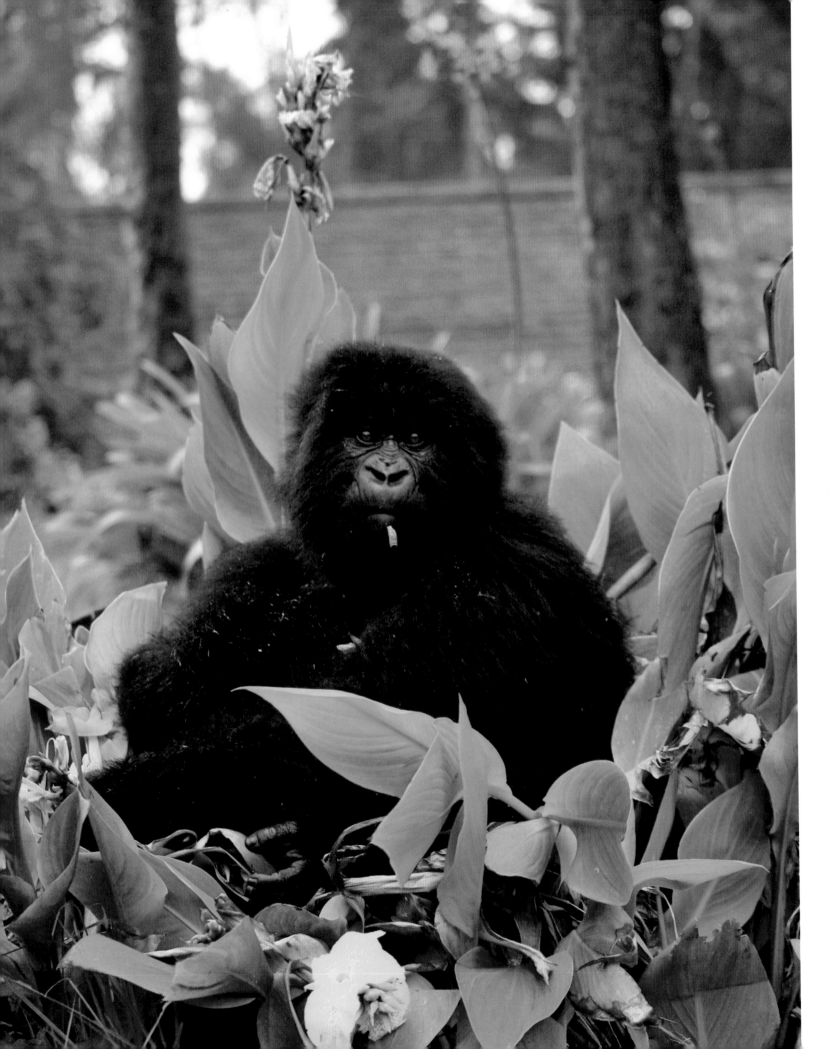

DURING THE ORGANIZATIONAL restructuring of the Office Rwandais du Tourisme et des Parcs Nationaux (ORTPN) in 2003, Prosper Uwingeli became the Research, Monitoring, and Planning Warden at Parc National de Volcans (PNV). Before coming to work in the PNV for ORTPN, he worked as a research assistant at the Karisoke Research Center (KRC) for three years. Born in the Ngoma district in eastern Rwanda, Prosper was working on his degree program in the social sciences at the National University of Rwanda in Butare when he went to the Virungas to assist Pascale Sicotte at the KRC with a study about the attitudes and perceptions of people living near PNV and the Nyungwe National Park. They were interested in their attitudes toward the parks, the gorillas, the forest, and the impact of those attitudes on conservation.

Prosper has counterparts in the Protected Area Authorities in both Uganda (Ugandan Wildlife Authority) and the Democratic Republic of Congo (Institut Congolais pour la Conservacion de la Nature). He works with them as part of the Transboundary Collaboration initiative formalized by the Memorandum of Understanding signed by all three countries. He and his counterparts work together in many capacities such as training, monitoring of gorilla groups, and the distribution of illegal activities, all part of the Ranger Based Monitoring program being implemented in the three adjacent parks. In addition to his work with other organizations, Prosper was also involved in the design and preparation of the PNV Five Year Management Plan that ORTPN has been implementing since 2005.

Prosper also works very closely with the Karisoke Research Center. KRC provides regular reports on their activities to ORTPN through the Research and Monitoring Warden. In his role with ORTPN, Prosper supports the work of research performed in the park by organizations like KRC, students from the National University, and visiting scientists from around the world.

Prosper was one of the authors on the Virunga Volcanoes Range Mountain Gorilla Census 2003 and continues to support other researchers as they complete their fieldwork and publish their findings. The role that Prosper plays within ORTPN, and the collaboration and support that he provides with other Protected Area Authorities and nongovernmental organizations provides an important link in the partnership between those organizations. It's that level of collaboration by people like Prosper and his colleagues that contributes significantly to the conservation of mountain gorillas in Uganda, Rwanda, and the Democratic Republic of Congo. After six years of intensive field experience within the Parc National des Volcans, Prosper is now completing his Master's of Science in Research Methods and Conservation Management degree at the University of Chester in the United Kingdom. Upon completing his studies, Prosper will return to continue his research work in Volcanoes National Park in Rwanda.

Opposite: Maisha, the orphaned mountain gorilla, is being kept in captivity until she is old enough to be reintroduced into a wild group. Staff from the Karisoke Research Center and the Mountain Gorilla Veterinary Project care for her around the clock at an undisclosed location near Parc National des Volcans, Rwanda. To date, all attempts to reintroduce confiscated mountain gorilla orphans into nonnatal groups in the wild have failed and ended with the death of the reintroduced gorilla. The most recent attempt was in 2002–2003. To answer questions about how to reintroduce Maisha to the wild successfully, a scientific technical steering committee was created to explore options and make recommendations for her disposition.

the DFGFI and the support of Office Rwandaise du Tourisme et des Parcs Nationaux (ORTPN), have maintained her in an undisclosed location near the Parc National des Volcans in Rwanda since that time. The stakeholders agreed on the first question, Should she be returned to the wild? Following the International Union for the Conservation of Nature and Natural Resources (IUCN) guidelines, the scientists charged with her care recommended her return to the wild.

The next set of questions is much more complicated. Why did the earlier reintroduction attempts fail, and what must be done to ensure the greatest chance of success in reintroducing Maisha to the wild? To try to answer these questions, a Scientific Technical Steering Committee (STSC) was created to explore the available options and make recommendations for her disposition. The STSC is composed of members from the two park authorities involved (Tony Mudakikwa from ORTPN and Deo Mbula from the ICCN), Chris Whittier from the MGVP, Maryke Gray from the IGCP, and Katie Fawcett from Karisoke Research Center. The STSC's definition of a successful reintroduction is clear: the gorilla becomes fully integrated into a wild group, reaches maturity, and produces healthy offspring.

The consensus was that for a reintroduction attempt to succeed two primary criteria had to be satisfied: (1) the gorilla must be behaviorally normal and (2) the gorilla must be age appropriate. Periodic psychosocial evaluations of Maisha were performed, which determined that she displayed many types of displacement behaviors and remained in a detached mental state, indicating that she was still coping with the posttraumatic stress of separation from her birth family. Out of concern for Maisha's immediate survivability, recommendations for her care included closer contact with her caregivers to simulate the contact she would normally have with other gorillas. Her habitat space was increased, and she needed more than one person engaging her in play at the same time. These modifications were designed to stimulate curiosity, bring her out of withdrawal, and stimulate her ability for learning to cope with new things, which would be crucial in her ability to adapt in the forest once reintroduced.

In a follow-up evaluation, Maisha's condition had improved. Reduced displacement behavior, reduced levels of anxiety or fear, appropriate levels of eye contact, and reciprocal interactions with her caregivers all indicated an improved psychological and emotional state. Recommendations were made for increased stimulus to new and novel food and play items, solicitation of play with her caregivers, and limited exposure outside of her enclosure to prepare her for the visual stimulus that will occur when she is eventually reintroduced. If Maisha continued to improve at the same rate, scientists believed she would achieve the emotional stability necessary to join a small group of similarly aged gorillas.

The MGVP veterinarians thoroughly examined Maisha and deemed that she was physically healthy. Their testing and analysis concluded that at the time she posed no obvious health risk to the wild gorilla population if she were to be reintroduced back into the Virunga Range. Drs. Whittier and Nutter further concluded that Maisha's

Humura from the Susa group sits quietly atop a fallen tree and surveys the group of tourists that are snapping nonstop in Parc National des Volcans, Rwanda.

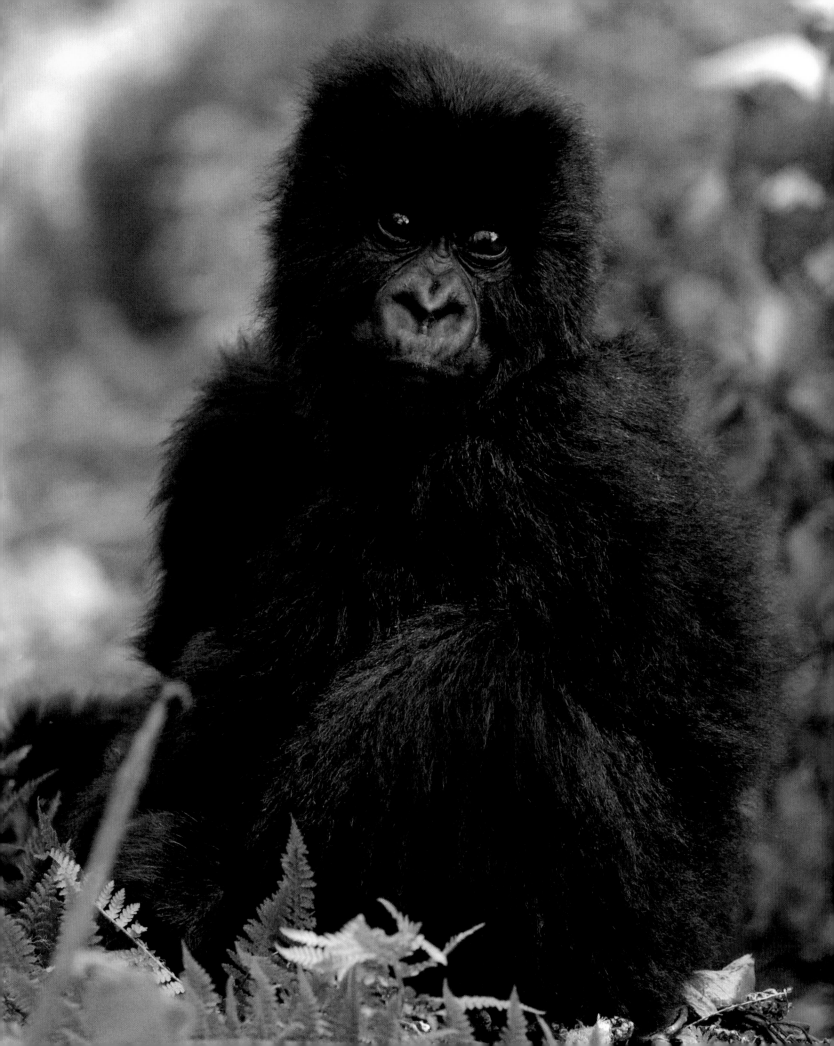

physical state and general health would likely be less significant factors in her successful reintroduction than her mental and behavioral state.

The current strategy for the reintroduction of Maisha is that she will be maintained until she is behaviorally normal and the appropriate age for a normal female transfer between gorilla groups. In this case, that age would be a minimum of five to six years old, the minimum age as a subadult when female gorillas change groups. The idea is that she will hopefully be perceived by the target group as a normally transferring female. Using a detailed decision tree based on the IUCN guidelines for the placement of confiscated animals, the STSC will continually reevaluate Maisha's condition, status, and viability and the groups targeted for reintroduction. Given the criteria established for a successful reintroduction, it will be years before the true measure of success can be taken, assuming Maisha survives to be accepted into a wild group. If this strategy works, this will be the first case in history in which a mountain gorilla has been successfully reintroduced into the wild. The hope for success is high as the Protected Area Authorities and the key scientific behavioral and medical experts leverage lessons learned from past attempts to create a successful model for the future.

Shining Stars

Out of all of the successes in mountain gorilla conservation, perhaps one of the most hopeful is the story of Nyabitondore and her twins, Impano and Byishimo, from the Susa group. Baby mountain gorillas are always fragile, requiring much care and attention from their mothers. With twins, Nyabitondore had twice the load to care for. There are no known incidents of mountain gorilla twins surviving in the wild; therefore, the odds were stacked against her from the beginning; yet still, she prevailed.

Impano and Byishimo were born in 2004 and are probably weaned by now. They will be eating other foods and will have made it through the most dangerous first few years of a young mountain gorilla's life. Although they are still young and need much support from their family, this is incredibly hopeful.

As we were finishing this chapter, we realized that our story has come full circle, from tourists wanting to see the twins as they trekked to visit the Susa group in chapter 1, to the rambunctious little juveniles we see today. They have journeyed beyond that point of total contact with their mother and they are literally all over the place, playing with the other members of their very large family. This is a wonderful testament to the work of conservation over the past forty years and a shining symbol of hope for the future. It is because of the collective work in conservation that has been done in the past four decades that the twins can play carefree and innocent, blissfully unaware of the context in which they are living. They now have a real chance for a future, a chance that mountain gorillas thirty years ago might not have had.

Nyabitondore from the Susa group holds close her young and fragile twins, Impano and Byishimo. Despite the challenges facing the twins and their mother, Nyabatindore is defying all odds. She is winning as she raises, protects, and cares for her fragile young offspring in this isolated patch of forest, completely surrounded by people. The Susa group is located in Parc National des Volcans, Rwanda.

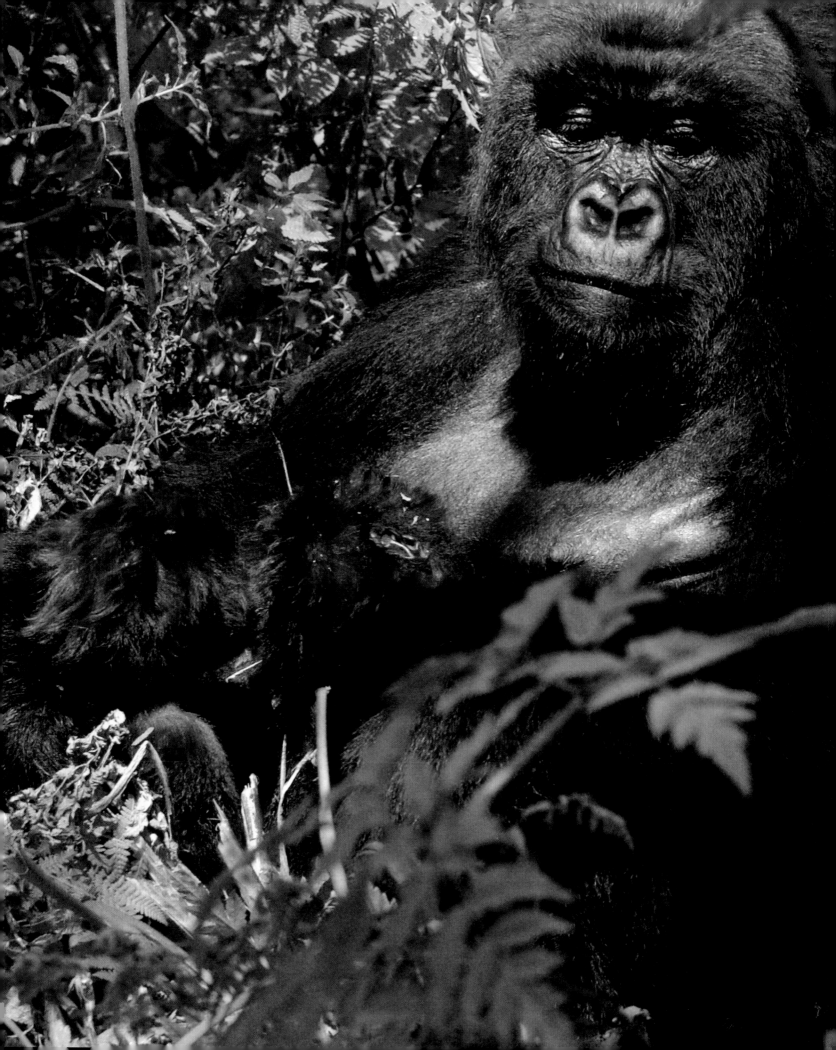

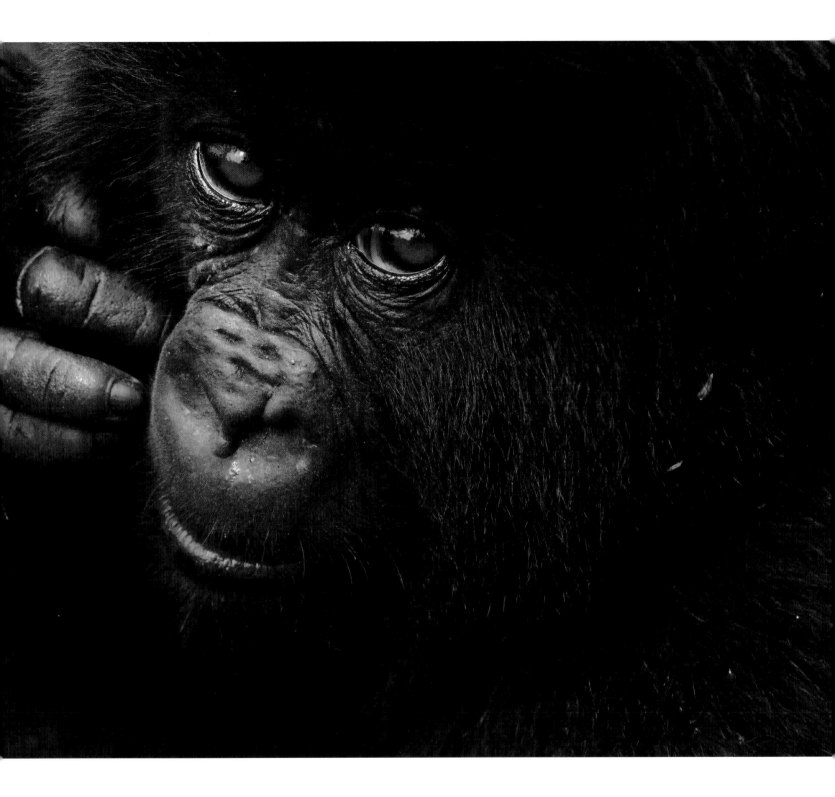

AFTERWORD

A Call to Action

NATURAL RESOURCES such as the spectacular Virunga and Bwindi forests and the mountain gorillas that inhabit them are part of their countries' national wealth and heritage. The loss of resources such as these is not merely a localized or regional loss but rather a loss to the entire country and to the world. Local governments are obligated to manage, conserve, and protect these natural resources; however, the international community must ask itself, what is their role? What is the responsibility of the international community to assist and support the efforts of the local governments in host countries when and where needed to accomplish these most important missions?

Furthermore, the question that must be asked in the same breath when speaking of conservation is whether the international community has a greater moral imperative in helping to alleviate poverty in these countries? Virtually every situation involving critically endangered species anywhere in the world at some level comes down to habitat loss. Habitat loss is almost always directly tied to human needs, encroaching on natural environments to satisfy their resource requirements. That human encroachment and those resource needs are almost always tied at some level, often fundamental levels, to political and socioeconomic issues and conditions that invariably involve moderate to severe levels of poverty. The people living near the mountain gorillas are suffering from some of the highest population densities in Africa while living in extreme poverty. The challenge lies in our ability to understand the linkages/interplay between human needs and the environment's ability to sustain those needs as well as maintaining the natural habitats, processes, and wildlife characteristic of those habitats. Effective and practical research can provide a great deal of information for planners and managers, as well as local decision makers, to enable people to use their natural resources without depleting or destroying them.

Previous page: The success of conservation efforts to preserve and protect mountain gorillas and the forests that they call home will continue to be directly tied to the people living near them.

When humans and animals compete for the same living space and natural resources, invariably the humans take precedence every time. If young females like Kubana from the Shinda group in Parc National des Volcans are to survive, this delicate balance between the needs of people and gorillas must be achieved.

Opposite: There is perhaps no more majestic or iconic animal among all of the endangered species than the mountain gorilla. Silverbacks like Ubumwe from the Amahoro group in Parc National des Volcans are truly magnificent in stature and demeanor. The gorilla has fascinated people and captured our imaginations as long as we have been aware of its existence. The catastrophic decline in the mountain gorilla population from the 1960s and 1970s through the early 1980s could have spelled the end for mountain gorillas. Through hard work, dedication, and sacrifice of many people in the host countries and the money provided by donors around the world, the mountain gorilla has survived. However, their future, even today, remains uncertain.

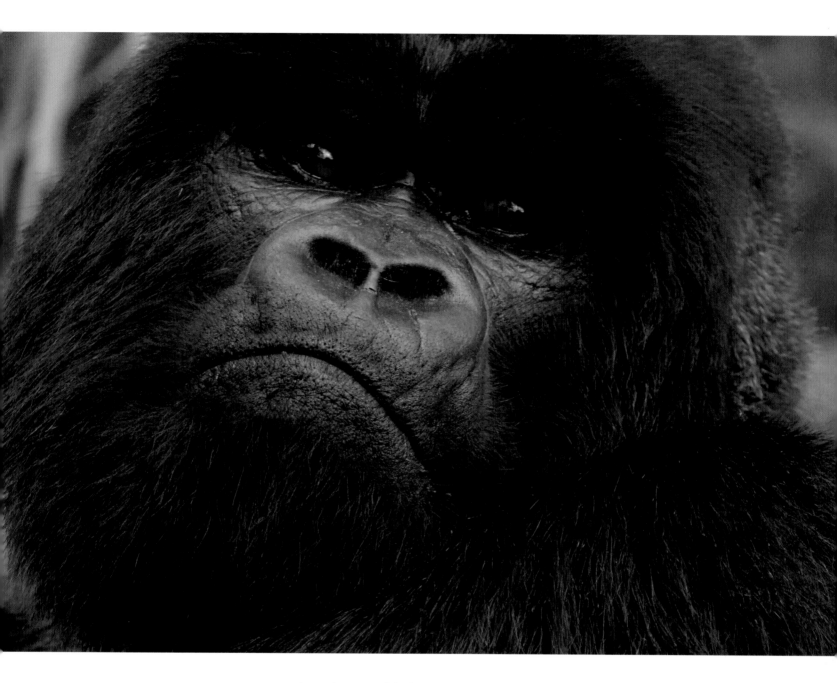

The assistance of the international community, through financial as well as technical support, is required to help people develop and implement strategies that allow populations to live dignified lives that safeguard the futures of their children and their natural environment.

The Gorillas

There is perhaps no more majestic or iconic animal among all of the endangered species than the mountain gorilla. Truly magnificent in both stature and demeanor, the gorilla has fascinated people and captured our imaginations as long as we have

Understanding the population dynamics of mountain gorillas is one of the tools that helps conservation managers and planners to evaluate the successes or failures of conservation and protection activities, and to plan conservation measures. Population dynamics can include information on the actual census counts, group composition, and changes over time. Censuses have been conducted in both the Virunga Volcanoes Range (VVR) and in the Bwindi Impenetrable Forest in Uganda. The information gleaned from those censuses has been vital to the planning and operational activities of both the Protected Area Authorities and the research community. Unfortunately, because of war and political instability, there were no censuses conducted for a fifteen-year period in the Virungas between 1989 and 2003.

The total population estimate for the most recent census in the VVR conducted in 2003 is 380 gorillas. That represents a 17 percent increase for the population since the last complete census was conducted in 1989. The annual growth rate of 1.15 percent for the VVR is lower than the 3.1 percent annual growth rate that was seen in the 1980s or the 3.8 percent projected annual growth rate that was forecasted by a population viability analysis. Understanding why that growth rate is much lower than experienced in the past or in projections is important for conservation planning. This could reflect a lower birth or natality rate or, more likely, an increased death rate, given that between twenty-four and twenty-nine gorillas died from unnatural causes due to the insecurity of the region between 1989 and 2003.

TABLE AFT.1 | POPULATION PARAMETERS FOR THE VIRUNGA VOLCANOES RANGE, FROM 1971 TO 2003

Census Years(s)	Total Gorillas Counted	Estimated Population Size	No. of Social Groups	Mean Group Size[a]	Median Group Size	No. of Solitary Males	% Multimale Groups	% Immature	% of Social Groups > 20 Individuals
1971–73	261	274	31	7.9 (na)	na	15	42	39.8	na
1976–78	252	268	28	8.8 (4.4)	7	6	39	35.8	3.5
1981	242	254	28	8.5 (na)	na	5	40	39.7	na
1986	279	293	29	9.2 (5.5)	8	11	14	48.1	7
1989	309	324	32	9.2 (7.1)	7	6	28	45.5	9
2000	359	359–395	32	10.9 (9.7)	8	10	53[b]	44.7[b]	15.6
2003	360	380	32	11.4 (11.2)	7.5	11	36	41.0	15.6

Source: Gray, Maryke, Alastair McNeilage, Katie Fawcett, Martha Robbins, Benard Ssebide, Deo Mbula, and Prosper Uwingeli. 2005. Virunga Volcanoes Range Mountain Gorilla census 2003. ICCN, UWA, ORTPN, B&RD, DFGF, DFGFI, IGCP, ITFC, MPIEA, WCS.

Note: na = data not available for calculating variable.

[a]Numbers in parentheses for mean group size is the standard deviation.

[b]Calculated from the seventeen habituated groups only.

been aware of its existence. The catastrophic decline in the mountain gorilla population that was witnessed through the 1960s and 1970s up through the early 1980s could have spelled the beginning of the end for mountain gorillas on this planet. It is only through the hard work, dedication, and sacrifice of many people in the host countries, and money provided by donors around the world, that the mountain gorilla has survived at all. Their future, even today, remains uncertain. Sadly, this was reinforced by the brutal killings of nine mountain gorillas in 2007 in the Democratic Republic of Congo. Only through the continued vigilance, hard work, and dedication of those same people and those that will follow in their footsteps, will the mountain gorilla be able to survive into the future. As conservation managers and

The total population estimate for the most recent census in Bwindi conducted in 2006 is 340 gorillas, which represent a 6 percent increase for the population since the 2002 census and a 12 percent increase since the 1997 census. This represents a 1.0 percent annual growth rate for the Bwindi gorillas, slightly less than the VVR gorillas.

With a combined total population estimate of 720, these numbers clearly indicate that the mountain gorilla populations are increasing. Closer examination of the data gathered in the census efforts raises important questions for understanding the population dynamics of habituated and unhabituated gorillas, however. In the VVR, 50 percent of the gorilla groups and 70.8 percent of all gorillas are habituated to human presence either for the purposes of tourism, research, or regular monitoring. The statistics show that the habituated groups are substantially larger than the unhabituated groups (16.8 vs. 5.9 mean group size). This was also the case in the 1989 and 2000 census population estimates. Further examination of the data for the VVR reveals that a subpopulation containing the three research groups from Karisoke plus the Susa tourist group not only constitute the largest groups of mountain gorillas anywhere, but they also account for virtually the entire population increase of the VVR gorillas. With approximately a 4 percent annual growth rate in this subpopulation, the reasons for this are likely due to varying levels of human disturbance, ecological conditions, and other demographic factors. For example, the tourism groups in the Democratic Republic of Congo have suffered a high mortality rate due to human-induced causes that largely center around the intensive use of their range by different armed groups over the past fifteen years. The sector of the park containing research groups and the Susa group have been visited daily for much of the past thirty years and consequently have had much better protection. This sector is also believed to provide some of the best gorilla habitat in the VVR in terms of food availability. In addition to better protection and habitat, these groups are predominantly multimale, which could reduce the risk of infanticide and, in turn, lead to improved survivability and overall group stability. The fact remains that certain groups within the habituated population of gorillas in the VVR (research groups plus Susa group) have demonstrated multiple signs of significantly higher growth rates than the unhabituated population in the VVR or in Bwindi for that matter. Understanding the reasons this variation exists is important so that conservation managers can factor this into their short- and long-term strategies for management of these populations of mountain gorillas and the protected areas they live in.

planners work to implement their strategies, both short and long term, there are challenges at every turn. Although there are many victories to celebrate, victories can and will become hollow and short-lived without the conviction and follow-through to make them long-term, sustainable successes. Vigilance is mandatory; complacency is not an option and could prove disastrous for the mountain gorilla. What has been demonstrated over the past twenty years, however, is that conservation and development strategies can work together and have real success, even during periods of extreme difficulty, such as the war and conflict of the past fifteen years.

The populations of mountain gorillas in both forest environments have increased, and with continued vigilance, their populations will likely continue to increase.

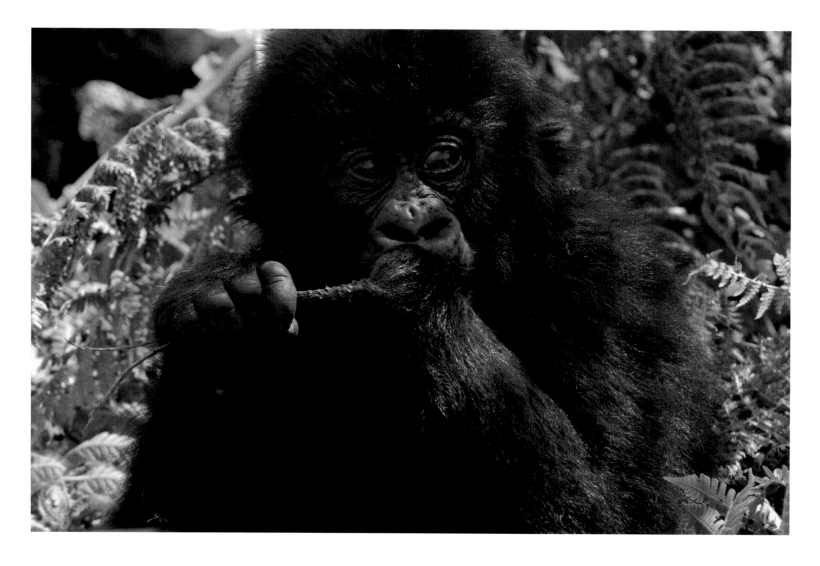

Approximately 41 percent of the population are immature individuals, which is generally considered to be a healthy percentage indicator for continued population growth. Further research is needed to better understand the population dynamics of mountain gorillas so that policy makers and the Protected Area Authorities can continue to make better, more informed decisions about conservation strategies. It is important to understand not only the differences between the Bwindi and Virunga populations but also the differences between the habituated and nonhabituated populations in both environments, including variation in population growth within different areas of the Virungas. Census information from the Virungas clearly indicates that the overall population increases in that environment can be directly attributed almost entirely to the larger groups (Karisoke and Susa groups). Why is that? All of these groups are habituated, but there are many more habituated groups scattered throughout the Virungas. Why have those groups not increased by as much? Why is there only a 1.15 percent annual growth rate in the Virunga population

As conservation managers and planners develop short- and long-term strategies, they face challenges at every turn. There are many victories to celebrate, but without follow-through, long-term successes are not sustainable. Vigilance is mandatory; complacency is not an option and could prove disastrous. As long as gorillas like Kalema from Group 13 in Parc National des Volcans lose hands due to snares, continued vigilance will be needed.

Opposite: The infant Dusangire from Group 13 stretches his legs and ventures out after a sudden rainstorm in Parc National des Volcans, Rwanda.

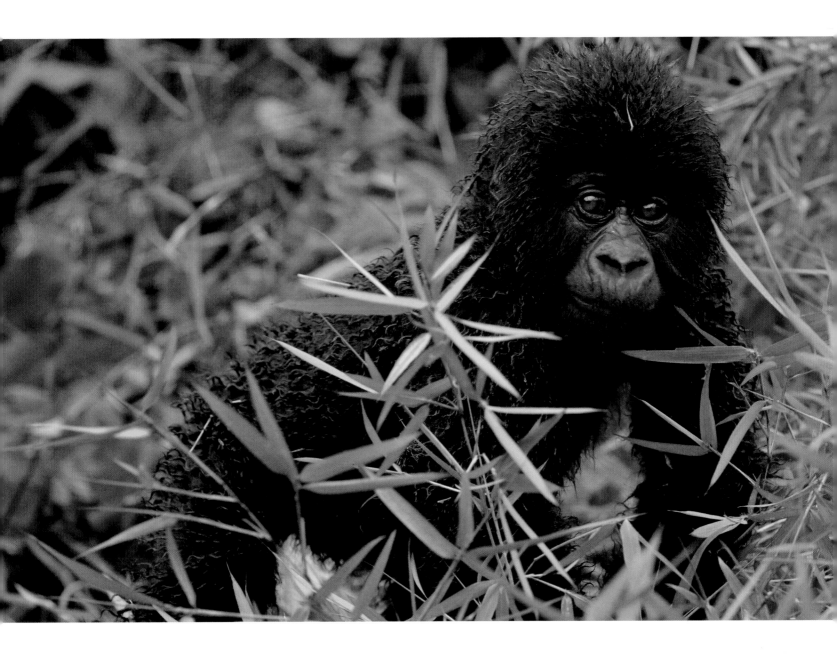

now as opposed to the 3 percent annual growth rate that was observed in the 1980s? Why has the Pablo group, the largest-known group of gorillas in the world, not split into smaller groups even though smaller satellite groups from within Pablo will venture off and then come back to unite with the rest of the group? What are the risks and implications of habituated groups that are this large being exposed to human contact on a daily basis? Would unhabituated gorillas be better off (i.e., by virtue of increased protection) by being habituated, and what are the associated costs of that in terms of disease risk and other detriments to a wild existence? These are questions that only time and carefully conducted research can answer. This is why the value of continued long-term research and monitoring is so important to the long-term success of mountain gorilla conservation. That is, in turn why the continued financial

support of practical and management-oriented monitoring and research is so vital to conservation success.

The Forests

The importance of the forests would seem to be a given; yet, invariably the economic and intrinsic value of these forests, unique in the world, is continually underappreciated. It goes without saying that with no forests, there will be no mountain gorillas. What bears repeating and emphasis is the greater economic value of the forests as protected areas and their greater role in the region. The Virungas would likely have never survived the past fifty years had there not been a substantial revenue-generating option to the alternatives of land clearing, development, and agriculture. The forest's environmental contributions as water catchments, soil conservation, and increasing rainfall to countries that are so heavily supported and impacted by agriculture cannot be overstated. The cultural value of these forests to the heritage and future of the people living near the forests is also often overlooked and underappreciated. The sheer biodiversity of these forests, designated as World Heritage Sites, is unique in Africa and throughout the world.

A proper understanding of the total economic value of these forests is vital to the decision-making process of policy makers in the local governments and in donor countries throughout the world. The Virunga and Bwindi forests are "island" habitats completely surrounded by people. The disappearance of the forests would spell the end for mountain gorillas, environmental disaster for the people living in the immediate area, and a severe blow to the economies of the affected host countries.

The People

The people that live near these forests in the three host countries face tremendous challenges. Bearing the greatest burdens and costs associated with conservation and protected areas, these people are often receiving the least amount of the benefit generated from mountain gorilla tourism. Faced with high-mortality rates, extremely high levels of poverty, and unemployment; lack of infrastructure, proper health care, and education, these people must overcome obstacles daily. When you look at marginalized sectors of the population such as the Batwa, these problems are compounded and further exacerbated by the denial of their historical access to the forest to help alleviate some of their needs and augment their livelihood strategies. Because of the overwhelming levels of poverty, people in situations like this not only have limited economic options but often have difficulty accessing programs that could potentially improve their condition such as credit and savings programs. These programs are generally geared toward people with more wealth and education; many of the Twa do not meet even the basic qualifications and requirements for

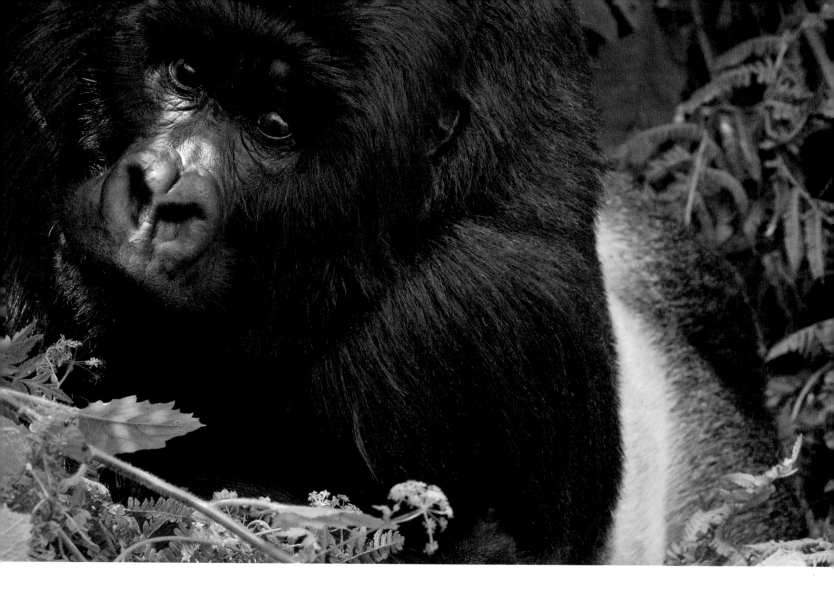

Despite Agashya's huge size, his posture is nonthreatening. This silverback from Group 13 in Rwanda is calm and relaxed as he stares intently into the camera lens.

participation. In addition to the community members that are better off, more educated, and better positioned to take advantage of existing programs, these groups of people are now targeted specifically by development programs in order that they receive benefits.

Although tourism has dramatically improved conditions for some of the people in the immediate areas in the parks, there is a huge disparity between the benefits that people receive living in areas like Buhoma in Uganda and Kinigi in Rwanda, where the park headquarters and tourist operations are located, and the communities in other areas bordering the parks that do not have access to tourists and the revenue they bring with them. Finding ways to smooth the distribution of benefit to all people living near the park will be key to leveling the playing field and improving the condition of the local people, their attitudes, and perceptions toward the protected areas, the authorities, and the gorillas.

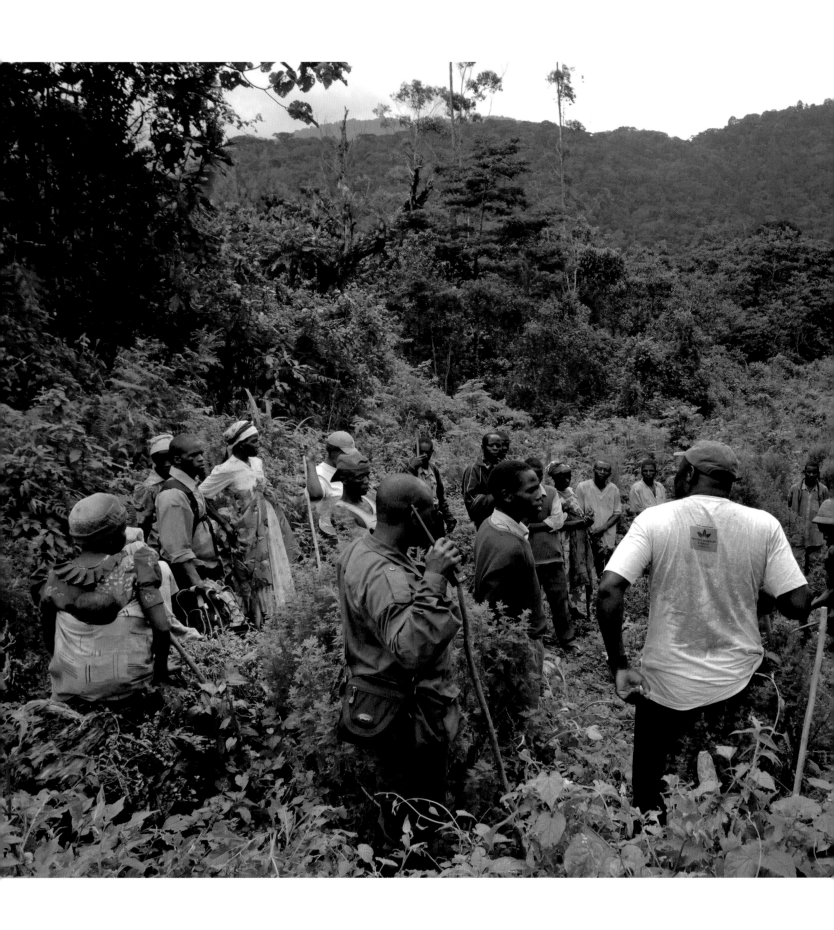

The Final Word

As the park authorities have grown and evolved, so too has their organizational capacity as they work together with one another, the nongovernmental organizations, and the local communities surrounding the parks. The partnership with the NGOs has proven to be effective and helpful in terms of training, capacity building, and providing technical and financial support to the park authorities. Those relationships should be maintained and nurtured in the future. The work of the NGOs, both conservation and research related, could simply not be done without the aid and support of the park authorities in all three countries. It is the park staff in the field that is making the difference day in and day out on the ground by protecting the gorillas and the parks and by facilitating the important work of research and forest- and community-based conservation.

The relationship between the park authorities and organizations such as the International Gorilla Conservation Programme and the Mountain Gorilla Veterinary Project in all three countries, DFGFI's Karisoke Research Center in Rwanda and the Democratic Republic of Congo; the Max Planck Institute for Evolutionary Anthropology and the Institute for Tropical Forest Conservation in Uganda, represent an important partnership between the NGOs and the park authorities that benefit all stakeholders. Research and monitoring are one of the critical inputs to conservation planning and management; yet, it only becomes effective when realized in the field. This is where the work of conservation comes into play.

The approaches to conservation have evolved over time and so too must the approaches to financing conservation efforts and activities. With significantly larger amounts of money available for development projects and the increased tendency toward basket funding, conservation NGOs and other partners will have to be more integrated in their approaches to the acquisition and allocation of funds between true development-related activities and more traditional conservation-related activities. So too, they will have to find their place as more funds are given directly to the governments in the host countries for distribution as part of their poverty-re-

Staff members from International Gorilla Conservation Programme and Uganda Wildlife Authority meet with members of the community as they work in the buffer zone for Bwindi Impenetrable National Park at Nkuringo, Uganda. The Human Gorilla Conflict Program, the multiple use zones, and the buffer zone project at Nkuringo, Uganda, could not happen without the partnership between the Protected Area Authorities, the nongovernmental organizations, and most importantly, the local communities. These types of programs are geared toward the essential goal of addressing burdens people living near the parks face daily.

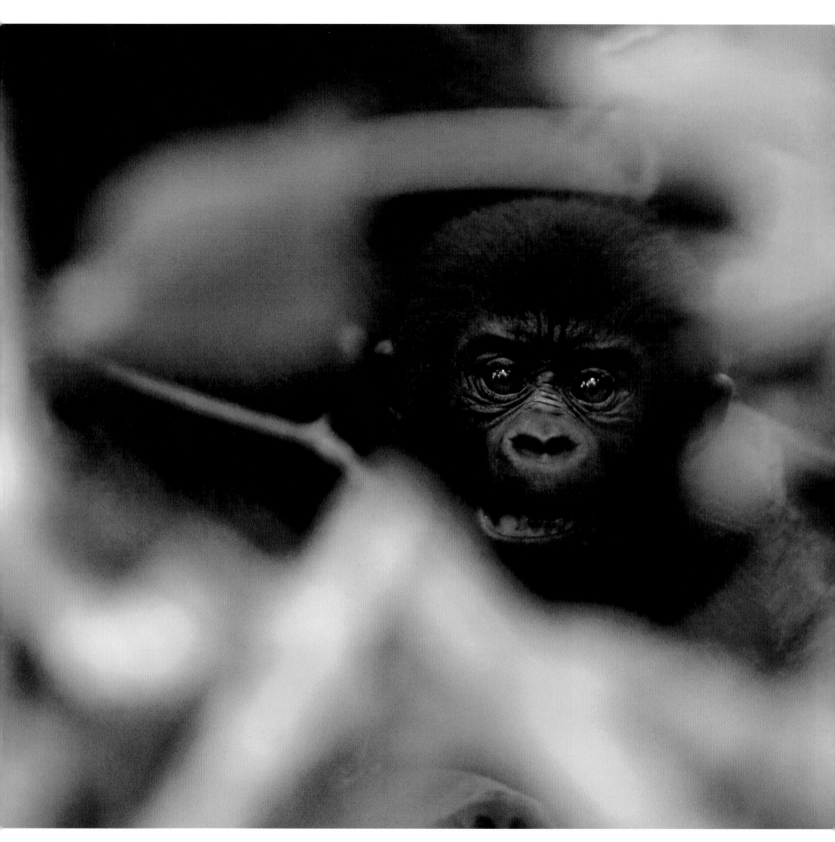

Happy, an infant from the Kyagurilo group in Bwindi Impenetrable National Park, stares at tourists through the underbrush. The reality facing conservation planners and managers is that as long as people and gorillas compete for resources, if the resource needs of the local people are not accounted for, those people will find a way to meet their resource needs, regardless of the legal or moral implications. Conservation without morality and social justice is unsustainable.

duction strategy programs. Creating a balance between all stakeholders and projects through collaborative strategy, planning, and implementation processes will be key to future successes. These partnerships must also work together across all of the host countries to find ways to draw in and retain more of the money spent on gorilla tourism and to better understand the distribution between local, national, regional, and international communities of interest.

For now, the mountain gorillas are doing well despite their fragile existence. They are safe from extinction at this time; however, the struggle is not over. One single instance of disease transmission under the right combination of circumstances could wipe out the entire population of gorillas in the Virungas or Bwindi. Think about that. One stroke of bad luck, one unfortunate exposure to the wrong person infected with a virus or disease that the gorilla's natural immune systems cannot fight off, could potentially drive this magnificent creature to extinction within a matter of months. The risk of disease transmission between gorillas and humans is real. The constant pressure to habituate more groups for tourism and the growing number of fast-moving tourists from all corners of the globe combined with the oftentimes lax enforcement of rules protecting gorilla health increase the risk for the transmission of disease. The movements of rebel groups across borders and the presence of military, militias, or refugees within protected areas only compound that risk. The global flow and mixing of potentially dangerous pathogens and the rapidly growing rural population without access to decent health care make the risk of disease transmission one of the most significant threats facing mountain gorillas today.

Although certain individuals or organizations may receive more notoriety or press in the light that shines on gorilla conservation, it is more important to remember that it is the work of many people, primarily African, who have made these programs a success. It is also important to understand that the success of the present, and the long-term success of the future lay squarely in the hands of the people of this region, not the NGOs or the outsiders, for the parks, forests, and the gorillas belong to them. No one person or organization can take all the credit for the survival of the mountain gorilla. It was, is, and will continue to be a collaborative team effort. This book is a tribute to their successes and a shout to the world to take notice, to make a choice to get involved, and to make a difference. In Africa, Australia, Asia, the United States, or wherever your part of the world is, we, the human species, for better or worse, have become the de facto caretakers for the planet and its places and creatures. Conservation without morality and social justice is simply not sustainable. Whether you are talking about the survival of the gorillas, or the people that live near them, survival is key and it is our responsibility. Don't take it lightly.

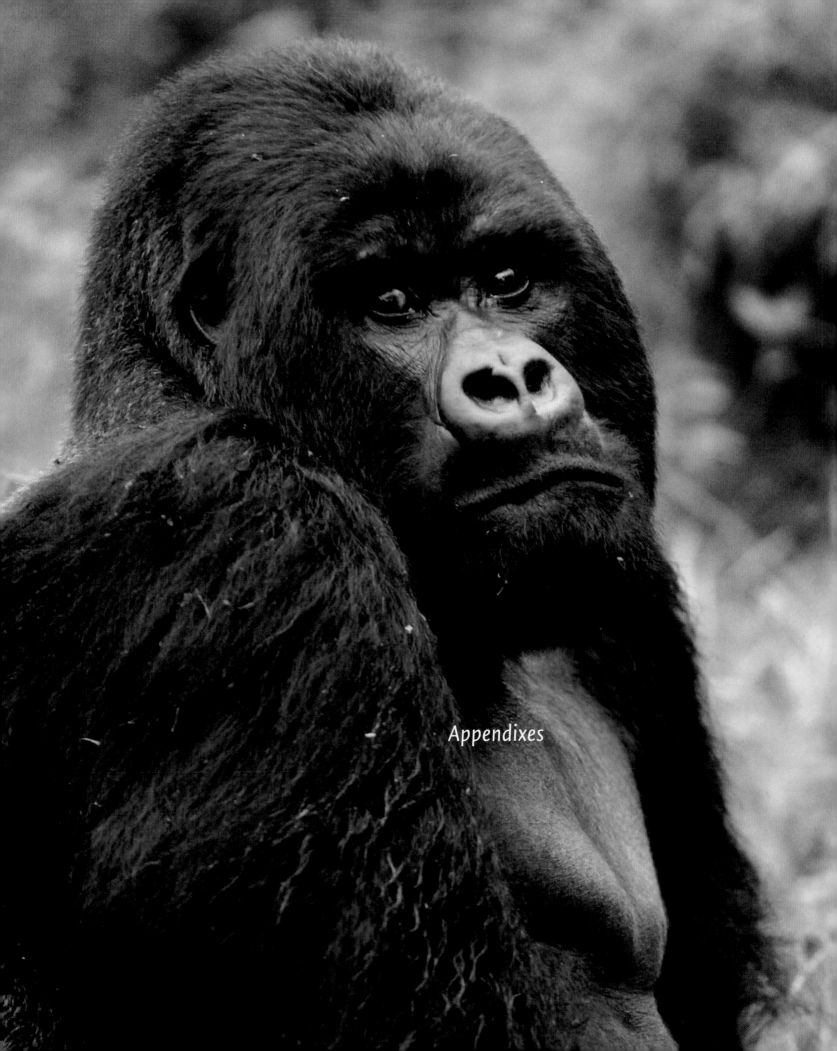

Appendixes

Appendix A

ORGANIZATIONS

Protected Area Authorities

Office Rwandaise du Tourisme et des Parcs Nationaux (ORTPN)

The Rwanda Tourism Board

Boulevard de la Révolution n° 1

PO Box 905

Kigali, Rwanda

Voice: +250 576514 or 573396

Fax: (250) 576515

Web: www.rwandatourism.com/home.htm

E-mail: reservation@rwandatourism.com

Institut Congolais pour la Conservacion de la Nature (ICCN)

Institut Congolais pour la Conservacion de la Nature (ICCN)

13, Avenue des Cliniques

Commune de la Gombe

B.P. 868 Kinshasa I

République Démocratique du Congo

Voice: 00243 8806065-00243 98277838-00243 98130296

E-mail: pdg.iccn@ic.cd

Uganda Wildlife Authority (UWA)

Uganda Wildlife Authority

Plot 7, Kiira Road

PO Box 3530

Kampala, Uganda

Voice: +256-41-355000

Fax: +256-41-346291

Web: www.uwa.or.ug

E-mail: uwa@uwa.or.ug

Institute for Tropical Forest Conservation (ITFC)

The Director
Institute of Tropical Forest Conservation
Mbarara University of Science and Technology
PO Box 44
Kabale
Uganda
Voice: +256 (0) 392 709753
Fax: +256 (0) 392 251753
Web: www.itfc.org
E-mail: info@itfc.org

MAX-PLANCK-GESELLSCHAFT

Max Planck Institute for Evolutionary Anthropology (MPIEA)

Max Planck Institute for Evolutionary Anthropology
Department of Primatology
Deutscher Platz 6
04103 Leipzig
Germany
Voice: +49 (341) 3550-0
Web: www.eva.mpg.de
E-mail: robbins@eva.mpg.de

Bwindi Mgahinga Conservation Trust (BMCT, formerly MBIFCT)

Geo Z. Dutki
Trust Administrator
Bwindi Trust House
Bwindi Mgahinga Conservation Trust
Plot 4, Coryndon Road
PO Box 1064
Kabale, Uganda
Voice: +256-486-424123
Fax: +256-486-424122
Web: www.bwinditrust.ug
E-mail: bmct@bwinditrust.ug

CARE

CARE USA
151 Ellis Street, NE
Atlanta, GA 30303-2440
USA
Voice: 404-681-2552
Voice: 800-521-CARE
Donor relations: 800-422-7385
Fax: 404-577-5977
Web: www.careusa.org
E-mail: info@care.org

The Dian Fossey Gorilla Fund International (DFGFI)

800 Cherokee Ave., SE
Atlanta, Georgia 30315-1440
USA
Voice: 800-851-0203
Voice: 404-624-5881
Fax: 404-624-5999
Web: www.gorillafund.org
E-mail: 2help@gorillafund.org

Mountain Gorilla Veterinary Project (MGVP)

MGVP, Inc.
c/o The Maryland Zoo in Baltimore
Druid Hill Park
Baltimore, Maryland 21217
Voice: 443-552-3385
Fax: 410-396-0300
Web (organization information): www.mgvp.org
Web (scientific information): mgvp.cfr.msstate.edu/mgvp/mgvp.htm
E-mail: mrcranfi@bcpl.net

**International Gorilla
Conservation Programme**

International Gorilla Conservation Program (IGCP)

Formed in 1991, IGCP comprises three
coalition partners: African Wildlife Foundation (AWF),
Fauna & Flora International (FFI), and the World Wide
Fund for Nature (WWF).

African Wildlife Foundation

1400 Sixteenth Street, NW

Suite 120

Washington, DC 20036

USA

Voice: +1 202 939 3333

Fax: +1 202 939 3332

Web: www.awf.org

E-mail: africanwildlife@awf.org

Fauna & Flora International

Great Eastern House

Tenison Road

Cambridge CB1 2TTUK

United Kingdom

Voice: + 44 (0) 1223 571000

Fax: +44 (0) 1223 461481

Web: www.fauna-flora.org

E-mail: africa@fauna-flora.org

WWF Eastern Africa Regional Programme Office (EARPO)

5th Floor of ACS Plaza Lenana Road No 1/1203

Nairobi

Kenya

Voice: +254 2 577355

Fax: +254 2 577389

Web: www.panda.org/earpo

E-mail: info@wwfearpo.org

Appendix B

Africa

Origins Safaris
Steve Turner
Voice: +254-(0)20-311191 or 222075
Fax: +254-(0)20-310698 or 216528
Web: www.originsafaris.info
E-mail: info@originsafaris.info

Silverback's Adventures
John Kayihura
Voice: +250 08304066 or +250 08520103 or
+250 08646291
Web: www.silverbacksadventures.rw
E-mail: info@silverbacksadventures.rw

United States

The Africa Adventure Company
5353 N Federal Highway, Suite 300
Fort Lauderdale, Florida 33308
USA
Voice: 954-491-8877
Toll free: 800-882-9453
Fax: 954-491-9060
Web: www.africanadventure.com
E-mail: noltingaac@aol.com

Europe

Volcanoes Safaris
PO Box 16345, London
SW1X 0ZD
Voice: +44 (0) 870 8708480
Fax: +44 (0) 870 8708481
Web: www.volcanoessafaris.com
E-mail: salesuk@volcanoessafaris.com
General inquiries: salesug@volcanoessafaris.com

Close Encounters LTD
Mercury House
Northgate
Nottingham
NG7 7FN
Voice: +44 (0) 870 094 8021
Web: www.closeencounters.travel
E-mail: kez@closeencounters.travel

SPAIN

Viajes El Corte Inglés
Viajes El Corte Inglés
Voice: 902 304020
Web: www.viajeselcorteingles.es
E-mail: tourmundial_paises@viajeseci.es

AUSTRALIA

African Wildlife Safaris
African Wildlife Safaris
1st Floor, 333 Clarendon Street
South Melbourne
VIC 3205
Australia
Voice: (61.3) 9249 3777
Fax: (61.3) 9696 4937
Web: www.aws.travel/
E-mail: info@africanwildlifesafaris.com.au

Appendix C

MILESTONES IN MOUNTAIN GORILLA CONSERVATION

1902—Scientific Discovery

While he is on a mission to visit Sultan Msinga of Rwanda, Captain Oscar von Beringe, a German explorer, shoots and kills two apes as he climbs Mt. Saby- inyo. One animal is sent to the Humboldt University Zoological Museum in Berlin, where it is later confirmed to be a new subspecies of gorilla. It is named in Captain von Beringe's honor. *Gorilla gorilla beringei* is later renamed *Gorilla beringei beringei* (see chapter 2).

1925—The First Steps for Conservation

An American named Carl Akeley convinces King Albert of Belgium to desig- nate the area surrounding the Virungas as a protected area and the gorillas as a protected species. Without this protection, there is little doubt that the moun- tain gorilla would have gone extinct by now, if for no other reason than loss of habitat (see chapter 17).

1959—The African Primate Expedition

George Schaller's work on the African Primate Expedition (A.P.E.) changes the very nature of our understanding of gorillas. Schaller spends a year of continu- ous observation and study of the life history of the mountain gorilla, the first long-term study of free-living gorillas ever conducted. Schaller details every aspect of ecology and behavior, including distribution, group dynamics, daily activities, social behavior, how the gorillas interacts with their environment, and the first census ever conducted of mountain gorillas (see chapter 17).

1967—The Karisoke Research Center

Dian Fossey continues the legacy of George Schaller's work as she sets up camp in the saddle area between two volcanoes, Mt. Karisimbi and Mt. Visoke, on the Rwandan side of the Virungas. On September 24, 1967, combining the names of the two mountains, the Karisoke Research Center (KRC) is born. The staff and visiting scientists of Karisoke study three or more of the habituated gorilla groups on the Rwandan side of the Virungas for the next forty years (see chapter 17).

1978—The Digit Fund

During the late 1970s, a series of tragic events occurs ultimately decimating one of the Karisoke gorilla research groups known as Group 4. On December 31, 1977, the silverback that Fossey had named Digit is killed and mutilated by poachers. Fossey establishes The Digit Fund in his memory in 1978. The money from the Digit Fund supports the Karisoke Research Center from that point on (see chapter 17).

1979—New Threats, New Ideas, and Alternative Approaches

A meeting is held at Karisoke with Dian Fossey, Robinson McIlvaine from the African Wildlife Foundation (AWF), Diana McMeeken, Bill Weber, Amy Vedder, Craig Sholley, and others to discuss the future of mountain gorilla conservation. The ideas that are circulated at the time combine protection and education with a full-blown, carefully structured tourism program. Those discussions and the exchange of ideas lead to the conception of what ultimately becomes the Mountain Gorilla Project (see chapter 18).

1979—The Mountain Gorilla Project

The British-based Fauna & Flora Preservation Society establishes a fund called the Mountain Gorilla Preservation Fund (MGPF) to raise money for gorilla conservation in the Virungas. The MGPF is designed specifically to work with Rwandan institutions to help the Rwandans better manage their own parks and protect their own natural resources. This fund would be used to create the Mountain Gorilla Project (MGP). The MGP is a three-tiered approach supporting antipoaching efforts, education, and a carefully managed tourism program. The work of the MGP is a crucial turning point in the future of mountain gorillas and creates the model for the rest of the region and ultimately is one of the significant determining factors in the attempts to secure the future of the mountain gorilla (see chapter 18).

1986—The Impenetrable Forest Conservation Project

The Bwindi forest faces tremendous challenges, including the theft of fuel wood, timber, bamboo, and poles; illegal grazing; smuggling of cattle, lumber, and gold; agricultural encroachment; and poaching. The pressure to make the forest reserve into a national park is on, and in 1986, Tom Butynski takes the lead as the director of the newly created Impenetrable Forest Conservation Project (IFCP). The work of the IFCP is an important part of the push for the forests at Bwindi and Mgahinga to be gazetted and eventually become national parks (see chapter 18).

1986—Dealing with Sick and Injured Gorillas

At the request of Dian Fossey, the Morris Animal Foundation (MAF) creates the Mountain Gorilla Veterinary Project (MGVP) in 1986 to help deal with sick and injured gorillas. With funding from MAF, the Volcano Veterinary Center is established by James Foster in Kinigi, Rwanda, in 1986. It later becomes the Mountain Gorilla Veterinary Project. In addition to helping to deal with the threats of poaching, a central focus of the MGVP is better understanding the cross-transmission of diseases (see chapter 18).

1987—The Ruhija Research Station

A research station is established at Ruhija in 1987 just inside the northeastern boundary of the Impenetrable Crown Forest Reserve. This station is the home of the Impenetrable Forest Conservation Project. A close program of collaboration, is established with CARE, by the creation of the Development Through Conservation project (DTC). The DTC trains and places fifty-five conservation extension assistants as links between the local communities and the DTC, providing conservation education and agroforestry information to the communities living around the park (see chapter 18).

1991—Institute for Tropical Forest Conservation

In Uganda, the Impenetrable Forest Conservation Project evolves into the Institute for Tropical Forest Conservation (ITFC). The ITFC functions as a research institute of the Mbarara University of Science and Technology and as a base of operations for visiting scientists similar to the Karisoke Research Center on the Rwandan side of the Virungas. The ITFC expands its focus beyond mountain gorillas to include the systematic inventory of fauna and flora and the initiation of conservation programs (see chapter 19).

1991—The International Gorilla Conservation Programme

The Mountain Gorilla Project evolves into the International Gorilla Conservation Programme (IGCP), with the formation of a formal coalition of several international conservation organizations. With a desire to broaden the scope and operate regionally in the overall landscape, IGCP focuses on critical conservation initiatives and works with many different stakeholders (see chapter 19).

1991—Civil War in Rwanda

After the Rwandan Patriotic Front (RPF) launches their initial invasion into Rwanda from their base of operations in Uganda, they maintain a presence in the Virunga Volcanoes for the period between January 1991 and 1994. Researchers and conservationists working in the Virungas are forced to evacuate several times during this period when the security situation deteriorates, which causes a major disruption to the monitoring of the gorillas (see chapters 14, 19).

1993—Habituation of Gorillas and the Development of Tourism in Bwindi

Having shown real benefits in the past for Rwanda, the push is on for gorilla tourism to be developed in Bwindi Impenetrable National Park (BINP). The International Gorilla Conservation Programme begins the habituation process with the Ugandan Game Departments rangers in 1991. BINP is opened for non-gorilla tourism in January 1993, and the first gorilla visits are made to the Mubare group in April 1993 (see chapter 19).

1994—The Impact of Conflict and the Refugee Crisis

The civil war that began in Rwanda in 1990 and the political unrest in the Democratic Republic of Congo in 1992 erupts into a catastrophic series of events, resulting in a genocide that would ultimately kill an estimated 800,000 people. In July 1994, following the war in Rwanda, hundreds of thousands of refugees cross into the DRC. They settled around the town of Goma, where they find what they were desperately seeking: water, firewood, and food, all provided by Virunga National Park (PNVi) and its immediate surroundings. In late 1994, the population of the refugees is estimated at 750,000 (see chapter 14).

1995—Mgahinga Bwindi Impenetrable Forest Conservation Trust

The first forest conservation trust fund in Africa is established by a Trust Deed under the Uganda Trust Act. It is called the Mgahinga Bwindi Impenetrable Forest Conservation Trust (MBIFCT). The purpose of the Trust is to support conservation activities and the biodiversity of the ecosystems in Bwindi Impenetrable National Park and Mgahinga Gorilla National Park.

1997—Ranger Based Monitoring in the DRC

The Ranger Based Monitoring program (RBM) is created by the International Gorilla Conservation Programme in response to a need for more information about the demographics and ranging patterns of the tourist groups of gorillas. There is also a need to better understand the nature of illegal activities within the park. The program is a tool for ecosystem surveillance and management of those ecosystems by park staff that uses a set of protocols for collecting data using low-tech methods that could be used by park staff conducting daily patrols (see chapter 20).

1998—Ranger Based Monitoring in Uganda

Data collection using the Ranger Based Monitoring techniques begins in Uganda (see chapter 20).

1998—*HuGo*

A workshop is held in Uganda with key stakeholders to discuss the problems that people living around Bwindi Impenetrable National Park suffer because of crop raiding from wild animals. The International Gorilla Conservation Programme in coordination with the Ugandan Wildlife Authority develop the HuGo program (Human Gorilla Conflict Program) to address the issues. The HuGo program institutes pilot programs for several solutions to the problems in Uganda and in Democratic Republic of Congo (see chapter 20).

1999—*Ranger Based Monitoring in Rwanda*

Data collection using the Ranger Based Monitoring techniques begins in Rwanda (see chapter 20).

1999—*Tourists Are Attacked in Bwindi and the Entire Region Is Affected*

Early on the morning of March 1, 1999, an attack occurs in Bwindi Impenetrable National Park (BINP). A large group of militia, believed to be *Interahamwe*, cross over the border from the Democratic Republic of Congo (DRC) to kidnap and subsequently murder eight tourists from the camps located across from the park headquarters. Several Ugandans and the warden of the park are also killed during the raid. The impact of this single event is enormous and is felt in Uganda, Rwanda, and DRC. Uganda's tourism program is severely affected as are the tourism programs in Rwanda and the DRC (see chapter 14).

2000—*An Attempt to Resettle Families in the Park Area in the Virungas*

In February 2000, the government of Rwanda plans to resettle families displaced by the war in an area within the park. The government had proposed a plan to degazette 627 hectares of the Parc National des Volcans, which represented about 5 percent of the remaining protected area, to make it available to 500 families from the Gishwati camp. The issue is ultimately presented to the president of Rwanda wherein the initiative is finally stopped.

2002—*A Resurgence in Direct Poaching of Mountain Gorillas*

After roughly an eighteen-year lull of mountain gorillas being killed or taken as a result of direct poaching, there is an extreme resurgence of gorilla poaching activity. Two adult females in the Susa group are killed, one infant is returned to the Susa group the following day but subsequently dies, and one more infant disappears. In a separate poaching incident in the Virungas that year, four additional adult gorillas are found dead and one infant is confiscated from poachers and dies after subsequent reintroduction attempts. In another incident in Bwindi, a poaching attempt is thwarted before it can be fully executed.

2003—Tourism Reopens in the DRC

Tourism to visit mountain gorillas is officially reopened in the Democratic Republic of Congo and tourists again began visiting the gorillas in Parc National des Virunga (PNVi). Although security problems still persist in varying sectors of the park on the Congo side of the Virungas, operations continue as the government works to further secure the area (see chapter 21).

2006—A Change in Strategy for Orphaned Gorillas

A Scientific Technical Steering Committee is created to explore the options for a possible reintroduction attempt for Maisha, a young female mountain gorilla. Maisha has been confiscated from poachers; therefore, a new strategy for reintroduction is developed in which she is maintained until behaviorally normal and the appropriate age for a normal female transfer between gorilla groups (see chapter 21).

2006—Transboundary Collaboration Agreement

A historic agreement is signed between the Democratic Republic of Congo, Rwanda, and Uganda to collaboratively manage the protected areas of the Central Albertine Rift in 2006. A ten-year transboundary strategic plan is agreed to that allows the wildlife conservation authorities of these three countries to work together to manage the rich and diverse ecosystems that lie across their borders (see chapter 21).

2007—Another Resurgence in the Poaching of Mountain Gorillas

Beginning in January, another resurgence in the deaths of mountain gorillas occurs in the Democratic Republic of Congo. Two gorillas are killed amid fighting between rebel and government forces. More gorillas are killed in May and June, and in July a silverback and three females (including a pregnant female) are shot, execution style, at close range making a total of nine gorillas killed in 2007 (see Afterword).

Appendix D

The following pages contain photos of vegetation commonly eaten by mountain gorillas in the Virunga and Bwindi forest environments. Additional photos are included that are indicative of the vegetation found in the designated habitat zones of each forest environment.

Habitat Zones of the Virunga Volcanoes

Zone: Alpine
Altitude: Above 11,800 ft (3,600 m)
Plant Shown: *Dendro senecio*

Areas above the limit of most herbaceous and woody plants, with low grass and mosses and occasional *Senecio johnstonii*. Bare rocky areas, especially on top of Mounts Mikeno and Sabyinyo are also included as Alpine.

Zone: Subalpine
Altitude: 10,800 ft (3,300 m) to 11,811 ft (3,600 m)
Plant Shown: *Dendro senecio*

High-altitude vegetation, up to 4–5 m in height, with abundant *Senecio johnstonii*, *Lobelia stuhlmanni*, and/or *L. wollostonii*, *Hypericum revolutum*, and *Rubus kirungensis*.

Zone: Brush Ridge
Altitude: 9,700 ft (2,950 m) to 10,800 ft (3,300 m)

Dense vegetation along the ridges and ravines on the sides of the volcanoes, with abundant *Hypericum revolutum* and shrubby growth of *Senecio mariettae*, reaching around 32 ft (10 m) in height.

Zone: Herbaceous
Altitude: 9,200 ft (2,800 m) to 10,800 ft (3,300 m)

Open areas with low 3–7 ft (1–2 m), dense herbaceous vegetation, generally on the sides of volcanoes, with very few *Hagenia abyssinica* and *Hypericum revolutum* trees.

Zone: Hagenia
Altitude: 9,000 ft (2,750 m) to 10,800 ft (3,300 m)
Plant Shown: *Hagenia abyssinica*

Equivalent to the "Saddle" zone of previous authors, a variable canopy woodland dominated by *Hagenia abyssinica* and *Hypericum revolutum* trees reaches up to 65 ft (20 m), with a dense herbaceous or, less frequently, grassy understory found in the saddles between certain volcanoes and on the less steep lower slopes.

Zone: Bamboo
Altitude: 8,400 ft (2,550 m) to
9,700 ft (2,950 m)
Plant Shown: Bamboo (*Yushinia alpina*)

Areas dominated by often monospecific stands of bamboo (generally 16 ft to 40 ft [5–12 m] high), mixed with a few trees and vines at lower altitudes.

Zone: *Mimulopsis*
Altitude: 8,400 ft (2,550 m) to 9,200 ft (2,800 m)

Open herbaceous areas, differing from the Herbaceous zone in being found at lower altitudes, generally in the flat saddle between Visoke and Sabyinyo and often dominated by *Mimulopsis excellens*.

Zone: Meadow
Altitude: 7,200 ft (2,200 m) to 12,100 ft (3,700 m)

Open grassy areas at a variety of altitudes. These areas are often marshy and contain very little gorilla food. A large, dry, shrubby area on the east side of Muhavura, which burned extensively in 1989, was included here as Meadow.

Zone: Mixed Forest
Altitude: 6,600 ft (2,000 m) to
8,400 ft (2,550 m)

A mixed-species montane forest, with abundant *Neobutonia macrocalyx* and *Dombeya goetzenii*. Other tree species include *Bersama abyssinica*, *Croton macrostachys*, *Clausena anisata*, *Maytenus heterophylla*, *Maesa lanceolata*, *Pygeum africanum*, and *Tabernaemontana johnstonii*. The open canopy reached up to 65 ft (20 m) high and the understory consisted of herbaceous vegetation, with dense patches of *Mimulopsis arborescens*.

Source: Alastair McNeilage, Diet and Habitat Use of Two Mountain Gorilla Groups in Contrasting Habitats in the Virungas, Chap. 10 in *Mountain Gorillas Three Decades of Research at Karisoke* (Cambridge University Press, Cambridge, 2001).

Foods Eaten by Mountain Gorillas in the Virunga Volcanoes

Giant Lobelia (*Lobelia gibberroa*)

Crassocephalum ducis

Vernonia aldofi fredricci

Carex bequaertii

Thistle (*Carduus nyassanus*)

Thistle (*Carduus leptacanthus*)

Eucalyptus (*Eucaluptus* sp.)—The gorillas come down out of the forest to eat the eucalyptus. They strip the bark and only eat the inside. This tree is an import and is also used for fuel wood.

Bamboo (*Yushania alpina*)—The leaves are eaten by the gorillas year round; however, the shoots are eaten only during the rainy season, when the plant is growing. The tough gray sheath is peeled away to get to the moist stem in the center.

Blackberry (*Rubus runsorensis*)—The leaves are eaten year round, and the fruits are eaten whenever they are available.

Bracken (*Pteridium aquilinum*)—This plant is eaten in the dry season.

Discopodium penninervum—The fruit of this plant is eaten all year long.

Basella Alba (*Rubus kirunge*)

Droguetia iners

Galium simense—This vine is eaten year round and is one of the most commonly eaten foods among mountain gorillas.

Large Stinging Nettles (*Girardinia bullosa*)—Grabbing or even accidently brushing up against one of these plants can be very painful. They have a sharp sting that can last for thirty minutes to an hour.

Small Stinging Nettles (*Laportea alatipes*)

Mikania capensis

Mountain Celery (*Peucedanum linderi*)—This herb is stripped and the center is eaten.

Plantago palmata—The gorillas will sometimes venture down and out of the forest to dig up this plant; they eat only the roots.

Pycnostachys goetzenii—This shrub is eaten year round.

Secamone africana—This vine is eaten year round and can be found in the Bamboo zone.

Urera hypselodendron Vernonia auriculifera Dendrosenecio adnivaris

Alchemilla johnstonii

Habitat Zones in Bwindi

Zone: Open Forest

A colonizing forest with noncontinuous canopy and characterized by mixed herbaceous ground cover of herbs and vines. In some valleys and lower slopes, a woody herb, *Mimulopsis arborescens*, that grows into large woody trees, is the dominant vegetation. When these plants die synchronously, it opens the understory to more light to create wide areas of herbaceous plants and vines. Trees are few and form a noncontinuous canopy cover; gap specialists such as *Neoboutonia macrocalyx*, *Allophyllus albisinicus* (Ruhija), *Milletia dura*, and *Albizia gummifera* (Buhoma) may be present. In some places, it is characterized by gaps dominated by herbaceous vines, such as *Serioitachys scandens* and *Mimulopsis* spp. When on slopes there might be a mixture of bracken ferns, herbs, and trailing vines or gaps dominated by bracken fern. Areas that result from clearings made by elephants, tree falls, and/or landslides also fall into this category. (*top*)

Zone: Mixed Forest

A habitat dominated by both understory and canopy trees and shrubs, usually interspersed with lianas and woody vines, especially *Mimulopsis* spp. The canopy is discontinuous, open, or partially closed. When on slopes in the Ruhija area, this forest type usually forms a transition between open forest and mature forest and is often dominated by a terrestrial woody shrub, *Alchornea hirtella*. In the Buhoma area, the ground layer is dominated by *Asplenium* and *Pteris* fern species or herbs. (*middle*)

Zone: Mature forest

A habitat with large, tall canopy trees that often bear lianas. The trees form a continuous canopy, and the undergrowth usually contains leaf litter and very scanty small herbs. In some places, the forest is stratified into tall canopy trees, a shrub layer with young trees whose diameter at breast height is <10 cm, and an herb layer with seedlings and saplings.

Zone: Swamp Forest

A habitat with temporary or permanent streams found on lower slopes or valleys. In a few places there may be some waterlogged open areas dominated by sedges. However, in most cases, it is composed of a mixture of herbs, vines, shrubs, and short trees usually found on the periphery of waterlogged swamp habitats. *Brillantaisia* spp. and *Mimulopsis arborescens* are often present. (*bottom*)

Zone: Riverine forest

A habitat with permanent or temporal streams or rivers and a continuous or open canopy. Dominant herbs include *Palisota mannii* and *Aframomum* spp.; dominant shrubs include *Brillantaisia* spp. The tree fern, *Cyathea manniana*, is often found here as well.

Zone: Regenerating forest

A previously anthropogenically disturbed (logged) habitat that may have been burned. Dominant vegetation includes grasses such as *Pennisetum purpureum*, sedges such as *Cyperus* spp., and the ferns of *Pteridium* spp. There are also herbs, vines, shrubs, and a few colonizing tree species such as *Maesa lanceolata* and *Xymalos monospora*.

Source: John Bosco Nkurunungi et al. A Comparison of Two Mountain Gorilla Habitats in Bwindi Impenetrable National Park, Uganda. *African Journal of Ecology* 42(2004): 289–297.

Foods Eaten by Mountain Gorillas in Bwindi

Mimulopsis solmsii

Blackberry (Rubus sp.)

Urera hypselodendron

Triumfetta cordifolia

Maesa lanceolata

Momordica foetida

Mimulopsis arborescens

Ipomea sp.

Momordica sp.

Lemonwood (*Xymalos monospora*)

Podocarpus milanjianus

Englerina woodfordioides

Ficus sp.

Chrysophyllum sp.

Vernonia calongensis

Olinia usambarensis

Piper capense

Myrianthus holsti

Olea sp.

Acronyms and Abbreviations

ACCRA: The ACCRA conference. In April of 1958 in Ghana, the ACCRA conference was held to host the Conference of Independent African States.

A.P.E.: The African Primate Expedition—The first study of free-living mountain gorillas conducted by Dr. George Schaller and Dr. John Emlen.

AWF: African Wildlife Foundation.

BINP: Bwindi Impenetrable National Park. A protected area in Uganda where mountain gorillas are found north and east of the Virunga Volcano Conservation area.

BM: Beetsme. The name of one of the Karisoke research groups of mountain gorillas in Parc National des Volcans in Rwanda.

CARE: A humanitarian organization fighting global poverty.

DFGFI: Dian Fossey Gorilla Fund International.

DFGFI-Europe: Dian Fossey Gorilla Fund Europe.

DRC: The Democratic Republic of Congo.

DTCP: Development Through Conservation Project.

FFI: Fauna & Flora International.

GMRTs: Gorilla Monitoring and Response Teams. These teams are part of the HuGo (Human Gorilla Conflict) program.

ha: Hectare. A unit of measure for land. One hectare equals 10,000 square meters.

HuGo: Human Gorilla Conflict Program. A program created and administered by IGCP, ICCN, and UWA to address conflict between gorillas and humans.

ICCN: Institut Congolais pour la Conservacion de la Nature. This is the Protected Area Authority for the Democratic Republic of Congo.

ICDPs: Integrated Conservation and Development Projects.

IFCP: Impenetrable Forest Conservation Project.

IGCP: International Gorilla Conservation Programme.

IMF: International Monetary Fund.

IPNB: Institute of the National Parks of Belgian Congo.

ITFC: Institute for Tropical Forest Conservation.

IUCN: International Union for the Conservation of Nature and Natural Resources.

IZCN: Zairean Institute for the Nature Conservation.

KRC: Karisoke Research Center.

LCSC: Local Community Steering Committee. The LCSC is the vital link between the communities and the Bwindi Mgahinga Conservation Trust. They are responsible for preselecting community projects, approving small project grants, and making recommendations for larger ones to the Trust Management Board.

MAF: Morris Animal Foundation.

MBCT: Mgahinga Bwindi Conservation Trust (formerly MBIFCT).

MBIFCT: Mgahinga and Bwindi Impenetrable Forest Conservation Trust.

MGNP: Mgahinga Gorilla National Park. This park is the Ugandan side of the Virunga Volcano Conservation area.

MGP: The Mountain Gorilla Project.

MGPF: Mountain Gorilla Preservation Fund.

MGVP: Mountain Gorilla Veterinary Project.

MPIEA: The Max Planck Institute for Evolutionary Anthropology.

NGO: Nongovernmental organization.

NTFPs: Non-timber forest products.

OCHA: Office for the Coordination of Humanitarian Affairs.

ORTPN: Office Rwandaise du Tourisme et des Parcs Nationaux. This is the Protected Area Authority for Rwanda.

PAAs: Protected Area Authorities. These are the government agencies responsible for the national parks in each country.

PNV: Parc National des Volcans. This park is the Rwandan side of the Virunga Volcano Conservation area.

PNVi: Parc National des Virunga. This park is the Congolese side of the Virunga Volcano Conservation area.

PRSP: Poverty Reduction Strategy Process. Developed by IMF and the World Bank to function like a template for the coordination and management of development efforts.

RBM: The Ranger Based Monitoring program was created by the IGCP in response to a need for more information about the demographics and ranging patterns of the tourist groups of gorillas, and to better understand the nature of illegal activities within the park.

RPF: The Rwandan Patriotic Front.

STSC: A Scientific Technical Steering Committee was created to explore the available options and make recommendations for the disposition of the orphaned infant mountain gorilla named Maisha.

UN: United Nations.

UNC: Uganda National Congress.

UNDP: United Nations Development Programme.

UNESCO: United Nations Educational, Scientific and Cultural Organization.

UNHCR: Office of the United Nations High Commissioner for Refugees.

UPC: Ugandan Peoples Congress—a successor to the UNC.

USAID: United States Agency for International Development.

USD: United States dollar.

UWA: Uganda Wildlife Authority.

VVR: Virunga Volcanoes Range.

WCS: Wildlife Conservation Society.

WTP: Willingness to Pay. A metric used when evaluating the non-use value of the forest.

WWF: World Wide Fund for Nature. One of the coalition partners that forms the International Gorilla Conservation Programme.

Sources and Suggested Reading

Abura-Ogwang, David. Establishment and Management of the Mgahinga and Bwindi Impenetrable Forest Conservation Trust (MBIFCT). Uganda.

Adams, W. M., and Mark Infield. 1998. Community Conservation At Mgahinga Gorilla National Park, Uganda. Paper No. 10. Community Conservation Research in Africa, Principles and Comparative Practice Working Papers. IDPM, University of Manchester, African Wildlife Foundation, Centre for Applied Social Sciences, University of Zimbabwe, and the Department of Geography, University of Cambridge.

African Ape Study Sites. Division of Social Sciences, University of California, San Diego. http://weber.ucsd.edu/~jmoore/apesites/ApeSite.html.

Ajayi, J. F. Ade, ed. 1998. *General History of Africa*. Vol. 6, *Africa in the Nineteenth Century until the 1880s*. James Currey, Oxford; UNESCO, Paris; University of California Press, Berkeley.

Ashley, Rebecca. 2005. Colonial Solutions, Contemporary Problems: Digging to the Root of Environmental Degradation in Kabale, Uganda. Agroforestry in Landscape Mosaics Working Paper Series. World Agroforestry Centre, Tropical Resources Institute of Yale University, and University of Georgia.

"*Australopithecus africanus*." Human Evolution at the Smithsonian Institution. www.mnh.si.edu/anthro/humanorigins/ha/afri.html.

Baumgartel, Walter. 1976. *Up among the Mountain Gorillas*. Hawthorn Books, New York and Robert Hale, London.

Beck, Benjamin B., Tara S. Stoinski, Michael Hutchins, Terry L. Maple, Bryan Norton, Andrew Rowan, Elizabeth F. Stevens, and Arnold Arluke, eds. 2001. *Great Apes & Humans: The Ethics of Coexistence*. Smithsonian Institution Press, Washington, DC.

Begun, David R. 2003. Planet of the Apes. *Scientific American* 289 (2): 79–83.

Begun, David R. 2004. The Three "Cs" of Behavioral Reconstruction in Fossil Primates. *Journal of Human Evolution* 46 (2004): 497–505.

Begun, David R., Erksin Güleç, and Denis Geraads. 2003. Dispersal Patterns of Eurasian Hominoids: Implications from Turkey. In Distribution and Migration of Tertiary Mammals in Eurasia: A Volume in Honour of Hans De Bruijn. J. W. F. Reumer and W. Wessels, eds. *Deinsea* 10:23–39.

Begun, David R., Carol V. Ward, and Michael D. Rose, eds. 1997. *Function, Phylogeny, and Fossils: Miocene Hominoid Evolution and Adaptations*. Plenum Press, New York.

Biryahwaho, Byamukama. Community Perspectives towards Management of Crop Raiding Animals: Experiences of Care-DTC with Communities Living Adjacent to Bwindi Impenetrable and Mgahinga Gorilla National Parks, Southwest Uganda. Wildlife Conservation Society.

Biswas, Asit K., and Cecilia Tortajada Quiroz. 1996. Environmental Impacts of Refugees: A Case Study. *Impact Assessment* 14: 21–40.

Boahen, A. Adu, ed. 1990. *General History of Africa*. Vol. 7, *Africa under Colonial Domination 1880–1935*. James Currey, Oxford; UNESCO, Paris; University of California Press, Berkeley.

Bonis, Louis De, George D. Koufos, and Peter Andrews, eds. 2001.

Hominoid Evolution and Climatic Change in Europe. Vol. 2, *Phylogeny of the Neogene Hominoid Primates of Eurasia*. Cambridge University Press, Cambridge.

Bradley, Brenda J., Martha M. Robbins, Elizabeth A. Williamson, Christophe Boesch, and Linda Vigilant. 2001. Assessing Male Reproductive Success in Wild Mountain Gorillas Using DNA Analysis. *Primate* 60 (1): 16–17.

Bradley, Brenda J., Martha M. Robbins, Elizabeth A. Williamson, H. Dieter Steklis, Netzin Gerald Steklis, Nadin Eckhardt, Christophe Boesch, and Linda Vigilant. 2005. Mountain Gorilla Tug-of-War: Silverbacks Have Limited Control over Reproduction in Multimale Groups. *Proceedings of the National Academy of Sciences* 102 (26): 9418–9423.

BSP Publications. Biodiversity Support Program. www.worldwildlife .org/bsp/publications/index.html.

Bush, Glenn. 2004. Conservation Management in Rwanda: A Review of Socio-economics and Ecosystem Values. Protected Area Biodiversity Project.

Bush, Glenn, Alphonse Kanobayita, Epimaque Rukingama, Anna Behm Masozera, George Wamukoya. 2005. Streamlining Poverty: Environment Linkages in the European Community's Development Assistance Report and Recommendations-Rwanda, Kigali.

Bush, Glenn, Simon Nampindo, Caroline Aguti, and Andrew Plumptre. 2004. The Value of Uganda's Forest: A Livelihoods and Ecosystems Approach. Albertine Rift Programme, EU Forest Resources Management and Conservation Programme, National Forest Authority.

Butynski, Thomas M. 1984. Ecological Survey of the Impenetrable (Bwindi) Forest, Uganda, and Recommendations for Its Conservation and Management. Wildlife Conservation International New York Zoological Society.

Butynski, Thomas M., and Jan Kalina. 1993. Three New Mountain National Parks for Uganda. *Oryx* 27 (4): 214–224.

Butynski, Thomas M., and Jan Kalina. 1998. Gorilla Tourism: A Critical Look. Chap. 12 in *Conservation of Biological Resources*. E. J. Milner-Gulland and Ruth Mace, eds. Blackwell Publishing, London.

Butynski, Thomas M., Samson E. Werikhe, and Jan Kalina. 1990. Status, Distribution and Conservation of the Mountain Gorilla in the Gorilla Game Reserve, Uganda. *Primate Conservation* 11:31–41.

Byamukama, James, and Stephen Asuma. 2006. Human-Gorilla Conflict Resolution (HuGo): The Uganda Experience. *Gorilla Journal*, no. 32, June. www.berggorilla.org/english/gjournal/texte/32hugo .html.

Bygott, David, and Jeannette Hanby. 1998. A Guidebook to Mgahinga Gorilla National Park and Bwindi Impenetrable National Park. Uganda Wildlife Authority.

Byrne, Richard W. 2001. Clever Hands: The Food-Processing Skills of Mountain Gorillas. Chap. 11 in *Mountain Gorillas: Three Decades of Research at Karisoke*. Cambridge University Press, Cambridge.

Carswell, Grace. 2003. Continuities in Environmental Narratives: The Case of Kabale, Uganda, 1930–2000. *Environment and History* 9 (2003): 3–29.

Causes of Death and Diseases of Gorillas in the Wild. 1994. *Gorilla Journal*, no. 9, December. www.berggorilla.de/english/gjournal/ texte/9disease.html.

Cousins, Don, and Michael A. Huffman. Michael A. 2002. Medicinal Properties in the Diet of Gorillas: An Ethno-Pharmacological Evaluation. Primate Research Institute, Kyoto University.

Cunningham, A. B. 1996. People, Park and Plant Use. Recommendations for Multiple-Use Zones and Development Alternatives around Bwindi Impenetrable National Park, Uganda. People and Plants Working Paper 4. UNESCO, Paris.

Demant, Alain, Patrick Lestrade, Ruananza T. Lubala, Ali B. Kampunzu, and Jacques Durieux. 1994. Volcanological and Petrological Evolution of Nyiragongo Volcano, Virunga Volcanic Field, Zaire. *Bulletin of Volcanology* (1994) 56:47–61.

Diamond, Jared. 1999. *Guns, Germs, and Steel: The Fates of Human Societies*. W. W. Norton, New York.

Dian Fossey Gorilla Fund International. 2005. *The Dian Fossey Gorilla Journal*, Spring.

Dian Fossey Gorilla Fund International. 2006. *The Dian Fossey Gorilla Journal*, Spring.

Dian Fossey Gorilla Fund International. 2006. *The Dian Fossey Gorilla Journal*, Winter.

Dutki, Geo Z. 2003. Mgahinga and Bwindi Impenetrable Forest Conservation Trust Fund (MBIFCT), Uganda. Vth World Parks Congress: Sustainable Finance Stream, Durban, South Africa.

Estes, Richard Despard. 1992. *The Behavior Guide to African Mammals*. University of California Press, Berkeley.

Fairhead, James, and Melissa Leach. 1995. False Forest History, Complicit Social Analysis: Rethinking Some West African Environmental Narratives. *World Development* 23 (6): 1023–1035.

Fleagle, John G., Charles H. Janson, and Kaye E. Reed, eds. 1999. *Primate Communities*. Cambridge University Press, Cambridge.

Fletcher, Alison. 2001. Development of Infant Independence from the Mother in Wild Mountain Gorillas. Chap. 6 in *Mountain Gorillas: Three Decades of Research at Karisoke*. Cambridge University Press, Cambridge.

Fossey, Dian. 1972. Vocalizations of the Mountain Gorilla (*Gorilla gorilla beringei*). *Animal Behaviour* 20:36–53.

Fossey, Dian. 1982. Reproduction among Free-Living Gorillas. *American Journal of Primatology*, 3 (Suppl. 1): 97–104.

Fossey, Dian. 1983. *Gorillas in the Mist.* Houghton Mifflin, New York.

Fossey, Dian. 1984. Infanticide in Mountain Gorillas (*Gorilla gorilla beringei*) with Comparative Notes on Chimpanzees. Pages 217–235 in *Infanticide, Comparative, and Evolutionary Perspectives.* G. Hausfater and S. Blaffer-Hrdy, eds. Aldine, New York.

Fossey, Dian, and Alexander H. Harcourt. 1977. Feeding Ecology of Free-Ranging Mountain Gorillas (*Gorilla gorilla beringei*). Pages 415–447 in *Primate Ecology: Studies of Feeding and Ranging Behaviour in Lemurs, Monkeys, And Apes.* T. H. Clutton-Brock, ed. Academic Press, London.

Ganas, Jessica, and Martha M. Robbins. 2004. Intrapopulation Differences in Ant Eating in the Mountain Gorillas of Bwindi Impenetrable National Park, Uganda. Max Planck Institute for Evolutionary Anthropology, Department of Primatology.

Ganas, Jessica, and Martha M. Robbins. 2005. Ranging Behavior of the Mountain Gorillas (*Gorilla beringei beringei*) in Bwindi Impenetrable National Park, Uganda: A Test of the Ecological Constraints Model. Max Planck Institute for Evolutionary Anthropology, Department of Primatology.

Ganas, Jessica, and Martha M. Robbins. 2006. Variability in Feeding Ecology between Groups of Mountain Gorillas (*Gorilla beringei beringei*) in Bwindi Impenetrable National Park, Uganda. Max Planck Institute for Evolutionary Anthropology, Department of Primatology.

Ganas, Jessica, Martha M. Robbins, John Boscoe Nkurunungi, Beth A. Kaplin, and Alastair McNeilage. 2004. Dietary Variability of Mountain Gorillas in Bwindi Impenetrable National Park, Uganda. *International Journal of Primatology* 25 (5): 1043–1072.

Geologic time scale. Wikipedia. http://en.wikipedia.org/wiki/Geologic_time_scale.

Global Volcanism Program. www.volcano.si.edu/.

Godwin, Sarah. 1990. *Gorillas.* Mallard Press, New York.

Gorilla Groups. Ape Alliance. www.4apes.com/gorilla/.

Gradstein, Felix M., James G. Ogg, and Alan G. Smith, eds. A Geologic Time Scale 2004. International Commission on Stratigraphy. www.stratigraphy.org/GTS04.pdf.

Gray, Maryke, Alastair McNeilage, Katie Fawcett, Martha Robbins, Benard Ssebide, Deo Mbula, and Prosper Uwingeli. 2005. Virunga Volcanoes Range Mountain Gorilla Census 2003. ICCN, UWA, ORTPN, B&RD, DFGF, DFGFI, IGCP, ITFC, MPIEA, WCS.

Groom, A. F. G. 1973. Squeezing out the Mountain Gorilla. *Oryx* 12: 207–215.

Groves, Colin. P. 2001. *Primate Taxonomy.* Smithsonian Institution Press, Washington, DC.

Groves, Colin. 2004. The What, Why and How of Primate Taxonomy. *International Journal of Primatology* 25 (5): 1105–1126.

Grubb, Peter, Thomas M. Butynski, John F. Oates, Simon K. Bearder, Todd R. Disotell, Colin P. Groves, and Thomas T. Struhsaker. 2003. Assessment of the Diversity of African Primates. *International Journal of Primatology* 24 (6): 1301–1357.

Hacia, Joseph G. 2001. Genome of the Apes. *Trends in Genetics* 17 (11): 637–645.

Harcourt, Alexander H. 1978. Strategies of Emigration and Transfer by Primates, with Particular Reference to Gorillas. *Zeitschrift für Tierpsychologie* 48:401–420.

Harcourt, Alexander H. 1979. Contrasts between Male Relationships in Wild Gorilla Groups. *Animal Behaviour* 5:39–49.

Harcourt, Alexander H. 1979. Social Relationships among Adult Female Mountain Gorillas. *Animal Behaviour* 27 (1): 251–264.

Harcourt, Alexander H. 1979. Social Relationships between Adult Male and Female Mountain Gorillas in the Wild. *Animal Behaviour* 27 (2): 325–342.

Harcourt, Alexander H. 1981. Gorilla Reproduction in the Wild. Chap. 10 in *Reproductive Biology of the Great Apes: Comparative and Biomedical Perspectives.* Charles E. Graham, ed. Academic Press, New York.

Harcourt, Alexander H. 1981. Intermale Competition and the Reproductive Behavior of the Great Apes. Chap. 12 in *Reproductive Biology of the Great Apes: Comparative and Biomedical Perspectives.* Charles E. Graham, ed. Academic Press, New York.

Harcourt, Alexander H. 1987. Behaviour of Wild Gorillas *Gorilla gorilla* and Their Management in Captivity. *International Zoo Yearbook* 26:248–255.

Harcourt, Alexander H., Dian Fossey, Kelly J. Stewart, and David P. Watts. 1980. Reproduction in Wild Gorillas and Some Comparisons with Chimpanzees. *Journal of Reproduction and Fertility,* Suppl. 28:59–70.

Harcourt, Alexander H., and J. Greenberg. 2001. Do Gorilla Females Join Males to Avoid Infanticide? A Quantitative Model. *Animal Behaviour* 62 (5): 905–915.

Harcourt, Alexander H., and A. F. G. Groom. 1972. Gorilla Census. *Oryx* 11:355–363.

Harcourt, Alexander H., P. H. Harvey, S. G. Larson, and R. V. Short. 1981. Testis Weight, Body Weight and Breeding System in Primates. *Nature* 293:55–57.

Harcourt, Alexander H., and Kelly J. Stewart. 1981. Gorilla Male Relationships: Can Differences during Immaturity Lead to Contrasting Reproductive Tactics in Adulthood? *Animal Behaviour* 29:206–210.

Harcourt, Alexander H., and Kelly J. Stewart. 1987. The Influence of Help in Contests on Dominance Rank in Primates: Hints from Gorillas. *Animal Behaviour* 35:182–190.

Harcourt, Alexander H., and Kelly J. Stewart. 1988. Functions of

Alliances in Contests within Wild Gorilla Groups. *Animal Behaviour* 109:176–190.

Harcourt, Alexander H., and Kelly J. Stewart. 2001. Vocal Relationships of Wild Mountain Gorillas. Chap. 9 in *Mountain Gorillas: Three Decades of Research at Karisoke*. Cambridge University Press, Cambridge.

Harcourt, Alexander H., Kelly S. Stewart, and Dian Fossey. 1976. Male Emigration and Female Transfer in Wild Mountain Gorilla. *Nature* 263:226–227.

Harrington, Spencer P. M. 1997. Earliest Agriculture in the New World. *Archaeology Magazine* 50, no. 4, July/August 1997. www.archaeology. org/9707/newsbriefs/squash.html.

Hartwig, Walter Carl, ed. 2002. *The Primate Fossil Record*. Cambridge University Press, Cambridge.

Hastings, Barkley E., David Kenny, Linda J. Lowenstine, and James W. Foster. 1991. Mountain Gorillas and Measles: Ontogeny of a Wildlife Vaccination Program. In the *Proceedings of the American Association of Zoo Veterinarians*. American Association of Zoo Veterinarians, Philadelphia.

Hatfield, Richard. 2005. Economic Value of the Bwindi and Virunga Gorilla Mountain Forests. AWF Working Papers, African Wildlife Foundation.

Hatfield, Richard, and Delphine Malleret-King. 2003. The Economic Value of the Bwindi and Virunga Gorilla Mountain Forests: A Report Submitted to the International Gorilla Conservation Programme (IGCP), Nairobi.

Hayes, Harold T. P. 1990. *The Dark Romance of Dian Fossey*. Simon & Schuster, New York.

Hill, Catherine M. 2002. People, Crops, and Wildlife: A Conflict of Interests. Pages 60–67 in *Human-Wildlife Conflict: Identifying the Problem and Possible Solutions*. C. Hill, F. Osborn, and A. J. Plumptre, eds. Albertine Rift Technical Report Series, Vol. 1. Wildlife Conservation Society, Bronx, NY.

Hochschild, Adam. 1999. *King Leopold's Ghost: A Story of Greed, Terror and Heroism in the Congo*. Mariner Books, New York.

Homsy, Jaco. 1999. Ape Tourism and Human Diseases: How Close Should We Get? A Critical Review of the Rules and Regulations Governing Park Management and Tourism for the Wild Mountain Gorilla, *Gorilla gorilla beringei*. International Gorilla Conservation Programme.

Hrbek I., and D. T. Niane, eds. 1992. *General History of Africa*. Vol. 3, *Africa from the Seventh to the Eleventh Century*. James Currey, London; UNESCO, Paris; University of California Press, Berkeley.

Human Genetics for the Social Sciences. *Evolutionary History of the Great Apes*. University of Colorado at Boulder, Department of Psychology.

http://psych.colorado.edu/hgss/hgssextrastuff/hgss_apes/hgss _apeevolution.htm.

Institut Congolais Pour la Conservacion de la Nature. www.iccnrdc .cd/.

Integrated Taxonomic Information System. www.itis.usda.gov/.

International Union for the Conservation of Nature and Natural Resources. 1994. World Heritage Nomination-IUCN Summary for Bwindi Impenetrable National Park (Uganda).

International Union for the Conservation of Nature and Natural Resources. 2000. *IUCN Guidelines For the Placement of Confiscated Animals*. IUCN, Gland.

Jensen-Seaman, M. I., and K. K. Kidd. 2001. Mitochondrial DNA Variation and Biogeography of Eastern Gorillas. *Molecular Ecology* 10:2241–2247.

Kalpers, José, Prosper Uwingeli, Justin Rurangirwa-Nyampeta, and Emmanuel Hakizimana. 2005. Volcanoes National Park, Park Management Plan 2005–2009. Office Rwandaise du Tourisme et des Parcs Nationaux.

Kalpers, José, Elizabeth A. Williamson, Martha M. Robbins, Alastair McNeilage, Augustin Nzamurambaho, Ndakasi Lola, and Ghad Mugiri. 2003. Gorillas in the Crossfire: Population Dynamics of the Virunga Mountain Gorillas over the Past Three Decades. *Oryx* 37: 326–337.

Kious, W. Jacquelyne, and Robert I. Tilling. 2002. *This Dynamic Earth: The Story of Plate Tectonics*. U.S. Geological Survey, Washington, DC. http://pubs.usgs.gov/gip/dynamic/dynamic.html.

Ki-Zerbo, J., ed. 1989. *General History of Africa*. Vol. 1, *Methodology and African Prehistory*. James Currey, London; UNESCO, Paris; University of California Press, Berkeley.

Ki-Zerbo, J., and D. T. Niane, eds. 1997. *General History of Africa*. Vol. IV, *Africa from the Twelfth to the Sixteenth Century*. James Currey, Oxford; UNESCO, Paris; University of California Press, Berkeley.

Kordos, Laszlo, and David R. Begun. 2002. Rudabánya: A Late Miocene Subtropical Swamp Deposit with Evidence of the Origin of the African Apes and Humans. *Evolutionary Anthropology* 11 (2): 45–47.

Lanjouw, Annette. 2002. International Gorilla Conservation Programme Profile. International Gorilla Conservation Programme, Nairobi.

Lanjouw, Annette. 2003. Building Partnerships in the Face of Political and Armed Crisis. International Gorilla Conservation Programme, Nairobi.

Lanjouw, Annette, Anecto Kayitare, and Helga Rainer. 2003. Transboundary Biodiversity Conservation in the Context of Regional Insecurity and Conflict. World Parks Congress, Durban.

Lanjouw, Annette, Anecto Kayitare, Helga Rainer, Eugène Rutaga-

rama, Mbake Sivha, Stephen Asuma, and José Kalpers. 2004. Transboundary Natural Resource Management: A Case Study by International Gorilla Conservation Programme in the Virunga-Bwindi Region, Nairobi.

Lukas, D., B. J. Bradley, A. M. Nsubuga, D. Doran-Sheehy, M. M. Robbins, and L. Vigilant. 2004. Major Histocompatibility Complex and Microsatellite Variation in Two Populations of Wild Gorillas. *Molecular Ecology* 13:3389–3402.

Makombo, John. 2003. Responding to the Challenge—How Protected Areas Can Best Provide Benefits beyond Boundaries, A Case Study of Bwindi Impenetrable National Park in Western Uganda. World Parks Congress, Durban.

Marchant, Robert, and David Taylor. 1997. Late Pleistocene and Holocene History at Mubwindi Swamp, Southwest Uganda. *Quaternary Research* 47:316–328.

Mazrui, Ali A., (Editor) and C. Wondji (Assistant Editor). 1999. *General History of Africa.* Unabridged ed. Vol. 8, *Africa since 1935.* James Currey, Oxford; UNESCO, Paris; University of California Press, Berkeley.

McNeilage, Alastair. 2001. Diet and Habitat Use of Two Mountain Gorilla Groups in Contrasting Habitats in the Virungas. Chap. 10 in *Mountain Gorillas: Three Decades of Research at Karisoke.* Cambridge University Press, Cambridge.

McNeilage, Alastair, Andrew J. Plumptre, Andrew Brock-Doyle, and Amy Vedder. 2001. Bwindi Impenetrable National Park, Uganda: Gorilla Census 1997. *Oryx* 35 (1): 39–47.

McNeilage, Alastair, and Martha M. Robbins. 2006. Bwindi-Impenetrable: 15 Years as a National Park. *Gorilla Journal of Berggorilla & Regenwald Direkthilfe* 32.

McNeilage, Alastair, Martha M. Robbins, Maryke Gray, William Olupot, Dennis Babaasa, Robert Bitariho, Aventino Kasangaki, Helga Rainer, Stephen Asuma, Ghad Mugiri, and Julia Baker. 2006. Census of the Mountain Gorilla *Gorilla beringei beringei* Population in Bwindi Impenetrable National Park, Uganda. *Oryx* 40:419–427.

Millwood, David, ed. 1996. The International Response to Conflict and Genocide: Lessons from the Rwanda Experience. Steering Committee of the Joint Evaluation of Emergency Assistance to Rwanda.

Minister of Finance and Economic Planning. 2004. *2003 Rwanda Development Indicators.* Pallotti-Press, Kigali.

Mokhtar, G., ed. 1990. *General History of Africa.* Vol. 2, *Ancient Civilizations of Africa.* James Currey, London; UNESCO, Paris; University of California Press, Berkeley.

Mountain Gorillas. Exploring the Environment. www.cotf.edu/ete/modules/mgorilla/mgvirungas.html.

Mountain Gorilla Veterinary Project. www.mgvp.org/.

Moyini, Yakobo. Analysis of the Economic Significance of Gorilla Tourism in Uganda. International Gorilla Conservation Programme, Nairobi.

Murphy, James. 2005. A World Heritage Species Case Study: Bwindi Gorillas, May 10.

Nadler, Ronald D. 1986. Sex-Related Behavior of Immature Wild Mountain Gorillas. *Developmental Psychobiology,* 19 (2): 125–137.

Nadler, Ronald D. 1989. Sexual Initiation in Wild Mountain Gorillas. *International Journal of Primatology* 10 (2): 81–92.

Nkurunungi, John Bosco, Jessica Ganas, Martha M. Robbins, and Craig B. Stanford. 2004. A Comparison of Two Mountain Gorilla Habitats in Bwindi Impenetrable National Park, Uganda. *African Journal of Ecology* 42:289–297.

Nsubuga, A. M., M. M. Robbins, A. D. Roeder, P. A. Morin, C. Boesch, and L. Vigilant. 2004. Factors Affecting the Amount of Genomic DNA Extracted from Ape Faeces and the Identification of an Improved Sample Storage Method. *Molecular Ecology* 13: 2089–2094.

Ogot, B. A., ed. 1999. *General History of Africa.* Vol. 5, *Africa from the Sixteenth to the Eighteenth Century.* James Currey, Oxford; UNESCO, Paris; University of California Press, Berkeley.

Orrego, Alfredo Jimeno for Dr. Ray Smyke. 1995. The Rwanda Crisis: Role of the International Community, Geneva.

Our Primate Origins: An Introduction. Human Evolution at the Smithsonian Institution. www.mnh.si.edu/anthro/humanorigins/ha/primate.html.

Owiunji, D., D. Nkuutu, I. Kujirakwinja, I. Liengola, A. Plumptre, Nsanzurwimo, K. Fawcett, M. Gray and A. McNeilage. 2004. The Biodiversity of the Virunga Volcanoes. WCS, DFGFI, ICCN, ORTPN, UWA, IGCP.

Plumptre, Andrew. n.d. Crop Raiding around the Parc National des Volcans, Rwanda: Farmer's Attitudes and Possible Links with Poaching. Wildlife Conservation Society.

Plumptre, Andrew. 2002. Extent and Status of the Forests in the Ugandan Albertine Rift. Albertine Rift Project.

Plumptre, Andrew J., M. Behangana, T. R. B. Davenport, C. Kahindo, R. Kityo, E. Ndomba, D. Nkuutu, I. Owiunji, P. Ssegawa, and G. Eilu. 2003. The Biodiversity of the Albertine Rift. Albertine Rift Technical Reports No. 3. http://albertinerift.org/arift-home/arift-publications/technicalreports.

Plumptre, Andrew J., A. Kayitare, H. Rainer, M. Gray, I. Munanura, N. Barakabuye, S. Asuma, M. Sivha, and A. Namara. 2004. The Socio-economic Status of People Living Near Protected Areas in the Central Albertine Rift. Albertine Rift Technical Reports No. 4. 127 pp.

Plumptre, Andrew J., Michel Masozera, and Amy Vedder. 2001.

The Impact of Civil War on the Conservation of Protected Areas in Rwanda. Biodiversity Support Program, Washington, DC.

Primate Info Net. The Wisconsin National Primate Research Center, University of Wisconsin. http://pin.primate.wisc.edu/.

Pringle, Heather. 1998. Neolithic Agriculture: The Slow Birth of Agriculture. *Science* 282 (5393): 1446. www.sciencemag.org/cgi/content/full/sci;282/5393/1446.

Quinn, Daniel. 1992. *Ishmael: An Adventure of the Mind and Spirit.* Bantam Books, New York.

Re-Introduction News (Newsletter of the Re-introduction Specialist Group of IUCN's Species Survial Commission). 2006. No. 25, April.

Richmond, Brian G., David R. Begun, and David S. Strait. 2001. Origin of Human Bipedalism: The Knuckle-Walking Hypothesis Revisited. *Yearbook of Physical Anthropology* 44:70–105.

Robbins, Andrew M., and Martha M. Robbins. 2005. Fitness Consequences of Dispersal Decisions for Male Mountain Gorillas (*Gorilla beringei beringei*). Max Planck Institute for Evolutionary Anthropology, Department of Primatology.

Robbins, Martha M. 1999. Male Mating Patterns in Wild Multimale Mountain Gorilla Groups. *Animal Behaviour* 57:1013–1020.

Robbins, Martha M. 2001. Variation in the Social System of Mountain Gorillas: The Male Perspective. Chap. 2 in *Mountain Gorillas Three Decades of Research at Karisoke.* Cambridge University Press, Cambridge.

Robbins, Martha M., and Alastair McNeilage. 2003. Home Range and Frugivory Patterns of Mountain Gorillas in Bwindi Impenetrable National Park, Uganda. *International Journal of Primatology* 24 (3): 467–491.

Robbins, Martha M., John Bosco Nkurunungi, and Alastair McNeilage. 2006. Variability of the Feeding Ecology of Eastern Gorillas. In *Feeding Ecology in Apes and Other Primates.* G. Hohmann, Martha M. Robbins, and Christophe Boesch, eds. Cambridge University Press, Cambridge.

Robbins, Martha M., and Andrew M. Robbins. 2004. Simulation of the Population Dynamics and Social Structure of the Virunga Mountain Gorillas. *American Journal of Primatology* 63:201–223 (2004).

Robbins, Martha M., Andrew M. Robbins, Netzin Gerald-Steklis, and H. Dieter Steklis. 2005. Long-term Dominance Relationships in Female Mountain Gorillas: Strength, Stability and Determinants of Rank. *Animal Behaviour* 142:779–809.

Robbins, Martha M., Pascale Sicotte, and Kelly Stewart, eds. 2001. *Mountain Gorillas: Three Decades of Research at Karisoke.* Cambridge University Press, Cambridge.

Roxburgh, Angus. 2005. Belgians Confront Colonial Past. *BBC News,* March. http://news.bbc.co.uk/1/hi/world/africa/4332605.stm.

Sarmiento, Esteban E., Thomas M. Butynski, and Jan Kalina. 1996.

Gorillas of Bwindi-Impenetrable Forest and the Virunga Volcanoes: Taxonomic Implications of Morphological and Ecological Differences. *American Journal of Primatology* 40:1–21.

Sarmiento, Esteban E., and John F. Oates. 2000. *The Cross River Gorillas: A Distinct Subspecies,* Gorilla gorilla diehli *Matschie 1904.* American Museum of Natural History, New York.

Schaller, George B. 1963. *The Mountain Gorilla: Ecology and Behavior.* University of Chicago Press, Chicago.

Schaller, George B. 1966. *The Year of the Gorilla.* University of Chicago Press, Chicago.

Seitsonen, Oula. 2004. Lithics after Stone Age in East Africa Wadh Lang'o Case Study. Master of Arts thesis, University of Helsinki.

Sicotte, Pascale. 1993. Inter-Group Encounters and Female Transfer in Mountain Gorillas: Influence of Group Composition on Male Behavior. *American Journal of Primatology* 30:21–36.

Sicotte, Pascale. 1994. Effect of Male Competition on Male-Female Relationships in Bi-male Groups of Mountain Gorillas. *Ethology* 97:47–64.

Sicotte, Pascale. 1995. Interpositions in Conflicts between Males in Bimale Groups of Mountain Gorillas. *Folia Primatologica* 65:14–24.

Sicotte, Pascale. 2000. A Case Study of Mother-Son Transfer in Mountain Gorillas. *Primates* 41:95–103.

Sicotte, Pascale. 2001. Female mate choice in mountain gorillas. Chap. 3 in *Mountain Gorillas Three Decades of Research at Karisoke.* Cambridge University Press, Cambridge.

Smuts, D., L. Cheney, R. M. Seyfarth, R. W. Wrangham, and T. Struhsaker. 1987. *Primate Societies.* Chicago, University of Chicago Press, pp. 155–164.

Space Radar Image of Karisoke & Virunga Volcanoes. NASA Planetary Photojournal. http://photojournal.jpl.nasa.gov/catalog/PIA01736.

Statistics for Tourists Visiting Parc National des Virungas. Provided by Honoré Mashagira, Provincial Director of North Kivu for Institut Congolais pour la Conservacion de la Nature.

Statistics for Tourists Visiting Parc National de Volcans. Provided by Rosette Chantal Rugamba, Director General of the Office Rwandaise du Tourisme et des Parcs Nationaux.

Stewart, Kelly. 2001. Social Relationships of Immature Gorillas and Silverbacks. Chap. 7 in *Mountain Gorillas Three Decades of Research at Karisoke.* Cambridge University Press, Cambridge.

Stewart, Kelly. 2003. *Gorillas Natural History and Conservation.* Voyageur Press, Stillwater, MN.

Stewart, Kelly J. 1977. The Birth of a Wild Mountain Gorilla (*Gorilla gorilla beringei*). *Primates.* 18 (4): 965–976.

Stewart, Kelly J. 1988. Suckling and Lactational Anoestrus in Wild Gorillas (*Gorilla gorilla*). *Journal of Reproduction and Fertility* 83:627–634.

Stewart, Kelly J., and Alexander H. Harcourt. 1987. Gorillas: Variations in Female Relationships. Pages 155–164 in *Primate Societies*. B. B. Smuts, D. L. Cheney, R. M. Seyfarth, R. W. Wrangham, and T. T. Struhsaker, eds. University of Chicago Press, Chicago.

Taylor, Andrea B., and Michele L. Goldsmith eds. 2003. *Gorilla Biology: A Multidisciplinary Perspective*. Cambridge University Press, Cambridge.

Taylor, Andrea B., and Colin P. Groves. 2003. Patterns of Mandibular Variation in *Pan* and *Gorilla* and Implications for African Ape Taxonomy. *Journal of Human Evolution* 44:529–561.

Thalmann, O., D. Serre, M. Hofreiter, D. Lukas, J. Eriksson, and L. Vigilant. 2005. Nuclear Insertions Help and Hinder Inference of the Evolutionary History of Gorilla mtDNA. *Molecular Ecology* 14:179–188.

Timeline: Emergency Situations and Their Impact on the Virunga Volcanoes. World Wildlife Fund. www.worldwildlife.org/bsp/publications/africa/144/timeline.htm.

The Uganda Agreement of 1900. www.buganda.com/buga1900.htm.

Uganda Wildlife Authority. 2001. Bwindi/Mgahinga Conservation Area General Management Plan. Uganda Wildlife Authority.

Uganda Wildlife Authority. 2002. Strategic Plan 2002–2007. Uganda Wildlife Authority.

UNEP World Conservation Monitoring Centre. www.unep-wcmc.org.

United Nations Environment Programme. 2005. Connecting Poverty and Ecosystem Services Focus on Rwanda. International Institute for Sustainable Development, Winnipeg.

Van der Linde, Harry, Judy Oglethorpe, Trevor Sandwith, Deborah Snelson, Yemeserach Tessema, Anada Tiéga, and Thomas Price. 2001. Beyond Boundaries: Transboundary Natural Resource Management in Sub-Saharan Africa. Biodiversity Support Program, Washington, DC.

Van der Veen, Lolke J., and Jean-Marie Hombert. 2001. On the Origin and Diffusion of Bantu: A Multidisciplinary Approach. Proceedings of the 32nd Annual Conference on African Languages (ACAL 32), Berkeley, CA.

Vedder, Amy L. 1984. Movement Patterns of a Group of Free-Ranging Mountain Gorillas (*Gorilla gorilla beringei*) and Their Relation to Food Availability. *American Journal of Primatology* 7:73–88.

Vigilant, Linda, and Brenda J. Bradley. 2004. Genetic Variation in Gorillas. *American Journal of Primatology* 64:161–172.

Virunga National Park. UNESCO World Heritage. http://whc.unesco.org/en/list/63.

Watts, David P. 1985. Relations between Group Size and Composition and Feeding Competition in Mountain Gorilla Groups. *Animal Behavior* 33:72–85.

Watts, David P. 1989. Ant Eating Behavior of Mountain Gorillas. *Primates* 30 (1): 121–125.

Watts, David P. 1989. Infanticide in Mountain Gorillas: New Cases and a Reconsideration of the Evidence. *Ethology* 81:1–18.

Watts, David P. 1990. Ecology of Gorillas and Its Relation to Female Transfer in Mountain Gorillas. *International Journal of Primatology* 11 (1): 21–45.

Watts, David P. 1990. Mountain Gorilla Life Histories, Reproductive Competition, and Sociosexual Behavior and Some Implications for Captive Husbandry. *Zoo Biology* 9:185–200.

Watts, David P. 1991. Harassment of Immigrant Female Mountain Gorillas by Resident Females. *Ethology* 89:135–153.

Watts, David P. 1991. Strategies of Habitat Use by Mountain Gorillas. *Folia Primatologica* 56:1–16.

Watts, David P. 1992. Social Relationships of Immigrant and Resident Female Mountain Gorillas. I. Male-Female Relationships. *American Journal of Primatology* 28:159–181.

Watts, David P. 1994. Agonistic Relationships between Female Mountain Gorillas. *Behavioral Ecology and Sociobiology* 34:347–358.

Watts, David P. 1994. The Influence of Male Mating Tactics on Habitat Use in Mountain Gorillas (*Gorilla gorilla beringei*). *Primates* 35 (1): 35–47.

Watts, David P. 1994. Social Relationships of Immigrant and Resident Female Mountain Gorillas. II. Relatedness, Residence, and Relationships between Females. *American Journal of Primatology* 32:13–30.

Watts, David P. 1995. Post-conflict Social Events in Wild Mountain Gorilllas (Mammalia, Hominoidea). I. Social Interactions between Opponents. *Ethology* 100:139–157.

Watts, David P. 1998. Long-Term Habitat Use by Mountain Gorillas (*Gorilla gorilla beringei*). 1. Consistency, Variation, and Home Range Size and Stability. *International Journal of Primatology* 19 (4): 651–680.

Watts, David P. 1998. Long-Term Habitat Use by Mountain Gorillas (*Gorilla gorilla beringei*). 2. Reuse of Foraging Areas in Relation to Resource Abundance, Quality, and Depletion. *International Journal of Primatology* 19 (4): 681–702.

Watts, David P. 1998. Seasonality in the Ecology and Life Histories of Mountain Gorillas (*Gorilla gorilla beringei*). *International Journal of Primatology* 19 (6): 929–948.

Watts, David P. 2000. Mountain Gorilla Habitat Use Strategies and Group Movements. Chap. 13: In *On the Move: How and Why Animals Travel in Groups*. Sue Boinski and Paul A. Garber, eds. University of Chicago Press, Chicago.

Watts, David P. 2001. Social Relationships of Female Mountain

Gorillas. Chap. 8 in *Mountain Gorillas Three Decades of Research at Karisoke*. Cambridge University Press, Cambridge.

Watts, David P., and A. E. Pusey. 1993. Behavior of juvenile and adolescent great apes. In *Juvenile Primates*. Michael E. Pereira, and Lynn A. Fairbanks, eds. Oxford University Press, New York.

Weber, A. W. 1983. Population Dynamics of the Virunga Gorillas: 1959–1978. *Biological Conservation* 26:341–366.

Weber, Bill, and Amy Vedder. 2001. In the Kingdom of Gorillas: Fragile Species in a Dangerous Land. Simon & Schuster, New York.

Whittier, Chris. 2002. Field Procedure Report: Poached Gorilla Post-Mortem Examinations. Mountain Gorilla Veterinary Project, Ruhengeri, Rwanda.

Whittier, Chris, and Eddy Kambale. 2006. Mountain Gorilla Veterinary Project Field Report: SEBAGABO, Mapuya Group, PNVi, Democratic Republic of Congo.

Whittier, Chris, Deo Mbula, Tony Mudakikwa, Katie Fawcett, and Maryke Gray. 2005. Report on Care and Disposition Recommendations. Confiscated Mountain Gorilla "MAISHA" Scientific Technical Steering Committee, Ruhengeri, Rwanda.

Wild, R. G., and J. Mutebi. 1996. Conservation through Community Use of Plant Resources. Establishing Collaborative Management at Bwindi Impenetrable and Mgahinga Gorilla National Parks, Uganda. People and Plants Working Paper 5. UNESCO, Paris.

Woodford, Michael H., Thomas M. Butynski, and William B. Karesh. 2002. Habituating the Great Apes: The Disease Risks. *Oryx* 36 (2): 153–160.

Yamagiwa, Juichi. 1986. Activity Rhythm and the Ranging of a Solitary Male Mountain Gorilla (*Gorilla gorilla beringei*). *Primates* 27 (3): 273–282.

Yamagiwa, Juichi. 1987. Intra-and Inter-group Interactions of an All-Male Group of Virunga Mountain Gorillas. *Primates* 28 (1): 1–30.

Yamagiwa, Juichi. 1987. Male Life History and the Social Structure of Wild Mountain Gorillas (*Gorilla gorilla beringei*). Pages 31–51 in *Evolution and Coadaptation in Biotic Communities*. S. Kawano, J. H. Connell, and T. Hidaka, eds. University of Tokyo Press, Tokyo.

Yamagiwa, Juichi, John Kahekwa, and Augustin Kanyunyi Basabose. 2003. Intra-specific Variation in Social Organizations of Gorillas: Implications for Their Social Evolution. *Primates* 44:359–369.

Yerkes, Robert M. 1927. *The Mind of a Gorilla*. Clark University, Worcester, MA.

Yerkes, Robert M., and Yerkes, Ada W. 1929. *The Great Apes: A Study of Anthropoid Life*. Yale University Press, New Haven, CT.

Index